



Annette Kuhn is Senior Professorial ⟨...⟩ ⟨...⟩s at Queen Mary University of London, a longstan ⟨...⟩ of the journal *Screen*, and a Fellow of the British Academ ⟨...⟩s published widely in the areas of cultural theory, visual culture, ⟨...⟩m history and cultural memory, with authored books including *Family Secrets: Acts of Memory and Imagination* (1995 and 2002); *An Everyday Magic: Cinema and Cultural Memory* (2002); *Ratcatcher* (2008); and (with Guy Westwell) *The Oxford Dictionary of Film Studies* (2012). She has edited and co-edited many anthologies, special issues of journals and reference books, including *Locating Memory: Photographic Acts* (with Kirsten Emiko McAllister, 2006) and *Screen Theorizing Today* (2009).

Little Madnesses

Winnicott, Transitional Phenomena
and Cultural Experience

Edited by Annette Kuhn

I.B. TAURIS

LONDON · NEW YORK

Published in 2013 by I.B.Tauris & Co Ltd
6 Salem Road, London W2 4BU
175 Fifth Avenue, New York NY 10010
www.ibtauris.com

Distributed in the United States and Canada Exclusively by Palgrave Macmillan
175 Fifth Avenue, New York NY 10010

ISBN: 978 178076 161 9

A full CIP record for this book is available from the British Library
A full CIP record is available from the Library of Congress

Library of Congress Catalog Card Number: available

Designed and typeset by 4word Ltd, Bristol
Printed and bound by CPI Group (UK) Ltd, Croydon, CR0 4YY

MIX
Paper from
responsible sources
FSC
www.fsc.org FSC® C013604

On the seashore of endless worlds children meet.

The infinite sky is motionless overhead and the restless water is boisterous. On the seashore of endless worlds the children meet with shouts and dances.

They build their houses with sand, and they play with empty shells. With withered leaves they weave their boats and smilingly float them on the vast deep. Children have their play on the seashore of worlds.

They know not how to swim, they know not how to cast nets. Pearl-fishers dive for pearls, merchants sail in their ships, while children gather pebbles and scatter them again. They seek not for hidden treasures, they know not how to cast nets.

The sea surges up with laughter, and pale gleams the smile of the sea-beach. Death-dealing waves sing meaningless ballads to the children, even like a mother while rocking her baby's cradle. The sea plays with children, and pale gleams the smile of the sea-beach.

On the seashore of endless worlds children meet. Tempest roams in the pathless sky, ships are wrecked in the trackless water, death is abroad and children play. On the seashore of endless worlds is the great meeting of children.

Rabindranath Tagore

Contents

List of Illustrations ix
List of Contributors xi
Foreword by Lesley Caldwell xv
Acknowledgements xxi

1. Little Madnesses: An Introduction 1
 Annette Kuhn

Part 1 Spaces and Frames **11**

2. Spaces and Frames: An Introduction 13
 Annette Kuhn

3. The Location of Virtual Experience 23
 Victor Burgin

4. The Playing Spectator 39
 Phyllis Creme

5. Home Is Where We Start From 53
 Annette Kuhn

6. Soundspace 65
 Amal Treacher Kabesh

Part 2 Media Users **77**

7. Media Users: An Introduction 79
 Matt Hills

8. Pleasure and Adult Development: 87
 Extending Winnicott into Late(r) Life
 C. Lee Harrington and Denise D. Bielby

9. Recoded Transitional Objects and Fan Re-readings 103
 of Puzzle Films
 Matt Hills

10. The Reality of the Experience of Fiction 121
 Serge Tisseron

11. On the Use of a Film: Cultural Experiences as 135
 Symbolic Resources
 Tania Zittoun

Part 3 Cultural Experience and Creativity 149

12. Cultural Experience and Creativity: An Introduction 151
 Patricia Townsend

13. Cultural Experience and the Gallery Film 159
 Annette Kuhn

14. Making Space 173
 Patricia Townsend

15. The Little Madnesses of Museums 187
 Myna Trustram

16. Found Objects and Mirroring Forms 203
 Kenneth Wright

Select Bibliography 215
Index 227

Illustrations

2.1	Winnicott's diagram of the transitional object	14
4.1	*Meet Me in St Louis:* An invitation into the film space – the greeting card	47
4.2	*Meet Me in St Louis:* Home – the Smith Family kitchen	49
9.1	*Inception:* Cobb (Leonardo DiCaprio) sees his children at the Limbo shoreline	104
9.2	*Inception:* the 'dream-share' world and Winnicott's diagram of the transitional object	107
9.3	The *Blade Runner* Collector's Set in its masculinised metallic box	115
9.4	A similarly masculinised metal carry-case for the *Inception* limited edition Blu-ray	115
14.1	*The Quick and the Dead*, video still	176
14.2	*Bay Mountain*, installation view	177
14.3	*Under the Skin*, animation still	178
15.1	Nickel silver spirit measure made to look like a thimble, made in England, 1880s	188
15.2	Miniature hourglass or egg timer, probably nineteenth century	191
15.3	Noah's Ark animals, made in England *c.*1850–1900. Note that one of the zebras is headless	197
15.4	Pewter spoon, made in England, *c.*1680s	197

Contributors

Denise D. Bielby is Professor of Sociology at the University of California, Santa Barbara, and holds affiliated appointments in the Department of Film and Media Studies and the Carsey-Wolf Center for Film, Television and New Media. She is the author of numerous scholarly publications on the culture industries of television and film, audiences and popular criticism and ageing and the life course. She is co-author (with C. Lee Harrington) of *Global TV* (2008), *Popular Culture* (2001) and *Soap Fans* (1995).

Victor Burgin is an artist and writer. He is Emeritus Professor of History of Consciousness at the University of California, Santa Cruz, Emeritus Professor of Fine Art at Goldsmiths College, University of London, and Professor of Media Philosophy at the European Graduate School, Saas-Fee, Switzerland. His cross-disciplinary work bridges media, culture and art; and his photographic and video work is represented in numerous public collections worldwide. His books include *In/Different Spaces* (1996), *The Remembered Film* (2004), *Components of a Practice* (2008), *Situational Aesthetics* (2009) and *Parallel Texts* (2011).

Lesley Caldwell is a psychoanalyst in private practice in London. She is an editor for the Winnicott Trust and chair of its Board of Trustees. She holds Senior Honorary Research Fellowships in the Italian department and the Psychoanalysis unit at University College London, where she organises the interfaculty seminar on psychoanalysis and contributes to the doctoral programme. Her publications include *Reading Winnicott* (2010, co-edited with Angela Joyce).

Phyllis Creme worked in educational development at University College London and has a background in the humanities. She has a longstanding interest in the relevance of Winnicott's ideas on play and creativity to both education and cinema, and her doctoral thesis was an exploration of playing, creativity and film spectatorship.

C. Lee Harrington is Professor of Sociology and affiliate of the Women's Studies Program at Miami University. She publishes in media studies, fan studies and the sociology of law, and is co-author of *Global TV* (2008) and *Soap Fans* (1995), and co-editor of *The Survival of Soap Operas* (2010), *Fandom* (2007), *Popular Culture* (2001), and of the journal *Popular Communication*.

Matt Hills is Professor in Film and TV Studies at the University of Aberystwyth. He has published widely on cult media and fandom, including books such as *Fan Cultures* (2002), *The Pleasures of Horror* (2005) and *Triumph of a Time Lord* (2010). His most recent book, a study of *Blade Runner*'s cult status, will be published in the 'Cultographies' series in 2012.

Amal Treacher Kabesh is Associate Professor in the School of Sociology and Social Policy at the University of Nottingham. She is currently completing a monograph entitled *Landscapes of Masculinities: In the Shadow of the Other*; and her publications focus on matters of subjectivity and emotions, bringing together psychoanalytic and cultural theory.

Annette Kuhn is Senior Professorial Fellow in Film Studies at Queen Mary University of London and a longstanding co-editor of the journal *Screen*. She has published widely in the areas of cultural theory, visual culture, film history and cultural memory, with authored books including *Family Secrets* (1995 and 2002), *An Everyday Magic* (2002), *Ratcatcher* (2008), and (with Guy Westwell) *The Oxford Dictionary of Film Studies* (2012).

Serge Tisseron is a psychiatrist and psychoanalyst, and Director of Research in the Université de Paris X. His interests include people's engagements with different kinds of images, especially comic strips, television and film; and his 40 or so books include *Comment Hitchcock m'a guéri* (2003) and *Qui a peur des jeux vidéo?* (2008, with Isabelle Grevillon). His work has been translated into 14 languages. www.sergetisseron.com

Patricia Townsend is an artist and a psychoanalytic psychotherapist. She was formerly a consultant psychotherapist in the NHS and is currently enrolled on a doctoral programme at the Slade School of Fine Art. Her thesis examines the artistic process from a psychoanalytic standpoint, drawing particularly on the work of Winnicott. www.patriciatownsend.co.uk

Myna Trustram is an independent arts and heritage consultant. She began her career as a social historian (*Women of the Regiment: Marriage and the Victorian Army*, 1984) and then held curatorial, management and research posts in museums and galleries. Recent trainings from the Tavistock Institute, the Tavistock Clinic and Group Analysis North influence her current work, which investigates the symbolic meanings of museums and their collections.

Kenneth Wright is a psychoanalyst in private practice and a Patron of the Squiggle Foundation. A well-known commentator on Winnicott, his books include *Vision and Separation: Between Mother and Baby* (1991) and *Mirroring and Attunement: Self-Realization in Psychoanalysis and Art* (2009).

Tania Zittoun is Professor of Psychology and Education in the University of Neuchâtel (Switzerland). A sociocultural psychologist, she is interested in the role of fiction in people's development, and her work also draws on the psychoanalytical tradition. Her books include *Donner la vie, choisir un nom: engendrements symboliques* (2005), *Transitions: Development Through Symbolic Resources* (2006) and (with co-editor Sergio Salvatore) *Cultural Psychology and Psychoanalysis: Pathways to a Synthesis* (2011).

Foreword

Lesley Caldwell

In this collection, which grew out of a workshop series under her coordination, Annette Kuhn makes a plea for the revitalisation of cultural theory through the exploration and utilisation of object-relations, particularly the work on transitional objects and transitional phenomena of the psychoanalyst and paediatrician Donald Winnicott. *Little Madnesses* brings together critics, curators, artists, academics and clinicians concerned with the understanding of cultural texts, of those who consume them as viewers and readers, and of those who produce them. In so doing, it provides testimony to the wealth of ideas originating in a serious engagement with a major figure of British psychoanalysis who was dedicated to bringing psychoanalytic ideas to wider audiences. To work on cultural and aesthetic experience in this tradition is to raise the common ground between the infant and the mother/first caregiver and the baby's dependence on that relationship for survival and growth. The contributors to this volume show the potential of this approach in their engagements with a range of diverse material, brought together by Winnicott's own questions about the unconscious links between body, mind and cultural experience established in a mental space that emerges simultaneously with the materialisation of the earliest sense of self.

In proposing that the sources of imaginative production and pleasure reside in the mind's ongoing encounters with others – both real and imaginary – in a space he termed 'potential', Winnicott linked the human ability to inhabit such a space, to be there, to the early emotional life of the infant. 'What are we doing' he asks, 'when we are listening to a Beethoven symphony or going to a picture gallery and what is a child doing when sitting on the floor playing with toys under the aegis of

the mother? And where are we (if anywhere at all) when we are doing what in fact we do a great deal of our time, namely enjoying ourselves?' (Winnicott 2005f: 142). These questions are located in an account of emotional development that reverses the primacy of the drives of the Freudian legacy, arguing that the first task of the infant is the establishment of a separate self: only then can the baby recognise his or her own desire as his or her own. That is, an awareness of self and other involves the establishment of a state of mind that allows 'creativity as a colouring of the whole attitude to external reality (Winnicott 2005c: 87). Through the temporal dimension of 'going on being' provided by the mother, a spatial dimension that is both conceptual and psychical emerges: its existence facilitates the baby's separateness, and later the ordinary satisfactions of the adult (Winnicott 2005a).

One of the areas discussed in this book is that of being a cultural producer. This involves putting something personal and specific into a general arena (culture) to be shared, used and commented upon by others. It is the 'place' where these artefacts exist – its shape and delineation, and how it is characterised for the individual – that is psychoanalytically significant. What might be involved in the capacity to make and to make use of these artefacts, and how their use enables the person to be 'with' himself or herself, is increasingly identified by Winnicott as central to the aims of psychoanalysis and to what it means to be alive. Winnicott makes producer and consumer equivalent inasmuch as they use and make use of something in different ways. What consumer and producer share is the capacity to draw upon an internal place where each can put a symbolic object imbued with the creativity of the one and simultaneously eliciting the other's wish to engage with it. The space created for the reader/ viewer partakes of the space belonging to, and initially used by, its creator. Something of personal significance has a more general resonance. For Winnicott, creative work involves the way psychic location and mental space shape relations with self, with others, in memory and in the work of culture. This is part of what the idea of transitional space develops.

Discussion of transitional objects and transitional phenomena and what they offer links a clinical theory and practice which emphasises Winnicott as the pre-eminent psychoanalyst of health and of what it means to be a healthy individual, a perspective often lacking in psychoanalysis's concern for treatment modalities and the understanding of the mind in difficulty. But if Winnicott stressed the normality of the transitional object, he also acknowledged its availability for

pathological use, and its relevance to the clinician in conditions like addiction, obsessionality and perversion. A close reading of the two published versions (Winnicott 1953; 2005a) of 'Transitional objects and transitional phenomena', together with the transcript of the original 1951 paper held in the Wellcome Library's archives, reveals the author's ongoing debate with himself and his revisitings and revisions of these ideas on the basis of continuing clinical experience and wide response from the psychoanalytic community. *Playing and Reality* (first published in 1971), whose first chapter is substantially a reprinting of the earlier version, nonetheless revises it and gestures towards some possible shifts of emphasis in the account of the transitional object. Neither of the two clinical examples included in this 1971 version supports the non-pathological use of a transitional object: their inclusion is strangely unsatisfactory, an inconclusive response to the complexity of this, Winnicott's best-known contribution.

But his commitment to the wider arena of potential space, the predominant emphasis adopted in *Little Madnesses*, is attested by his claim that it is *Playing and Reality* in its entirety that constitutes a sustained reflection on transitional phenomena and their importance for clinical psychoanalysis and a psychoanalytic investigation of cultural experience. The project of *Playing and Reality* contains the distillation of a lifetime of clinical work, and it is Winnicott's interest in patients who cannot play or occupy the transitional arena that informs it. The papers on playing, creativity, psychical location and the split-off male and female elements to be found in men and women lend themselves to debates about aesthetic experience in ways that extend beyond Freud's reductionism in cultural matters. They are themes embedded in theoretical advance and discussions of clinical technique in which psychoanalysts are still engaged. The papers on 'The use of an object' (Winnicott 2005d) and 'The mirror role of mother and family in child development,' (Winnicott 2005g), significant contributions respectively to a psychoanalytic theory of aggression and to the widening implications of the infantile acquisition of selfhood, also offer much to understanding cultural encounters and transitionality.

Playing as a creative experience in the space-time continuum is most thoroughly described, because to arrive at a first rudimentary capacity to inhabit the transitional area, then to play, later to dream, and later still to engage in an analysis, involves those processes of illusion and disillusion that, for Winnicott, form the basis of the child's earliest contacts. Playing involves a relation with, and a care of, the self, it

is a form of living well (Winnicott 2005b), and a mature capacity for playing depends on an ability to distinguish reality from fantasy and past from present; to give a space to the creative imagination which is neither delusional nor literal. In condensing both first symbol and first possession, the baby's transitional object gathers together a material object and a framework for thinking about it. This leads on to its implications for adult cultural life.

A psychoanalytic investigation of cultural experience and a revaluation of ordinary life and ordinary satisfactions that draws on Winnicott involves an interrogation of the existence of a sustaining self, a self able to engage with and make use of the world, of relationships with persons and things located in 'the *potential space* between the individual and the environment,' a space of 'maximally intense experiences' (Winnicott 2005e: 138). Christopher Bollas's paper, 'The transformational object' (Bollas 2011) develops the idea of the mother's provision of a continuity of being as the condition of separateness and the illusion that enables it: in emphasising the first 'environment mother' as a process (from the point of view of the baby), Bollas ties her/this process to 'cumulative internal and external transformations' (2011: 2). A 'transformational object' is first experientially identified by the infant with processes that alter self-experience at Winnicott's 'relating to an object' stage (what Bollas terms a 'recurrent experience of being').

The mother's holding facilitates a 'coming into being' and then a 'going on being' – both processes of transformation. Bollas extends this to adult life, where an object is sought for its 'function as a signifier of transformation'. Here, the object forms part of a psychic inventory of refinding or further elaborating the early processes through which the self emerged. Art continues these infantile transformational experiences in what it offers of the pleasures of self development, enjoyment and knowledge. The early mother-infant dyad remains as a memory trace shaping the adult's encounter with the object-world. With Winnicott, Bollas maintains the object's potential for hope: even in conditions of emotional difficulty, the search is for the traces of an early self embedded in the relation with the mother. In this account, compulsive behaviour is the symptom of a search for something that was there, and then withdrawn or lost: this hinges on a particular kind of understanding of deprivation as a wish to mend the ego structure. Bollas illustrates this by a discussion of both the artwork and the clinical situation. Winnicott relates the object's becoming an object – its recognition as external and independent – to the active nature of the

drive, which carries a ruthlessness that instantiates the existence of the world of the subject and of external reality. His proposal of the creation of the object through its being placed beyond the self, beyond the infant's control, through the very same process that creates the infant as itself a separate unit through the loss of the external object as a subjective object is the theoretical advance of Winnicott's great 1968 paper, 'The use of an object and relating through identifications' (Winnicott 2005d).

The ability to use the creative basis of destructiveness and the necessary aggression that forms part of the creativity of everyday life and of the work of art was initially dependent on the non-retaliatory response of the mother, that is, the actual role of the external object. This is vital to the process of 'being found instead of placed by the subject in the world'. The 'I' of the infant subject, constituted along with the subjectivity of the object, the real mother who survives, is the guarantor of the continuing existence of an alive internal object. The otherness of the object and of external reality, created out of the infant's destroying it, makes the child's destructiveness of the (internal) object as the infant's omnipotent creation an agent of transformation that continues in unconscious fantasy. But only the healthy individual can sustain these inevitably conflictual aspects of the psychical apparatus. An undeveloped internal relationship with fantasised subjective objects, a failure to develop the internal spaces that facilitate negotiation with otherness, may keep the person safe from an encounter with the world, but at the cost of really being alive. Winnicott develops the essential place of internal conflict established in the second Freudian model. Being able to use that conflict is the mark of the healthy individual and of the creativity he argues for as a common capacity of cultural producer and consumer.

In *Little Madnesses*, the interest in space and frame and in the changing forms of media and art and how these may be understood sit alongside a consistent attention to the kinds of interstitial skills deployed by cultural users and makers. The aim of *Little Madnesses* is to extend discussion of the person and the experience of being alive through research into cultural practices and cultural forms not traditionally considered psychoanalytic, by drawing on the psychoanalytic account deriving from Donald Winnicott. In so doing, Winnicott's work may find other audiences, while across a range of disciplines research into, and understanding of, cultural and aesthetic experience stand to be enriched.

References

Bollas, Christopher (2011). 'The transformational object', *The Christopher Bollas Reader*, New York: Routledge, 1–12.

Winnicott, Donald W. (1953). 'Transitional objects and transitional phenomena: a study of the first not-me possession', *International Journal of Psycho-Analysis* 34, 89–97.

——— (2005). *Playing and Reality*, 2nd edn., Routledge Classics; London: Routledge.

——— (2005a). 'Transitional objects and phenomena', Chapter 1 of *Playing and Reality*, 1–34.

——— (2005b). 'Playing: a theoretical statement', Chapter 3 of *Playing and Reality*, 51–70.

——— (2005c). 'Creativity and its origins', Chapter 5 of *Playing and Reality*, 87–114.

——— (2005d). 'The use of an object and relating through identifications', Chapter 6 of *Playing and Reality*, 115–127.

——— (2005e). 'The location of cultural experience', Chapter 7 of *Playing and Reality*, 128–139.

——— (2005f). 'The place where we live', Chapter 8 of *Playing and Reality*, 140–148.

——— (2005g). 'Mirror role of mother and family in child development', Chapter 9 of *Playing and Reality*, 149–159.

Acknowledgements

Little Madnesses had its beginnings in a period of study leave funded by the Arts and Humanities Research Council. One of the objectives for the sabbatical was to pursue a longstanding interest in the work of D.W. Winnicott and what it might offer to the study and understanding of films and cinema. This eventually led to the formation of the Transitional Phenomena and Cultural Experience study group (T-PACE: http://www.sllf.qmul.ac.uk/filmstudies/t_pace/index.html), which consists of colleagues from a number of universities and disciplinary backgrounds – the latter including, as well as film studies, cultural psychology, cultural studies, film studies, media studies and practice-based research in photography and video. The founding members of T-PACE were Suzy Gordon, Matt Hills, Patricia Townsend, Amal Treacher Kabesh and Tania Zittoun, with myself as convenor; the group was later joined by Phyllis Creme. From late 2006, T-PACE held regular meetings to discuss the ideas and writings of Winnicott and others, and to share our own work. Between 2008 and 2010 the group benefited from funding, provided through the British Academy's Small Research Grant scheme, that covered members' costs in attending meetings and made it possible to arrange three one-day workshops (hosted by Queen Mary University of London, the University of Cardiff and University College London) with invited speakers and discussants, whose topics ultimately shaped the contents of *Little Madnesses*.

I should like to express my gratitude to all the members of T-PACE, past and present, for their commitment to the project, and in particular Amal Treacher Kabesh, Matt Hills, Tania Zittoun and Patricia Townsend for their contributions to the organisation of the

workshops. For their contribution to workshop debates, thanks are due to all participants and especially to speakers Amanda Bingley, Claire Pajaczkowska and Emma Wilson (The Kinesis of Spaces and Frames, September 2008); Seth Giddings, Helena Kennedy and Joanne Whitehouse-Hart (Media Users, April 2009); and Sharon Morris and Kenneth Wright (Transitional Space, Cultural Practice and Creativity, November 2009). I am most grateful to I.B.Tauris, and especially to Philippa Brewster, for their confidence in and continuing support for this project; to Jean Barr, who read and commented on several draft chapters; and to Lesley Caldwell, who generously contributed the Foreword. The work of the late Roger Silverstone has been a source of inspiration from the beginning.

Winnicott's sketch of the transitional object (Figures 2.1 and 9.2) is reproduced by permission of the Marsh Agency on behalf of the Winnicott Trust. Thanks are due to the author and to the editor of *L'Homme* for permission to publish my translation of Serge Tisseron's 'La réalité de l'expérience de fiction' as Chapter 10. Figures 15.1, 15.3 and 15.4 are reproduced courtesy of Ben Blackall, and Figure 15.2 by permission of Manchester City Galleries. Rabindranath Tagore's poem 'On the seashore' is from *The Crescent Moon*, an anthology of poems translated from the original Bengali by the author and published in 1913 by Macmillan & Co.

1 Little Madnesses: An Introduction

Annette Kuhn

The aim of this book is to develop and revitalise cultural theory, cultural practice and cultural policy by exploring the potential of the concepts of *transitional objects* and *transitional phenomena* to extend and deepen understanding of a range of aspects of cultural experience. These terms were introduced into object-relations psychoanalysis by the British paediatrician and child analyst Donald Woods Winnicott (1896–1971), who also gave the evocative name of 'little madnesses' to people's most intensely felt enthusiasms, emotional investments and attachments within the sphere of culture.

Winnicott's ideas are complex and nuanced, but he wrote and spoke them – in wide-ranging venues including specialised clinical papers, books and articles directed at parents and educators, and popular radio talks on childcare, parenting, and issues of adolescence – with beguiling and deceptive clarity (Winnicott 1964; Winnicott 1965; Winnicott 1986; Winnicott 2002).[1] There is something pragmatic, kindly and accessible about his words that invokes in the reader or the listener a sense of recognition and concurrence rather than a critical response or an exegetical impulse. Winnicott makes sense. The situations, set-ups, feelings and relationships that he described feel intuitively familiar: they chime with what we already know about ourselves, while opening up fresh insights. They portray a recognisable world of attachments, and of ways of living well through our attachments: a world that Winnicott came to understand in a practical way, by observing the behaviour of adults, adolescents, children and infants for whom these attachments have been skewed or have failed; as well as of people who started life in an ordinary 'good enough' environment.

Along with the other contributors to *Little Madnesses*, I would say that Winnicott's ideas are not the kind which lend themselves to being 'applied' in an after-the-fact manner. What they do, rather, is offer fresh ways of thinking about one's current concerns – issues and questions that one is already thinking about or working on. One's own thinking and preoccupations are engaged, in other words. In a very Winnicottian way (we shall see what this means later), Winnicott's ideas seem to offer exactly the kind of discovery or answer you were unaware of seeking. One of Winnicott's many appealing maxims is: 'if I knew what I was doing, it wouldn't be research'. This piece of wisdom seems especially apt here. If this introduction conveys a different impression – perhaps that the contributors to *Little Madnesses* regard themselves as 'applying' Winnicott's ideas to something else, be that 'something else' cinema, perambulation, video games, or aesthetics, say – it will have failed to convey the open-minded spirit of enquiry that motivates this book. For once in contact with Winnicottian thinking, the 'something else' in question has a way of turning into a rather different, and usually surprising, something else.

* * *

Winnicott's distinctive contribution to conceptualising the psycho-dynamics of cultural experience lay in his model of the processes through which humans develop a relationship, comfortable or otherwise, between the inner world of the psyche and the external world of objects. If well-balanced, Winnicott argued, this relationship is at the heart of the feeling that life is satisfying and enjoyable. It begins with the infant's 'theoretical first feed'. This is a reference to the baby's discovery, as if all by itself, of the source of the food it needs; and to the experiencing of itself as creator of the needed object (the breast). This originary pattern of object-relating hinges upon illusion – 'the mother makes it possible for the baby to have the illusion that the breast... has been created by impulse out of need' (Winnicott 1988: 101) – and gives the baby confidence that the desired object can always be found, and thus the capacity to tolerate its absence. This is the grounding for the infant's emergence from a state of fusion into involvement with external reality, 'a place from which objects appear and in which they disappear' (106).

Winnicott's observations of infant behaviour led him to the conclusion that in this process the baby appears to be inhabiting and using an 'illusory world which is neither inner reality nor external

fact' (Winnicott 1988: 106), a third space in which the infant appears to be claiming, with the tacit consent of those around it, a magical control over the world. Winnicott named this intermediate area *transitional*; transitional objects being the objects associated with this experience and transitional phenomena the techniques. Transitional objects, as is widely known, are the ubiquitous first 'not-me' possessions of very young children: the piece of rag or old blanket that for the toddler is her very own discovery and creation, and yet is accepted as belonging to the world outside herself. Transitional objects have a physical existence, and at the same time they are pressed into the service of inner, psychical, reality.

Transitional objects and transitional phenomena belong in an intermediate space between inner and outer worlds, partaking of both; and Winnicott noted that their part in negotiating the relationship between inner and outer reality is not confined just to infancy and childhood but persists throughout the lifespan:

> Out of these transitional phenomena develop much of what we variously allow and greatly value under the headings of religion and art and also the little madnesses which are legitimate at the moment, according to the prevailing social pattern (Winnicott 1988: 107).

It is in this third area that cultural experience belongs. Reflecting on the state of mind – a kind of absentmindedness or reverie – associated with creativity and with what Winnicott called 'maximally intense experiences' (Winnicott 1991a: 135), Winnicott's colleague Marion Milner noted that this state calls for a certain mental setting, 'an attitude, both in the people around and in oneself, a tolerance of what may at moments look very much like madness' (Milner 1971: 164). This is what Winnicott meant by his statement that 'we are poor indeed if we are only sane' (Winnicott 1958: 150) – that a modicum of madness is a requisite of sanity. It is in our socially and culturally sanctioned 'little madnesses' that we find respite from the adult's burden of having to maintain a clear boundary between inner and outer worlds, between fantasy and fact. This is where we find the enthusiasms and the passions that excite our creative imaginations, where we may seek a mental and physical place, as adults, to play.

Winnicott's insights on 'the experience of things cultural' took off from Freud's concept of sublimation, the unconscious process through which sexual drives are diverted towards new, non-sexual, aims such as intellectual enquiry and artistic creation (Freud 1977). Winnicott's contribution was to locate the place where the individual's experience

and use of culture have their origins, where they live and work, in the psyche, in the object-world, and in the interaction between the two; and also to consider how and why cultural experience can be part of a satisfying life, a life in which one has a 'sense of being alive and inhabiting one's own body' (Milner 1987: 289). This is what is meant by 'the location of cultural experience', which is the title of one of Winnicott's most celebrated essays (Winnicott 1991a). Cultural experience, in short, is an extension of the transitional phenomena of infancy and childhood: it belongs to the dynamics of the inner-world/outer-world encounter. Cultural experience is located – has its place – in the intermediate area between the individual psyche and the environment, partaking of both. This third area, the *'potential space* between the individual and the environment' (1991a: 135, Winnicott's emphasis), is that of play; and 'playing leads on naturally to cultural experience and indeed forms its foundation' (Winnicott 1991b: 143). Perhaps in response to Freud's idea of sublimation as a redirection of the sexual drive, Winnicott adds that these are 'body experiences' that 'belong to object-relating of a non-orgiastic kind' (1991a: 136); and, crucially, that these experiences depend on 'relaxation in conditions of trust based on experience' (Winnicott 1991c: 75). The reference to bodily experience is a reminder of the observation that the psychical foundation of the relationship with external reality is in the 'theoretical first feed', in which the infant's illusory relation with the breast gives it its first 'material with which to create' (Winnicott 1988: 106).

Winnicott noted that transitional phenomena are a resource that can be drawn on beyond childhood, and that they are the foundation of adult creativity and cultural experience – activities which, like playing, are located in 'the *potential space* between the individual and the environment'. Potential space can be understood as a place that contains fantasy and reality, 'me' and 'not-me', and what in semiotic terms could be characterised as sign and referent. As such, it is the place where one learns to symbolise and communicate; and this in turn depends on the formation of subjectivity – of self as differentiated from, as well as part of, the external world:

> Paraphrasing Winnicott, one could say that potential space lies between the symbol and the symbolised. To distinguish symbol from symbolised is to distinguish one's thought from that which one is thinking about, one's feeling from that which one is responding to. For symbol to stand independently of symbolised, there must be a subject engaged in the

process of interpreting his perceptions (Ogden 1985: 137; see also Green 1995; Jernstedt 2000).

The quality of the potential space, Winnicott stressed, is something that varies from individual to individual (Winnicott 1991a: 138, since its circumstances, its environment, are themselves variable.[2]

As far as cultural experience is concerned, a key aspect of the outer-world dimension is what Winnicott called the inherited tradition: something that pre-exists, and exists independently of, the individual and is socially and culturally shared. It belongs 'in the common pool of humanity, into which individuals and groups of people may contribute, and from which we may all draw if *we have somewhere to put what we find*' (Winnicott 1991a: 133, Winnicott's emphasis). Thus in potential space an individual can engage with the (external) inherited tradition whilst bringing something of their own inner world to it, both drawing upon and feeding into a personal style or idiom. In other words, cultural experience is one of the expressions of the perpetual interplay of inner and outer, of separateness and union. This is the pattern of the child's absorbing play; and given favourable conditions – trust, confidence and a facilitating environment – it is the template for finding and expressing one's own idiom in creative living. It is also the place of the endless possibility for discovering something in the world for oneself, for making it one's own and making it live:

> The interplay between originality and the acceptance of tradition as the basis for inventiveness seems to me to be just one more example, and a very exciting one, of the interplay between separateness and union (Winnicott 1991a: 134).

Like the theoretical first feed, the transitional object and playing, therefore, cultural experience is located in this third area, this potential space, between the individual's inner psychic reality and the outside world. The capacity to play and the capacity to live creatively are grounded in similar psychical set-ups and processes: the negotiation of inner and external realities, the latter including cultural inheritance, the 'inherited tradition'. Cultural experience is satisfying for the individual to the extent that the interaction takes place in a setting of relaxation, trust and reliability – in a good-enough holding or facilitating environment. This is the pattern and the foundation of the satisfaction, delight and joy that can be afforded by 'maximally intense' cultural experience.

This book is premised on the observation that the interplay of our inner and outer worlds is a lifelong process that is formed through early object-relating and in playing; and that this same process continues through adulthood in our various engagements with cultural experience. Winnicott did not develop this idea a great deal further than the allusion to art and religion. But his thinking does suggest fresh ways of exploring the interaction between the psychical and the social/ cultural, between our inner and outer worlds, between our own creativity and the 'inherited tradition'. It maps intriguing pathways towards an understanding of how we can engage with the world at a public, social, level without setting aside our inner lives, our emotions and our psychical investments. More specifically, it can shed light on the many ways in which people use, relate to, consume, enjoy, interact with and make their own cultural texts, objects and practices, both as individuals and as members of communities of different kinds.

* * *

There is a long tradition, from Freud onwards, of writings on art and literature – and latterly on newer popular media – by psychoanalysts. Alongside this, psychoanalytic thinking, terms and concepts have been widely deployed by scholars and researchers in non-psychoanalytic fields of enquiry – in the study of culture generally and of media and cultural texts more specifically. The most prominent of these contributions have been in the areas of literary theory, art theory and film theory, and in psychoanalytically informed readings and interpretations of literary, cinematic and media texts. This work draws overwhelmingly on terms and concepts adopted and adapted from the writings of Sigmund Freud and Jacques Lacan: voyeurism, fetishism, scopophilia, the mirror phase and theories of subjectivity, for example. Alongside this, Carl Jung's thinking on archetypes has informed analysis of themes in literary and cinematic genres such as horror and science fiction. There are a number of widely cited ventures by analysts working in the object-relations tradition of Melanie Klein into readings and interpretations of themes and characterisations in fictions of various kinds (for example, Segal 1955), as well as some psychoanalytic interpretations of literature and art from a Winnicottian standpoint (for example, Rudnytsky 1993; Caldwell 2000). But comparatively speaking, object-relations psychoanalysis is not widely referenced disciplines other than psychoanalysis. It can certainly be argued that the Winnicottian model – the concepts of transitional

phenomena and potential space, along with the emphasis on the part played by illusion in the individual's relationship with external reality – remains an underused resource in the quest for a nuanced understanding of cultural experience within humanities and social science disciplines and associated professions.

This is a pity, because those working in disciplines and professions like sociology, cultural studies, film studies, media studies, art education, art history and museum studies could productively draw on the Winnicottian model in inquiring into people's engagements and relationships with cultural institutions, objects and practices, and in parlaying their enquiries into practice and policy. There have been a few pioneering endeavours here, especially by researchers in cultural and media studies. These include Roger Silverstone's work on television and everyday life; Matt Hills on fan cultures; Dovey and Kennedy on computer games and their users; Stuart Aitken and Thomas Herman on children's geographies; and Lee Harrington and Denise Bielby on television soap operas and their fans (Silverstone 1994; Harrington and Bielby 1995; Aitken and Herman 1997; Hills 2002; Dovey and Kennedy 2006); and indeed new work by several of these researchers is represented among the contributions to this book. But work of this kind is scattered and sporadic, and remains marginal within its own disciplines. It certainly shows little sign at present of becoming a trend or a current within any area of cultural research, practice or policy; and – mercifully, perhaps – appears not to be a school of thought that one can sign up to. Could this be because everyone who comes upon Winnicott's work likes to feel that this is something of their own, that they are making the discovery for themselves? If that is the case, it is hard to resist the thought that this is just how Winnicott would have liked it.

That said, *Little Madnesses* seeks to explore, extend and promulgate the ideas of Winnicott and others in the object-relations tradition, especially as these ideas can contribute to a deeper understanding, across a range of non-psychoanalytic disciplines and practices, of cultural experience and of people's uses of, and relationships with, culture. Contributors to the book come from a variety of disciplinary and professional backgrounds. They reflect on a range of cultural texts and practices and explore different methods and approaches in studying and interpreting them, drawing on and broadening out Winnicottian and other object-relations thinking in new ways. Each contribution foregrounds its modes of engagement with the relevant psychoanalytic concepts and considers the relationship between these and its particular objects of enquiry. The latter fall roughly into the three

categories – at points overlapping – that are reflected in the book's structure: embodied negotiations of physical and virtual spaces; the psychosocial relationship between media consumption and cultural identity; and the aesthetic and creative aspects of cultural experience.

* * *

Part One of *Little Madnesses*, 'Spaces and Frames', focuses on the back-and-forth movements between inner and outer worlds that characterise transitional phenomena. Spatial, kinetic and liminal metaphors abound in Winnicott's thinking and writing (Davis and Wallbridge 1990), and the concept of transitional phenomena offers a fresh approach to understanding both everyday spatial practices in the domestic and social worlds, such as walking around one's neighbourhood or using a computer, and the spatial engagements involved in cultural practices like going to the cinema and watching films. The contributions to Part One include work on cultural practices and experiences involving various bodily, virtual-bodily, and mental spaces. These range from the multisensorial spaces of cultural geography – inhabiting, negotiating, and moving in and through familiar environments, for example – to the geographies of virtual spaces and environments like those of video games and films, and viewers' and users' mental and bodily engagements with them.

In Part Two, 'Media Users', Winnicott's work is extended to contemporary media culture. This section focuses on cultural experience in terms of media use and the psychosocial relationship between media consumption and lived cultural identity, drawing on and adapting Winnicott's theory of transitional phenomena in the context of contemporary, pervasively mediated, cultures. To what extent are contemporary subjects' inner and outer worlds interrelated via intense, absorbing, and trusted media – texts, hardware, and digital platforms? How might a reading of Winnicott enable a move beyond the preoccupation with 'resistance' that dominates so much work in media studies and cultural studies, whilst retaining a broadly sociological and cultural-political dimension? Media fans, users and consumers who concentrate on media products and make them part of their daily lives and their routine cultural experiences arguably display forms of everyday creativity and a healthy engagement with symbolic worlds rather than, as is sometimes assumed, deviant or pathological behaviours. Winnicott's work is also explored here as it sheds light on the 'commodification' of transitional phenomena via Hollywood films, on

the processes through which audiences engage with media texts, and on the element of playing in media use.

Winnicott did not fully develop a theory of artistic creativity as such, but he did emphasise the central importance of creativity in everyday living, linking this to the question of how life becomes meaningful (or not). His writings on transitional phenomena were central in his (and others') exploration of these questions. Part Three, 'Cultural Experience and Creativity', takes these as a starting point and extends them to consider the creative process: not only in artists but also in those who engage with cultural objects made by others. It considers artistic creativity in relation to self-realisation, the processes by which artists create internal spaces for themselves in which they can work, and the similar mental and physical processes at work in the 'aesthetic feeling' that is sometimes experienced by viewers of works of art and other 'auratic' cultural objects. Building on Winnicott's own work and on the ideas of Winnicottian writers such as Marion Milner (Milner 1987), this concluding section of *Little Madnesses* sets out new approaches to understanding creativity and cultural engagement on the part of both the artist and the consumer of art.

Notes

1 Many of Winnicott's writings are published in different versions and editions and / or by different publishers. Each contributor to this volume has referenced their own preferred sources in their citations of Winnicott's work. The Bibliography lists only one version of the main Winnicott writings cited throughout *Little Madnesses*. A complete listing of published works by Winnicott can be found in Abram (2007); while Karnac (2007) lists published works based on Winnicott's ideas and writings.

2 As Victor Burgin points out in Chapter 3 ('The Location of Virtual Experience'), while a number of writers and practitioners in the Winnicottian tradition use the term *transitional space* as an alternate to *potential space*, Winnicott himself did not do so. However this usage is now embedded (and accepted) in the literature, and figures in a number of the contributions to this book.

References

Abram, Jan (2007). *The Language of Winnicott: A Dictionary and Guide to Understanding His Work*, 2nd edn., London: Karnac.

Aitken, Stuart C. and Herman, Thomas (1997). 'Gender, power and crib geography: transitional spaces and potential places', *Gender, Place and Culture* 4(1), 63–88.

Caldwell, Lesley (ed.) (2000). *Art, Creativity, Living*, Winnicott Studies Monograph Series, London: Karnac Books for the Squiggle Foundation.

Davis, Madeline and Wallbridge, David (1990). *Boundary and Space: An Introduction to the Work of D.W. Winnicott*, London: Karnac.

Dovey, Jon and Kennedy, Helen W. (2006). *Game Cultures: Computer Games as New Media*, Maidenhead: McGraw-Hill.

Freud, Sigmund (1977). 'Three essays on the theory of sexuality (1905)', *The Pelican Freud Library*, vol.7, Harmondsworth: Penguin, 45–169.

Green, André (1995). 'Potential space in psychoanalysis: the object in the setting', in Simon A. Grolnick and Leonard S. Barkin (eds), *Between Reality and Fantasy*, 167–187.

Grolnick, Simon A. and Barkin, Leonard S. (eds) (1995). *Between Reality and Fantasy: Winnicott's Concepts of Transitional Objects and Phenomena*, Northvale, NJ: Jason Aronson, Inc.

Harrington, Lee, C. and Bielby, Denise (1995). *Soap Fans: Pursuing Pleasure and Making Meaning in Everyday Life*, Philadelphia, PA: Temple University Press.

Hills, Matt (2002). *Fan Cultures*, London: Routledge.

Jernstedt, Arne (2000). 'Potential space: the place of encounter between inner and outer reality', *International Forum of Psychoanalysis* 9(1–2), 124–131.

Karnac, Harry (2007). *After Winnicott: Compilation of Works Based on the Life, Writings and Ideas of D.W. Winnicott*, London: Karnac.

Milner, Marion (1971). *On Not Being Able to Paint*, London: Heinemann.

—— (1987). *The Suppressed Madness of Sane Men: Forty-four Years of Exploring Psychoanalysis*, Hove: Brunner-Routledge.

Ogden, Thomas H. (1985). 'On potential space', *International Journal of Psycho-Analysis* 66(2), 129–141.

Rudnytsky, Peter L. (ed.) (1993). *Transitional Objects and Potential Spaces: Literary Uses of D.W. Winnicott*, New York: Columbia University Press.

Segal, Hanna (1955). 'A psycho-analytical approach to aesthetics', in Melanie Klein (ed.), *New Directions in Psycho-Analysis*, London: Tavistock, 384–405.

Silverstone, Roger (1994). *Television and Everyday Life*, London: Routledge.

Winnicott, Donald W. (1958). *Collected Papers: Through Paediatrics to Psycho-Analysis*, London: Tavistock.

—— (1964). *The Child, the Family, and the Outside World*, Harmondsworth: Penguin.

—— (1965). *The Maturational Processes and the Facilitating Environment: Studies in the Theory of Emotional Development*, London: Hogarth Press.

—— (1986). *Home Is Where We Start From*, Harmondsworth: Penguin.

—— (1988). 'Establishment of relationship with external reality', *Human Nature*, London: Free Association Books, 100–115.

—— (1991a). 'The location of cultural experience', *Playing and Reality*, London: Routledge, 128–139.

—— (1991b). 'The place where we live', *Playing and Reality*, London: Routledge, 140–148.

—— (1991c). 'Playing: creative activity and the search for self', *Playing and Reality*, London: Routledge, 71–86.

—— (2002). *Through Paediatrics to Psychoanalysis: Collected Papers*, London: Karnac Books.

Part 1

Spaces and Frames

2 Spaces and Frames: An Introduction

Annette Kuhn

In a brief case study of 1960, Winnicott tells of a seven-year-old boy who was brought to see him by his parents. A round of the Squiggle Game (Abram 2007: 329–336) revealed that the boy was in some way preoccupied by string; and his parents were indeed able to confirm that he was prone to stringing things around the house together. They were 'liable to find that he had joined together chairs and tables; and they might find a cushion, for instance, with a string joining it to the fireplace' (Winnicott 1965: 154). Winnicott right away explained to the parents that their son was dealing with a fear of separation (from the mother who, aside from absences due to giving birth, had been hospitalised for depression), and that the string obsession was an attempt on the boy's part to disavow his fears. This intriguing and unsettling story, conjuring as it does images of a 1950s sitting room transformed into a cat's cradle of an installation space, also prompts reflections on what string might symbolise.

Drawing a comparison with the telephone, Winnicott pointed out that in this instance string was being used as a technique of communication. One might also think of the string or the thread that is literally, associationally or virtually present in the *fort/da* game, in which the infant throws a cotton reel from its cot in the confident expectation that it will be picked up and returned to him – reeled in, so to speak: this being a rehearsal of, and a coming to terms with, the mother's temporary absences (Freud 1984). In the Greek myth of Ariadne and the Labyrinth, it is string or thread that makes it possible for Theseus to leave a secure and familiar place and venture into the unknown without fear of being unable to find his way back 'home', because the thread will guide him. More prosaically, the string that ties up a parcel

holds everything together in another way, keeping things from getting lost, falling apart, or generally going astray or awry. What string was doing for Winnicott's string-boy, and what it is doing in its various symbolisms, is to bridge absences/*spaces*, be these literal, physical, metaphorical, mythical, virtual or psychical. Together, the case study and the symbolism of string provide a vivid example of the centrality of space and spatiality in Winnicott's thinking.

In a reminder of the dynamic and dialectical quality of Winnicott's model of the psyche and the object-world, an aptly-titled introduction to his work pairs the key trope of space with its counterpart, boundary (Davis and Wallbridge 1990) – the fundamental boundary being between 'me' and 'not-me'. In this model, space can be psychical and/or symbolic and/or real. However, the key to the Winnicottian model lies not in the two terms, space and boundary, per se nor even in the relationship between them, but in a third term, an intermediate area, between 'me' and 'not-me'. This is the *potential space*, the domain of transitional objects and transitional phenomena: the space of illusion, imagination, and fantasy, of playing and of cultural experience. Winnicott's own descriptions of this 'space between', along with the topographical sketches that sometimes accompany them (Figure 2.1), graphically convey its relational quality (Tonnesmann 2000). Writers and clinicians drawing on the Winnicottian tradition have deployed other evocative spatial images: the bridge, the passport, the 'friendly expanse' and the frame.

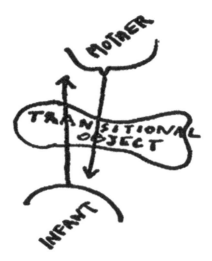

Figure 2.1 Winnicott's diagram of the transitional object

Potential space has a key role to play in people's inner *and* outer worlds. Its sphere of activity lies between these two worlds, between me and not-me; while at the same time it acts as a kind of bridge – a vector of contact and communication between them, just as a bridge spans a river and makes each bank accessible to the other – though each still remains a distinct space in its own right. The banks of the river are separate spaces, but the bridge permits traffic between them. Extending the metaphor, one could even say that the length and breadth of the bridge and the direction, and the freedom or the constraint, of the traffic flow are symbolic variables that set the timbre of an individual's particular negotiation of inner and outer worlds. The bridge image is used, for example, by Gilbert Rose in his book *The Power of Form,* in which he notes that the transitional object (which of course 'lives' in potential space) 'bridges between the new and strange and the good, old familiar'; as well as by Andrea Sabbadini in his idea of a 'bridge space' that connects the virtual, illusory, world of film with external reality (Rose 1980: 195; Sabbadini 2011).

Discussing Winnicott's definition of the transitional object, Adam Phillips notes that the important point about the object as far as the child is concerned is not what it *is* but what it *does*: he suggests that it works like a *passport* that enables the child to travel in and across the space between subject and object (Phillips 1988: 118). A significant feature of bridges and passports is that they facilitate something that can be tricky in certain circumstances; and besides this they suggest a sense of movement or travel, a sense of a coming and going that can be easeful, or not.

This trope of psychical movement back and forth across boundaries or frontiers, of entering and leaving different spaces, has an embodied quality about it (as noted in the previous chapter, for Winnicott potential-space activity is grounded in body experience). This quality of embodiment can be literal – physical as well as metaphorical-psychical; and this is especially apparent in processes of separation-individuation. The child's psychical emergence from a state of fusion with the mother, according to Winnicott, is facilitated by the transitional phenomena of the third, intermediate, space. It is extended in the process of physical separation as the toddler experiments with moving out of the mother's sight and into another room, say, or lingers in the doorway between rooms enjoying the best of both merging-separation worlds (Bergman 1995; Mahler 1986). It is then continued as the older child ventures forth outside the home to explore new places, perhaps indulging in some risk-taking, perhaps seeking

a 'home away from home', before returning to the 'zone of security'
that is home (Balint 1959). This very same back-and-forth movement is
typically re-enacted in the narrative arc of children's fiction, according
to Margaret Rustin and Michael Rustin. '[T]he recurrent experience of
separation and reunion provides a central topic', they find, in the works
discussed in their study of modern fiction for children (Rustin and
Rustin 2001: 3). This movement of separation and reunion is exactly
the pattern of the child's physical/bodily negotiation of 'friendly
expanses' (Balint 1959): her bold – and possibly unsettling – venture
into the new and unfamiliar and her return (changed, perhaps) to the
familiar. Both are explorations – the one in the imagination, the other
in reality – that involve coming and going between the familiar and
the unfamiliar and back again, back 'home'.

From a phenomenological standpoint, this also describes a bodily,
virtual-bodily, and mental-psychical relationship with 'home' – home
as both a symbol of security and a real place. Here, in the philos-
opher Gaston Bachelard's words, home is 'the site of the to-ing and
fro-ing of inside and outside' (Bachelard 1971, quoted in Silverstone
1999: 89); and the emphasis here on psychical-physical movement
is a reminder of the real or imagined activity of the *body* in these
processes. As already noted, the earliest experienced boundary is that
between 'me' and 'not-me' – and this of course is a bodily experience,
with the infant's skin serving as the boundary between inside/'me'
and outside/'not-me' (Bick 1968). Other negotiations of inner and
outer worlds – playing, perhaps, above all – may involve the body in
different, but likewise physical-psychical, ways. The body gives us a
sensorium: we engage with the external world through sight, sound,
smell, taste, touch. Sensory experience may be perceived as something
inner, but it is through the body's sense organs that we engage with
the world beyond our own skin.

The inner-outer quality of sensing has a particular meaning in rela-
tion to the sense-experience of bodily movement – what is called, in
the psychology of perception, *proprioception*. The psychical and phys-
ical movement back-and-forth that marks potential-space activity is
clearly proprioceptive: a person can sense, invoke and recall bodily
movement even when not actually moving her body. This type of
proprioception has been termed 'ecological perception'. Ecological
perception is an embodied kind of perception that is formed in relation
to the environment: there is a 'porousness between one's self, one's
body, and the objects or images of the world' (Rutherford 2003: 10).
Ecological perception can be experienced across a range of activities

including, and perhaps principally, playing and its adult equivalents: computer gaming, watching films, or walking along familiar streets taking in the sights, sounds and smells. In such activities, senses other than proprioception may also be involved – in the actual moment and/ or in imagination and memory – while the environment itself provides a frame or setting for the activity and the experience.

Home, whether figuring as real or symbolic, may act as a kind of bookend – a boundary or a frame – for potential-space activity: within this frame the individual's negotiation with the new, the unfamiliar, can take place in security. A frame can be thought of as something that *contains* space, in the sense of keeping it in place, binding it and bounding it. One of the many enabling paradoxes in Winnicott's thinking is the idea that boundaries and frames have an essential part to play in the inner-outer dynamic because they give 'form and there- fore meaning' (Davis and Wallbridge 1990: 144) to these experiences. Potential space brings together inner and outer, while at the same time the frame separates inside from outside. Frames and boundaries can be psychical and/or material. Marion Milner, for example, cites the real temporal frame that separates what goes on in the analytic hour on the one hand from everyday life on the other; containing, enhancing and distilling the psychoanalytic process (Milner 1987). Daily life generates countless instances of actual temporal and spatial frames and bounda- ries which form, shape and give structure to activities and processes that may be variously psychical and/or physical. For Winnicott, the 'good enough' environment provides a frame in exactly this way: it contains, it holds, it facilitates.

The centrality of 'home' as a zone of security in processes of separation-individuation is well illustrated at a real-word level in what geographers call children's mobilities: the places (their attrib- utes, their distance from home, and so on) that children are permitted to go to when not accompanied by adults. These permitted mobili- ties of course vary according to the child's age, as well as socially, culturally and historically. Today, for example, walking or cycling to school on one's own or with other children is in some circumstances regarded as permissible once a child reaches a certain age (Kullman 2010); while going to the cinema unaccompanied, at one time regarded as an ordinary and acceptable, even a desirable, aspect of children's mobility, tends now to be entirely off the agenda. There is also an important mental/psychical component of children's mobilities, in that children develop their own detailed 'mental maps' of what is permissible and accessible territory as against what is out of bounds

(Hart 1979). Adults, too, have favourite walking routes through their own 'manor'; routes that, in imagination and memory, may become imbued with a dreamlike quality (Bollas 2000; de Certeau 1984); while the real and imaginary spaces of home – the place we start from – can, in Bachelard's words, be a 'place where reality and reveries are indistinguishable' (Bachelard 1971: 121; see also Philo 2003; Winnicott 1986). This is why people's childhood mental maps can remain alive, in embodied memory, into old age.

Spatial, liminal and kinetic imagery abounds in Winnicott's thinking; and there is a paradoxical quality to the intermediacy that defines potential space. As the domain of cultural experience, potential space at once conjoins and separates subject and object. From the infant's earliest 'not-me' experiences to everyday creativity and cultural experience in the lives of adults of all ages, the paradox of boundary and bridge permeates, at every level, the relationship between inner and outer realities, shaping a dynamic in which symbolisation and imagination play a key role, shaping our inner lives and our public selves.

* * *

The contributions to Part One of *Little Madnesses*, 'Spaces and Frames', are directed at the spatial, liminal and kinetic – that is, the ecological – aspects of cultural experience. In Chapter 3 ('The Location of Virtual Experience'), Victor Burgin inquires into the notion of potential space and explores it as a hermeneutic device for thinking about 'the sea-change in pictorial space brought about by the advent of the computer'; a shift, as Burgin argues, that brings the registers of material and psychical representation closer together because computer associations mimic primary-process thinking. He points to the etymological kinship, in the idea of something not (yet) actualised, between potential space and virtual space, and re-examines, in relation to illusion and symbolisation, the centrality of point of view in the idea of the virtual image.

Addressing what might be called 'the world in the cinema', Phyllis Creme's contribution, 'The Playing Spectator' (Chapter 4), develops and extends those areas of psychoanalytic film theory that address cinema's distinctiveness as a medium in terms of both the textual organisation of films and their address to the spectator-consumer. She explores the spectator's engagement with cinema as a kind of Winnicottian playing in potential space, in that this engagement draws on both the inner world of fantasy and the outer world

of reality in offering a 'playspace' that can be entered and left. This, Creme points out, is a space – crucially – where the question of 'truth' or 'fact' does not arise. She considers that the distinctively illusory quality of film, and in particular the ways in which cinema organises and presents fictional spaces, is peculiarly capable of evoking in the spectator the desire to experience a suspension of disbelief. With a close analysis of the opening of *Meet Me in St Louis* (Vincente Minnelli, 1944), Creme shows how, by 'framing' the real space in front of the camera and constructing an apparently three-dimensional, internally coherent, and yet entirely fictive space within the film frame, cinema can 'invite' the spectator into the fictional space of the screenplay – and, in the same movement, into her own potential space. This, she suggests, sheds light on the psychical and virtual-bodily processes through which spectators can be 'moved' by a film, and even feel themselves to be 'inhabiting' the spatio-temporal world on the cinema screen. Creme's contribution offers specific suggestions as to how Winnicottian and post-Winnicottian thinking on framing and aesthetic experience, alongside the associated notions of space and boundary, can contribute to an understanding of the psychodynamics and the phenomenology of the 'world in the cinema' and of the cinematic experience. Some of these issues are taken up again in Part Three, 'Cultural Experience and Creativity'.

If the 'world in the cinema' is the topic of Creme's contribution, Annette Kuhn's 'Home Is Where We Start From' (Chapter 5) looks at what may be termed 'cinema in the world'. Drawing on oral and written recollections of cinema-going in 1930s Britain gathered in the course of research on cinema and memory, Kuhn explores the notion of memory as potential space. The cinema-going memories of this generation, especially as they are expressed in accounts of cinema visits made in early childhood, display a collective and a spatial quality as well as a marked insistence on place. This 'topographical memory talk' is essentially about children's mobilities, and typically incorporates discursive navigation of the routes between home and the neighbourhood picture house. There is a proprioceptive quality in these memories, as speakers appear to relive the bodily sensation of moving in and through a very particular and familiar set of places. This in turn suggests that the activity and the experience of recollection may, in certain circumstances (here in accounts of leaving home, walking down familiar streets, and finding oneself at a favourite cinema), have the sensuous, kinetic quality of the movement back and forth, the ebb and flow, characteristic of the inner world/outer

world dynamic, of processes of separation-individuation, and in general of negotiation of potential space (Kuhn 2004). Kuhn contends that, with its foregrounding of spatiality, liminality and movement, cinema memory constitutes a highly distinctive variant of cultural memory; and that the idea of cultural memory as potential space both sheds light on a significant historical moment and set of cultural practices and also enable us to imagine, even to predict, the future of cinema memory.

In 'Soundspace' (Chapter 6), Amal Treacher Kabesh addresses sound from a Winnicottian perspective. Sounds, familiar and strange, are rooted in space and place, from the sounds of home to the noises of the city. They may be different for everyone, but in object-relations terms sound has common features: the maternal voice envelops the infant; the rhythms of the environment can stand in for the mother and provide a holding space. Sounds, Kabesh explains, connect inner and outer, public and private; they connect our own bodies with those of others, our home spaces with the spaces beyond home. Sounds, in these respects, work much like the string that had become an obsession for Winnicott's young client (see Chapter 1): it both inhabits and connects spaces; and these spaces can exist equally in the physical environment and in the imagination – and in the place where the two meet: the potential space.

References

Abram, Jan (2007). *The Language of Winnicott: A Dictionary and Guide to Understanding His Work*, 2nd edn., London: Karnac.

Bachelard, Gaston (1971). *The Poetics of Reverie: Childhood, Language, and the Cosmos*, trans. Daniel Russell, Boston, MA: Beacon Press.

Balint, Michael (1959). *Thrills and Regressions*, International Psycho-Analytic Library, 54; London: Hogarth Press.

Bergman, Anni (1995). 'From mother to the world outside: the use of space during the separation – individuation phase', in Simon A. Grolnick and Leonard S. Barkin (eds), *Between Reality and Fantasy: Winnicott's Concepts of Transitional Objects and Phenomena*, Northvale, NJ: Jason Aronson, Inc., 147–65.

Bick, Esther (1968). 'The experience of the skin in early object relations', *International Journal of Psycho-Analysis* 49, 558–566.

Bollas, Christopher (2000). 'Architecture and the unconscious', *International Forum of Psychoanalysis* 9(1–2), 28–22.

Certeau, Michel de (1984). *The Practice of Everyday Life*, trans. Steven Rendall. Berkeley, CA: University of California Press.

Davis, Madeleine and Wallbridge, David (1990). *Boundary and Space: An Introduction to the Work of D.W. Winnicott*; London: Karnac.

Freud, Sigmund (1984). 'Beyond the Pleasure Principle (1920)', *Pelican Freud Library*, vol. 11, Harmondsworth: Penguin.

Hart, Roger (1979). *Children's Experience of Place*; New York: Irvington Publishers, Inc.

Kuhn, Annette (2004). 'Heterotopia, heterochronia: place and time in cinema memory', *Screen* 45(2), 106–114.

Kullman, Kim (2010). 'Transitional geographies: making mobile children', *Social and Cultural Geography* 11(8), 829–846.

Mahler, Margaret S. (1986). 'On human symbiosis and the vicissitudes of individuation', in Peter Buckley (ed.), *Essential Papers on Object Relations*, New York: New York University Press, 200–221.

Milner, Marion (1987). 'The framed gap (1952)', *The Suppressed Madness of Sane Men*, Hove: Brunner-Routledge, 79–82.

Phillips, Adam (1988). *Winnicott*, Fontana Modern Masters, London: Fontana Press.

Philo, Chris (2003). '"To go back up that side hill": memories, imaginations and reveries of childhood', *Children's Geographies* 1(1), 7–23.

Rose, Gilbert J. (1980). *The Power of Form: A Psychoanalytic Approach to Aesthetic Form*, Psychological Issues Monographs, 49, New York: International Universities Press.

Rustin, Margaret and Michael Rustin (2001). *Narratives of Love and Loss: Studies in Modern Children's Fiction*, revised edn., London: Karnac.

Rutherford, Anne (2003). 'Cinema and embodied affect', *Senses of Cinema* 25. Available at: http://www.sensesofcinema.com/2003/feature-articles/embodied_affect/ (accessed 6 May 2011).

Sabbadini, Andrea (2011). 'Cameras, mirrors, and the bridge space: A Winnicottian lens on cinema', *Projections* 5(1), 17–30.

Silverstone, Roger (1999). *Why Study the Media?*, London: Sage Publications.

Tonnesmann, Margret (2000). 'Donald W. Winnicott's diagram of the transitional object, and other figures', in Bernard Burgoyne (ed.), *Drawing the Soul: Schemas and Models in Psychoanalysis*, Encyclopaedia of Psychoanalysis, London: Rebus Press, 22–33.

Winnicott, Donald W. (1965). 'String: a technique of communication', *Maturational Processes*, 153–157.

——— (1965). *The Maturational Processes and the Facilitating Environment: Studies in the Theory of Emotional Development*, International Psycho-Analytic Library, 64, London: Hogarth Press.

——— (1986). *Home Is Where We Start From*, Harmondsworth: Penguin.

3 The Location of Virtual Experience

Victor Burgin

D.W. Winnicott prefaces his essay of 1967 'The Location of Cultural Experience' with the opening line of Rabindranath Tagore's poem 'On the Seashore': 'On the seashore of endless worlds, children play' (Winnicott 1982: 112). I have not been able to locate the source of Winnicott's version of this line, which differs from Tagore's own translation of his Bengali original: 'On the seashore of endless worlds children meet' (Tagore 1913). Play is nevertheless unambiguously at issue throughout the rest of the short poem. A seashore is a liminal and shifting place of exchange between land and sea, where the question of the priority of either is not to be formulated. As such it may serve as a metaphor for the location of cultural experience as Winnicott conceives it, in an 'intermediate zone' between shared empirical reality and personal psychical reality (Winnicott 1982: 30). Winnicott's idea of the location of cultural experience derives from his answer to the question of the fate of the transitional object: it is 'not forgotten ... not mourned' but rather 'loses meaning ... because the transitional phenomena have become diffused, have become spread out ... over the whole cultural field' (Winnicott 1982: 5; Winnicott 1989). The examples of cultural experience that Winnicott gives in this paper include listening to music, looking at paintings and reading. At the beginning of the twenty-first century our cultural experience may now routinely include the exploration of the internet and computer based 'virtual worlds'. Winnicott defines the location of cultural experience as a 'potential space'. The psychoanalyst and painter Marion Milner refers to this as 'an essentially pictorial concept' (Milner 1978: 39). She does not elaborate on her remark, but it suggests we might use Winnicott's idea of potential space as a hermeneutic device for

thinking about the sea-change in pictorial space brought about by the advent of the computer.

* * *

Introducing his 'attempt to clarify the concept of potential space' one commentator judges the idea 'enigmatic' as it is 'difficult to extricate the meaning of the concept from the elegant system of images and metaphors in which it is couched' (Ogden 1985: 129). Winnicott was first and foremost a clinician, who expressed his insights without attention to philosophical quiddities, and it would be inappropriate to parse his language for academically conventional definitional rigour.[1] It is not inappropriate however to clarify one's own understanding of Winnicott's terms when setting out to use them. In a book published in 2000 the psychology professor and psychoanalyst Michael Civin speaks of 'the concept of potential space, which has evolved from the notion of transitional space introduced by ... D.W. Winnicott' (Civin 2000: 37). In a publication of 2011 the psychoanalyst James E. Gorney speaks of 'the possibilities of establishing "transitional space" and "potential space" (Winnicott 1953) within the consulting room' (Gorney 2011: 60). The double quotation marks around the expressions in the above excerpt are in the original, and the bracketed citation refers to Winnicott's essay 'Transitional Objects and Transitional Phenomena'. The expression 'transitional space' however does not appear in that essay, nor have I been able to find it elsewhere in the volumes by Winnicott on my bookshelves.[2] The expression is widely used, and I have used it myself. I cannot be certain that Winnicott himself never used it; but whether he did or not, to speak of both 'transitional space' and 'potential space' may encourage the impression that there are two concepts where there is only one. In what follows therefore I shall use only the latter expression.

I assume that the idea of the 'transitional object' is well known to most readers of the present volume. I nevertheless wish to clarify my own understanding of some of its salient features. In 'Transitional Objects and Transitional Phenomena' Winnicott remarks:

> It is not the object, of course, that is transitional. The object represents the infant's transition from a state of being in relation to the mother as something outside and separate (Winnicott 1982: 17).

Here, the spatial setting of the object is subsumed to the *temporal* process that it both facilitates and represents. In an extended discussion

of the transitional object the French psychoanalyst André Green never-
theless writes:

> It is easy to see that Winnicott has in fact described not so much an
> object as a space lending itself to the creation of objects. Here the line
> itself becomes a space; the metaphorical boundary dividing internal
> from external, that either/or in which the object has traditionally been
> entrapped, expands into the intermediate area and playground of transi-
> tional phenomena (Green 1986: 285).

In the first sentence of the above passage the word 'object' occurs
twice but with different implications. The first occurrence *by definition*
refers to an object in the material sense.[3] In Winnicott's terms a transi-
tional 'object' is a physical object, a transitional 'phenomenon' is not.
He writes:

> … an infant's babbling and the way in which an older child goes over
> a repertory of familiar songs and tunes while preparing for sleep come
> within the intermediate area of transitional phenomena, along with the
> use made of objects that are not part of the infant's body yet are not fully
> recognized as belonging to external reality (Winnicott 1982: 2).[4]

The second occurrence of the word 'object' in Green's sentence
implies a psychoanalytic understanding of the term.[5] Winnicott saw
the formation of an internal object as a necessary precondition for the
establishment of a transitional object. We may recall the example of
the historically earlier passage from the physical object 'milk' to the
psychoanalytic object 'breast' at the origins of fantasy and sexuality
(Laplanche and Pontalis 1986). Here the infant's act of sucking, function-
ally associated with the ingestion of food, becomes enjoyed as 'sensual
sucking', a pleasure in its own right. In so far as the somatic experience
of satisfaction survives, it does so as a constellation of visual, tactile,
kinaesthetic, auditory and olfactory 'memory-traces' (Freud 1953: 538).
This psychoanalytic 'breast' does not correspond to the real anatomical
organ but is fantasmatic in nature. The transitional object heralds the
emergence of the capacity to distinguish between imaginary and real,
and as the child's 'first symbol' it heralds the advent of the symbolic.

The transitional object is neither internal nor external, and the second
sentence of the passage I cite from André Green invokes Winnicott's
dissolution of the 'line' that 'traditionally' divides the field of our
objects. The philosopher Gilbert Ryle has observed that in the division
of our experience into 'internal' and 'external': 'transactions between

the episodes of the private history and the public history remain myste-
rious, since by definition they can only belong to neither series' (Ryle
1963: 14). In my own understanding, the transitional object is located
in a *time of transition* and a *space of transaction*[6] – this latter is a 'potential
space' in that a successful outcome to the exchanges between infant
and mother is not guaranteed in advance but requires the facilitating
environment of 'good enough' mothering. This is to acknowledge the
etymological kinship of 'potential' space and *virtual* space.

* * *

In popular usage the adjective 'virtual' tends mainly to take one or
other of two meanings. An etymological origin of one of these is in the
Latin *virtus*, a compound of *vir* – 'man' or 'hero'– and *tus*, 'quality'.
Virtus (the origin of the word 'virtue') denoted the general physical and
moral qualities to which all men should aspire. Another etymology is
in *virtualis*, which in a philosophical context denoted a *potency* not yet
actualised – Aristotle gives the example of the oak virtually present in
the acorn. Here we approach one modern everyday use of the word: as
in, for example, 'Surveys tell us that virtually all architectural offices
are using computers now' (Neubert 1993). In these examples 'virtual'
is opposed to 'actual'. Not every acorn encounters conditions favour-
able to arboreal metamorphosis, and many architects raised economic
and aesthetic objections to computer assisted design, the widespread
adoption of which was not guaranteed. In the other popular meaning
of 'virtual' the term is opposed not to 'actual' but to 'real'. It is this sense
of the term that informs popular understandings of 'virtual reality'.
However, although it is widely associated with the idea of illusory
computer-generated environments, many will have first encountered
the term 'virtual' in school optics classes. In optical physics a 'real'
image is one that occupies an objective size and position in space inde-
pendently of the position of the observer. The reflection of an object in
a plane mirror is a real image, as is a photographic image, or the image
on a computer or cinema screen. A 'virtual' image is one that may vary
in size and/or position in relation to the point of view of the observer.
 In the first of his published seminars Jacques Lacan explains 'the
strict intrication of the imaginary world and the real world in the
psychic economy' (Lacan 1988a: 78) with reference to an optical illu-
sion created by the coincidence of real and virtual images in a concave
mirror: a vase stands on an open-sided box in which an inverted
bouquet of flowers is suspended – but to the eye of the observer,

looking into the mirror, the bouquet appears to be upright and placed in the vase. Lacan writes:

> This is nothing other than the imaginary phenomenon which I just spelt out in detail for you in the animal. The animal makes a real object coincide with the image within him (Lacan 1988a: 158–159).

The idea that 'the place where we live' is a hybrid world 'between external or shared reality and the true dream' (Winnicott 1982: 30), in which an imaginary world is combined with the world of real objects, is of course present early in the history of psychoanalysis. In his essay of 1914 'On Narcissism' Freud observes:

> A patient suffering from hysteria or obsessional neurosis has ... substituted for real objects imaginary ones from his memory, or has mixed the latter with the former ... (Freud 1957: 74).

In more phenomenological terms, Henri Bergson had already argued in his book of 1896 *Matter and Memory*:

> Perception is never a simple contact of the mind with the object present; it is entirely impregnated with memory-images which complete it while interpreting it (Bergson 1999: 147).

Describing the process of attempting to recover a memory, he writes:

> ... we detach ourselves from the present in order to replace ourselves first in the past in general, then in a certain region of the past: a work of groping (*tâtonnement*), analogous to focusing a camera. But ... the memory still remains in a virtual state. Little by little it appears as a nebulosity which condenses; from the virtual state it passes into the actual ... (148).[7]

The first of these observations by Bergson about perception and memory implies a distinction between 'virtual' and 'real', the second opposes 'virtual' to 'actual'. Both of these uses of the term 'virtual' are apposite when describing the 'place where we live': memories, always more or less combined with fantasies, are the virtual (immaterial) 'overlay' (see Freud 1961) through which we perceive what is physically real. At any given moment, however, this overlay represents only a more or less contingent actualisation of what is 'virtual' (latent) in the totality of memory. The advent of photography in the nineteenth century provided a material analogue of these inseparable immaterial processes.

Gilles Deleuze notes that 'actual perception has its own memory as a sort of immediate double, consecutive or even simultaneous'

(Deleuze and Parnet 1996: 183). Lacan remarks: 'The perceptual system is a kind of sensitive layer, sensitive in the sense of photo-sensitive' (Lacan 1988b: 140). The photographic image formed when the shutter is released is for an instant an analogue of the ephemeral memory-trace as virtual double of the real; its moment of coincidence with the time of the object instantly passes and the memory-trace then becomes 'virtual' in the other sense – as *latent* within the photo-sensitive emulsion. Derrida speaks of 'the impression and the imprint, ... the pressure and its trace in the unique instant where they are not yet distinguished the one from the other' (Derrida 1995: 99). This is the moment of a photographic exposure. It is the inaugural moment in the formation of any indexical sign whatsoever, but the comprehensively *illusory* indexicality of the photograph was unprecedented in the history of representations. In this, the invention of photography constitutes a 'second revolution' in the history of Western pictorial space after the revolution inaugurated by the invention of perspective. Computer-generated simulation has brought a third revolution in pictorial space, one that transforms not only the correspondences between image and perception, but also those between technology and psychology.

* * *

Immediately after the line of verse Winnicott cites, Tagore's poem continues: 'The infinite sky is motionless overhead'. The words 'infinite' and 'motionless' do not suggest an intermediate zone where memory and fantasy mingle with everyday reality. Tagore's words rather suggest the type of space as presented in Plato's *Timaeus*: space as *chora* – a space 'which exists forever and is indestructable, and which acts as the arena for everything that is subject to creation' (Plato 2006: 45). In his book of 1961 *Totality and Infinity: An Essay on Exteriority* Emmanuel Levinas writes:

> ... is not this spatial void a 'something', the form of all experience, the object of geometry, something seen in its turn? ... the notions of intuitive geometry will impose themselves upon us from things seen: the line is the limit of a thing, the plane is the surface of an object. Geometrical notions impose themselves on the basis of a something. ... they are limits of things. But illuminated space implies the attenuation of these limits to the point of nothingness, their vanishing (Levinas 2009: 206–207).

An infinite and motionless continuum in which visible objects appear in terms of 'lines' and 'planes' receding to a vanishing point – this is

the geometrical and optical ground of the pictorial space that emerged in the West in the early fifteenth century, based on the principles of the propagation of light in straight lines, and the projection of points on these lines upon a plane surface to represent a three-dimensional object in terms of two-dimensional space. André Green writes of potential space: 'the line itself becomes a space'. In the space of geometrical mathematics a 'point' has no dimension and a 'line' has one dimension, we enter two-dimensional space when a minimum of three lines meet to form a closed path and thereby a 'plane'. The extrusion of two-dimensional planes into a third dimension produces 'the space where we live' in its geometrical description. Winnicott begins an addendum to his paper 'The Location of Cultural Experience' with an anecdote that may evoke this space. He tells of falling asleep while sitting on the floor of his room, 'facing the dark end of the room'; he continues:

> … when I woke before I opened my eyes I knew for certain that I was facing the window; yet of course I also knew, as soon as I began to think, that I was the other way round. I gave myself a long time to get the full sensation of this mirror experience (Winnicott 1989: 200).

From this story it is a short associative step to the analytic setting, where the recumbent analysand – 'in the dark' about her or his desire – faces the analyst who is both a neutral mirror (in Freud's metaphor), but may also be perceived as a potential source of illumination, a 'window on the world' outside the patient's pathologically blinkered view. Setting aside all that has been written about the clinical circumstances of the psychoanalytic setting, we may assume that with relatively few exceptions (Sándor Ferenczi conducted an analysis on horseback) most psychoanalytic sessions take place in the setting of a rectangular cuboid. In the West this has been the place where we live for most of our history. Firm walls, a solid floor and a secure roof are the taken for granted precondition for any 'holding environment' whatsoever, whether therapeutic, carceral or carnal. Overcoming the terror of the 'blank' page, whatever we sketch on it – squiggle game or city plan – is laid over a virtual geometrical grid. It is the nature of this implicit perspectival space that has changed with the coming of the computer.

Although based on natural phenomena – the physics of light and the physiology and psychology of visual perception – the Western perspectival system of representation is not in itself natural (Panofsky 1993); nor, as the pictorial traditions of such civilisations as those of Egypt and China demonstrate, is it inevitable.[8] I have referred to

computer-generated imagery as the third of the 'revolutions' in pictorial space inaugurated by the invention of perspective; in the previous revolution photography had replaced perspective drawing as the principal mode of image making in everyday life. Photography was consistent with the central impulse of the industrial revolution: the delegation of previously time-consuming and skilled manual tasks to the automatic operation of machines. Where photography represents a shift from manual to mechanical execution, computer imaging effects a shift from mechanical to electronic execution. As before, the shift is both quantitative and qualitative – an increased amount of information is deployed in the interests of a higher degree of mimetic realism. However, where photography *represents* the object in front of the camera, the computer *simulates* the object itself. The perspectival principles expressed by the algorithms that govern computer-generated space are in direct line of descent from Euclid via Brunelleschi, but are now accompanied by routines that replicate a variety of non-Euclidean geometries, the behaviour of light as it is transmitted, absorbed and reflected by an infinite variety of surfaces, the atmospheric conditions at any given time and place on earth, and so on – all with potentially infinite parametrical variation. The means of electronic computation however not only expand pictorial space beyond traditional perspectival space – the space of drawing, canvas, photographic print or cinema screen – they also bring the registers of material and psychical representations into closer alignment.

In an essay published in 1990, the year the World Wide Web was invented, I describe everyday life in the 'developed' world as taking place in 'an image saturated environment which increasingly resembles the interior space of subjective fantasy turned inside out' (Burgin 1996: 121). The arrival of the web vastly accelerated what Lev Manovich characterises, in his book of 2001 *The Language of New Media*, as the 'trend to externalize mental life' (Manovich 2001: 57). The meaning of an image is largely a product of its relations with the other images with which it may be consciously or unconsciously associated. Today the processes of association have become increasingly automated. For example, if I go to the YouTube website to search for a particular clip I will be offered not only the clip for which I am looking (assuming I am successful) but also a column of thumbnail images of other clips that the program believes are related to my search. Clicking on any one of these will again summon not only the selected clip but a further column of apparently aleatory alternative choices. I may quickly find myself far from my original point of departure.

To immediate appearances it may seem that a spontaneous 'drifting' of associations has taken place analogous to the type of free movement of thoughts in, for example, daydreaming.[9] Such mimicking of spontaneous human mental processes may produce the uncanny impression of an auxiliary intelligence at work, forming associations on my behalf and *in my place*. Just as the digital convergence of the once distinct technologies of film, photography and video has dissolved the previously categorical distinction between still and moving images, so the absolute differentiation of interior from exterior associative processes can no longer be maintained in an electronic environment. For all that images made using a computer may retain a familiar rectangular format, they are assembled in a space no longer bound by any material frame but which rather opens upon the entire field of the internet. In imitating 'primary process' thinking – thinking governed by 'the primacy of the signifier' – this internet may now represent a form of *prosthetic unconscious*[10] as well as a form of prosthetic memory.

* * *

Winnicott suggested that what he saw in interactions between mothers and small children might be found throughout all cultural experience. In the age of electronic media the truth of his intuition is manifest in everyday life in a variety of ways. What commuting reader of Winnicott has not thought of the transitional object when witnessing the love, anxiety and aggression with which fellow travellers treat the mobile phones to which they cling? Or again, when travelling by car one is now less likely to rely on a two-dimensional paper map – an unambiguously separate diagram – than on a three-dimensional simulation, evolving in real time, of the actual space through which one moves, an intermediate space one may feel as much a part of as the space beyond the windscreen. I began with the idea of considering how computational pictorial space might appear if viewed through the prism of Winnicott's concepts of transitional objects and phenomena, and the potential space in which these take place – the eventual 'location of cultural experience'. Building upon the foundational studies of the paleontologist André Leroi-Gourhan, the French philosopher Bernard Stiegler rejects accounts of culture that isolate it from technique. He writes:

> Man is a cultural being to the extent that he is also essentially a technical being: it is because he is enveloped in this technical third memory that he

can accumulate the intergenerational experience one often calls culture –
and this is why it is absurd to oppose technique to culture: technique is
the condition of culture in that it allows its transmission (Stiegler 2004:
59–60).

Just as cultural experience takes place in an 'intermediate zone'
between internal and external realities, so it is located in a hybrid space
between the biological human being and its mnemotechnical pros-
theses: from the beginnings of writing to present varieties of electronic
inscription – these latter, as already noted, increasingly the prosthetic
extension of psychological processes. It is no longer surprising that the
author of a book about 'an [architectural] office of the electronic era'
should speak of 'electronically generated emotional spaces' (Galofaro
1999: 72).

The history of Western pictorial representational systems is in good
part a story of the perfection of mimesis, of a desire for illusion that the
advent of the computer has not diminished.[11] Computer simulation
however exceeds mimesis; in such diverse fields as economics and
epidemiology, military planning and meteorology, it is a technique of
investigation, understanding and prediction. A recent book offers the
following succinct definition of 'simulation':

> A simulation is a representation of a source system via a less complex
> system that informs the user's understanding of the source system in a
> subjective way (Bogost 2008: 98).

In this definition, transitional objects and phenomena – in Winnicott's
terms the child's 'first symbols' – may also be seen as belonging to a
space of *simulation*: in which, for example, the child may safely test the
object's ability to withstand attack.[12] To think of the transitional object
in terms of simulation is to emphasise both its temporal aspect and its
transactional aspect: what in computer terms we may call its 'inter-
activity' – for example, the agency of the real mother is never absent
from the scene (indeed Winnicott notes that she herself may serve as
transitional object). All spaces of simulation are forms of 'potential
space' in the variety and unpredictability of the interactively creative
outcomes they may allow. The simulational aspect of computational
pictorial space is further analogous to that of the transitional object in
that such freedoms may be constrained.[13] Although Bernard Stiegler
finds technique to be the very condition of culture he cautions:

> … there is that epoch of technique called *technology*, which is our epoch,
> where culture enters into crisis, precisely because it becomes industrial

and as such finds itself submitted to the imperatives of market calcula-
tion. (Stiegler 2004: 60)[14]

The authors of a book about computer games credit Winnicott's ideas
with having helped them 'grasp the psychic significance of play as
a crucial part of our experience of culture'. They write: 'Computer
games can be seen as "transitional phenomena" which facilitate
exchange between the subject and the mediated environment' (Dovey
and Kennedy 2006: 32). On the other hand they also observe that:
'More and more developers are licensing already existing engines on
which to produce their games' (98–99).[15] The market imperative of
conformity to the formulaic in the interests of maximum return on
investment typically provides the player with the interactive freedom
of a rat in a clinical psychologist's maze.[16] There is a tendency among
British psychoanalysts[17] to personify the ideal of *unfettered* play in a
certain figure of the 'artist' – a childlike *fou savant* they indulge with
a mixture of condescension and envy. Many artists derive narciss-
istic gratification from inhabiting this role, which in a Winnicottian
perspective may be seen as a 'false self' (Winnicott 1965) compliant
with stereotypes from media-based common sense and opinion.
Winnicott emphatically asserts: 'it is necessary ... to separate the idea
of creation from works of art' (Winnicott 1982: 79).

The psychoanalyst author of a book on 'psychoanalysis and art'
prefaces a discussion of Marcel Duchamp's 'readymades' with the
observation that, 'the artist's found objects resemble the child's tran-
sitional object in that they exist in reality before being selected and
endowed with meaning' (Adams 1993: 188). This is true, but it is no
less true of the shell the holidaymaker chooses from countless others
on the beach and uses to enrich her or his fantasy life when back in the
workplace. Those who work as artists have no royal road to childhood
experience that is closed to others. What endows the artist's found
object with *exceptional* meaning comes from such things as its discur-
sive context in art criticism and its economic context in the art market
– in short, from *history*. It is above all history that is absent from the
sentimental idealisation of artistic 'play' – not least of those media-
friendly forms of behaviour that are more often childish than childlike.
We complete the picture that Winnicott's citation invokes only if we
read Rabindranath Tagore's poem to its conclusion:

> On the seashore of endless worlds children meet. Tempest roams in the
> pathless sky, ships are wrecked in the trackless water, death is abroad and
> children play (Tagore 1913).

Notes

1 For a *mise en scène* of the incommensurability of Winnicott's mode of thought and that typical of English 'natural language' philosophy see Anthony Flew, 'Transitional Objects and Transitional Phenomena: Comments and Interpretations', in Simon A. Grolnick and Leonard Barkin (eds), *Between Reality and Fantasy*: 485–501.

2 At least not by 'scanning', I have not re-read every word.

3 From an observational viewpoint, albeit not necessarily from the point of view of the child.

4 From a logical point of view we might say that the relation between transitional objects and transitional phenomena is 'non-commutative': all transitional objects are in a literal sense transitional phenomena, but not all transitional phenomena are (physical) objects.

5 The fact that the word is in the plural – 'objects' – signals that it is not the transitional object that is at issue. Winnicott is clear that there is only *one* transitional object.

6 Again, from an observational point of view. Winnicott emphasises: 'There is no interchange between the mother and the infant'. D.W. Winnicott, 'Transitional Objects and Transitional Phenomena', in *Playing and Reality*: 14.

7 Bergson describes the process of 'condensation' here as if it were a quasi-natural process, the image of 'groping' however gestures towards the fuller account that may be found in Bachelard's use of Pierre Janeret's work in his criticism of Bergson. Bachelard speaks of 'the role played by dramatic thought' in memory; he writes: 'We retain only what has been dramatised by language; any other judgement is fleeting': Gaston Bachelard, *La dialectique de la durée*.

8 The ideological implications of single viewpoint perspective were debated in film and photography theory in the 1970s and 1980s – when Freud's account of voyeurism, Lacan's idea of the 'gaze' and Foucault's concept of panopticism were marshalled, even conflated, in a critique of perspective as *mise en scène* of imaginary mastery and control. My own writings during the 1980s drew upon psychoanalytical accounts of space to counterbalance the empirico-Euclidean spatial models prevailing in the work of the 'new geographers' at that time (see my introduction to *In/Different Spaces: Place and Memory in Visual Culture*). For example, in an essay published in 1987 I referred to Jacques Lacan's use of non-Euclidean geometrical figures – the torus and the Borromean knot, the Moebius strip and the Klein bottle – as heuristic aids in the representation of unconscious structures, where inside and outside, manifest and repressed, form a single continuous surface, and where absences are structuring. I asked: '… why should we suppose that the condensations and displacements of desire show any more regard for Euclidean geometry than they do for Aristotelian logic?' (*In/Different Spaces*: 47). Without negating the ideological critique of perspective it must be acknowledged that the model of perspective implicit in the critique had been displaced almost as soon as it was introduced – for example, in the shift from single to multiple viewpoint perspective, with a consequent decentralisation of vanishing points, in the transition from Renaissance to Baroque. The controlling principle nevertheless remains the simulation of 'natural' appearances until the innovations best exemplified by Cubism in the early years of the twentieth century. Even here, however, the degree of 'innovation' was measured against, and derived from, established principles of

perspectival projection – in all senses a case of the exception proving the rule. Indeed Panofsky saw the modernist attempt to break with the conventions of perspective as merely a further stage in the development of perspective.

9 In reality a computer program has formed a chain of associations between images from a database on the basis of key searchwords ('metatags') attached to those images – in effect replacing 'free association' with bound association.

10 In Freudian terms I am speaking here of the 'descriptive' rather than the 'structural' meaning of 'unconscious'.

11 Thus the observation: 'It is a remarkable paradox that a technology based on the production of images with no "real world" referent should have become obsessed with optical realism': Jon Dovey and Helen W. Kennedy, *Game Cultures: Computer Games as New Media*: 53.

12 The *fort/da* game might also be described in such terms. See Freud, 'Beyond the Pleasure Principle': 14ff.

13 For example, by a mother who places too many demands on the baby. Constraints leading to 'false self' constructions may later be imposed by older siblings – for example, see D.W. Winnicott, 'Dreaming, Fantasying, and Living', in *Playing and Reality*: 34.

14 The word 'technique' – in effect the same word in Stiegler's French – derives from the Greek *techne*. Stiegler notes that Aristotle uses 'techne' to speak of the act of bringing into being what nature alone cannot accomplish.

15 The 'game engine' is the 'deep structure' of the game – the underlying computer code that determines the limits of the possible for any game whatsoever based on it.

16 Nevertheless, albeit exceptionally, even the most narrowly programmatic of video games have proved vulnerable to creative *détournement*. For example, the author of the 'machinima' film *My Trip to Liberty City* (Jim Munroe, 2004) describes it as: 'A video travelogue of my time as a Canadian tourist in Liberty City, the setting for the video game *Grand Theft Auto 3*'. Declining the invitations to violent criminal activity that are the game's *raison d'être*, Munroe's avatar opts for *flaneurie*. (The practice of 'machinima' allows the production of 'films' shot entirely with virtual cameras in such virtual worlds as those of 'massively multiplayer online role-playing games' and *Second Life*. Machinima originated in the 1980s in the use of playback facilities programmed into video games to allow players to document the 'speed runs' in which they rapidly complete a 'level' of the game. Since then, the form has evolved to the point where it now has its own annual 'film festivals'.)

17 At least since the work of Phyllis Greenacre: see 'The Childhood of the Artist: 47–72. I note that a commentator finds that: '... far beyond describing talent or genius, ... Greenacre, in deep and wonderful ways, illuminates the psychic life of *all children* and, in so doing, of all of *us*': Ellen Handler Spitz, 'New Lamps for Old?: 563.

References

Adams, Laurie Schneider (1993). *Art and Psychoanalysis*, New York: HarperCollins.
Bachelard, Gaston (1989). *La dialectique de la durée*. Paris: PUF.
Bergson, Henri (1999). *Matière et mémoire*, Paris: PUF.

Bogost, Ian (2008). *Unit Operations: An Approach to Videogame Criticism*, Cambridge, MA: MIT Press.

Burgin, Victor (1996). 'Paranoiac space' (1990) in *In/Different Spaces: Place and Memory in Visual Culture*, Berkeley. CA: University of California Press, 117–136.

Civin, Michael (2000). *Male, Female, Email: The Struggle for Relatedness in a Paranoid Society*, New York: Other Press.

Deleuze, Gilles and Parnet, Claire (1996). *Dialogues*, Paris: Flammarion.

Derrida, Jacques (1995). *Archive Fever: a Freudian Impression*, Chicago, IL: University of Chicago Press.

Dovey, Jon and Kennedy, Helen W. (2006). *Game Cultures: Computer Games as New Media*, Maidenhead: McGraw-Hill.

Flew, Anthony (1978). 'Transitional objects and phenomena: comments and interpretations', in Simon A. Grolnick and Leonard Barkin (eds), *Between Reality and Fantasy*: 485–501.

Freud, Sigmund (1953). 'The interpretation of dreams', *The Standard Edition of the Complete Psychological Works of Sigmund Freud, Volume V (1900–1901)*. London: Hogarth Press.

———— (1955). 'Beyond the pleasure principle', *The Standard Edition of the Complete Psychological Works of Sigmund Freud, Volume XVIII (1920–1922)*, London: Hogarth Press: 7–64.

———— (1957). 'On narcissism', *The Standard Edition of the Complete Psychological Works of Sigmund Freud, Volume XIV (1914–1916)*, London: Hogarth Press: 73–104.

———— (1961). 'A note upon the mystic writing pad', *The Standard Edition of the Complete Psychological Works of Sigmund Freud, Volume XIX (1923–1925)*, London, Hogarth Press: 227–234.

Galofaro, Luca (1999). *Digital Eisenman: An Office of the Electronic Era*, Basel: Birkhäuser.

Gorney, James E. (2011). 'Winnicott and Lacan: a clinical dialogue', in Lewis A. Kirshner (ed.), *Between Winnicott and Lacan: A Clinical Engagement*, New York: Routledge: 51–64.

Green, André (1986). 'Potential space in psychoanalysis', in *On Private Madness*, London: Hogarth Press: 277–296.

Greenacre, Phyllis (1957). 'The childhood of the artist: libidinal phase development and giftedness', *The Psychoanalytic Study of the Child*, 12: 47–72.

Grolnick, Simon A. and Barkin, Leonard (eds) (1978). *Between Reality and Fantasy: Transitional Objects and Phenomena*, Northvale, NJ: Jason Aronson Inc.

Lacan, Jacques (1998a). *The Seminar of Jacques Lacan, Book I: Freud's Papers on Technique, 1953–1954*, New York: Norton.

Lacan, Jacques (1988b). *The Seminar of Jacques Lacan, Book II: The Ego in Freud's Theory and in the Technique of Psychoanalysis 1954–1955*, New York: Norton.

Laplanche, Jean and Pontalis, Jean-Bertrand (1986). 'Fantasy and the origins of sexuality', in Victor Burgin, James Donald and Cora Kaplan (eds), *Formations of Fantasy*, London: Methuen: 5–34.

Levinas, Emmanuel (2009). *Totalité et infini: Essai sur l'extériorité*, Paris: Livre de Poche.

Manovich, Lev (2001). *The Language of New Media*, Cambridge, MA: MIT Press.

Milner, Marion (1978). 'D.W. Winnicott and the two-way journey', in Simon A. Grolnick and Leonard Barkin (eds), *Between Reality and Fantasy*: 37–42.

Neubert, Reid M. (1993). 'What is CAD really?', *Progressive Architecture*, 4: 60.

Ogden, Thomas H. (1985). 'On potential space', *International Journal of Psycho-Analysis*, 66: 129–141.

Panofsky, Erwin (1993). *Perspective as Symbolic Form*, Cambridge, MA: MIT Press.

Plato (2006). *Timaeus* and *Critias*, Oxford and New York: Oxford University Press.

Ryle, Gilbert (1963). *The Concept of Mind*, Harmondsworth: Penguin.

Spitz, Ellen Handler (1989). 'New lamps for old?: reflections from and on Phyllis Greenacre's "childhood of the artist"', *Psychoanalytic Review* 76: 557–566.

Stiegler, Bernard (2004). *Philosophe par accident: Entretiens avec Élie During*, Paris: Galilée.

Tagore, Rabindranath (1913). *The Crescent Moon* (translated from the original Bengali by the author), London: Macmillan, 1913.

Winnicott, Donald W. (1953). 'Transitional objects and transitional phenomena: a study of the first not-me possession', *International Journal of Psycho-Analysis*, 34: 89–97.

—— (1965). 'Ego distortion in terms of the true and false self', *The Maturational Processes and the Facilitating Environment: Studies in the Theory of Emotional Development*, International Psycho-Analytic Library, 64, London: Hogarth Press: 140–152.

—— (1982). *Playing and Reality*, Harmondsworth: Penguin.

—— (1989). 'The fate of the transitional object', in Clare Winnicott, Ray Shepherd, Madeleine Davis (eds), *Psycho-Analytic Explorations*, Cambridge, MA: Harvard University Press: 53–58.

4 **The Playing Spectator**

Phyllis Creme

Cinema is magic – an 'everyday magic' (Kuhn 2002); just as Winnicott's 'playing' is an everyday creativity that we can all enjoy, whether or not we seem to be creative in the usual rather restrictive sense of being an 'artist'. For Winnicott the capacity to play is everyone's birthright. It is a mark of psychic health and the major aim of therapy – not just to cure 'illness' but as a way of experiencing a sense of meaning and of the self in life. Playing takes place in potential space, Winnicott's rather mysterious and reverberative contribution to an understanding of cultural experience, indeed of all kinds of situations where we experience an alive connectedness with the world. Playing can manifest itself 'in the choice of words, in the inflections of the voice and indeed in the sense of humour' (Winnicott 1971a: 40). Potential space provides a 'third area' between the person's inner world and the 'world of shared reality' (Winnicott 1971b: 110). It is not a gap, a separation, or a boundary between inner and outer but a place of creative connectedness. As André Green puts it:

> The line becomes a space; the metaphorical boundary that divides internal from external, that either/or in which the object has traditionally been entrapped, expands into the [...] playground of transitional phenomena. (Green 1978: 177).

Watching a film as a kind of playing can be both a 'relief' from, and also something that revives our everyday lives. Annette Kuhn's study of people's memories of cinema-going in the 1930s reveals how pleasurable feelings associated with informants' absorption in the film and the experience of being in the cinema could have a lasting impact (Kuhn 2002). This chapter explores film viewing as an instance of playing and

specifically considers how the spectator first enters the film's 'play-onscreen' and in the same movement enters her own potential space.

When I decided to study for a PhD in film studies in the late 1980s my 'secret questions' were: 'Why do I cry at the movies, even, sometimes, at a "bad" movie?', 'What makes me "believe" in it, and why is this pleasurable?' I felt that my engagement came from somehow entering the film as I watched – not from a distanced, critical position but from a quite different stance and place. I cried because I seemed to be taking part in that play-onscreen that had become 'my' film. My questions were not addressed by theories of film spectatorship, favoured at the time, based on psychoanalytic ideas around the pleasures of looking, unconscious drives, and gender: cinema treated as a rather pathological pleasure (Mulvey 1975; Britton 1978). More direct cinematic pleasures seemed to be untheorised, with little reference made to questions of subjectively-felt experience.

I looked to Winnicott, as an object-relations psychoanalyst interested in non-pathological creativity, for help. Drawing on his ideas on transitional objects, potential space and playing; on current film theory; on a complex film, *Meet Me in St Louis* (Vincente Minnelli, 1944); and on my own experiences of watching films, I conceived a model for the film viewer that I called the 'playing spectator'. The playing spectator is a Winnicottian viewer who comes to an encounter with film with a desire to play (Creme 1994): at that time no-one, to my knowledge, had used Winnicott to look at film spectatorship.

And so I made a story of the playing spectator's entry into the film and her journey through it. I was trying to locate the familiar sense of making a psychic shift to another domain, away from our everyday perception that I saw as a move, sustained or momentary, into potential space. We can, I think, note this shift many times in our daily lives. It is like Coleridge's 'willing suspension of disbelief that constitutes poetic faith' (Coleridge 1991: 169), though we cannot will ourselves to make it. In that space – unless we are jolted out of it – we 'believe' in what is happening onscreen – like children in their make-believe games, the prototype of Winnicott's playing. The spectator can wait in front of the empty screen for the film to unfold both on the screen and inside her. The process of luring and allurement of the spectator into the film activates her wish to be there, on the screen, playing her part. The screen space makes available a playspace and, conversely, the spectator's use of her own potential space enables her to participate in the screen/play, as player or director or even, more abstractly, by following camera movements, images and sounds and

by continually shifting roles and places, just as children do in their pretend games.

Winnicott valued paradox that is allowed to stand and not be resolved (Winnicott 1971d: 53): belief and not-belief can coexist. The notion of potential space is paradoxical: it can serve as a 'bridge' (Kuhn 2010, Sabbadini 2011) between the person and the outside world: it links but it also separates (though a bridge is rather narrow); it can be a space with potential (like an empty cinema screen) which, if all goes well for the growing child, is not actually empty but is occupied by the creative activity that connects inner and outer worlds. It represents a metaphorical, inner experience; but actual, physical, playspaces are also important. Children play in real spaces that they adapt as settings for their scenarios. 'I need my own space' is a statement of both physical and psychological need. Virginia Woolf's *A Room of One's Own* (Woolf 2000) is concrete enough, but the author must own it inwardly as well as materially for it to be available as a writing space. A cinema is also an actual – and, in the 1930s, a lush – setting for viewing films; but the 'reality' of film is also a mysterious and illusory play of shadows that we can use as our own, inner, playspace.

The idea of a 'playing spectator' is also a paradox. A 'spectator' simply watches the film unfold in front of her. By contrast, playing a part is an active, not a passive, state, even while the spectator remains in her seat. The spectator begins to play as she makes that shift into her own potential space and starts to participate in the action that she now both watches and enacts, apparently passive but at the same time active. Film and spectator interact in a mutual, overlapping potential space as the apparently uncrossable offscreen/onscreen barrier appears to be crossed. As I engage with it, the film that is given me out there on screen becomes my own creation, like a found object: 'the film is what I receive and also what I release' (Metz 1982: 51). Playing is 'inherently exciting and precarious' (Winnicott 1971a: 52). It can break down through the incursion of 'instinctual arousal', as he puts it: unconscious forces that the film spectator may also at times desire; or, at moments when she becomes an external 'critic' rather than a participant. These moments can be evoked by the film's workings, drawing us further in, or distancing us at moments when we are jolted out of our suspension of disbelief.

In general, film criticism maintains the boundary between film and spectator, who is conceived as placed firmly outside the screen space – as ideal viewer, as voyeur, as controller of the film narrative. We may choose to maintain the unbridgeable line between spectator and

screen and keep our psychic distance. However, when a film succeeds in holding our attention and catching our belief, then our experience is that, psychically, we step over that physically impassable line to take part – in different, shifting ways – in the screen/play. Cinematic spaces are various and actual: space within the film frame; space between the frame and what it appears to 'close off' around it; and space between screen and audience. However, while the film exists 'out there' on the screen, the spectator also knows (but usually does not take into account) that it is merely the effect of a play of light on a flat surface and lacks a material, physical existence. Being both material and illusory, film also has a wavering psychical existence. The spectator may make use of this ambiguous space in engaging with a film, when her psychic move into her own potential space seems to be replicated by her move into the screen space: I imagine myself inside a space depicted on a screen; I move through a film that has become a film in my head. If film space is a metaphor for potential space, which in its turn represents a psychic experience, then the spectator registers the metaphor as both an inner, psychic space and also as the outer space onscreen where she can find a place.

How does the spectator make the move into the screen space? André Green's account of the theatre spectator's psychic movement onto stage (Green 1979) gives a useful pointer. Informed by Lacan's account of the gaze, as well as by Winnicott and notions of different boundaries both physical and psychic, Green (1978; 1979) explores how the spectator psychically crosses the offstage/onstage boundary to play a part in the drama. The spectator enters the theatre, leaving behind the space of the outside world; the walls of the auditorium represent the boundary between himself and his external objects, or in Winnicottian terms between his inner and outer world. Although Green does not posit it in these terms, the theatre, like cinema, is a location for cultural activity and thus already a potential space. The spectator can leave the world of objects behind, withdraw from his habitual need to negotiate that world, and go into the theatre 'as a resting place' (Winnicott 1971c: 2). The stagespace offers 'a series of positions that it invites the spectator to take up in order that he may fully participate in what is offered him on stage' (Green 1979: 3).

As the play begins, the boundary between the outside world and the theatre is replaced by the boundary between the stage and the auditorium. At the moment the curtain rises and the lights go out, the spectators' negotiation with the external world is replaced by their encounter with the stage world, or as Green puts it: 'the relationship of

otherness between the subject and the world is replaced by the otherness of the spectator in respect of the objects of the gaze' (Green 1979: 4). If we envisage this new encounter as happening both within the potential space 'where everything is permissible' (Winnicott C. 1978: 29), and at the same time as a simple substitute for the spectator's negotiation with external objects, then the spectator's 'belief' in what is happening onstage may be doubly reinforced: she will be inclined to accept the 'reality' of the stage events as a replication of what she takes as reality in the external world; and in her potential space this replication allows her to suspend disbelief, to abandon habitual reality testing and engage instead with the 'reality' of the drama.

The curtain rises, the lights go out, and as the spectator's gaze encounters the drama it 'meets a barrier that stops it and sends it back to the onlooker as source of the gaze' (Green 1979: 3). Already the 'otherness' of the spectacle has been modified by a sensed inherent identity between object and subject, originating from the Lacanian Mirror stage, where the subject identifies with a reflection of an idealised version of himself (Lacan 1977). As a result, now 'the gaze explores the stage from the point at which the spectator is himself observed' (Green 1979: 4). The spectator has crossed the second boundary between auditorium and stage and is now 'on' the stage, in the guise of the other. Possibilities for this kind of 'identification' are extended by Konigsberg (1996) in relation to film, from a specifically Winnicottian perspective. He suggests that the spectator may identify with the characters on screen as transitional objects, already invested with a part of himself and a part of the spectator's own story. As the spectator's gaze meets and crosses the boundary between auditorium and stage, the third boundary comes into play: that between onstage and the invisible offstage, which for Green represents the space of the repressed unconscious that can never be transgressed. What is happening onstage, then, seems to be hiding the full truth, hiding what is repressed and unsaid. The spectator remains in thrall to a search for the solution to the enigma of the source of what is said onstage, and even for a sense of her own unconscious and hidden self, identifying as she now does with the happenings and characters on stage. It is a search and an enigma that can never be solved and will always therefore intrigue and draw in the spectator.

In the cinema, we are also invited into the film space from a darkened auditorium, where the apparent reality of film is more marked than in the theatre, inviting us to suspend disbelief more easily. The boundaries between onscreen and offscreen space are more fluid and

shifting than in the theatre. From a Winnicottian perspective, film space becomes more immediately available to the spectator 'echoing the ways in which we negotiate the spaces and boundaries of our inner and outer worlds through transitional processes' (Kuhn 2010: 96). Like offstage space, offscreen space is mysterious and hidden but – an important difference – there is always the possibility of its being given back to the spectator from one shot to another. Moreover, in film offscreen space may seem to represent the real world that the screen frame cuts off, as well as the unconscious (and for Winnicott the unconscious comes to represent the source of creativity as well as repressed memories). Each shot may set up the desire for what may be (but is not yet) revealed by the next. The playing film spectator is used to making such shifts from one domain to another.

The possibility of crossing the barrier from offscreen space into the film/play is an intrinsic part of getting 'involved' in a film narrative. At certain moments, determined by the film's operations as well as by a subjective, psychic trigger, we 'cross' the screen barrier and psychically step over into the action of the film, into the place of the screen-playing. In the same moment our own psychic operations move us into the potential space where our own playing takes place.

* * *

Meet Me in St Louis, set in St Louis at the time of the International Fair of 1903, is a musical starring Judy Garland and directed by Vincente Minnelli, with beautiful mise en scène and virtuoso camerawork: Minnelli himself thought the screenplay 'magical' (Kaufman 1994: 59). The Smith family is disconcerted when Mr Smith announces that his firm wishes him to move to New York. This causes conflict between himself and the rest of the family – his wife, their four children, a grandfather and a cook; but in the end the father gives in to his family's wishes to remain in St Louis. The film is constructed around seasonal episodes: Summer, Autumn, Winter and Spring. It ends with the opening of the St Louis Fair, the coupling of the older children, and the family's differences resolved. The film is set mainly in and around the Smiths' home, its emotional centre.

In the mythology of cinema, Meet Me in St Louis is a 'classic' (Kaufman 1994) that viewers 'love' and that families sit down together to watch – these days in front of the television. It presents the American small town, epitomised in a large 'ordinary' family, that offers all its inhabitants can ever wish for; an uncomplicated blend of tradition and hope

for the future (in the Fair); and above all an assertion of family values and the comfort of home. Kaufman asserts that one appeal of the film lies in its nostalgia for an idealised world that we know is 'untrue', yet that we long for. For the playing spectator, however, at the same time it *is* 'true', in the paradoxical knowledge referred to by Christian Metz:

> I shall say that behind any fiction there is a second fiction: the diegetic events are fictional, that is the first; but everyone pretends to believe they are true and that is the second; there is even a third: the general refusal to admit that somewhere in oneself one believes they are genuinely true. (Metz 1982: 72).

The idea of the Smiths' home is fundamental to the film's appeal, and for Winnicott home is not so much an idealisation of nostalgia but is simply, and crucially, 'where we start from' (see Chapter 5), the basis of our sense of self.

In spite of its slight, apparently light-hearted and idealised, plot with musical and comic/ironic elements, and pleasing *mise en scène*, the film has a dark side, manifested in oddities, ruptures and disjunctions in the film's surface structure, along with some very intense moments that are out of key with the rest of the film – moments where incest, sadomasochism, patricide and castration are figured, and that may be read as representing the return of the repressed (Britton 1978). For this reason, the film is usually classed as a family melodrama as well as a musical. For the playing spectator, I suggest, this brings about a break-down in playing at certain points, and these moments are equivalent to what Winnicott refers to as the incursion of instinctual forces (Winnicott 1971a: 52).

For the playing spectator, the work of the opening sequence of *Meet Me in St Louis* is to make available a place onscreen, and by the same token to set up her psychic move into her own potential space. It establishes the setting of the narrative, demonstrates that the film is a musical, and introduces the Smith family's house and home. The film opens with a background chorus singing the title song 'Meet me in St Louis, meet me at the Fair' as the credits roll on a 'greeting card' background, each section ornately decorated. The chorus invites the spectator to meet an unknown speaker ('me') at the Fair, in a story-like town at a particular moment in history, and with a promise of child-hood pleasures and excitement. In its direct address, the song suggests that a place is awaiting the spectator, the addressee. This is the initial invitation into potential space, the domain of playing: the city and the Fair will become the locus for the family's desires and their fears of

change, and also a metaphor for a young girl's growth into sexuality and assumption of her family's and society's values and expectations.

So far the singing is disembodied, the voices of an offscreen chorus: as yet there is no action of which the spectator can be a part. The song begins a moment before the credits start, with the muted fanfare that will herald each new seasonal episode in the film and finally the Fair itself; so at this moment there is not yet any place for the spectator except in the singing itself. However, the song also suggests a dance: it is in 3/4 time and a few minutes into the film will be shown as a traditional waltz when we will see the old-style grandfather dancing, and we can inwardly dance along. So the spectator at this moment has the possibility of two positions: outside the film's action because nothing is yet happening, but also already within the narrative space as both the singer and also as receiver of the invitation to the Fair. Beginning the film with a song/dance, without any competing visual element, may serve as a particularly strong invitation to enter potential space. As there is nothing, or no-one, concretely 'out there' – the music being disembodied – the spectator internalises the music and the beat of the dance. It is as if the film is already embedding itself in the spectator's own psyche, so that the image that will in a moment emerge onto the screen will seem to be partly projected from herself.

The dance beat associates the music and the sense of a dance movement with the verbal significance of the song, the down beat stressing the words, *Meet, Louis* and *Fair:* the invitation, the place and the 'magical' Fair. The spectator is drawn into a physical response to the 'catchy' tune and rhythm, which encourages her to dance and sing along, inwardly moving to the fast beat of the waltz contained within the emphatic down beat swing which contains and frames it: the beat is measured, but with an underlying sense of excitement in the faster pulse that is barely contained and that could at any moment break out (as the feet of waltzers move quickly inside the slower sway of their bodies, each contained by the other). In this way the dance tune can be registered as a contained space that is also replete with a promise of breaking into a greater excitement. The 'invitation' is also suggested by the greeting card background for the credits, though less markedly than in the song (a greeting card may or may not be an invitation). The song moves on to other, more sentimental, theme tunes, on both the soundtrack and also the credits, promising different kinds of pleasure. For a moment, when the credits are finished, the screen goes blank and dark; we are left in expectation, aware of the framing of the film screen, marking it off as a seemingly separate space, a framing-off

from the external world within which another world is given form. The pause is held long enough to signal the break between the credits and the beginning of the film story and to mark a move for the spectator into the narrative.

This blank screen is a space to be filled, and the spectator waits in expectation. It can be perceived as a space for projection of the spectator's desires that this film has already evoked, desires to do with nostalgia for childhood pleasures in a utopian town. The blank space is quickly filled with another 'card', this time an illustrated and more authentic-looking 'greeting card' labelled 'Summer', a still showing a house (the Smiths' family house) in the background, a coach and horse in the road in the foreground, and an expanse of green space (Figure 4.1). This will be the 'home' of the film, the major site of its, and of our, wishes.

At this point, just before the film is set in motion, let us pause to look at where the spectator is now placed. She may have been inwardly singing along with the theme song and moving with its dance-rhythm beat as both receiver and speaker of the invitation. The singing and the dance have moved the spectator into a third space, away from our negotiation with the everyday 'real' world. At the same time as the spectator is active as the singer, she is also the recipient of the

Figure 4.1 *Meet Me in St Louis:* An invitation into the film space – the greeting card

invitation to the Fair, though without being able to respond to it – in part because the song has already moved on to other songs from the film. The film will plot its predetermined course but the spectator will, at some points at least, seem to own or speak it. We will both 'find' and 'create' this film as it unfolds before us, with us as willing participants.

We are taken forward towards the house (the perspective is well marked in this shot), leaving the coach and horse at frame left, with all but the horse's head out of frame: an edgy framing – edgy in a way that is typical of this film – which, if sustained, could be disconcerting. At this point, however, the picture comes to life; the coach and horse begin to move, right, towards frame centre and across the screen; and the moving picture story begins. The moment is marked but, happening quickly and fluidly, not strongly: the magic of an inanimate object stirring into life is also given as 'natural'. In the same instance the monochrome photo-like image framed in the centre of the card changes to colour. In film, pictures magically, and yet apparently quite simply and naturally, come to life. As in the moment of play and illusion when the baby, with an accompanying sense of excitement and mastery, has a sense of having made what is in fact presented to it, no-one asks 'who' makes the coach move and sets the story in motion. The spectator is a part of it as she is brought into the picture (the camera tracking in at the very moment of the still image's coming to life). The camera, now panning right, maintains this involvement for the spectator, in a movement that recalls the fundamental exhilaration and surprise of film as moving pictures. We now see activity – pedestrians and a beer cart with two boys apparently mocking passers-by and fighting: an image slightly out of key with the so far sentimental images, but again in a way that is characteristic of the film.

At this moment, a boy on a bicycle crosses at an angle and, a little daringly, in front of the traffic on the road, and wheels round over the expansive lawn towards the house, tracked by the camera. As the house is reached, in a rapid and fluid dissolve we are taken into the Smiths' kitchen, with a homely image of a steaming vat and three family figures, the wife, the cook and the son, tasting the contents (Figure 4.2). We have been taken deeper into the space of the opening image and into the story, to the heart of the family and the setting for the coming drama. The film's operations have put the playing spectator in place, here in the home; and her film/play, the musical with its vicissitudes of the family melodrama, is about to begin.

The Hollywood musical is an apt genre for the playing spectator. Since it is clearly marked as an 'artificial' genre, it invites participation

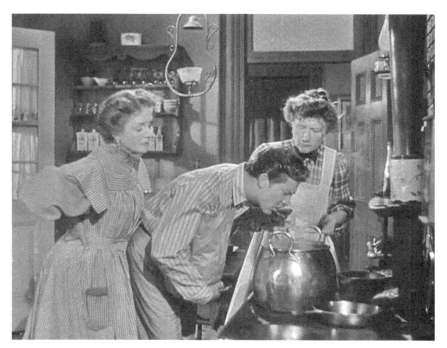

Figure 4.2 *Meet Me in St Louis:* Home – the Smith Family kitchen

in ways that are unlike those of a classic narrative film where the spectator is invited to take part in a life-story, constructed naturalistically. Dance, song, heightened visual patterning within and between shots, camerawork – all elements that are outside language and have to do with image, sound and movement – evoke a sensed experience that precedes language. For some of Kuhn's 1930s cinema-goers it is the musical, notably Ginger Rogers and Fred Astaire in *Top Hat* (Mark Sandrich, 1935) that particularly invited their participation: a sense of dancing along, and of dance as a signifier for sex as part of their 'courting' in the back row of a darkened cinema:

> You are carried into the space of your imagination, that other space where you are utterly graceful and where the dance of courtship proceeds, with never a false step, towards its climax (Kuhn 2002: 193).

This is more than 'escapism'; it is life enhancing. Adam Phillips recalls a story about Winnicott that, in a comment on the music hall, reveals Winnicott's approach to creative enjoyment and the role of art and culture in life. In opposition to Melanie Klein's views on art as essentially reparative, an attempt to ward off infantile guilt, Winnicott said:

> ... one is at a music hall and on the stage come the dancers trained to live-liness. One can say here is anal control, here is masochistic submission to discipline, and here is a defiance of the super-ego. Sooner or later one adds: here is LIFE (Phillips 1988: 54).

<p style="text-align:center">* * *</p>

We value film. Annette Kuhn's informants showed how their memories of cinema were still working their magic after many decades. Film brings its magic to the willing spectator through its illusionistic, precise and careful way of managing filmic space and narrative to construct a potential space. Winnicott intriguingly also refers to the exciting 'magic' of the 'precariousness' of play that arises from the intimacy between mother and child, the very foundation of playing (Winnicott 1971a: 47); and part of the everyday magic of cinema is that the film seems to be 'my film' in an intimate way. For Winnicott this creative, everyday magic is what makes life worth living:

> It is in playing and only in playing that the individual child or adult is able to be creative and to use the whole personality, and it is only in being creative that the individual discovers the self (Winnicott 1971d: 54).

References

Britton, Andrew (1978). '*Meet Me in St Louis*: Smith or the ambiguities', *Australian Journal of Screen Theory* 3, 7–25.

Coleridge, Samuel T. (1991). *Biographia Literaria* (1817), London: Dent.

Creme, Phyllis (1994). 'The Playing Spectator: an exploration of the applicability of the theories of D.W. Winnicott to contemporary concepts of the viewer's relationship to film', PhD Thesis, University of Kent.

Green, André (1978). 'Potential space in psychoanalysis: the object in the setting', in Simon A. Grolnick and Leonard S. Barkin (eds), *Between Reality and Fantasy*, 169–189.

——— (1979). *The Tragic Effect: The Oedipus Complex in Tragedy*, Cambridge: Cambridge University Press.

Grolnick, Simon A. and Barkin, Leonard S. (eds) (1995), *Between Reality and Fantasy: Winnicott's Concepts of Transitional Objects and Phenomena*, Northvale, NJ: Jason Aronson, Inc.

Kaufman, Gerald (1994). *Meet Me in St Louis*, London: British Film Institute.

Konigsberg, Ira (1996). 'Transitional phenomena, transitional space: creativity and spectatorship in film', *Psychoanalytic Review*, 83(6), 865–889

Kuhn, Annette (2002). *An Everyday Magic: Cinema and Cultural Memory*, London: I.B.Tauris.

——— (2010). 'Cinematic experience, film space, and the child's world', *Canadian Journal of Film Studies* 19(2), 82–98.

Lacan, Jacques (1977). 'The mirror stage as formative of the function of the I as revealed in psychoanalytic experience', *Ecrits: A Selection*, London: Tavistock Publications, 1–7.

Metz, Christian (1982). *The Imaginary Signifier: Psychoanalysis and Cinema*, London: Macmillan.

Mulvey, Laura (1975). 'Visual pleasure and narrative cinema', *Screen* 16(3), 6–18.

Phillips, Adam (1988). *Winnicott*, London: Fontana.

Sabbadini, Andrea (2011). 'Cameras, mirrors, and the bridge space: a Winnicottian lens on cinema', *Projections* 5(1), 17–27.

Winnicott, Clair (1978). 'D.W. W.: a reflection', in Simon A. Grolnick and Leonard S. Barkin (eds), *Between Reality and Fantasy*, 17–33.

Winnicott, Donald W. (1971a). 'Playing: a theoretical statement', *Playing and Reality*, London: Tavistock Publications: 38–52.

——— (1971b). 'The place where we live', *Playing and Reality*, London: Tavistock, 104–110.

——— (1971c). 'Transitional objects and transitional phenomena', *Playing and Reality*, 1–25.

——— (1971d). 'Playing: creative activity and the search for the self', *Playing and Reality*, 53–64.

Woolf, Virginia (2000). *A Room of One's Own* (1929), Harmondsworth: Penguin.

5 Home Is Where We Start From

Annette Kuhn

This chapter explores some of the ways in which cinema memory – memories relating to films, cinema-going and film viewing, and the distinctive discursive features of these memories – works as a partic-ular type of cultural memory. I argue that the concepts of transitional object, potential space and transitional phenomena, as developed by D.W. Winnicott, are pertinent and illuminating in this regard, espe-cially as they shed light on psychodynamics and spatiality. I also suggest that these ideas have predictive potential, in that they can help us imagine the *future* of cultural memory and cinema memory.

The data and the thinking underpinning these propositions emerge from an encounter between two rather different projects. The first is a study of cinema culture and cinema-going in Britain in the interwar years which began a number of years ago with some oral history fieldwork, and led to the creation of an archive of interview and questionnaire material: this is still ongoing.[1] The second consists of recent work exploring the potential of Winnicottian object-relations for extending and deepening our understanding of cultural experi-ence in general, and of cinema in particular. By its nature, this latter project concerns itself both with *cinema* in its social-institutional sense and with *film* in its textual, metapsychological or phenomenological sense.[2] The cinema/film distinction is important, and it is perhaps worth stressing that this chapter concerns itself largely with the former – with cinema as an institution and with cinema-going as a social and cultural practice.

One of the key findings of the 1930s cinema culture project was that for this particular generation cinema-going was the occasion for people's very earliest ventures into the world beyond the home:

> Close to home, almost an extension of home, and yet not home, 'the
> pictures' is remembered as both daring and safe. Referencing Freud,
> Michel de Certeau suggests that the back and forth (*fort/da*) movement
> and the 'being there' (*Dasein*) which characterise spatial practices re-enact
> the child's separation from the mother. To translate this conceit to cinema
> memory, it might be argued that, for the 1930s generation, cinema consti-
> tutes a transitional object (Kuhn 2002: 36).

The allusion to de Certeau is to his evocative essay 'Walking in the
city', in which it is proposed that the everyday 'spatial practice' of
walking urban streets is imbued with a particular experience of move-
ment, a 'moving into something different' that repeats 'a decisive
and originary experience, that of the child's differentiation from the
mother's body' (de Certeau 1984: 109). How was this insight – that, for
the 1930s generation at least, 'cinema constitutes a transitional object'
– arrived at? Why is it important? And what might it suggest about
the peculiarities of cinema memory and about the future of cinema
memory, now that cinema in the form the 1930s generation knew no
longer prevails?

Above all, it is about how place and space figure in certain kinds of
memory-stories, and about how memory works through the body, or
is embodied. In his phenomenological study of remembering, Edward
Casey says that *place* is important in remembering because 'it serves
to *situate* one's memorial life' in several possible ways. Firstly, Casey
suggests, places can act as containers of memory; secondly, places
can be *mise en scènes*, or settings, for remembered events; and thirdly,
memory itself is like – or indeed is – a place that we can revisit (Casey
1987: 183–184). Therefore memory both *is* a topography and *has* a
topography. It should be noted that at this point the issue is *place* rather
than the more abstract space. The idea of place suggests attachment
– 'being in', belonging – or its absence. Attachment in turn implies a
bodily relationship, even a merging of boundaries, between body and
place. It is in the idea of space, perhaps, that *movement* (movement in
and movement through) arguably figures the more pervasively; but
figurations of both place and space are, as will become apparent, inter-
twined in the psychodynamics of cinema memory.

It was surprising at first to observe how insistently place figured in
the memories of 1930s cinema-goers. Because this finding is discussed
in some detail elsewhere, however (Kuhn 2002 Chapter 2; Kuhn 2004),
I shall mention only those aspects of it that are relevant to the current
argument. There is a great deal of variation in how place is evoked

in these cinema-goers' memories, and in how metaphors of place organise their memory talk. Nonetheless, emerging from the mix is an overall sense, above all in informants' accounts of their childhood cinema-going, of a navigation in embodied imagination, even as they speak, of mental topographies of familiar, remembered territory. This topographical memory talk, evoking as it does a set of spatial practices associated with very specific places, offers important clues as to the ways in which cinema memory works as a distinctive form of cultural memory.

One key finding, for example, is the prevalence of the discursive 'walking tour' in informants' accounts of their early cinema-going: a retelling of their journeys to the picture house, always (implicitly or explicitly) undertaken on foot, and often including very precise details of street names and familiar landmarks. One typical account is a lengthy discursive walking tour by a 79-year-old informant who had lived in Bolton, near Manchester, since the age of five. Her 'tour' includes the following:

> This is St Helen's Road. Beyond. Perhaps about ten minutes from here. Down there. You get the main road. Eh there was the [name of cinema] it was called.... And that was all along that road. But going over to Dean Road, there was the Fern Cinema....[3]

This is an embodied and kinetic memory – a reliving, through the body, of the remembered experience of moving through space and also in and through a very particular and still familiar, though now changed, set of places.

A number of aspects of this kind of topographical memory talk make it distinctive. Firstly, the starting point for the memory-journey is usually the family house, the home; secondly, the journey is highly goal-directed, its destination being the neighbourhood picture house or picture houses; thirdly, there is a sense that the same journey was frequently and repeatedly undertaken; and this is associated, fourthly, with a sense of the journey's ordinariness, its routine quality. Finally, a return home is part of the remembered journey, though this is often implicit in the speaker's account.

Underlying the feeling of coming and going, of repeated movement away from home and back again and of the everydayness of the journey's topography, is a sense of *fort/da*, a trying out of separation and independence in a psychical, emotional and physical space of belonging, security, containment. As observed and reported by Freud, the baby's *fort/da* game (repeatedly throwing a cotton reel out of its cot

and its mother/carer repeatedly picking it up and giving it back, to the baby's delighted cries of 'Fort!' [gone] and 'Da!' [here]) rehearses presence and absence and models the lesson that things (including and especially mother) continue to exist even when out of sight (Freud 1984). For object-relations psychoanalysis the psychical activity at work here figures in specific processes of separation-individuation in which the infant and toddler, in a series of phases lasting until the age of about three, separates itself from the external world and from its mother/primary carer and becomes a distinct self – a process, importantly, that does not stop at the age of three: 'For the more-or-less normal adult, the experience of being fully "in" and at the same time basically separate from the world "out there" is one of the givens of life that is taken for granted' (Mahler 1979: 131). For Winnicott, along with the security of a holding environment the young child's use of the transitional object figures crucially here.

Home is where the 1930s cinema-goers' remembered pedestrian journeys to the cinema begin. The places and the landmarks named along the way act, in their accounts, like a string that keeps them virtually joined to home, even as they venture away from home and into parts of the outside world that feel familiar and safe, guiding them as they eventually make their way back home. In these memories of being in places and moving through spaces, in other words, the cinema as a place figures as a kind of extension of home. It is significant that these memories invoke a particular sort of cinema building: the neighbourhood picture house, invariably remembered as modest and accessible ('one on every street corner', as a number of informants put it). This is another aspect of their home-like quality (I shall return to the question of different types of cinema building). It is also worth pointing out that informants' memories of *going to* the pictures are more numerous and lengthier in the telling than are memories of *being at* the pictures. Going-to and being-at memories also differ markedly in both content and timbre. I shall come back to this point as well.

The observation quoted at the beginning – that cinema seemed to constitute a transitional object for the 1930s generation – did not, when it was written, feel like a particularly profound insight, nor was it a very considered conclusion. Neither Winnicott nor object-relations theory were cited because it never occurred to me to do so. The term transitional object is commonplace in everyday parlance, and its usage at this point was undoubtedly imprecise. But this seemingly throwaway allusion somehow set off a new train of thought and a fresh direction for research; and the engagement with writings on, and

participation in discussions of, transitional objects and culture that ensued have shown that this casual statement contained an idea that was well worth refining, and exploring in greater depth.

Transitional objects are the ubiquitous first possessions of infants and young children (it may be a teddy, or even an old bit of cloth or blanket) that belong at once to the child and its inner world and to the outside world, occupying the place of imagination, an intermediate position between fantasy and reality. Winnicott famously said: 'No human being is free from the strain of relating outer and inner reality' (Winnicott 1991b: 18), and transitional objects and transitional phenomena help in the negotiation of that relationship. They inhabit what Winnicott called an 'intermediate zone', a 'third area'. This is neither inner psychical reality nor the external world of behaviour and objects, but the space between the two – a bridge, so to speak, that keeps them both apart and joined together. Importantly, transitional objects are material objects, things: they have a physical existence and are pressed into the service of inner reality. They are at once part of the subject and not the subject, and in inner life inhabit the intermediate zone, the space between inner and outer worlds (Davis and Wallbridge 1990).

Winnicott used the term 'potential space' to refer to this third area, the intermediate zone or space inhabited by transitional phenomena. The spatial trope is crucial. Winnicott's insights on transitional objects link them largely to childhood and developmental issues, in particular to the activity of playing, whose defining characteristics he regarded as a sense in the child of preoccupation, absorption and near-withdrawal, with the activity itself being experienced as outside the individual and yet not belonging entirely to the external world. Any objects drawn from the external world and used in playing are also imbued with the timbre of inner reality. It is also clear that Winnicott believed that alongside their developmental role, transitional phenomena have a structural aspect as well. In particular, he explored the relationship between transitional phenomena and the ways in which adults experience and relate to culture and creativity (Winnicott 1991a). For present purposes, I am interested in exploring both the developmental and the structural aspects of transitional phenomena.

With regard to the former, as noted above, Winnicott linked transitional objects and associated behaviours and psychical processes in infants and young children with issues of separation. This clearly means separation from the mother or primary carer in the first instance but, as Winnicott's dictum 'Home is where we start from'

suggests, this extends to include separation from a mother-associated place-object, the *home* (Winnicott 1986; Bergman 1995). In either case, separation is part of a process of development of self as apart from the outside world, and as described by Winnicott this process serves as a bridge between the familiar and the unfamiliar, and so eases the child's engagement with and acceptance of the new. It should also be borne in mind that potential space at once joins objects together and separates them from each other. The structural aspect of transitional phenomena references the fact that the dynamic equilibrium of inner and outer reality is not confined to the transitional objects of childhood, but continues through adult life. We continue re-enacting playing and other transitional processes throughout life in relation with our 'adult' transitional objects and phenomena: for the task of relating outer and inner reality, the task of 'reality acceptance', is never done with (Winnicott 2002: 240).

Place-memory, topographical memory, is pervasive in 1930s cinema-goers' talk, as we have seen, and it often manifests itself through tropes of physical movement. As an embodied, kinaesthetic form of memory discourse, place-memory and its invocation of spatial practices re-enacts the interaction of inner and outer worlds that characterises transitional phenomena. And also, through the remembered experience of bodily movement through space in the journeying to and from particular places (here between home and the local picture house) it invokes the rhythms and the repetitions, the ebbs and flows, of separation processes. It might not be strictly accurate to state that, for people recollecting and reliving their own film-going as children and adolescents in the 1930s, the cinema building, the picture house, functions as a transitional *object*. But it can certainly be posited that for this generation the regular comings and goings from home to the familiar neighbourhood picture house and back again partake of the potential-space activities of relating inner and outer worlds; and that in the particular social and cultural circumstances of their time and place these were part of the separation from home, and of the exploration of places outside home, that are part of growing up.

> As the realization of the irreconcilability of home and outside space becomes a reality, transitional spaces become a necessity for comfortable functioning. In the outside world these transitional spaces must contain elements of both the mother and world outside: the home away from home, the home on wheels, the freedom to come and go, a place to play (Bergman 1995: 64).

* * *

What happens inside the cinema? The remembered walk to the picture house on the street corner is a process of enacting and of restaging one's belonging to a place-object that is outside home and yet like home: one's locality, one's neighbourhood, one's 'manor'. What then takes place inside the cinema is rather different: it embraces the virtual experiencing of other, unfamiliar, places. There are in fact two levels involved in the remembered experience of being inside the cinema: being inside the cinema building and in the auditorium on the one hand; and 'being in' (or inside) the world on the screen on the other.[4] Significantly, 1930s cinema-goers' memories of being inside the cinema are far fewer in number, and often seem less coherent, than their descriptions of the walk from home to the picture house. Yet at the same time, these rare accounts show an exceptionally vivid and emotionally invested quality. They are often also, and perhaps relatedly, unanchored in space and/or time (as in flash-like memories of isolated images or scenes from films, usually frightening or funny ones); or they may be rueful stories about the speaker's failure to understand or properly to negotiate the difference between everyday space and time and space and time in the cinema – as in memories of sitting through several performances, losing track of time and, once back home, getting into trouble with anxious parents (Kuhn 2011). In different ways, all these types of memory are about a difficulty or lack of proficiency in negotiating the relationship between illusion and reality; and/or about testing the limits of separation and independence; and/or about managing the transition from the everyday world to the world of cinema and film and back again.

In these stories, the experience of anticipating the move from the everyday world into the cinematic and the filmic worlds is remembered above all as straddling the border between different realities:

> Standing in the street queuing in pleasant anticipation of what the next couple of hours had to offer, as the lights dimmed and the screen lit up away we were transported into a world of fantasy.

It is also recalled as involving an involuntary, passive journey, as informants repeatedly talk about being (temporarily) 'transported' or 'carried away':

> It's like being in another world... And then when I come out, I'm a bit, you know, kind of ooh! A bit, eh, carried away. And, eh, then I come down to earth eventually.[5]

It was noted earlier that two very different types of picture house coexist in 1930s cinema-goers' memories, and that the neighbourhood or street corner type is associated particularly with place-memory, with the 'containing' quality of the home from home, and with spatial practices associated with the negotiation of separation-individuation issues. The neighbourhood cinema may thus be regarded as in a sense part of home, or at any rate attached to home. The other sort of cinema, by contrast, is remembered as a place that is wholly separate from the familiar and the everyday. It embodies, in memory, some or all of the following characteristics: it is one of the new 1930s supercinemas, or 'dream palaces'; it is outside one's own neighbourhood – in another town, perhaps, or in the city centre – and is reached not on foot but by mechanised means of transport; it is a place to go on special occasions rather than as part of a weekly routine; the decor and general ambience of the place are luxurious, exotic and other-worldly; and it is associated with memories of courtship or romance – that is, with adolescence and adulthood rather than with childhood.

* * *

These characteristics, I would suggest, have some bearing on how we might imagine the future of cinema memory – by which I mean how (and indeed whether) cinema might figure today in transitional processes, in negotiations of inner and outer realities and processes of separation; and thus how today's cinema-goers and consumers of films might remember these things in years to come. Questions to be addressed in this context might include: Does cinema figure at all today as a transitional phenomenon; and if so, how? How might this involve issues of place and/or space? How might it involve the body? How might the distinction and the relationship between *cinema* and *film* operate today and in the future?

In approaching these questions, it is clearly essential to take into account the impact of changes in the ways in which films and cinema are delivered to the consumer, and in how and where films are consumed and used. But it goes beyond this, I believe. Transitional processes are not transhistorical: reality perception and experience of the outer-inner relationship are historically and culturally anchored. It is also worth stating that transitional phenomena, particularly but not exclusively as experienced or remembered in adulthood, can have a collective dimension and so become part of a generational memory bank, as indeed appears to be the case with the memories of cinema-goers of the 1930s.

A number of features of present-day cinema might be regarded as relevant to a discussion about the future of cinema memory. For example, there are far fewer cinema buildings today than there were in the 1930s, in real terms the cost of admission is higher, and the frequency of cinema attendance per capita is much lower now than it was in the 1930s. In short, the public places where one goes to see films today are less available to be experienced as part of the daily routine or of the life of a neighbourhood, or as homes from home. Also, the fact that young children no longer attend cinemas unaccompanied by adults has implications for issues around home and not-home spaces, for spatial practices and for separation-individuation. Because of the element of distance, people of all ages will generally be less likely today to walk to the cinema and more likely to get there by car or public transport. This will surely have implications for the nature of one's attachment (or lack of it) to the place, and to memories of the activity of getting there – to the content, weight and experienced significance of the remembered journey.

Furthermore, there is of course now a wide range of technologies through which films are delivered to and consumed by viewers. For a number of years films old and new have featured regularly in the schedules of broadcast, cable and satellite television, for example. As Roger Silverstone has noted, television texts and even the television set itself may acquire some of the qualities of transitional objects: it is a constant, and constantly available, presence in the home; it possesses some of the qualities of the mother/carer; its schedules and content have a cyclical, routine quality, providing a temporal frame for the viewer and offering a venue for exploring and testing the relations between reality and fantasy (Silverstone 1994: 15). Video and DVD permit repeated viewings of films, allowing the viewer to pause, skim and so on: the film text itself consequently becomes a different sort of object – one to be mastered, perhaps, rather than submitted to. We can possibly surmise that different processes of fantasy, illusion, projection or introjection may be involved, say; and even that the boundary between cinema as an institution and film as text becomes more permeable.

Today, too, a wide range of forms of entertainment is available, many of them new: for the 1930s generation, by contrast, cinema was clearly the main, if not the only, attraction. Cinema is rarely now regarded as cutting edge in the way it was in the 1930s: films and cinema are merely one element in a sprawling and heterogeneous media ecology. In this milieu, new modes of delivery of films and new technologies for their

delivery make possible a range of different spatial and bodily relationships with the 'cinematic apparatus'– the physical or the material means of consuming film texts. To the extent that these relationships are potentially more tactile, more immediate, the relationship between films and viewers might in some circumstances become more like that between toys and their users (Young 1989). And yet, to return to Winnicott, we can see that the toy/playing aspect can still potentially involve the kinds of outer world/inner world dynamics at work in transitional phenomena; and that this in turn is likely to impact on future cultural memory. These questions point towards areas of phenomenological and metapsychological inquiry that are ripe for exploration.

The consumption of films and cinema today involves distinctive modes of sociability, relations to places and spatial practices. For example, home media consumption and the attendant organisation of domestic space have implications for the negotiation of separation issues (as in adolescent 'bedroom culture', for example). On the other hand, going out to see a film in a cinema today is perhaps not unlike 1930s cinema-goers' relationship to cinemas of the second category – those remembered as special, distant, outside the everyday. What will happen to place-memory if the embodied links between home and places outside home are thus transformed, even eroded?[6]

This small case study, along with the questions it leaves us with, suggest that the Winnicottian concepts of potential space and transitional phenomena can certainly offer a great deal not only to the student of cultural memory but also to the cultural researcher interested in exploring the interaction between the psychical and the social-cultural, both in general and in relation to the consumption and use of cultural and media texts of different kinds and in different times and places.

Notes

1 Cinema Culture in 1930s Britain (CCINTB), Economic and Social Research Council project R000 23 5385. The archive is housed in the Special Collections section of Lancaster University Library, and CCINTB references in subsequent notes are to files in the archive.

2 Transitional Phenomena and Cultural Experience (T-PACE). http://www.sllf.qmul.ac.uk/filmstudies/t_pace/index.html (accessed 15 August 2011).

3 CCINTB T95-46, Freda McFarland, interviewed Bolton, 7 June 1995.

4 In Chapter 4, 'The Playing Spectator', Phyllis Creme looks at the psychodynamics of the spectator's 'entry' into the world on the cinema screen.

5 CCINTB 95-232-1, Raymond Aspden, Lancashire, letter to Valentina Bold, n.d.
 1995; CCINTB T95-158, Tessa Amelan, interviewed Manchester, 28 May 1995.
6 On the transformation of cinematic experience in the era of new media, see
 Casetti (2009).

References

Bergman, Anni (1995). 'From mother to the world outside: the use of space during the separation-individuation phase', in Simon A. Grolnick and Leonard S. Barkin (eds), *From Fantasy to Reality*, Northvale, NJ: Jason Aronson, Inc, 147–165.

Casetti, Francessco (2009). 'Filmic experience', *Screen* 50(1): 56–66.

Casey, Edward (1987). *Remembering: A Phenomenological Study*, Bloomington, IN: Indiana University Press.

Certeau, Michel de (1984). *The Practice of Everyday Life*, Berkeley, CA: University of California Press.

Davis, Madeline and David Wallbridge (1990). *Boundary and Space: An Introduction to the Work of D.W. Winnicott*, London: Karnac.

Freud, Sigmund (1984). *Beyond the Pleasure Principle* (1920), Pelican Freud Library, vol. 11, Harmondsworth: Penguin, 269–338.

Kuhn, Annette (2002). *An Everyday Magic: Cinema and Cultural Memory*, London: I.B.Tauris.

——— (2004). 'Heterotopia, heterochronia: place and time in cinema memory', *Screen* 45(2): 106–114.

——— (2011). 'What to do with cinema memory?', in Richard Maltby, Daniel Biltereyst and Phillipe Meers (eds), *Explorations in New Cinema History: Approaches and Case Studies*, Malden, MA: Wiley-Blackwell, 85–97.

Mahler, Margaret S. (1979). *The Selected Papers of Margaret S. Mahler, Vol II: Separation-Individuation*, New York: Jason Aronson.

Silverstone, Roger (1994). *Television and Everyday Life*, London: Routledge.

Winnicott, Donald W. (1986). *Home Is Where We Start From*, Harmondsworth: Penguin.

——— (1991a). 'The location of cultural experience', *Playing and Reality*, London: Routledge, 128–139.

——— (1991b). 'Transitional objects and transitional phenomena', *Playing and Reality*, London, Routledge, 1–34.

——— (2002). *Through Paediatrics to Psychoanalysis: Collected Papers*, London: Karnac Books.

Young, Robert M. (1989). 'Transitional phenomena: production and consumption', in Barny Richards (ed.), *Crises of the Self: Further Essays on Psychoanalysis and Politics*, London: Free Association Books, 57–72.

6 Soundspace

Amal Treacher Kabesh

For D.W. Winnicott, authenticity of the self and true engagement in life involve being able to sustain healthy pursuits that bring about a sense of aliveness. As Adam Phillips points out, the questions for Winnicott centre on what we depend on to make us feel alive or real. Where does our sense come from, when we have it, that our lives are worth living? (Phillips 1988: 5). While Freud believed that the individual's relationship with society and culture is fundamentally compromised, indeed is based on disavowal and repression (Freud 2002), Winnicott understood culture as potentially benign and facilitative, as human beings discover their capacities to live a satisfying life.

Contemporary British psychoanalytic theory emphasises object-relations – a term which indicates that as human beings we gain identity and substance through our initial relationships with our primary caregivers (usually, though not necessarily, mothers). The work of Melanie Klein informed a radical shift from the Freudian theory of the drives to an emphasis on the idea that we become human beings through and within our relationships with other people. These relationships constitute psychic life with all the associated nuances of fantasy, emotion, thought and activity. While Kleinian object-relations emphasises the complexity of human beings and stresses unconscious fantasy, divided thinking and protracted movement towards maturity, Winnicott's view of how and who we become is gentler, though still robust, centring on the human capacity to relate and engage with other human beings and the environment we inhabit.

This chapter takes as its starting point the vital knowledge gained from psychoanalytic object-relations theory that we become human subjects through internalising our relationships with other human

beings; and extends this view to explore our engagement with the environment. I would like to edge towards adding to the object-relations framework a view that the senses – sounds, smells, taste, touch and sight – are involved in building a relationship with the external world. These senses enable us to feel our way into being. The senses, like the infant's apprehension of the world outside itself, are inchoate and without boundaries, yet remain formative throughout life. What, then, is the continuing place of the senses in adult lives? How do adults engage with the sensory order as 'not just something one sees or hears about [but] something one lives' (Howes 2005: 3)?

The senses are interconnected, and the strands woven together in a knot. Smell, sound, taste, vision and touch are interlinked sensual experiences. The senses are inextricably linked: to hear we also see, to touch we also taste, to smell we also see. As David Howes points out, the senses are ways of perceiving, and the word *sens* in French means both sense and direction (Howes 2005: 9). Sometimes the senses work together and at other times they are confusing, producing a jagged experience. Each sense is a 'nodal cluster, a clump, confection or bouquet of all the other senses' (Connor 2005: 323). The senses, though, interact with the perception of the external world; they are a part, and a means, of perceiving that world and meeting other bodies.

While the senses are interlinked and it is difficult adequately to convey the shredded experience of the senses, I focus on sound as a foray into explicating how human beings internalise, inhabit and find ways of being in our environments. Taking sound as a specific aspect of the sensorium, I explore how it is an object that provides many important functions: sound can provide consolation and support and enables us to give meaning to our environment as we locate ourselves emotionally and physically. Sounds comfort, embrace and throw us into ourselves and outwards into an engagement with others. As Diane Ackerman writes, '[S]ounds thicken the sensory stew of our lives, and we depend on them to help us interpret, communicate with, and express the world around us' (Ackerman 2000: 175).

Drawing on Winnicott, the primary focus of this chapter is the facilitating and supportive, as opposed to the disruptive and problematic, aspect of sound. I explore how sound is an object that, like the transitional object, is out there waiting to be found and used by the growing infant as it takes in sounds from outside itself and, in turn, impacts on the world through sounds of its own and discovers the me/not-me distinction. Sound exists in space and fills up spaces and places as it travels indiscriminately. Sound respects no boundaries as it

resonates and reverberates, connecting inner and outer space. I use the term soundspace to indicate that sound is rooted in space and place. Soundspace is full of the sounds of other human beings and noises of the environment, just as space is full of overlapping sounds.

As is no respecter of boundaries, and sounds of the home interact with, and are permeated by, the sounds of the environment, I do not differentiate between sounds of the home and sounds of the surroundings. I take *habitus* to indicate the intersections of internal and external environments. Homes and the external environment are teeming with diverse sounds – human voices, the activity of people inhabiting domestic space and the sounds of domestic machinery. Similarly, the external world is full of voices that are not familiar, the activities of human beings moving through places, cars, the sounds of animals, other environmental sounds. Michael Bull and Les Back point out that everyday life is mediated by a multitude of sounds and 'waking, walking, driving, working and even falling asleep are all done to music, or some other acoustic accompaniment' (Bull and Back 2003: 1). These sounds are in the very air around us and evoke emotions and imaginings. For example, as Ben Highmore writes, to live in a city 'is to live a physical geography via a superabundance of imaginary renderings. Our most intimate contact with the city is inseparable from the fears, anxieties, desires, attractions, distractions and propulsions that constitute the lived imaginary of urbanism' (Highmore 2005: 140).

Sound is textured and, as Martha Nussbaum implies in an exploration of the emotions evoked by listening to music, it 'is another form of symbolic representation'. 'It is not language,' she says, but we need not 'cede all complexity, all sophistication in expression to, language' (Nussbaum 2001: 264). Needless to say, various sounds have diverse effects and provoke different interactions and responses. I focus in this chapter on similarities in the effects of sound on human beings, in order to explore how sounds enable connection between self and others and enable human beings to inhabit their environment. I want to make clear that I do not draw a strict boundary between childhood and adulthood, as I take the view that there is not a clear demarcation between stages of life. Our adult experiences draw upon states of mind, experiences, feelings and fantasies set down during childhood, and in any case our needs for attachment, belonging, support and consolation persist into adulthood.

It is commonplace in psychoanalytic writing to refer to the maternal voice as an envelope, something that surrounds and enfolds the child

in a comforting manner: as such it is the root of pleasure in sound and music. As Guy Rosolato argues, the maternal voice is the 'first model of auditory pleasure ... that which might be called a sonorous womb, a murmuring house' (Rosolato, quoted in Silverman 1988: 84). In this view, the infant-mother dyad is built upon the mother's care and affection. While Winnicott perhaps tends to romanticise mothering, he is deeply appreciative of the ordinary mother and her ability to provide solid care and affection. The 'good-enough mother' carefully introduces the infant to the external environment as the tones, rhythms, pitch and even the very sound of her voice can contain, soothe, console and waken the infant. As Christopher Bollas puts it, 'the mother's aesthetic of care passes through her tongue, from cooing, mirror-uttering, singing, storytelling, and wording into the world' (Bollas 1993: 43). The voices that surround and respond to the infant provide support, consolation and pleasure for the developing child as these sounds enter the complex space of the home. The rhythms and tone of the voice, alongside the repetition of familiar and familial sounds, provide continuity of care and enable the infant to locate itself in a soothing and containing soundspace. The rhythms of the environment can stand in for the mother and provide an emotional space for continuity of being. In this way sound functions as an aspect of the facilitating environment that supports the child in her sense of being.

An important way that we occupy our habitat is through inhabiting our bodies securely. Sound, I am suggesting, has a particular function as it enables a capacity to inhabit one's body and to locate the self in relation to others and to the environment. Adam Phillips describes Winnicott's notions of the self as based on a view that there is something 'essential about a person that is bound up with bodily aliveness' (Phillips 1988: 3). The self is first and foremost embodied, and feeling alive in one's own body is important for continuity of being in one's familial and social environment. Maturity, for Winnicott, involves the infant's growing capacity to integrate overwhelming and chaotic emotions and fantasies. This integration involves thought and the developing capacity to orientate oneself in time and space. This is an achievement on the child's part, and of course is not brought about through autonomous competence; rather, the child needs the attention and care of the primary caregiver. The sounds made by the caregiver are an important aspect of this care and function as a transitional object that is capable of providing the 'beseeching subject [with] an experience where the unintegrations of self find integrations' (Bollas 1993: 41).

One way that we discover bodily integration is through movement. There are many sounds that encourage, indeed provoke, movement: adults sing to the child as they hold her, play soft music to encourage her body to calm down into sleep, or indeed play music to encourage the child to move. Sound and movement can be linked, and both are a means of coming into contact with other human beings and of sensing our way into environmental space. Giuliana Bruno explores the definition of haptic as that which is 'able to come into contact with' (Bruno 2002: 6): a function of skin, the sense of touch, constitutes the reciprocal contact between people and the environment, both housing and extending communicative interface. The haptic, moreover, is also related to kinesthesis, the ability of our bodies to sense our movement in space.

* * *

Anne Rutherford explores vision as an embodied process; she relies on the work of James Gibson in her argument for an 'ecological approach to perception' (Rutherford 2003: 6). I want now to apply the notion of proprioception to sound and to argue that sound gives us vital knowledge about our habitus and the self. Gibson, Rutherford writes,

> discards the subjective-objective dichotomy in traditional models of perception, and in doing so radically rethinks the notion of the senses. This is the core of his ecological approach to perception: that perception is an environmental process. By this he means that the perceiver constantly locates him or herself in the environment, that what we perceive is not data about the environment out there, but 'the significance of surfaces in relation to our body' (Rutherford 2003: 7).

Perception, therefore, involves the positing of oneself as an embodied entity in a meaningful way in relation to the environment and what the environment offers. This view of proprioception is close to Bull and Back's notion of 'voice-bodies' (Bull and Back 2003: 70) which draws attention to how the body is critically involved in the production of sound: as we speak and produce different sounds the noise strokes the skin. We feel sound as it brushes our skin and it is through skin and sound that

> the world and the body touch, defining their common border. Contingency means mutual touching: world and body meet and caress in the skin ... things mingle among themselves [and] ... I am no exception to this ... I mingle with the world which mingles itself in me' (Connor 2005: 322).

There is pleasure in moving, taking up and filling up space, and in exploring sound and space as a sensual being.

Through our earliest sounds we experience the lived texture of home and other human beings. The rhythms, tone and sounds made by other human beings are an important aspect of embodied experience: they may be in the background or to the fore, but in any event they are part of the lived environment of our lives. The bodily experience of sound enables visceral feeling and sensation as it reverberates through the body. Sound is physical because to hear we have to take in sound and allow it to reverberate through the body. Critically, sounds fill up the spaces between human beings, allowing us to connect with one another. Sounds we produce can caress, reassure and reach out towards other human beings. For Winnicott connection between self and other is crucial for mental health; and as sounds cut across space connecting self and other they intersect across that space, enabling a mutual soundspace. Joint sounds produce enjoyment and pleasure in shared experience. For example, near my home in Cairo I notice three young girls sitting oiling one another's hair. As they stroke and tend to their hair, they are practising a particular sound that women make – I can only describe this as an undulating trilling – and they correct one another, try again to make the right sound and volume and delight in themselves and one another when they produce the correct sound. Sound, I suggest, may be one of the first ways that we as human beings learn that we can create something from our own body, and it provides a step into the beginning of play and creativity. We enjoy both our own capacity to play and the gift of watching others play. For example, I was never allowed to make this particular sound when I was growing up in Cairo, and I regret that I cannot make it, but I enjoy the sight and sound of these young girls sounding out their voices, impacting on their environment and, above all, having fun. As Nussbaum points out, we also gain enjoyment and pleasure from the activities and capacities of other human beings (Nussbaum 2001: 272).

Sound enables us to develop a sense of self as we make sounds through babbling, crying, playing with toys and words, and as we develop increasingly sophisticated language. Hopefully, other human beings respond with care and joy at the sounds we make and can contain their own emotions and fantasies as the child makes sounds and uses words that do not belong to them. This is a mutual emotional activity, as both adults and children discover through sounds. For our capacities for relatedness, identification and imaginative responses to develop and to enrich both ourselves and others,

we need to discover, and indeed relish, the me/not-me relationship. For Winnicott the merged infant cannot, indeed should not, be able to distinguish between him/herself and the other person; but for maturational development to take place the budding human being needs to discover what belongs and does not belong to the self. Critically, within a Winnicottian framework, it is the environment that makes it possible for the individual to grow from dependence to a personal way of being.

An important development towards a personal way of being is knowing that one has a voice which can be heard, that one can make a sound which impacts and can influence other human beings. We play with sound and can delight in our capacity to produce a noise that reassures us that we exist. Claire Pajaczkowska, for example, considers how humming, like doodling,

> exists in a space that links inner and outer, subjective and objective realities; the visceral resonance of sound that vibrates through muscle, tissue and bone is also the sound wave that is heard through the ear and reaches out to some external object or other (Pajaczkowska 2007: 33).

Babbling, humming, whistling, crying or simply making noise may be one of our first experiences that we are capable of creatively impacting on other human beings, ensuring not only that they exist but that they also respond and react to our noise. As Annette Kuhn writes, '[E]very child surely knows the loneliness of not being heard, not being listened to; knows, too the desire to heal the rift between itself and the world' (Kuhn 1995: 31).

With luck we can make sounds to impact on our environment, and Winnicott wholeheartedly approved of the way human beings use our environments to get what we need to enrich the self. Winnicott distinguishes between object relating – which he argues is when the subject can allow the object to become meaningful – and allowing the object to change the self. The use of an object involves object relating, but critically the object is known to be outside of the self and not imbued with projections; it is, rather, an aspect of reality (Winnicott 1991b). The capacity to use the object involves critically understanding that the object is outside of omnipotent control but, paradoxically, is there to be used by the self. This involves destruction of a fantasy that the object is part of the self in order that the object be placed in a shared reality. It is the survival of self and the object that leads to hope and love.

Sound through verbal and non-verbal communication – tone, rhythm and pitch of the voice – facilitates belonging and identification.

The human being has to survive the fantasies, the inchoate emotions and the relentless demands that are made by others on the self. Sound always survives: in this way the environment supports the developing human being, as the environment will always survive the noises made and the noises discovered. Winnicott stressed that '[R]eal development can only come out of, and is the process of finding, belief in the environment' (Phillips 1988: 64). This is not just about survival, but is importantly about the human need for attachment, as sound can embody the 'idea of our urgent need for an attachment to things outside ourselves that we do not control, in a tremendous variety of forms' (Nussbaum 2001: 272). Crucially, in order to develop into a human being we have to identify with others, as identification is about relatedness and is vital for sustaining relationships.

On the other hand, this is not necessarily a scenario of blissful plenitude. Kaja Silverman argues that the maternal voice can be experienced as a 'cobweb' that entraps and holds down the infant. The mother's voice, along with external sounds, are the 'first encounter that there is something outside of us…that which chart space, delimit objects, help us to define the world' (Silverman 1988: 76). There is a paradox in relation to sound, for while sounds enfold us they also introduce difference and rupture the illusion of plenitude. As Steven Connor puts it, there are

> two primary aspects of sound, namely its power to penetrate boundaries, and by a reparative action, its power to form protective milieux. Put simply, sound can be both an intolerable wound, and an armour or cataplasm against the injurious effects of sound itself. Sound pervades, but also surrounds (2003: 70).

The disruption that sound can cause to one's mood, emotions and state of mind is something to be contained and tolerated. Tolerance is gained through knowing that the self is disrupted but can survive the intrusion of noises made by others and the environment. While sound punctuates space it also helps human beings to locate themselves in a shared environment. For example, in Egypt the call for prayer echoes across the air and is part of the shared soundspace. Sound in this instance locates human beings in time and functions as a reminder of the passing of time.

Sounds, though, can facilitate a welcome intrusion, as they can helpfully provide breaks from isolation and unhealthy dwelling in fantasying. In his essay 'Dreaming, Fantasying, and Living', Winnicott explores how fantasying is an isolated (and isolating) phenomenon

as it absorbs energy but does not contribute to either dreaming or to living (Winnicott 1991a: 26). In this essay Winnicott explores the differences between fantasying and imagining, and asserts that 'creative playing is allied to dreaming and to living but essentially does *not* belong to fantasying' (1991a: 31). This is because fantasying interferes with action, with life and, crucially, with psychic reality. Fantasying paralyses action, which engages with possibility and real planning. As Winnicott poignantly asserts, the self and other are always entwined and none of us can be understood as separate. Furthermore, we cannot be separated out from the sensorium we inhabit and internalise for, as Howes asserts, since 'the mind is necessarily embodied and the senses mindful, then a focus on perceptual life is not a matter of losing our minds but of coming to our senses' (Howes 2005: 7). Sound enables us to build up and to know what is available. Importantly, for Winnicott, reality is enriching and reassuring in the way it sets limits to fantasy and brings satisfaction.

While we are peopled by others – indeed we cannot be without human relationships – for Winnicott we also have to find and use internal space to function, reflect and imagine. We need to be able to hear ourselves think. In his essay 'The Capacity to be Alone', Winnicott explored an essential paradox, which is that the capacity to be alone is achieved through being '*in the presence of* [the] *mother*' (1990: 30). Sound can support the individual in being alone in contemplative silence, and in being alone with oneself with all the fullness that that implies. Winnicott writes that the 'capacity to be alone is based on the experience of being alone in the presence of someone' (Winnicott 1990: 33); and I am extending his thinking to contend that human beings develop the capacity to be alone through sound. Sound is one way of dealing with troubles – noise made by others and the noise of our own thinking, feelings and fantasies – and it is a means through to hearing ourselves think in order to deal with experiences of living and the vexed endeavour of being alone and with others.

Sound orientates us. It is a crucial part of our mental landscape as we sense, take in and become placed through the material landscape: taking in the sounds of Cairo is very different to taking in the sounds of London, say. Cairo is a sound society, it is loud and full, and in this sound experience there is the 'phantasmagoric structure of feeling that hits us with the full impact of real feeling' (Nussbaum 2001: 267). What happens out there, critically, becomes internalised and develops into part of the mind itself, part of conscious life and the unconscious. Encounters with objects, relationships, ideas and other people become

part of who we are. It matters where we are and where we have come from: it is significant that we can experience 'the living, breathing city – its streets, its atmosphere, its smells, the rich variety of its everyday life' (Pamuk 2005: 216). The environment can be determined, for, as Fran Tonkiss writes, '[C]ities, after all, insist on the senses at the level of sound. It is easier and more effective to shut your eyes than it is to cover your ears. Ears cannot discriminate in the way eyes can – as with smell, hearing puts us in a submissive sensuous relation to the city' (Tonkiss 2003: 304).

As Edward Casey argues, 'we are not only *in* places but *of* them. Human beings are ineluctably place-bound' (1996: 19, Casey's emphasis). Sound enables us to know where we are and to locate ourselves physically as well as emotionally. The senses are loaded with memories, narratives and emotions, for as Steven Feld argues, 'as place is sensed, senses are placed; as places make sense, senses make place' (Feld 1996: 91). Making sense is inextricably linked to matters of belonging. Les Back explores the importance of belonging to argue that home 'means simply the centre of one's world, not in a geographical but an ontological sense, a place to be found, a place of Being' (Back 2003: 325). This profoundly Winnicottian sentiment is further elaborated as Back goes on to assert that being at home is not simply about living at a particular address or residence but is achieved 'through the interconnection of habitation, memory and ritual'; and, citing John Berger, 'without a home at the centre of the real, one was not only shelterless, but also lost in non-being, in unreality. Without home everything was fragmentation' (Back 2003: 325). Being at home with all the sounds that are produced and enjoyed provides a constant sensory and ontological centre. We take places and our senses with us, as André Aciman poignantly explores in his memoir *Out of Egypt* (Aciman 1997). Aciman describes the viscerality of belonging and explores how human beings internalise places; we take them with us and inside us, even as we are on the move or inhabiting another location. In a sense we never leave anywhere behind, as the mind is constituted by relations with other human beings and, simultaneously, is a palimpsest of places and senses. We move homes and habitus but we do so from our starting place of belonging.

Sound can transform the self as it brings about aliveness, richness and depth of experience. Sound is vital and can be spellbinding for, as Bollas describes it, a spell 'holds self and other in symmetry and soli-tude, time crystallizes into space, providing a rendezvous of self and other (text, composition, painting) that actualizes the deep rapport

between subject and object' (Bollas 1993: 40). Through soundspace we can feel delight, relief, hope and pleasure through understanding something about life, oneself and others. Soundspace is a vital aspect of our lives.

References

Aciman, André (1997). *Out of Egypt*, London: Harvill Press.

Ackerman, Diane (2000). *A Natural History of the Senses*, London: Phoenix.

Back, Les (2003). 'Sounds in the crowd' in Michael Bull and Les Back (eds), *The Auditory Culture Reader*, 311–328.

Bollas, Christopher (1993). 'The aesthetic moment and the search for transformation', in Peter L. Rudnytsky (ed.), *Transitional Objects and Potential Spaces: Literary Uses of D.W. Winnicott*, New York: Columbia University Press, 40–49.

Bruno, Giuliana (2002). *Atlas of Emotions*, London: Verso.

Bull, Michael and Back, Les (eds) (2003). *The Auditory Culture Reader*, Oxford: Berg.

Casey, Edward (1996). 'How to get from space to place in a fairly short stretch of time', in Steven Feld and Keith Basso (eds), *Senses of Place*, 13–52.

Connor, Steven (2003). 'The help of your good hands: reports on clapping', in Michael Bull and Les Back (eds), *The Auditory Culture Reader*, 67–76.

———— (2005). 'Michel Serres' five senses', David Howes (ed.), *Empire of the Senses*, Oxford: Berg, 318–334.

Feld, Steven (1996). 'Waterfalls of song: an acoustemology of place resounding in Bosavi, Papua New Guinea' in Steven Feld and Keith Basso (eds), *Senses of Place*, Santa Fe: School of American Research Press, 91–135.

Freud, Sigmund (2002). *Civilisation and Its Discontents*, London: Penguin Modern Classics.

Highmore, Ben (2005). *Cityscapes*, Basingstoke: Palgrave Macmillan.

Howes, David (2005). 'Introduction' in David Howes (ed.), *Empire of the Senses: The Sensual Culture Reader*, Oxford: Berg, 1–17.

Kuhn, Annette (2002). *Family Secrets: Acts of Memory and Imagination*, Rev edn., London: Verso.

Nussbaum, Martha C. (2001). *Upheavals of Thought: The Intelligence of Emotions*. Cambridge: Cambridge University Press.

Pajaczkowska, Claire (2007). 'On humming: reflections on Marian Milner's contribution to psychoanalysis' in Lesley Caldwell (ed.), *Winnicott and the Psychoanalytic Tradition*, London: Karnac Books, 33–48.

Pamuk, Orhan (2005). *Istanbul: Memories of a City*, London: Faber and Faber.

Phillips, Adam (1988). *Winnicott*, London: Fontana.

Rutherford, Anne (2003). 'Cinema and embodied affect', *Senses of Cinema*, 25, [online] Available at: http://www.sensesofcinema.com/2003/feature-articles/embodied_affect/ (accessed 9 December 2011).

Silverman, Kaja (1988). *The Acoustic Mirror: The Female Voice in Psychoanalysis and Cinema* (Theories of Representation and Difference), Bloomington, IN: Indiana University Press.

Tonkiss, Fran (2003). 'Aural postcards: sound, memory and the city', in Michael Bull and Les Back (eds), *The Auditory Culture Reader*, 303–309.

Winnicott, Donald W. (1990). 'The capacity to be alone', *The Maturational Process and the Facilitating Environment*, London: Karnac, 29–36.

——— (1991a) 'Dreaming, fantasying and living', *Playing and Reality*, London: Routledge,26–37.

——— (1991b) 'The use of an object and relating through identifications', *Playing and Reality*, London: Routledge, 86–94.

Part 2

Media Users

7 Media Users: An Introduction

Matt Hills

D.W. Winnicott's work has very little to say about the media, let alone about its audiences. Andrea Sabbadini observes that 'I could only find two passing references to cinema in Winnicott's writings' (2011: 18), and despite appearing in a series of BBC broadcasts, Winnicott also has little to say about radio or television (Silverstone 1994: 23). This raises a sensible enough question: why has Winnicott's work become relevant to some of those studying and theorising media audiences, users and fans?

Winnicott offers a valuable resource for audience studies, and fan studies, by virtue of his focus on creativity. As John Wiltshire points out, Winnicottian object-relations can respond to the

> need to reintroduce the concept of creativity... into critical discourse. Winnicott is one of the few writers to offer sustained attention to the origins of creativity... [and] offers a series of ideas and concepts with which to approach a notion that was no doubt discarded because... it was used 'to designate a locus of opacity' (Wiltshire 2001: 6).

It may seem odd for audience studies to have need of a theory of creativity, given that the field had, across the 1980s, become characterised by a focus on the 'active audience'. But this approach – often caricatured and linked to the work of John Fiske – formed the backdrop to appropriations of Winnicott in media studies in the likes of Harrington and Bielby's *Soap Fans* (1995), with its somewhat Fiskean subtitle, *Pursuing Pleasure and Making Meaning*, and also in Roger Silverstone's *Television and Everyday Life* (1994). Harrington and Bielby – whose more recent work is represented in this book (see Chapter 8) – returned to the concept of audience pleasure. This had undoubtedly been present

in Fiske's writings (see Jenkins 2010: xxx), but in a highly codified and reductive manner, readable as a function of audience 'resistance' and meaning-making.

Harrington and Bielby sought to take a more psychodynamic stance to audience pleasure by introducing the notion that soap operas could function as transitional phenomena for their fans – the significance of such texts being both created and found, and occupying a third space or 'intermediate area' of cultural experience. By so doing, Harrington and Bielby participated in one theoretical strand moving out of active audience theory, a line of work which was articulated with this theory's concerns, and yet at the same time was no longer enclosed within a solely semiotic model of audience identity. Roger Silverstone's book, published a year earlier, had similarly sought to get beyond the active/passive binary of audience theorising, and beyond audience studies' semiotic/sociological confines via a turn to Winnicott. Of the 'paradox' of the transitional object – 'the baby creates the object, but the object was there waiting to be created' (Winnicott 1971: 104) – Silverstone notes that:

> it runs very powerfully through all discussions of the role of television and of the television audience. ...while we may not wish to question the child, we do have to question the implications of that paradox as it works its way through the experience of culture, and especially the experience of television (Silverstone 1994: 14).

The question is one of the kinds of (psychical as well as social) uses that can be made of television and its texts; and of how a medium such as television – and now, perhaps, increasingly smartphones and web-based media as well – can be embedded into the 'ontological security' or object-constancy of trusted, ritualised daily life and its everyday creativity (Silverstone 1994: 16–17). The use of media objects, and hence the audience's conceptualisation as 'media users', plays into tensions between activity/passivity, and creativity/addiction, where 'the introduction of new media is most often associated with the fear of addiction' (Silverstone 1994: 14). Drawing on Winnicott's case study of a seven-year-old boy who was obsessed with string (1971: 18–23), Silverstone cautions that the use of television can be considered as potentially both 'pathological and non-pathological, creative and addictive' (1994: 13). Activity (the creative audience) and passivity (the dependent audience) can be closely related, and thus careful attention needs to be paid to the object uses of different media and assorted texts. For Winnicott, the obsessive string-boy – who constantly

tied chairs and tables together, and was even found tying string around his sister's neck – was fixated with this material as a symbolic denial of separation from his mother. The string symbolised joining together in the face of powerful insecurity and anxiety; an unhealthy failure to achieve separation from the mother that led to drug addictions in adult life (Winnicott 1971: 23).

But media users are not drug users, even if a mobile phone charging up overnight, or a Facebook page returned to insistently, may seem like new iterations of 'the plug-in drug' (Winn 2002). The aim of Part Two of *Little Madnesses*, rather, is to consider the ordinary creativity of audiences instead of problematically assuming that lifelong fandom of the same text or genre (Chapter 8), repeated viewing of the same text (Chapter 9), immersion in fiction (Chapter 10), or specific engagements with media (Chapter 11) can somehow represent failures to achieve self-autonomy. Such media uses may, viewed through a particular lens, seem aberrant, deviant, or even addictive: is the repeat viewer not stuck on a certain text? Is the reader immersed in fiction not seeking to problematically block out their real life? Is the viewer who returns to watch parts of a film, as some kind of comfort or reassurance, not using this object as a prop or a crutch for their sense of self? Winnicottian theory enables a way of sensitively moving past commonsensical (and 'passive audience') judgements which denigrate media users, whilst holding onto the tension between creativity and dependence, between the paradox of 'did you create that or did you find it?'

And of course theory itself can be creatively re-read and returned to, just as media texts can be creatively re-viewed and held on to by their fans. It is striking that we rarely encounter the notion of readers addicted to Freud instead of Facebook, or Marx instead of media. Theory's re-readers instead usually establish dignified schools of thought, or initiate cultural traditions. Indeed, Winnicott's work has itself inspired its own adherents, devotees and fans:

> [R]e-reading *Playing and Reality* for the sixth or sixteenth time was as exciting and stimulating as the first time.... In this exercise I wanted to 'join him up'... 'Fancy, "one rose seen in seven ways" – what a marvellous idea!' Winnicott scrawled these words, a line taken from Virginia Woolf's *To the Lighthouse* (1927), in a note to Renata Gaddini written while hospitalized in New York after a heart attack... . Both I and what I discover are different roses now compared to when I first read the book (Issroff 2001: 69).

Being a media user (akin to being a re-reading theorist) can, as in Judith Issroff's account, be a matter of excited creativity, desired unity, and yet recognition of the self's change, difference and growth. Like a piece of string which both joins and separates, threads together and distances, Winnicottian audience/fan studies (Hills 2002; Sandvoss 2005) have likewise re-read active audience theory. This process has contested the idea that to psychoanalyse audience engagements is to pathologise them, or to render adult media use necessarily regressive. Winnicott's *Playing and Reality* (1971) offers material for theorising audiences' playing and enthusing (Longhurst 2007) and has been as useful in computer game studies (Dovey and Kennedy 2006) as in fan studies, productively joining up inquiries into 'new' and 'old' media attachments rather than falsely fetishising 'the new'.

I want now to draw out some theoretical and argumentative threads which join together the four chapters gathered in Part Two, beginning with 'Pleasure and Adult Development: Extending Winnicott into Late(r) Life' by C. Lee Harrington and Denise D. Bielby (Chapter 8). This contributes to debate in the field by considering how media and fan studies' deployment of Winnicott has centred on differences between child and adult uses of transitional phenomena. Prior work has debated whether adult fandoms are in some way 'regressive' in their object use (Hills 2007; Sandvoss 2008). However, Harrington and Bielby complicate this by restoring the question of ageing, and of generational fan identity: how might soap fans' affective relationship to their favoured television shows alter across the life course? And how can this be linked to Winnicottian – and Bollasian (Bollas 1987) – object-relations theory? Chapter 8 makes a particularly fruitful contribution by focusing on sociological particularities as well as psychoanalytic theories, addressing the need to remain cognisant of specific audiences and texts. Indeed, Harrington and Bielby close their chapter by suggesting that 'object-relations theory has (paradoxically) given little thought to the distinct structure of the actual object selected.... What are the qualities of the objects we choose that facilitate our entering "particular psychic states"?' Soap operas, they suggest, may be especially 'user-friendly' objects in the sense of Winnicottian 'use', given the way that they engage with affective realms.

This question of textual specificity is one that reverberates through Matt Hills's 'Recoded Transitional Objects and Fan Re-readings of Puzzle Films' (Chapter 9). Hills examines Christopher Nolan's blockbuster film *Inception* (2010) with a view to analysing how it has incited such fervent fan re-reading, whilst also drawing upon work on repeat

viewers of *Blade Runner* (Ridley Scott, 1982). Focusing on *Inception* as another kind of 'user-friendly' object enables Hills to consider how the film invites emotional fusion between text and audience and yet simultaneously undermines this, with its abrupt ending (and other textual qualities) working to dis-illusion the audience – again in a Winnicottian sense – and so impress upon them the writer-director's creative imagination. Hills links this to an argument about differing, oscillating modalities of fan object-use, as well as addressing how *Inception* represents culturally coded versions of transitional phenomena (dreamshare and totems) which are appropriate for the adult male audience. Throughout Hills's essay, as in the preceding chapter by Harrington and Bielby, a concern for text and audience specificity is shown.

Where Hills focuses on passionate re-readers of puzzle films, Serge Tisseron's 'The Reality of the Experience of Fiction' (Chapter 10) – here translated into English for the first time – begins by quoting from a fan who feels too close to an Australian television show, *Water Rats*. Tisseron engages with 'the experience of fiction' in a variety of ways, demonstrating that audiences' 'cultural experience' of media texts can sometimes be troubling to them rather than straightforwardly pleasurable. Like Hills, Tisseron considers oscillating, varying modalities of audience object-use. While Hills focuses partly on (dis)illusionment, however, Tisseron considers how 'fiction sets in play a continuous back-and-forth movement between the internalisation of certain of the hero's traits and the projection of certain aspects of oneself onto the hero'. Importantly for Tisseron, this process can also enable audiences to find a place for split-off parts of the self: 'The reader or viewer expels and places elsewhere – into a fictional character – traits in herself that she is unaware of or refuses to acknowledge'. In this sense, fiction can suddenly feel almost too (psychically) real for its readers, as it brings into the media user's consciousness something that had not previously been available to it, reconfiguring self-identity rather than merely mirroring this, or propping it up. And Tisseron also makes the useful point that a Winnicottian focus on creativity can link the *auteur* and the spectator: 'there is no difference between the dynamics of creative production and creative reception. The point in either case is the alternating movement between those two moments: "in front of" the image and "inside" the image'. Again, this also casts further light on the preceding chapter, in which Hills theorises re-reading Nolan fans as both immersed in *Inception* and detached from it.

Tisseron's careful consideration of how fictions can be used by their audiences then leads effectively into Tania Zittoun's 'On the Use of a

Film: Cultural Experiences as Symbolic Resources' (Chapter 11), which closes Part Two. Zittoun, like Harrington and Bielby, is interested in considering how adult object-use develops, and thus how specific objects can be used as 'symbolic resources'. And like Hills, Zittoun revisits Winnicott's concept of 'cultural experience', here with a view to linking this to experiences of cinema-going. Zittoun makes sensitive use of interview material to support her arguments; and this attentive response to empirical detail – rather than grand theorising – is also something – I suspect very Winnicottian – that is threaded through all the chapters in Part Two, and is especially evident in its opening and closing contributions. Zittoun draws on a number of her respondents' statements to demonstrate how films become emotionally and existentially significant for them, facilitating 'lifelong creativity' which is a matter both of immersion and of distancing/reflection. Again, audiences are shown not simply to fuse emotionally with media texts (a kind of dependence), but also to (re)shape and (re)orient the self (a kind of agency).

Blurring binaries of active/passive and inner/outer, while exploring audiences' creativity in ways that are not solely reducible to sociological variables and semiotic vectors – but which nonetheless remain attentive to them – these four chapters all positively represent ways in which Winnicottian object-relations can inform audience studies. Media users, and the object-use of media texts, can and should be theorised by moving beyond reductive notions of childhood and adulthood (Harrington and Bielby), 'immersion' (Hills), 'identification' (Tisseron), and pre-existent cultural identity (Zittoun). Through creative object-use, indeed, the playing self can be transformed. Above all, Winnicott offers a powerful sense of the vitality, and the healthiness, and indeed the very *ordinariness*, of media culture's 'little madnesses'; whether these are sticking with a beloved soap opera across the life course, re-reading a puzzle film many times over to search for 'clues', being emotionally troubled by one's closeness to a media text, or finding a way to cope with racism by repeatedly watching a particular film.

In all sorts of contexts, media users avoid being merely targeted or directly addressed by the media, instead relating to specific products as both 'created' and 'found'. And as Roger Silverstone reminds us, we 'have to question the implications of that paradox as it works its way through the experience of culture' (Silverstone 1994: 14). Of course, some media consumption – often that of the non-fan, or the ataraxic, indifferent audience – may be a kind of 'degree zero' object-use, in which the viewer's or reader's sense of self is not at all engaged by

that text, and where the text is encountered solely as a part of external reality. This distancing may even be true of some academic readings:

> Let us… admit a *degree zero* of use of cultural elements. …A movie is seen because it is good fun…. The semiotic prism would miss the *meaning for person* pole. A particular case of zero use is the *literate expert use*: here, the cultural elements might be addressed formally, or historical-critically, but again, without any links to personal resonance (a *cold* mediation) (Zittoun 2006: 203).

Media studies has, to date, assumed that these sorts of readings are diametrically and perhaps even ideologically opposed, split into the 'good' critical-historical interpretation and the 'bad' untutored response of 'it was just fun'. But the Winnicottian study of audiences and readers, thought of as media users, may be able to think more precisely about how our inner, psychical realities are engaged – and how and when they go missing – in various sorts of media use. It may even be possible to consider whether forms of media consumption engage with Winnicott's notions of the 'true' and 'false' self (1971: 120), though this remains a question to be explored by further studies – which it is to be hoped will follow on from, and develop out of, those threaded together here.

References

Bollas, Christopher (1987). *The Shadow of the Object: Psychoanalysis of the Unthought Known*, London: Free Association Books.

Dovey, Jon and Helen Kennedy (2006). *Game Cultures*, Maidenhead: Open University Press.

Harrington, Lee C., and Bielby, Denise (1995). *Soap Fans: Pursuing Pleasure and Making Meaning in Everyday Life*, Philadelphia, PA: Temple University Press.

Hills, Matt (2002). *Fan Cultures*, London and New York: Routledge.

——— (2007). 'Essential tensions: Winnicottian object-relations in the media sociology of Roger Silverstone', *International Journal of Communication*, 1: 37–48.

Issroff, Judith (2001). 'Reflections on *Playing and Reality*' in Mario Bertolini, Andreas Giannakoulas and Max Hernandez (eds), *Squiggles and Spaces*, Volume 1, Philadelphia, PA: Whurr Publishers, 59–70.

Jenkins, Henry (2010). 'Why Fiske still matters', in John Fiske (ed.), *Understanding Popular Culture*, 2nd Edition, London and New York: Routledge, xii–xxxviii.

Longhurst, Brian (2007). *Cultural Change and Ordinary Life*, Maidenhead: Open University Press.

Sabbadini, Andrea (2011). 'Cameras, mirrors, and the bridge space: A Winnicottian Lens on Cinema', *Projections* 5(1): 17–30.

Sandvoss, Cornel (2005). *Fans: The Mirror of Consumption*, Malden, MA: Polity Press.

——— (2008). 'On the couch with Europe: the Eurovision Song Contest, the European Broadcast Union and belonging on the Old Continent', *Popular Communication: The International Journal of Media and Culture* 6(3): 190–207.

Silverstone, Roger (1994). *Television and Everyday Life*, London: Routledge.

Wiltshire, John (2001). *Recreating Jane Austen*, Cambridge: Cambridge University Press.

Winn, Marie (2002). *The Plug-in Drug: Television, Computers and Family Life*, Harmondsworth: Penguin.

Winnicott, Donald W. (1971). *Playing and Reality*, Harmondsworth: Penguin.

Zittoun, Tania (2006). *Transitions: Development through Symbolic Resources*, Greenwich, CT: Information Age Publishing.

8 Pleasure and Adult Development: Extending Winnicott into Late(r) Life

C. Lee Harrington and Denise D. Bielby

In *Lastingness: The Art of Old Age*, author Nicholas Delbanco questions whether there is a form of creative expression 'that requires, as prerequisite, the long view of the elderly' (Delbanco 2011: 199). *Lastingness* is among a spate of recent books that explore creativity and artistry in later life – together with Anthony Storr's *Solitude* (Storr 1989), Edward Said's *On Late Style* (Said 2006), and David Galenson's *Old Masters and Young Geniuses* (Galenson 2006). Delbanco aims to articulate how one might 'negotiate the forty or fifty years' between a 'promising' (young) artist and a 'distinguished' (old) one (Delbanco 2011: 32). Of the various barriers to creative expression in late life he identifies, including trouble finding new subjects and the 'deep paralysis of repetition', he suggests that 'failure of illusion is perhaps the most insidious' as '[d]isbelief gets harder to suspend' (29). While Delbanco's analytic focus is professional artists, musicians and writers, his argument raises broader questions about how processes of human ageing shape our capacity for creativity, imagination and playfulness. What happens to illusion and to the pleasure(s) of illusion as we age?

In a volume on Winnicott's 'little madnesses', a chapter on adults and ageing potentially engages the 'madness' question more closely than do others, as the illusory experiences allowed to the infant – the realness of the cherished blanket or teddy bear – become hallmarks of not-so-little lunacy when claimed too openly or insistently in adulthood. While Winnicott's focus on infancy and childhood does not preclude discussion of adult experiences, as we discuss below, he does not fully consider how human development – particularly *emotional* development – across the lifespan might temper his theories. In this chapter we extend Winnicott's ideas into adulthood and later life by

exploring transitional phenomena and illusory play among mature media fans. Despite the narrative of decline stereotypically associated with ageing, empirical evidence points to heightened emotional mastery and complexity over time and increases in positive emotional experiences that suggest intriguing possibilities for imaginative play in mid life and late life. Drawing on gerontological and human development literatures to complement the expansion of Winnicottian theory in fan studies over the past decade, we argue for different uses of transitional phenomena among older adults.[1]

In the following two sections we briefly discuss Winnicott and age/ageing and the ways Winnicottian theory has been utilised within media fan studies. We then turn to our primary topic, emotional development in adulthood, and explore its implications for illusory play in late(r) life.

* * *

Winnicott suggests that transitional phenomena begin to appear somewhere between four and twelve months of age and are used by infants to negotiate the boundaries between internal and external realities. Transitional phenomena represent early stages of the use of illusion, the infant's emotional attachment to an object that is not part of his or her body – a doll or a stuffed animal – but 'are not fully recognized as belonging to external reality' (Winnicott 1971: 2). Transitional phenomena thus exist in an intermediate or in-between realm of experience, an 'exciting interweave of subjective and objective observations' (64). In infancy intermediate realm play is necessary for the child to form a healthy psychic relationship with the external world. However, Winnicott emphasises that negotiating the boundaries between inner and outer realities is a universal and lifelong endeavour:

> It is assumed that the task of reality-acceptance is never completed, that no human being is free from the strain of relating inner and outer reality, and that relief from this strain is provided by an intermediate area of experience [which] is in direct continuity with the play area of the small child who is 'lost' in play (Winnicott 1953: 96).

In both infancy and adulthood, the intermediate realm and the imaginative or illusory play that occurs therein function as both a *resting* space and a *growing* space (Fogel 1992: 212).

This is not to suggest that the experiences of children and adults are identical. For example, Winnicott claims that for the sake of the child's

health the intermediate realm should not be challenged (Winnicott 1953: 90), the transitional object should not be changed except by the infant, and that in a normal developmental process the object simply loses meaning over time – it is neither forgotten nor mourned but rather diffused over the larger cultural field (Winnicott 1953: 91).[2] As we discuss below, all three expectations are routinely breached in adulthood. Perhaps the most important contrast with infant experiences is that the 'naturalness' of transitional realm play is mitigated in adulthood by its confinement to certain domains (the arts, religion, philosophy, and so on) or to its concealment from others. Adults place themselves at risk when their imaginative play involves basic social transgressions or when adults put 'too powerful a claim on the credulity of others, forcing them to acknowledge a sharing of illusion that is not their own' (Winnicott 1953: 90).

Much of the psychoanalytic literature on Winnicott and adulthood returns to the question of health/lunacy/madness in its focus on the professional therapeutic relationship between patient and analyst. Indeed, 'what had occurred in childhood was Winnicott's lens through which he understood adult patients as well' (Gargiulo 2004: 104); and Winnicott's own therapeutic practice was guided by a belief that the analyst's core job was to foster the adult patient's capacity to engage in imaginative play. However, our main point in this chapter is that even as adults' transitional realm play is valued for its growth potential, as noted above, adult development per se was undertheorised by Winnicott.

Below we discuss ways in which Winnicottian theory has been utilised by media scholars, particularly in fan studies and in the emergent literature on evocative objects. As will become clear, the interpretation and application of Winnicott in these literatures remains unresolved: our goal is to move toward resolution by (re)introducing *age* into the conversation.

* * *

We first wrote of Winnicott and media fandom in the early 1990s, suggesting that the medium of television and the unique qualities of serial narratives made daily television soap operas ideal for use as transitional objects (Harrington and Bielby 1995). We argued that the common stereotype of soap fans that confuse reality and fantasy is more accurately a form of playing with the boundaries between the two – core to the pleasure of soap fandom is the 'as-if' relationship between the fictional and nonfictional[3], particularly in the domain of

soaps' core narrative focus: romance. Our writing at that time did not consider Roger Silverstone's now influential work on Winnicott and television (Silverstone 1994), and we have not revisited our original postulation in any depth. Since the early 1990s, however, Winnicottian theories have been embraced within fan studies – more so than in media studies in general (Hills 2007) – in part because Winnicott leaves a rich conceptual space for the formation of fan communities:

> If the adult can manage to enjoy the personal intermediate area without making claims, then we can acknowledge our own corresponding inter-mediate areas … We can share a respect for illusory experiences, and if we wish we may collect together and form a group on the basis of the similarity of [those] experiences (Winnicott 1953: 96, 90, emphasis deleted).

Matt Hills in *Fan Cultures* offered a cogent critique of both Silverstone's and our work, and in particular our replication of a confusion noted in Winnicott – the failure to distinguish between the transitional object proper and the larger cultural field which eventually displaces it, and the failure to articulate how that displacement is actually accomplished (Hills 2002: 107). Hills argues for a critical distinction between 'media texts used as "proper" transitional objects (closely akin to Winnicott's own definition), and those used by fan audiences as "secondary" transitional objects, which though intensely cathected, remain more culturally intersubjective' or communal (Hills 2007: 44). As such, Hills argues, secondary transitional objects cannot be 'possessed' in the same way as primary objects. Over the past decade Hills and Cornel Sandvoss have debated whether fan attachment to secondary transitional objects in adulthood is regressive, in that such affective attachments are associated with a particular developmental stage of childhood (Hills 2002, 2007; Sandvoss 2005, 2008). Simply put, Silverstone and Sandvoss say 'yes'; Hills concludes 'no'.

Winnicottian thinking is also evident in the literature on evocative or 'living' objects that connects properties of the object itself to affective meaning in the self. In *Evocative Objects*, editor Sherry Turkle gathers scientists, humanists, artists and designers to reflect on objects that they love – a rolling pin, a painting, apples or a stuffed rabbit – asking each author to follow the object's associations: 'where does it take you; what do you feel; what are you able to understand' (Turkle 2007: 7). Turkle ultimately echoes Winnicott in concluding that '[o]bject play – for adults as well as children – engages the heart as well as the mind; it is a source of inner vitality' (309). Christopher Bollas (Bollas 1992, 2009) makes lifespan issues more explicit via a subset of evocative objects

he terms *generational objects*, 'those phenomena that we use to form a sense of generational identity' (1992: 255) and explore links between self-in-present, self-in-past, and the collective experiences of our generation. In the context of media fandom, for example, the notion of generational objects is reflected in Malcolm Jones's lament to one's childhood self upon the publication of the last Harry Potter novel; in Annette Kuhn's book on memory among Britain's first cinema-going generation; and in Will Brooker's analysis of different generational readings of the *Star Wars* text (Brooker 2002; Jones 2007; Kuhn 2002). Hills engages a related aspect of Bollas's work through a study of the entering and leaving of fandoms and the role of the chance, or 'aleatory', object in fandom across the life course (Hills 2005).

Our goal is not to resolve the Silverstone/Hills/Sandvoss debate, nor to evaluate Bollas's claims directly (though we return to both issues below) but rather to nudge the conversation towards a greater consideration of ageing itself. Elsewhere we review the past 25 years of fan studies through a gerontological lens, and suggest various ways in which media fandom is age-structured (Harrington and Bielby 2010). Even a cursory contemplation of Winnicott and fandom in the context of adult ageing points to meaningful ways in which lifespan issues shape transitional realm play. Consider again Winnicott's assertion that transitional phenomena should not be challenged, should not be changed except by the infant, and that they simply lose meaning over time. Adult media fans routinely experience violations of all three expectations. They are held accountable to age norms in ways that younger fans are not (see, for example, Vroomen on 'arrested development' charges against adult fans of the Spice Girls [Vroomen 2004]); fan objects routinely disappear or are altered as veteran artists negotiate the physical/cognitive changes associated with their own ageing process (see Williams on 'post-object fandom' [Williams 2011]); and their disappearance or alteration can be deeply mourned by fans (see any number of fan bloggers on the ongoing demise of the US soap opera genre). Moreover, broader cultural anxieties – the state of the economy, the potential for a terrorist attack, global climate change, and so on – can attenuate adult access to transitional phenomena (LaMothe 2005: 51).

But how does the adulthood of adults – the *agedness* of adults – shape intermediate realm play? Consider the following quote from Henry Jenkins, a key figure in fan studies and one of the participants in Turkle's project on 'object intimacies', as he describes how ageing has modified his love for superhero comics. He writes that after being a boyhood fan he:

... returned to comics sometime in my mid-thirties – searching for some-thing I couldn't name at the time. A few years later, when I was diagnosed with gout, I found myself drawn even more passionately back into the [comics] world A growing recognition of my own mortality drew me into the death-defying world of the superheroes, who, unlike me, never grow older and never had bodies that ached. For me, the comics work as a reverse portrait of Dorian Gray: They remain the same while my body ages and decays At one point in my life I read these stories to learn what it was like to have the power and autonomy of adulthood. Now, I read them to see how to confront death and still come out the other side. (Jenkins 2007: 201, 205).

To return to our opening question: what happens to illusion and to the pleasure(s) of illusion, as we age? In previous work we drew on Erik Erikson's (1959) eight-stage model of human development from birth to death to consider media fandom in different stages of adulthood and to assess how physical and cognitive changes associated with ageing might modify fandom over time (Erikson 1959; Harrington and Bielby 2010). Given the central role of *affect* in transitional realm play, we focus below on issues of emotion and human development. We then suggest ways in which emotional changes associated with ageing might amend transitional realm play over time.

* * *

In their groundbreaking book *The Hidden Genius of Emotion*, Carol Magai and Jeannette Haviland-Jones draw on attachment theory, dynamic systems theory, emotions theory and complementary theory to propose that emotion is the missing link in modern developmental theory (Magai and Haviland-Jones 2002: 4). Over the course of the twentieth century there have been, with few exceptions (for example, Jean Piaget, Silvan Tomkins and Carroll Izard), 'only sporadic and super-ficial treatment of the emotions and their role in human development' (8). Winnicott himself referenced infants' 'excited love' of transitional objects (as well as hatred and aggression towards them); (Winnicott 1953: 91), but in general was vague about the emotional 'content' of the transitional realm. According to Magai and Haviland-Jones, devel-opmental theory has been dominated by two central fictions – the notion of 'early experiences' and the 'doctrine of continuity' (Magai and Haviland-Jones 2002: 27) – that obscure the *specificity* by which emotions facilitate or enable development and that assume a shared

(rather than a unique) pattern of emotional experience. They critique both stage models and accretion models of development[4] in arguing that the fact that 'people begin at one place and end at another does not tell us that the path between is common to us all' (483). Their central thesis, which they note is heavily indebted to Tomkins, is that 'affect is the central organizing force in individual personality and the integrative link between domains of psychological functioning' (xi). As such, emotions are key to understanding 'both the power and the limits of our romances of early experience and continuity' (30).

In *Soap Fans*, we suggested that the pleasures of adult fandom are perhaps too elusive, often beyond the ability of fans themselves to comprehend and articulate; and equally elusive to analysts who risk rationalising pleasure away rather than clarifying it (Harrington and Bielby 1995: 121). Recent meta-analytic reviews by Lewis (2008) and Magai (2008) prove helpful by revealing the specificities of emotional development over the life course, even as the authors acknowledge that developmental issues are one of the 'least understood aspects of emotion' (Lewis 2008: 312). In short, what are variably termed primary or basic emotions (such as fear or joy) emerge in the first eight or nine months of life (Lewis 2008: 315). In the second half of the second year of life, the new cognitive capacity for self-awareness allows another set of emotions, such as embarrassment and envy, to emerge (316). Between two and three years of age children gain the capacity to 'evaluate their behavior against a standard' (317) and by the end of the third year 'almost the full range of adult emotions can be said to exist' (304). More relevant to our purposes is Magai's discussion of 'long-lived emotions', or affect at the other end of the life course (Magai 2008). Her review includes both theoretical postulations and empirical findings. We list selected key empirical findings below:

1. cross-sectional data indicate that positive affect increases over the adult years and negative emotion decreases or remains level (381); however, longitudinal data reveals declines in both positive and negative emotion toward the very end of the lifespan (382);
2. 'emotional information differentially engages older adults'; that is, older adults 'tend to show a positivity bias' (386);
3. 'the ability to regulate emotion voluntarily does not decline with age and perhaps may even improve' (387);
4. age 'appears to bring with it an increasing appreciation for the affective aspects of life and social relations' (388);

5. both theoretical models and empirical findings suggest 'greater emotional complexity with age' (388).[5]

While these findings do not name pleasure per se, and indeed 'pleasure' is typically treated as a diffuse or combinatory experience in the emotions literature, the findings do hint at ways that the emotional or affective dimension of transitional realm play might transform with age. In a recent article (Harrington et al. 2011) we drew on these findings to suggest that mature fans may be 'better' fans in their capacity to engage more deeply, selectively, and appreciatively with media texts than younger fans. Below, we move towards a closer consideration of that possibility.

* * *

We draw here on data collected for a separate project on long-term soap opera acting and viewing (Harrington and Brothers 2010).[6] Given that the data were collected within a gerontological (not a Winnicottian) framework, our discussion should be considered illustrative rather than conclusive. However, we believe the data offer insight into ways that fan pleasures may change over time. For example, lifelong soap fans report that their taste in characters has changed in a common direction: in adolescence or early adulthood they were deeply invested in 'good' characters but became more intrigued by villains as they aged. In their own articulation, this speaks to a gradual accumulation of personal life experiences and a growing awareness of life's disappointments, subtleties and complexities (see point 5):

> I do think at a younger age I was startled by the extent to which people were able to deceive each other. I am less startled by that now. Albert Ellis once said that we are all born with the talent for 'crooked thinking' and I have learned over time that this is true (65-year-old female, soap viewer for 50 years).

> When I was younger I always hated the villains As I've gotten older, I have found that these characters have become my favourites! The way I see it, when I was younger, I saw things in terms of black and white, right and wrong, good and evil. Now that I'm older, I tend to appreciate the complexity of character over whether the character is 'good' or 'bad' Complexity of character and motivation is much more interesting to me than bland goody goodies now. I like to think that means I am a

more complex person who is willing to see shades of grey rather than strict black and white. I doubt I would be able to articulate this if I hadn't watched soaps most of my life (female in her late 30s, soap viewer for 30 years).

While an interest in villains might seem contradictory to the positivity bias that Magai (2008) documents (findings 1 and 2 above), fans point out that villains tend to have 'better' storylines and are more deeply layered characters, thus enhancing viewing pleasure. The positivity bias also reveals itself in how long-term fans respond to potential narrative content. When asked if they would like to see storylines reflecting certain realities of ageing – cognitive decline, late-life widowhood, assisted care facilities, and so on – the younger fans in our sample (which we defined around US soaps' target demographic of 18 to 49 year-olds) responded positively but the older fans (aged 50+) were more ambivalent, saying such stories are either too depressing or hit too close to home, thus disrupting the illusory potential of the viewing experience:

> One would think that persons my age might be interested in seeing storylines involving these issues that we are going through or have already experienced – I'm not sure if I want to see these unavoidable life circumstances as part of my entertainment (70-year-old female, soap viewer for 45 years).

> I absolutely detest storylines of this type. I see all of that I want in real life…. I am not one who longs to see more of the veteran actors. I do not care to watch them until they get doddering …. There is a lot to be said for growing old with dignity (50+-year-old female, soap viewer for 51 years).

Finally, a positivity bias is reflected in a near-universal distaste for onscreen depictions of romantic intimacy among veteran actors/ mature characters. While fans in our study want older characters to *have* relationships, they do not want to see physical expressions of it onscreen (other than handholding or chaste kissing), a view less readily expressed towards younger actors/characters. This may reflect a deep-seated ageism in the culture at large as well as older viewers' discomfort with the realities of their own changing bodily aesthetics and sexual functioning (though widespread social science data confirm continued sexual expression across adulthood and late life). It also raises interesting questions about the visual or expressive content of romantic fantasy (imaginative play) in late(r) life.

That age brings with it 'an increasing appreciation for the affective aspects of life and social relations' (Magai's previous point '4') is also affirmed by long-term soap viewers. Not only does the soap genre itself celebrate emotional and romantic relationships (raising the empirical question of whether certain media forms are more amenable to late-life fandom than others), but fans report that *shared* soap-watching over time enhances the depth and multidimensionality of their own offscreen relationships:

> Soap operas bonded me [with my mother and grandmother] and gave us 'female time' before my father arrived home from work. It is now a cherished memory of my mother and grandmother. Every day at 3 pm [they are still] 'with me' in a certain way. For that, I am forever grateful to Irna Phillips for having created 'Guiding Light' seventy years ago I'm not certain that I realized it at the time of watching or when I was much younger, but now, looking back, I am able to see [how much] I value the women in my life (59-year-old female, soap viewer for 20+ years).

This fan goes on to explain that in her younger years she found watching male characters more pleasurable but the onscreen develop-ment of female relationships taught her to value and prioritise those relations in her own life, a quality she is grateful to have cultivated.

In addition to illustrating Magai's findings about age and emotional development, conversations with long-term soap opera fans also point to ways in which the function of the intermediate realm may shift emphasis over time. Recall that the transitional realm is both a *growing* space and a *resting* space, a dual function that presumably holds true across the lifespan. Our conversations with soap fans indicate that in their transitional realm play, growth is associated more with their *youthful* fandom and rest with their more *mature* fandom. Older fans describe soaps as currently offering them 'solace,' 'comfort,' 'safety' and 'familiarity'; but report that in their younger years soaps were core to their psychological maturation. This 24-year-old fan articulates the developmental opportunities offered via soap opera:

> I do think that soaps very directly open up the chance to ask a lot of hypothetical questions, often about balancing work and family lives, or what one would do in cases of moral ambiguity (male, has no memory of life without soaps).

And this 60-year-old fan reflects on a key message she learned from the soaps:

> When I was around 19, the character Althea really helped me in some decision making around relationships. I would ask myself 'What would Althea do?' What I learned about myself is that it is not a sign of weakness to allow oneself to be vulnerable. That was an important lesson (female, soap viewer for 25 years).

Interestingly, most soap fans report a withdrawal from character-specificity in their affective investment and imaginative play over time. They report being 'obsessed with' and 'devoted to' specific characters or relationships in their youthful fandom, but note an investment in the fan community as a whole or in the more generalised rituals of soap-watching in their mature fandom. By associating growth with youthful fandom we do not mean to imply that the capacity for human development ends at some point in the lifespan. The very process of getting old 'poses challenges, and perhaps threats, to the self' (George 1998: 139); and indeed Henry Jenkins's earlier quotation points to ways in which evocative objects can be central to interpreting end-of-life issues. Rather, we point out that in whatever ways older adults' imaginative play is growth-oriented, it does not appear to engage soap operas as transitional objects (at least not for these fans). In part this is no doubt due to elements of production. The youth orientation of the US soap industry and the resultant marginalisation of veteran actors and 'mature' storylines leave minimal opportunity *to* draw on soaps as a growing space in late(r) life.[7] But this finding also points to one of the key psychological dimensions of culture and ageing: 'I think where I am in my life has determined how I respond to soaps' (female, 40+ years watching soaps, 52 years old).

* * *

We conclude with three brief provocations. Firstly, to return to the Silverstone/Hills/Sandvoss debate, use of media texts as transitional objects in adulthood may be neither wholly regressive (in that transitional objects are associated with a specific stage of child development) nor wholly non-regressive (in that they have entered the larger cultural field) but rather potentially *progressive* in ways that Winnicottian theory does not anticipate. Without a consideration of ageing itself – without situating theories of child development alongside theories of lifespan development – we cannot fully grasp how adult intermediate realm play compares to that of a child (see Bollas 1995). Even the most seemingly linear of psychodynamic stage theory

models, such as Erikson's (1959) noted earlier, emphasise the *dialectical* movement across phases (see Marcia 2010) – the simultaneous and mutually informative forward steps and backslides and re-visitations that comprise the behavioural and emotional lives of most Westerners in late modernity.

Secondly, we highlight Bollas's insight that object-relations theory has (paradoxically) given little thought to the distinct structure of the actual object selected (Bollas 1992: 4). What are the qualities of the objects we choose that facilitate our entering 'particular psychic states' (6)? At this point in fan studies, scholars are moving away from studying specific fan communities – soap fans or *Doctor Who* fans or fans of China's Super Girl singing contest – to focusing on broader dimensions of fandom and fan affect. What is at risk in this shift? We reiterate our 1995 claim that US soap operas might serve as particularly 'user-friendly' objects (in the Winnicottian sense of 'use') in that the core of the genre and the 'work/play' of the transitional realm engage the same domain – affect itself. We also note that one of soaps' central structural elements – its multigenerational storytelling – may *inhibit* it from use as a generational object as conceptualised by Bollas (1992), a point notable given that 'generation' is one of the few ways that adult ageing has been visibilised in media fan studies.

Finally, what *does* happen to illusion as we age? One viewer echoed Delbanco by telling us, 'I am not the easily entertained, naive, willing to watch anything … person I was back then. I am older and wiser and less willing to suspend disbelief' (female, 51-year soap watcher, declined to state age). There is no indication from the gerontological literature that the human capacity to engage in illusory play disappears (dependent on changes in cognitive functioning, of course); but the accumulation of life experiences and the realities of bodily ageing and impending mortality may well modify the frequency, duration and/or 'content' of that play. Our suggestive data point to the growing importance of the 'rest' (rather than the growth) function of the intermediate realm as one ages, a finding consistent with Lars Tornstam's concept of late-life gerotranscendence, a 'more cosmic and transcendent [worldview], normally accompanied by a contemplative dimension' (Tornstam 1997: 143). Old age may thus be accompanied by a more meditative dimension to intermediate realm play than heretofore realised. Perhaps that *is* the 'long view of the elderly' (Delbanco 2011).

Notes

1 See Zittoun (2006: 45–46) for justification of the use of psychoanalytic models in the framework of cultural developmental psychology.

2 By 'larger cultural field' Winnicott refers to 'the whole intermediate area between "inner psychic reality" and "the external world as perceived by two persons in common"'. He writes, 'At this point my subject widens out into that of play, and of artistic creativity and appreciation, and of religious feeling, and of dreaming, and also of fetishism, lying and stealing, the origin and loss of affectionate feeling, drug addiction, the talisman of obsessional rituals, etc.' (1953: 91).

3 On the 'as-if' relation, see Chapters 10 and 11 in this volume.

4 Stage models of development propose that people evolve through fairly linear developmental epochs. In contrasting accretion models, 'personal qualities become ever more well formed and structuralised over time. As individuals develop, they become more well articulated and more fully evolved versions of their younger self' (Magai and Haviland-Jones 2002: 476). Both approaches fail to help us understand 'individual difference or developmental divergence' (476).

5 Complexity is defined as 'involving an increased range of emotions, or as consisting of blends or overlaps among negative emotions or between positive and negative affects' (Magai 2008: 384).

6 The data were collected via interviews with soap viewers who have been watching the same show for at least 20 years and actors who have played the same role for at least 15 years. Viewers' ages ranged from 24 to 73 (median age: 59). Viewers were asked questions about their history of viewing, the varying role soaps has played in their lives over time, and whether (and if so, how) age has shaped their interpretive readings or what they 'get' out of soaps. For additional details on project design see Harrington and Bielby (2010). Consistent with narrative theory, we do not approach viewer data as factual accounts of viewers' experiences. Rather, the interview transcript is a text (as is this analysis of it) and the past itself is 'mediated, indeed produced, in the activity of remembering' (Kuhn 2002: 9).

7 We note Hills's (2002: 107) insight that an industrial or ideological logic may run counter to Winnicott's contention that transitional objects are both created and found. Our point here, following Bollas, is that 'We do not know why we choose objects, but certainly one reason is because of their "experience potential," as each object provides "textures of self experience"' (Bollas 2009: 87).

References

Bollas, Christopher (1992). *Being a Character: Psychoanalysis and Self-Experience*, New York: Hill and Wang.

——— (1995). *Cracking Up: The World of Unconscious Experience*, New York: Hill and Wang.

——— (2009). *The Evocative Object World*, London: Routledge.

Brooker, Will (2002). *Using the Force: Creativity, Community and Star Wars Fans*, New York and London: Continuum.

Delbanco, Nicholas (2011). *Lastingness: The Art of Old Age*, New York and Boston: Grand Central Publishing.

Erikson, Erik H. (1959). *Identity and the Life Cycle: Selected Papers*, New York: International Universities Press.

Fogel, Gerald I. (1992). 'Winnicott's antitheory and Winnicott's art: his significance for adult analysis', *The Psychoanalytic Study of the Child*, 47: 205–222.

Galenson, David W. (2006). *Old Masters and Young Geniuses: The Two Life Cycles of Artistic Creativity*, Princeton, NJ: Princeton University Press.

Gargiulo, Gerald J. (2004). *Psyche, Self and Soul: Rethinking Psychoanalysis, the Self and Spirituality*, London and Philadelphia: Whurr Publishers.

George, Linda (1998). 'Self and identity in later life: protecting and enhancing the self', *Journal of Aging and Identity* 3(3): 133–152.

Harrington, Lee, C. and Bielby, Denise (1995). *Soap Fans: Pursuing Pleasure and Making Meaning in Everyday Life*, Philadelphia, PA: Temple University Press.

——— (2010). 'A life course perspective on fandom', *International Journal of Cultural Studies* 13(5): 429–450.

Harrington, Lee, C. and Brothers, Denise (2010). 'Life course built for two', *Journal of Aging Studies* 24: 20–29.

Harrington, Lee, C., Bielby, Denise and Bardo, Anthony R. (2011). 'Life course transitions and the future of fandom', *International Journal of Cultural Studies*: 567–590.

Hills, Matt (2002). *Fan Cultures*, London: Routledge.

——— (2005). 'Patterns of surprise: the "aleatory object" in psychoanalytic ethnography and cyclical fandom', *American Behavioral Scientist* 48(7): 801–821.

——— (2007). 'Essential tensions: Winnicottian object-relations in the media sociology of Roger Silverstone', *International Journal of Communication* 1: 37–48.

Jenkins, Henry (2007). 'Death-defying superheroes', in Sherry Turkle (ed.), *Evocative Objects: Things We Think With*, Cambridge, MA: MIT Press, 195–207.

Jones, Malcolm (2007). 'Harry Potter: the end is here; darker, deeper and defying expectation, "The Deathly Hallows" is indeed magic ', *Newsweek Magazine,* 30 July.

Kuhn, Annette (2002). *An Everyday Magic: Cinema and Cultural Memory*, London: I.B.Tauris.

LaMothe, Ryan (2005). *Becoming Alive: Psychoanalysis and Vitality*, London and New York: Routledge.

Lewis, Michael (2008). 'The emergence of human emotions', in Jeannette M. Haviland-Jones, Michael Lewis and and Lisa F. Barrett (eds), *Handbook of Emotions*, 3rd edn., New York and London: The Guilford Press, 304–319.

Magai, Carol (2008). 'Long-lived emotions: a life-course perspective on emotional development', in J. M. Haviland-Jones, M. Lewis and and L. F. Barrett (eds), *Handbook of Emotions*, 3rd edn.; New York and London: The Guilford Press, 376–392.

Magai, Carol and Haviland-Jones, Jeannette (2002). *The Hidden Genius of Emotion: Lifespan Transformations of Personality*, Cambridge: Cambridge University Press.

Marcia, James E. (2010). 'Life transitions and sress in the context of psychosocial development ', in Thomas W. Miller (ed.), *Handbook of Successful Transitions Across the Lifespan*, New York: Springer, 19–34.

Said, Edward W. (2006). *On Late Style: Music and Literature against the Grain*, New York: Pantheon.

Sandvoss, Cornel (2005). *Fans: The Mirror of Consumption*, Oxford: Polity.

———— (2008). 'On the couch with Europe: the Eurovision Song Contest, the European Broadcast Union and belonging on the Old Continent', *Popular Communication: The International Journal of Media and Culture* 6(3): 190–207.

Silverstone, Roger (1994). *Television and Everyday Life*, London: Routledge.

Storr, Anthony (1989). *Solitude*, London: Flamingo.

Tornstam, Lars (1997). 'Gerotranscendence: the contemplative dimension of aging', *Journal of Aging Studies*, 11(2): 143–154.

Turkle, Sherry (ed.) (2007). *Evocative Objects: Things We Think With*, Cambridge, MA: MIT Press.

Vroomen, Laura (2004). 'Kate Bush: teen pop and older female fans', in Andy Bennett and Richard A. Peterson (eds), *Music Scenes: Local, Translocal, and Virtual*, Nashville, TN: Vanderbilt University Press, 238–253.

Williams, Rebecca (2011). '"This is the night TV died": television, post-object fandom and the demise of *The West Wing*', *Popular Communication: The International Journal of Media and Culture* 9(4): 266–279.

Winnicott, Donald W. (1953). 'Transitional objects and transitional phenomena: a study of the first not-me possession', *International Journal of Psycho-Analysis* 34: 89–97.

———— (1971). *Playing and Reality*, London: Tavistock.

Zittoun, Tania (2006). *Transitions: Development Through Symbolic Resources*, Greenwich, CT: Information Age Publishing.

9 Recoded Transitional Objects and Fan Re-readings of Puzzle Films

Matt Hills

Coincidentally, the quotation from the poem by Rabindranath Tagore used by D.W. Winnicott to introduce his essay, 'The Location of Cultural Experience' ('On the sea-shore of endless worlds, children play'; Winnicott 1971: 112) parallels the opening scene of *Inception* (Christopher Nolan, 2010) (Figure 9.1). Here, we see children playing on a shoreline, and they are represented in such a way as to appear hallucinatory or illusory. Only later do we discover that the shoreline is itself a key part of *Inception*'s multiple dream worlds.

Despite such collisions and resonances, Winnicott's work has been very much underused in film studies, leading Andrea Sabbadini to remark recently that Winnicottian film analysis remains 'scanty' (2011: 17). Although Vicky Lebeau refuses to 'set up an opposition between Lacan and Winnicott' (2009: 37n16), it is tempting to feel that Lacanian orthodoxy has displaced Winnicott's approach. If Winnicott's theory of transitional phenomena has found a place in media studies (Silverstone 1994), then it is probably in analyses of fans and their ordinary creativity – their 'little madnesses' (Hills 2002: 104; Hills 2007; Harrington and Bielby 1995; Sandvoss 2005). In this chapter, I want to bring together Winnicottian thoughts on fandom with a consideration of the puzzle film, here tackled primarily in the form of *Inception*, with reference to its forerunner *Blade Runner* (Ridley Scott, 1982). My aim is twofold: to theorise a specific type of fan activity – that of ongoing re-reading or decoding that continues long after a film's release and long after an initial viewing – and to consider those aspects of the 'textual organisation' of the puzzle film that hold fan attention (Elsaesser 2009: 38).

Considering the textual structures of *Blade Runner* and *Inception* is important because I want to suggest that there is a danger, in deploying

Figure 9.1 *Inception:* Cobb (Leonardo DiCaprio) sees his children at the Limbo shoreline

Winnicott, of moving too quickly to general propositions; for example, that 'cinema can function as a kind of transitional object, partly found by spectators… and partly… created by them' (Sabbadini 2011: 27), or that '[c]inema can be, or be like, a transitional phenomenon. This is the secret of cinephilia' (Kuhn 2005: 414). If we move too quickly to the general, we replay Winnicott's distaste for examples: in *Playing and Reality*, he notes that: 'examples can… begin a process of classification of an unnatural and arbitrary kind, whereas the thing that I am refer- ring to is universal and has infinite variety' (1971: xii). And by refusing to face the specific, we begin to lose theorisation of the particular in favour of an unhelpful blanket interpretation. After all, fans of *Blade Runner* or *Inception* are not simply cinephiles; *these* cultural objects, and not others, hold their immersed attention and are rendered powerfully meaningful.

Furthermore, Winnicott modestly downplays the 'cultural' in his formulation of cultural experience: 'I have used the term cultural experience as an extension of the idea of transitional phenomena and of play without being certain that I can define the word "culture". The accent indeed is on experience' (Winnicott 1971: 116). By contrast, I want to re-accent the 'cultural' in this formulation, considering how *Inception* is culturally and textually constructed. My approach reson- ates with those of Kuhn (2005) and Lebeau (2009), though I would suggest that the former downplays story content, while the latter very much downplays *audio*visuality, focusing on film as visual culture.

As a puzzle film, *Inception* has certainly given rise to widespread re-viewing (see Bordwell 2010) and to particularly intense fan debate. The site Nolanfans.com, which hosts subforums dedicated to each of Nolan's films, currently has 2,196 topics for *Inception*, compared to 519

for *The Dark Knight Rises* and 163 for *The Dark Knight*. It also offers fan-made T-shirts for *Inception* specifically, and this film is evidently a favoured focal point on the site.[1] *Inception* displays key textual qualities of the puzzle film identified by Barbara Klinger in her study of repeat viewing, textual attributes that are also spelled out in Thomas Elsaesser's work on the 'mind-game film':

> Puzzle films typically display... a confusion of objective and subjective realms; a visually dense style; an ending that depends on a reversal or surprise that makes viewers re-evaluate their experience with the text; and the presence of an initially occult meaning that requires re-viewing to uncover the text's mysteries (Klinger 2006: 157).

> A protagonist seems deluded or mistaken about the difference between reality and his/her imagination, but... there is no perceptible difference either in the visual register or in terms of verisimilitude, between real and imagined, real and simulated, real and manipulated.... A protagonist has to ask himself: 'who am I and what is my reality?' (Elsaesser 2009: 17)

The relevance to a Winnicottian reading may seem all too obvious: *Inception* (like incarnations of *Blade Runner*) plays out a textual game of blurring subjective/objective, and inner/outer. These texts narratively stage a Winnicottian theory of 'cultural experience', representing protagonists whose inner worlds appear indistinguishable from diegetic worlds of external reality. In point of fact, both *Blade Runner* and *Inception* do more than merely blur subjective/objective, as if staging transitional phenomena. As science-fiction thrillers they raise the question of whether transitional or potential spaces can be impinged upon from without:

> [T]his potential space may become filled with what is injected into it from someone other than the baby. It seems that whatever is in this space that comes from someone else is persecutory material, and the baby has no means of rejecting it. Analysts need to beware lest they create a feeling of confidence and an intermediate area in which play can take place and then inject into this area or inflate it with interpretations which in effect are from their own creative imaginations (Winnicott 1971:120).

The origami unicorn in *Blade Runner* implies that Deckard's (subjective) dream of a fantastical unicorn is (objectively) known to Graf, and hence that Deckard is a replicant. And the totem that originally belonged to Mal (Marion Cotillard) – the pewter spinning top that we fail to see fall over or continue spinning unnaturally at the end of

Inception – ambiguously hints that Cobb's reunion with his children may be a fantasy, and hence that he may be trapped in a real-seeming dream-state. Inner and outer worlds threaten to mesh together for Deckard and for Cobb, but in a way that is 'persecutory' rather than creatively playful, implying a dangerous loss of self for each protagonist. Some have even read *Inception*'s dream-share technology as a metaphor for film itself, suggesting that the dreams its characters immerse themselves in should be interpreted as coded portraits of audience-film interaction, it being especially notable that contemporary media (PCs, film, television) are otherwise absent from the diegesis (Westfahl 2010; see also Nolan 2010: 19). Again, however, this reading suggests the danger of 'implanted ideas' (Westfahl 2010).

Reading these puzzle films as mirroring Winnicottian theory via their textual blurring of subjective/objective – that is to say, as narrative stagings of Winnicottian preoccupations – is not how I want to approach them. Such a stance on textuality has occasionally been taken in the past, where rare Winnicottian analyses of specific cultural texts have been conducted, as for example, in Brooke Hopkins's study of the Christian resurrection story: 'From this Winnicottian reading… I think it is possible to see why the account would have such (relatively) lasting appeal… [Jesus] is the embodiment of "object-constancy"' (Hopkins 1993: 256). The problem with this style of reading is that it merely affirms a detail in the starting theory, as if threading together psychoanalysis and text, without tension or even creative play. Instead, the text perfectly mirrors the theory, as if attuned to it like an impossibly idealised mother.

It is highly tempting to read *Inception* as a sort of Winnicottian blockbuster. As well as the parallel pointed out at the beginning of this chapter – that between the film's opening scene and the epigraph framing Winnicott's 'The Location of Cultural Experience' – and the matter of 'persecutory' material being injected into the dream-share world, there are many other coincidental resonances. At one point Cobb draws a diagram for Ariadne (Ellen Page) to indicate how 'your mind… creates and perceives a world simultaneously' (Nolan 2010: 65). He draws a line bisecting a circle made of two arrows ('creating' and 'perceiving'), in what could almost be Winnicott discussing the transitional object itself (Figure 9.2).

This aleatory mirroring of *Inception* and Winnicott – both being focused on processes of creativity that blur subject and object, after all – is further compounded by the fact that both also feature the paintings of Francis Bacon. *Inception* does so as a marker of its first dream-share

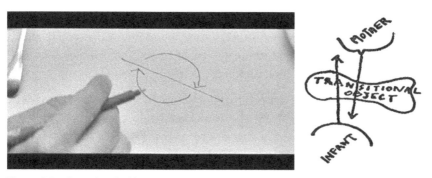

Figure 9.2 *Inception:* the 'dream-share' world and Winnicott's diagram of the transitional object

'unreality' (or distorted perception), while Winnicott links Bacon's distorted portraits to the matter of mother-baby mirroring (Winnicott 1971: 137; Lebeau 2009: 36–37; Sabbadini: 2011: 27). And Nolan's film represents highly personalised not-me possessions which characters seek not to share and which secure their sense of self, although these are called totems rather than transitional objects. Despite this profusion of overlaps, however, I will not reduce one complex textual organisation to another: such a move would fail to recognise the specificities of psychoanalytic and filmic creativity.

An alternative way of thinking with Winnicott has been to stress not a fusion of text and theory, but rather a merging of audience with text. This may also seem alluring when addressing *Blade Runner* fans who are caught up in a 'deeply immersive atmosphere' (Gray 2005: 114), or Christopher Nolan fans for whom *Inception* holds similar appeal. A number of theorists have considered storytelling, entertainment and film in this way, Almatea Usuelli Kluzer among them:

> We could say that the fascination of storytelling… is based largely on the creation of a meaningful universe, a closed world in which every element has its place. Storytelling creates the illusion that the subject and the object are tuned to one another, that the inner and outer worlds correspond to each other and that the subject's experience is meaningful, and saved from chaos (Kluzer 2001: 56).

An experience of text-audience fusion is also discussed by Emily Cooper, this time in relation to film spectatorship:

> Cooper relates Winnicott's concept of *unintegration* (the baby's primitive state of complete merging with mother) to the experience of watching a movie, 'which invites you to feel a one-ness or fusion with the emotional

force of the film'... As to narrative film, Cooper states that its primary task 'is to feed us information at the pace at which we can digest it, and at precisely the moment we desire it... The magic of timing in film is crucial' (Sabbadini 2011: 24, citing unpublished work by Emily Cooper).

The suggestion is that entertainment furnishes a 'vast, self-evident order' where it 'is the story, the plot that I rely on to repair all the damage done to me by my messiness, powerlessness, defectiveness in ordinary life' (Randolph 1991: 62, 64). And that in re-reading, even more so than in a first experience of a text, 'emotional identi-fication may be entered into... more completely and with greater assurance because the reader knows the tale *exactly*' (Odden 1998: 135). For Karen Odden, citing Winnicott's 'Transitional Objects and Transitional Phenomena' (Winnicott 1971: 12), this knowledge returns the re-reader

> to the drama of primary identification... This is the psychological state of the infant before the necessary 'disillusionment' in which the mother gradually effects 'incomplete adaptation to [the infant's] need, [which] makes objects real, that is to say hated as well as loved' (Odden 1998:135–136).

However, this recurrent emphasis on text-audience fusion in Winnicottian readings does not strike me as relevant to *Inception*. It takes an ambiguous stance on emotional satisfaction, suggesting via Cobb that 'We yearn for people to be reconciled, for catharsis'. But the catharsis achieved by Robert Fischer (Cillian Murphy) at the film's conclusion is itself narratively framed as a fraudulent, 'persecutory' impingement set-up by Cobb's team. Although a cathartic process is staged, the text undermines this for its audience, positioning satisfac-tion as desired but dangerous. Similarly, Cobb's emotional journey – his wish to be reunited with his children – is figured ambivalently. At the very moment he sees his children's faces for the first time in the film (they have been withheld up to this point), Cobb is distracted from looking at the spinning top's motion. Viewers are thus invited to parallel Cobb with Fischer; considering whether Cobb's emotional satisfaction is also unreal:

> James and Philippa TURN – see their Dad. He steps to the window, watching their BRIGHT FACES SHINING as they run towards him... Behind him, on the table, the spinning top is STILL SPINNING. And we –

FADE OUT.
CREDITS.
END. (Nolan 2010: 218).

Like Fischer's reconciliation with his dying father in the third dream level, Cobb's moment of reunion with his children is undermined, and coloured by ambiguity. *Inception* sets up emotional hooks for its audience, offering moments of 'unintegration' or text-audience fusion, but it refuses to let these moments stand. Jeanne Randolph, in her Winnicottian study of art and entertainment, compares a small face-shaped puzzle found in an art gallery shop with other 'fabricated objects' such as popular films and television. In contrast to the 'vast, self-evident order' of typical Hollywood fare, Randolph reads this face puzzle rather differently:

> the fabrication of illusion is foremost…. Interpretation is foremost (but not dominated as it is in ideology). The blurring of subjective truth with objective truth is flaunted (not hidden…). Ambiguity is presented as having potential (not as inconvenience or vulnerability…) (Randolph 1991: 68).

I want to suggest that for fans re-reading *Inception* as a puzzle it is this modality of response that is textually invited. The film-object offers ambiguous 'potential', but this foregrounding of interpretation is *only made possible by the text's specific disillusionments*, primarily its ending. This is a major subject of fan debate, with Nolanfans.com including a poll for audience readings. Although *Inception*'s shooting script concludes with a 'FADE OUT' to 'CREDITS', the film itself does something rather different. It does not gradually let go of the filmic image, the spinning totem, but instead cuts abruptly to black, synchronised with a rapid whooshing sound which intensifies a sense of the diegesis being suddenly stolen away. And over this blackness which has suddenly obliterated the diegetic world at a vital moment of meaning, appear the specific words 'I N C E P T I O N' as one caption and then 'A film written and directed by Christopher Nolan'. The agency of the writer-director is stressed via this move – crucial meaning is withheld, and the filmmaker's structuring of material made obvious, but this frustration for the viewer is immediately linked to Nolan's named authority. Ambiguity is thus framed by Nolan's authorial claim: the film is disillusioning as it has been knowingly designed to frustrate the audience's desire for emotional catharsis and 'self-evidential order'. As Andrea Sabbadini notes:

[T]he authorial voice sometimes makes itself more audible through a deliberately emphatic use of certain filming techniques... . This is perhaps much as the growing baby renouncing his primary narcissism eventually realizes that there is a real person behind the breast... . This oscillatory movement... between two states of consciousness is something we are... familiar with from our psychoanalytic work (Sabbadini 2011: 25–26).

The intrusion of the 'authorial voice' – or the rather literal intrusion of Nolan's name since this seems to crash in from outside the diegesis – demarcates a move away from 'primary narcissism', or fusion between self and (m)other, and towards recognition of the separate, disillusioning other. In short, Nolan 'challenges' the audience with 'a little bit of a shift' (Nolan 2010: 15). In the BFI IMAX screening that I attended, there were audible groans as the film's title and then Nolan's credit obscured the spinning totem and spectators realised there would be no dream / reality resolution.

Like Sabbadini, John Wiltshire emphasises the importance of considering how readers are (dis)illusioned when they become engrossed in a text:

[W]e can imagine that the reader oscillates between one mode of relating and another when they come to 'love' a text. The usefulness of Winnicott... in this context is that [his work provides] ...a concept of... love which is free from any connotations of idealisation and reverence [since the 'loved' object can only be trusted once it has undergone psychic destruction: MH] (Wiltshire 2001: 49).

The reader who 'loves' a text, and returns to it over and over again, thus shifts between recognising that 'this object has a reality beyond one's own mental construction of it' while also relating to the object as 'to use Winnicott's term, a subjectively perceived object... . In this modality, the [text]... is not outside, but within the narcissistic enclosure of the self' (Wiltshire 2001: 49). Rather than simply being akin to a transitional object – paradoxically both found and created – the fans' re-read, re-experienced text oscillates between being recognised as hailing from the other's creative imagination and acting as a narcissistic extension of self. What distinguishes it is a sense of the other's creativity, lacking in the case of the proper transitional object, nonetheless combined with an immersive fusion of text-audience. Rather than being fully paradoxical, the object is instead oscillatory, in psychical motion between 'created' and 'found'. It is transitive rather than transitional. In *Theatres of the Mind*, Joyce McDougall links 'addictive play'

to pathological transitional objects which she terms 'transitory objects', these being reiterated and sought ceaselessly as symbolic substitutes for the mother of infancy (McDougall 1986: 66–67). It should be noted that my supplement to Winnicott in no way pathologises fan re-readers: transitive objects are re-read, re-experienced and reiterated, but not within addictive play.

The transitive object – a sort of psychical spinning top – is missed by certain works on fandom. For example, Cornel Sandvoss's *Fans* proposes 'a model of fandom as a form of narcissistic self-reflection… between the fan and his or her object of fandom' (Sandvoss 2005: 98). For Sandvoss, the fan object should be viewed as a 'textual extension of the self' (102), indicating 'fans' failure to recognise boundaries between themselves and their object of fandom' (121) and taking us back to a purely fusional account of fan practices. Following Sabbadini and Wiltshire, I would suggest that there is not enough external reality or disillusionment in Sandvoss's theory; there is not enough sense of the other's creative imagination that media fans engage with (e.g. the role of auteurs such as Ridley Scott or Christopher Nolan). Developing the psychical dynamism that I am gesturing towards, Tania Zittoun has offered a more convincing, and far more multiple, taxonomy of one fan's object uses which retains a focus on re-experiencing, and also on fan creativity in the face of the (textual) other's creativity (Zittoun 2006: 140–141).

However, I do not want to mount a general theory of fan re-reading here; rather, I want to consider the specifics of *Inception* and how it incites fan re-reading (Jenkins 1992: 69). In *Convergence Culture*, Henry Jenkins quotes Neil Young of Electronic Arts discussing 'additive comprehension':

> He cites… *Blade Runner*, where… a small segment showing Deckard discovering an origami unicorn invited viewers to question whether Deckard might be a replicant: 'That changes your whole perception of the film, your perception of the ending… . The challenge for us… is how do we deliver the origami unicorn, how do we deliver that one piece of information that makes you look at the films differently' (Jenkins 2006: 123).

In fact, *Blade Runner*'s origami unicorn does something more than just add to narrative understanding; it hints at meanings that are not always confirmed. As such, this diegetic object works to open up the narrative world, making *Blade Runner* a (dis)illusioning artefact – one which resists the subject's understanding, but without being purely frustrating or disappointing. Linked with its hyper-detailed *mise en scène*,

much of which can only be glimpsed (Hills 2011), *Blade Runner* incites re-reading because it creates a breach in visibility and a powerful gap in its narrative ordering, yet it continues to offer multiple pleasures of genre, characterisation, special effects, and musical score. Studies of *Blade Runner*'s online fandom have stressed how the fan community searches 'for answers [via] an obsessive return to the 'original' text(s)... in order to pick over ...clues and build threads of logic' (Brooker 1999: 60). However, this is not simply about restoring viewer mastery which the text has disrupted: as Jonathan Gray points out, *Blade Runner*'s fan re-readers

> appeared quite ambivalent... as to whether they... wanted... an end to its mysteries... This anxiety was more explicitly stated by [some]... 'I like to think that there is no answer to the question of whether Deckard is human or replicant, and I'd like it to remain ambiguous (Gray 2005: 116–117).

What these fans seem to value is a form of nourishing object-relationship with *Blade Runner* where discoveries can be anticipated: 'many of the fans spoke... of how they often found "new" elements upon yet another viewing' (Gray 2005: 116). *Blade Runner*, for its re-reading fans, is an enigmatic object through which they can experience moments of everyday creativity: 'some texts ask instead of answer, and... continued open-endedness becomes a large part of what they "mean"' (Gray 2005: 117–118). Indeed, these fans disliked 'being told what to think', and so rejected the Director's Cut for making it too obvious that Deckard was a replicant (Gray 2005: 117).

Inception is very much the heir to *Blade Runner*'s empire: the spinning top totem is its 'origami unicorn', similarily it asks a question rather than answers one. Christopher Nolan is savvy enough to recognise that – unlike the *Blade Runner* Director's Cut – he should offer no resolution to questions about the film's ending, leading devotees at Nolanfans.com to repeatedly cite the director's published remarks:

> I've been asked the question more times than I've ever been asked any other question about any other film I've made... . What's funny to me is that people really do expect me to answer it. ...I put that cut there at the end, imposing an ambiguity from outside the film. ...The real point of the scene – and this is what I tell people – is that Cobb isn't looking at the top. He's looking at his kids. He's left it behind. That's the emotional significance of the thing (in 'Nolan comments on the ending of Inception'; Samsara17, 6 August 2011).

Responding fans note 'This was posted looooong ago' (Vader182, 6 August 2011, and 'This is pretty old yea. …Nolan did cut it to black for a reason, and that cut has left a mystery for a big part of the massive audience' (tykjen, 7 August 2011). Such replies indicate that new information – new readings and discoveries – are especially valued by fan re-readers, whilst the fact that Nolan's comments are so well known, and so frequently reposted, indicates the respect accorded to his statements. As Thomas Elsaesser notes, 'directors themselves, as integral parts of the film's marketing, provide additional clues… to suggest that the featured world can be opened up, expanded, [made] …into occasions for further para-textual or hyper-textual activity' (2009: 30). But when directorial comments are old news, they cease to offer fuel for 'further… activity', even though Nolan studiously keeps *Inception*'s ambiguity alive. In a sense, it is what he does not say that is more important to sustaining the film's re-readings.

It is striking that for both *Blade Runner* and *Inception* it is small, handheld diegetic objects that become focal points for fans' 'creative apperception' (Winnicott 1971: 76). As narrative artefacts, the origami unicorn and the spinning top stand in for and recode transitional objects. In Christopher Bollas's terms, they are 'mnemic objects' (1993: 34–35), but mnemic in a special way, I think, which recalls the third space, between inner and outer, at the inception of very first transitional object. Mentioning Winnie-the-Pooh, Winnicott notes that 'other authors… have drawn on [i.e. represented: MH] these objects that I have specifically referred to and named' (1971: 47). The filmic coding here is, of course, not as direct as in the case of Winnie-the-Pooh, or other representations of childhood experience (Kuhn 2005; Kuhn 2010). Instead, these narrative artefacts disguise the transitional object by making it appropriate for adult use. Above all, they culturally masculinise the proper transitional object, removing it from connotations of childishness or effeminacy (teddy bears and blankets are hardly masculinised within patriarchal culture). *Blade Runner* and *Inception* recognise more about cultural experience, in a sense, than Winnicott: they show an awareness of gender codings surrounding transitional phenomena and potential spaces (Kahane 1993).

Although there may be no gender difference '*between boy and girl in their use of the original not-me possession*' (Winnicott 1971: 5, Winnicott's emphasis), intermediate areas of cultural experience tend to be culturally gendered. *Inception*'s substitute transitional phenomena

– tangible things reminiscent of the proper transitional object – are always hard rather than soft objects that could be cuddled (Winnicott 1971: 6); for example, Ariadne's chess piece; Mal/Cobb's spinning top; and even Fischer's pinwheel, though it is not a totem. We might even describe these *recoded transitional objects* as 'hard toys' rather than feminised 'soft toys', demarcating a cultural distance from the proper transitional object whilst mnemonically recoding and symbolising it.

Both *Blade Runner*'s origami unicorn and *Inception*'s spinning top have also been reproduced as official replicas. The limited edition DVD/ Blu-ray case for each film includes the relevant 'hard toy' or collectible (Figures 9.3 and 9.4). This blurring of diegetic and extradiegetic objects indicates that fans' re-reading should be addressed not just as interpretive activity: 'the experience of fandom as an embodied *consumer* activity' also calls for consideration (Bainbridge and Yates 2010: 7). By purchasing replica origami unicorns or spinning tops (the latter also having been available as pre-release promotional items for *Inception* at major US fan conventions), re-readers acquire physical objects that mnemonically carry their imaginative engagements with a film text. The film's potential space can thus be carried over, or bridged (Sabbadini 2011), into interactions with material objects. As Caroline Bainbridge and Candida Yates observe, 'the notion of "the object" extends to the material form of the DVD box set itself' (2010: 14) or even to diegetic objects replicated as extradiegetic collectibles. Cornel Sandvoss describes this sort of fan memorabilia in the following terms:

> material objects of fandom... can equally function as transitional objects. These various fan memorabilia then constitute transitional objects that create a common realm between the fan and the star [or text – MH], while the star [or film text – MH] remains the primary object of fandom. Hence physical objects of fandom such as records, autographs or photos function as second-order transitional objects – the physical transitional objects inside transitional objects – that function as intermediate spaces between the self and the actual (transitional) object of fandom which itself is absent. (Sandvoss 2005: 90).

Fans of *Inception*, that is, can engage with 'second-order' transitional phenomena recursively nested 'inside' their relationship to the film. However, Sandvoss only moves down one level (text to physical object). *Inception*, I would hazard, is more complex and so requires a movement down two levels, because it specifically

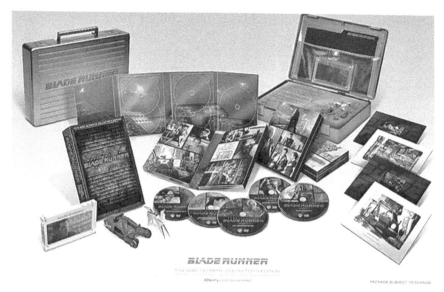

Figure 9.3 The *Blade Runner* Collector's Set in its masculinised metallic box

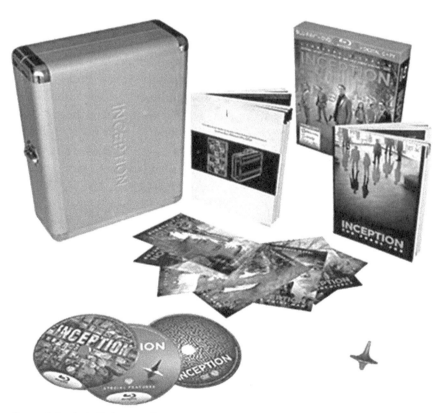

Figure 9.4 A similarly masculinised metal carry-case for the *Inception* limited edition Blu-ray

represents recoded, masculinised, transitional phenomena within its diegesis:

Level One: TEXTUAL WORLD
(fan re-reading and interpretation of the overarching diegesis)

↓

Level Two: RECODED TRANSITIONAL OBJECTS
(specific textual elements, e.g. totems; dream-share)

↓

Level Three: PHYSICAL REPLICAS OF RECODED
TRANSITIONAL OBJECTS (DVD collectibles/promos)

The emotional importance of owning the limited edition Blu-ray briefcase set is testified to by the fact that it has a thread that is 210 posts and 23 pages long at the Nolan Fans website. Some fans collect together links to YouTube unboxing videos – these are self-recorded videos which show fans opening and unpacking a new Blu-ray or DVD release for the first time while providing a running commentary on the packaging and contents (for example, movieman1005, 4 December 2010) – while others upload photos including the spinning-top replica shown in closeup in their hand (AaronFaulkner, 3 December 2010). Bainbridge and Yates go on to analyse DVD collection as a 'homosocial space' (2010: 16–17), a conclusion that resonates with *Blade Runner*'s and *Inception*'s masculinising of their representations of transitional phenomena, as well as with the phenomenon of unboxing videos, where fans record and share the physical details of limited edition box sets.[2] This gendering is also of a piece with *Inception*'s devaluation of the maternal: Mal is an exaggeratedly bad mother who fails to perceive the reality of her children, let alone recognise their needs; while Cobb's mother exists only as a voice on the phone. The text is one-sidedly concerned with paternal relations; whether Cobb can be a 'good enough' father by returning to his children – and returning their gaze – and exploiting Fischer's relationship with his father. This offers another reason why Winnicottian analyses of film have been scanty: Hollywood all too often prioritises Oedipalised fathers and sons rather than the mother/baby relation.

Like *Blade Runner*, *Inception* has a 'forensic fandom' which embraces a 'detective mentality, seeking out clues... This forensic engagement finds a natural home in online forums, where viewers gather to posit

theories and debate interpretations' (Mittell 2009: 128–129; Brooker 1999: 57), for example, forums such as Nolanfans.com. Here, fans can contribute textual details they have noticed ('Little moments in the background that are easy to miss?'), as well as addressing questions such as 'How many mistakes did you find in Inception?' There is clearly an aspect of fan identity performance going on – like the online *Memento* fans studied by Claire Molloy, *Inception*'s fans are also engaged in defining their tastes as culturally valued:

> [D]isbelief was expressed by fans about those who …claimed that they had no need for repeat viewings to appreciate its complexity fully… . For fans the ambiguity, 'working out', multiple viewings and discussion with other forum members were part of the pleasures of the text… . Films that necessitated such practices were constructed as 'intelligent' whilst also conferring the same status on those who pursued… close readings (Molloy 2010: 107).

But this hardly seems to capture the fans' proliferation of theories. Posters at Nolanfans.com are not only engaged in accumulating textual knowledge through repeat viewing; they are looking for new discoveries, as Matei Călinescu stresses in his work on re-reading:

> A final element that contributes directly to the excitement of playing the game of reading… . I shall call 'heuristic hope' or the hope of making a discovery. Readers may hope that something in a particular act of reading… might lead them to an independent discovery. This heuristic hope… is a state of *creative readiness* (Călinescu 1993: 139–140).

Re-reading as playing, for Călinescu, is 'a game (competitive, cooperative, or mixed)… vital [and] healthy (in Winnicott's sense)' (1993: 141). This sense of healthy, creative re-reading is clear, for instance, in the Nolanfans.com thread 'Top vs Ring: Theories About the end [sic]', where posters debate whether Cobb's wedding ring 'is the true tell of being in a dream or not' (AaronFaulkner, 17 July 2010). Subsequent posters recognise this reading's creativity, saying 'Nice catch!' (Eternalist, 17 July 2010) or 'very nice post original poster' (Jesus of Suburbia, 17 July 2010). The thread's starter then assures fellow fans:

> Trust me, go back and watch the film again. It takes a very keen eye but I've watched it three times already and I haven't found any evidence to go against it. Furthermore, you have to think of this as a filmmaker (which I am) and not just a fan. As a filmmaker you use certain visuals as reference points of character, time, emotion, etc. This is the purpose of the ring; as stated in my theory (AaronFaulkner, 17 July 2010).

Thinking 'as a filmmaker' suggests a recognition of Nolan's creative imagination. Although this re-reading fan seems immensely close to the text, he is also wholly aware of it as a construction, *contra* Thomas Elsaesser's suggestion that fan forums treat puzzle film narratives as if they are real (2009: 35), and in line with what I have termed here the 'transitive object' of *Inception*.

There are many aleatory 'Winnicottisms' in *Inception*: the quotation Winnicott uses to introduce 'The Location of Cultural Experience' parallels the film's opening scene: like *Playing and Reality*'s discussion of Francis Bacon, *Inception* includes a Bacon painting; the dream-share technology of the film is similar to Winnicott's account of transitional phenomena, being at once 'created' and 'perceived'; also, this dream-share can be 'injected' into from without; characters carry personalised not-me possessions (totems) which secure their sense of self; and the film's ending ambiguously blurs inner and outer by withholding the answer to the question: 'dream or reality?'. Despite all these resonances, however, I would argue that we cannot simply read *Inception* as a WB (Winnicottian Blockbuster) film, as if object-relations theory is somehow textually mirrored and reproduced.

Instead, in this chapter I have stressed the *cultural* aspects of cultural experience, highlighting the way in which *Inception* (like *Blade Runner*) presents audiences with an 'excessively enigmatic' (Elsaesser 2009: 37), and so disillusioning, diegetic world; one that stresses authorial voice, and hence allows fans to use it as a transitive object – both immersive and recognised as authored, a product of the other's creative imagination. I have also considered how *Inception* (and *Blade Runner*) represent culturally gendered and recoded transitional objects: in effect, these puzzle films do more than simply blur subjective/objective realms. They simultaneously create filmic potential spaces which are culturally appropriate for hegemonic adult male audiences (Bainbridge and Yates 2010), depicting totems, or the infamous origami unicorn, as masculinised symbols of transitional phenomena. Furthermore, fans consume these symbols via their replication as physical artefacts, meaning that fan re-reading also blurs diegetic and extradiegetic realms as it engages with film commodities. Transitive objects – along with recoded transitional objects – can encourage us to think about how film texts intersect dialectically with the work of D.W. Winnicott, creating as well as finding this valuable theoretical resource.

Notes

1 See Nolan Fans, http://www.nolanfans.com/forums (accessed 20 December 2011); Nolan Fans Shirt Shop, http://www.nolanfans.com/shirt (accessed 20 December 2011).
2 For example, *Blade Runner* (see http://www.youtube.com/watch?v=9k_8eaS7IC0); *Inception* (see http://www.youtube.com/watch?v=mVokHhwdka4&feature=fvwrel) (accessed 20 December 2011).

References

Bainbridge, Caroline and Yates, Candida (2010). 'On not being a fan: masculine identity, DVD culture and the accidental collector', *Wide Screen* 1(2): 1–22.

Bollas, Christopher (1993). *Being a Character: Psychoanalysis and Self Experience*, London: Routledge.

Bordwell, David (2010). '*Inception*; or, dream a little dream within a dream with me'. Available at: http://www.davidbordwell.net/blog/2010/08/06/inception-or-dream-a-little-dream-within-a-dream-with-me/ (accessed 1 August 2011).

Brooker, Will (1999). 'Internet fandom and the continuing narratives of *Star Wars*, *Blade Runner* and *Alien*', in Annette Kuhn (ed.), *Alien Zone II*, London: Verso, 50–72.

Călinescu, Matei (1993). *Rereading*, New Haven, CT: Yale University Press.

Elsaesser, Thomas (2009). 'The mind-game film', in Warren Buckland (ed.), *Puzzle Films: Complex Storytelling in Contemporary Cinema*, Malden, MA: Wiley-Blackwell, 13–41.

Gray, Jonathan (2005). 'Scanning the replicant text', in Will Brooker (ed.), *The Blade Runner Experience: The Legacy of a Science Fiction Classic*, London: Wallflower Press, 111–123.

Harrington, Lee C., and Bielby, Denise (1995). *Soap Fans: Pursuing Pleasure and Making Meaning in Everyday Life*, Philadelphia, PA: Temple University Press

Hills, Matt (2002). *Fan Cultures*, London: Routledge.

——— (2007). 'Essential tensions: Winnicottian object-relations in the media sociology of Roger Silverstone', *International Journal of Communication*, 1: 37–48.

——— (2011). *Cultographies: Blade Runner*, London and New York: Wallflower Press/Columbia University Press.

Hopkins, Brooke (1993). 'Jesus and object-use: a Winnicottian account of the resurrection myth', in Peter L. Rudnytsky (ed.), *Transitional Objects and Potential Spaces*, 249–260.

Jenkins, Henry (1992). *Textual Poachers*, New York: Routledge.

——— (2006). *Convergence Culture: Where Old and New Media Collide*, New York: New York University Press.

Kahane, Claire (1993). 'Gender and voice in transitional phenomena', in Peter L. Rudnytsky (ed.), *Transitional Objects and Potential Spaces*, 278–291.

Klinger, Barbara (2006). *Beyond the Multiplex: Cinema, New Technologies, and the Home*, Berkeley, CA: University of California Press.

Kluzer, Almatea U. (2001). 'Illusion and reality in the work of D.W. Winnicott', in Mario Bertolini, Andreas Giannakoulas, and Max Hernandez (eds), *Squiggles and Spaces Volume 2*, Philadelphia, PA: Whurr Publishers, 49–58.

Kuhn, Annette (2005). 'Thresholds: film as film and the aesthetic experience', *Screen* 46(4): 401–414.

——— (2010). 'Cinematic experience, film space and the child's world', *Canadian Journal of Film Studies* 19(2): 82–98.

Lebeau, Vicky (2009). 'The arts of looking: D.W. Winnicott and Michael Haneke', *Screen* 50(1): 35–44.

McDougall, Joyce (1986). *Theatres of the Mind: Illusion and Truth on the Psychoanalytic Stage*, London: Free Association Books.

Mittell, Jason (2009). '*Lost* in a great story: evaluation in narrative television and television studies', in Roberta Pearson (ed.), *Reading Lost*, London: I.B.Tauris, 119–138.

Molloy, Claire (2010). *Memento*, Edinburgh: Edinburgh University Press.

Nolan, Christopher (2010). *Inception: The Shooting Script*, San Rafael, CA: Insight Editions.

Odden, Karen (1998). 'Retrieving childhood fantasies: a psychoanalytic look at why we (re)read popular literature', in David Galef (ed.), *Second Thoughts: A Focus on Rereading*, Detroit, MI: Wayne State University Press, 126–151.

Randolph, Jeanne (1991) 'Illusion and the diverted subject: a psychoanalysis of art and entertainment', in *Psychoanalysis and Synchronized Swimming* Toronto, ON: YYZ Books, 55–70.

Sabbadini, Andrea (2011). 'Cameras, mirrors, and the bridge space: a Winnicottian lens on cinema', *Projections* 5(1): 17–30.

Sandvoss, Cornel (2005). *Fans: The Mirror of Consumption*, Cambridge: Polity Press.

Silverstone, Roger (1994). *Television and Everyday Life*, London: Routledge.

Westfahl, Gary (2010). 'Nolan's labyrinth: a review of *Inception*'. Available at: http://www.locusmag.com/Reviews/2010/07/nolan%E2%80%99s-labyrinth-a-review-of-inception/ (accessed 1 August 2011).

Wiltshire, John (2001). *Recreating Jane Austen*, Cambridge: Cambridge University Press.

Winnicott, Donald W. (1971). *Playing and Reality*, Harmondsworth: Penguin.

Zittoun, Tania (2006). *Transitions: Development Through Symbolic Resources*, Greenwich, CT: Information Age Publishing.

10 The Reality of the Experience of Fiction[1]

Serge Tisseron

A reader writes to the fan magazine *100% ados*:

> Dear Anne, I have a problem. I'm a fan of the Australian police series *Water Rats*. But the thing is, I take it too much to heart. When something sad happens I get depressed. How can I get some distance from it? It's only a story. I feel so stupid.

This young woman's appeal for help raises questions that go well beyond adolescents' relationships with fiction.[2] It broaches what might be called the paradox of fiction: the fact that we can let ourselves be 'carried away' by a story and at the same time regard these feelings as excessive, if not shameful. We feel caught in the act of believing something that is untrue, and at the same time are well aware that, in the words of the letter writer, 'It's only a story'. But would the writer have had a problem if her television series had not unsettled her so much?

Humans have invented fiction as a space where we can freely and safely put the sense of reality on hold. Fiction does not make us believe that it is real, but it does not stop us from responding to it 'as if' it were – though the 'as if' response has its limits if something we prefer to forget enters into the story. Willingly suspending a sense of reality and restoring it at will is a uniquely human trait, a kind of recharging of one's inner batteries; so much so that we are sometimes tempted to do it in real-life situations. For example, some people deliberately incite a sense of exhilaration when driving, by handling the car as if their actions had no real-life consequences – even at the risk of causing an accident.

Sometimes suspending the sense of reality is not about playing with emotions that feel pleasurable so much as defending oneself against

troublesome thoughts and feelings. Anyone putting themselves in this frame of mind has decided in some sense to treat the real events they are involved in as if they were a game. For example, in Patrick Rotman's documentary about the Algerian war, *L'ennemi intime* (broadcast on France 3, March 2002), one of the torturers explains that he did not experience his barbaric acts as real. Similarly, Michael Haneke's fiction film *Funny Games* (1997) portrays exactly this attitude towards cruelty.

We always have the choice of treating reality as a game, but some kinds of fiction make this particularly easy: which is exactly why people seek them out. In the world of fiction, nothing is gratuitous. Concrete reality may well be put on hold, but only in order to grant the inner world a wider sphere of action. Fiction lets people see their lives differently, and with greater clarity, when they are moved by a desire to understand something in their own lives that feels unclear – or else, as if through a glass darkly, when they want to hide something painful from themselves. This is why some kinds of fiction seem to hold a mirror up to society – Laurent Cantet's film *Ressources humaines/ Human Resources* (1999) is a good example – while other kinds, romance and melodrama for instance, aim to make us forget about social issues.

It can be mystifying that the word 'fiction' refers both to stories that make us forget about reality and also to those that force us to confront it. There have been various attempts to deal with this conundrum. There are writers and directors who talk, for instance, of a 'cinema of the real' or a 'fiction of the real'; while documentary makers might refer to 'false fiction based on real life' or 'false fiction based on reconstructed experience' (Rossignol 2001). Interesting as such distinctions might be, however, we must remind ourselves that it is the consumer who determines the reality status of the piece of work she is reading or watching. She can always refuse to be absorbed in the way the fiction demands; while there is nothing to stop her responding in a manner that is not proposed by the text (Tisseron 2003). Fictions are shaped not just by their address but also by the uses that consumers make of them. The ways in which people relate to images and narratives can be as significant as the attributes of the texts themselves.

People are free to regard the lives they lead as not truly engaging. But this attitude has its risks, as those who share the same reality can always remind them. On the contrary, all fiction creates a frame, and it is for the user alone to determine whether the world inside the frame bears any relation to reality. At this point we might enquire whether our choice of fictions is made on the basis of our capacity to 'defictionalise' them – to regard them as personally relevant, in other words.

Users will often make moral judgements about fictional characters as if they were real people, even to the point of psychologising those characters. In short, we are always seeking parallels with our own lives in the fictions we are drawn to. Consequently, carried along by this quest, we can easily respond in the same way to documentary as to fiction. Proof of this was given several years ago, in an investigation in which young people were shown passages of drama and news from television (Tisseron 2000). The respondents asked exactly the same questions of both: could this or that character have behaved any differently? And what would I have done in their situation? In other words, the impulse that draws a viewer into engaging with a work of fiction knows nothing about the distinction between the fictional and the real, even though that distinction might be restored on a second viewing: witness the tendency among viewers to confuse actors with their roles in films or plays.

This is why it is incorrect to speak of 'identifying with the hero' when thinking about how people relate to fiction. This presupposes a one-way relationship, whereas fiction sets in play a continuous back-and-forth movement between the internalisation of certain of the hero's traits and the projection of certain aspects of oneself onto the hero. The reader or viewer expels and places elsewhere – into a fictional character – traits in herself that she is unaware of or refuses to acknowledge. In all fiction the internal conflicts of the reader or viewer are deployed in such a way that all the unresolved parts of the viewer manage to find some kind of support. A film's success is often a function of the number of these supports it offers. For example, films like *Titanic* (James Cameron, 1997), *Brotherhood of the Wolf* (Christophe Gans, 2001), and *The Matrix* (Andy Wachowski and Larry Wachowski, 1999) offer numerous possible figures onto which the viewer might project facets of herself. This is why conversations about films and novels are so important in many people's social lives. In recounting a passage from a film or a novel in which a particular character is introduced, we draw on the part of ourselves that has been projected onto that character in such a way as to feel a connection with that character. In this way fiction can ease people's inner worlds whilst nurturing their social lives. Without this permanent reinvention of the works we engage with, they would be lifeless: this is true even in a culture like our own in which the author counts for everything and the reader or viewer for nothing.

This use of fiction, however, presumes that we can switch at will between two opposing and complementary states of mind: firstly,

believing in and succumbing to the fiction; and secondly, ceasing to believe and disengaging from it. Moving between these states is possible because images invite us to become simultaneously held by and distanced from them. The strategy most frequently deployed in this movement is to take account of the frame or the medium of the image. Perceiving the content of the image tends to block awareness of the medium: it seems that we cannot attend to both at once. Ernst Gombrich noted a constant oscillation between these two modes of perceptual attention – the one privileging content and the other privileging medium – but suggested that the viewer does not give the same quality of attention to both (Gombrich 1960). To understand this, we need only look at how infants develop these two modes of attention: a detour that is rewarding because it will also help us understand why humans create fictions. Every newborn comes to images via the images it has created inside itself, images in the form of hallucinations in which he is 'immerged': only then can these images be seen as 'objective' under his gaze.

The first images that the infant discovers are sensual, emotional and kinetic: these are experienced as fused with their associated bodily states. The infant is caught by them rather than mastering them. Here, the infant's state is more like that of the dreamer who feels part of the dream that is his own creation rather than a subject looking at an inner image. The infant is 'inside' the image, experiencing sensations, emotions and bodily states that are indissolubly mingled with visual representations. What the infant discovers in this moment is the possibility of feeling contained by an image that he himself has created in and for his own inner world.

It is only at a second stage that the infant transforms these initial images by placing them under his inner gaze. It becomes possible for the infant to recognise that he carries the image of his mother inside himself when she is absent from his field of vision. In short, he makes the shift from an image that constitutes a visual, sensual and kinetic space that enfolds him to one that he experiences himself as standing in front of. After this initial experience, he will try to create material images that allow him to relive this founding moment: the choice of being either 'inside' – where the image seems to contain him – or 'outside' the image, or in a sense in front of it, in a relation of critical distance. All image media and formats, from painting to LCD screens and including film and television, meet these two conditions. We can be certain, too, that future formats will do the same: give us images that create an ever more intense simulation of real presence through

which we can explore the illusion of encountering others, while at the same time giving us the option of distancing ourselves. But the ease with which we repeat this founding moment in our inner lives finds its counterpart in the very structure of the representations themselves. If humans can switch so readily between belief and non-belief, this is because the psychical representations that we form from reality and its images, be these fictional or real-life, are one and the same. The root of any confusion between fiction and reality has nothing to do with any resemblance between the two. It has to do with a shared third term: the inner representations we all create for ourselves, representations produced through the same processes in both cases.

In *Confessions*, Jean-Jacques Rousseau considers his response to literary fiction:

> My restless imagination took a hand which saved me from myself and calmed my growing sensuality. What it did was nourish itself on situations which had interested me in my reading, recalling them, varying them, combining them, and giving me so great a part in them, that I became one of the characters I imagined, and saw myself always in the pleasantest situations of my own choosing. So in the end, the fictions I succeeded in building up made me forget my real condition, which so dissatisfied me (Rousseau 1953: 48).

Rousseau is considering how reading prompts the workings of his imagination; but the same process is at work with images. The film or television viewer is also nourishing [his imagination] with situations that 'interest him'; and not only remembering them, but also 'recalling them, varying them, combining them', so that the pleasure he derives from the fictional states he imagines leads him to 'forget [his] real condition, which so dissatisfied [him]'. In fact, in evoking the work of his imagination as prompted by fiction, Rousseau is emphasising an important point: that the work of adapting and combining elements of fiction and appropriating them is just as much about the components of the fiction itself as it is about the reader's own desires and inner images.

From every event, real or fictional, everyone produces their own set of *personal representations* at the intersection of what they see, hear and experience. These feel no less 'true' than reality itself. What we call 'reality' possesses not one, not two, but three indissociable aspects: firstly, the object world; secondly, the ever-increasing numbers of images produced via various technologies, all of which obey their own rules; and thirdly, personal representations fashioned from the first two. This is why the main problem with distinguishing between

'reality' and 'images', 'fiction' and 'documentary', arises not just from the image's capacity to appear true to life but also from the means we deploy in internalising the entirety of our experiences. Nothing in our inner representations indicates whether the original experiences were real or fictional: this distinction always has to be introduced from the outside. This is perhaps possible only through psychical work paralleling that of constructing the representations themselves – the work that we call criticism. This work is critical in two respects: firstly, because it submits our inner representations to the light of reason; and secondly, because it is always provisional and always incomplete.

We can now pinpoint the common features of the processes at work in the assimilation of new experiences, be these of reality or of images, of documentary or of fiction. Here again Rousseau offers guidance: he says he recalls what he has read and also what he has imagined; and he varies, combines and appropriates it. This is precisely what happens and, as Rousseau implies, it takes time. The process of psychical assimilation is repeated over and over again. At the start we name what we have seen, heard and understood – both for ourselves and for those around us. This is why we talk to friends about a scene from a film, a novel or the news that has made a strong impression. If we can, we then name the feelings it evokes. We also speak of thoughts, realistic or otherwise, that come to mind; and if we are close to whomever we are talking to we might also recall memories, fantasies and daydreams stirred up by the scene. And it is rarely sufficient to do this only once. We need to become familiar with a new experience, work ourselves around it, explore its various facets; and try to persuade others to put it in the context of, and use it to improve, their own lives. It is only in this way that experience, whether fictional or real, can become incorporated into our inner worlds and be available for use in our daily lives.

This process of assimilation, or introjection (Abraham and Torok 1978), is at work in all our experiences, and is never completely conscious or willed. It is guided by the human impulse to assimilate experiences in order to cope more effectively with new ones, just as the digestive system assimilates the food that will nourish and strengthen us so that we can grow, develop resistances and repair damaged tissue. As a general rule, if a piece of art is not transformed and assimilated through a person's own senses and emotions, and if no connections are made with his own thoughts and reveries, it cannot exist or come to life. This process is not just about constructing the inner world; it is also essential in building social life. To make a place in our inner lives for stable and viable representations, they need to be shared with

others – or at least with a significant other. This is how attachments are created (Tisseron 2002).

However, to understand how fiction affects us we need to consider another mechanism through which our experiences of the world are internalised. If a piece of fiction holds our attention and prompts a desire to discuss it with others, this could be because there is something about it that resonates with our own daydreams and preoccupations. It could also be because these experiences evoke earlier ones that remain unassimilated. These might be real-life experiences, or else be images felt as too intense or too brutal, or ones that are incomprehensible in the context of one's environment. In such cases sensations, emotions, bodily states and representations of self and others activated by the experience become shut off, along with the associated fantasies, in a kind of 'psychic vacuole'.

The problem is that at any time the content of such 'vacuoles' can be released by new experiences – and these, once again, can be real or fictional. Former experiences come back into play, so that something that could not previously be assimilated now can be, either because the person is stronger psychologically or because the environment is now ready to allow it. Situations like this are not always easy, because the person might be experiencing feelings that are out of kilter with the surface content of the situation or the images. Perhaps this is what happened with the young woman who was so troubled by *Water Rats*. These feelings and fantasies can certainly return at odd moments – when idly driving along, perhaps, or playing with the children, or making love – or in the form of unsettling nightmares. But fiction is peculiarly capable of provoking such 'returns' since, in the process of consuming fiction there is nothing to do but abandon ourselves to the thoughts, reveries and memories it stirs up. When an image disturbs or fascinates, it would be wrong to try to repress it; because if we know how to make use of it, it can be the starting point of a productive encounter with the self (Tisseron 2003).

This approach allows us to understand that there is no difference between the dynamics of creative production and creative reception. The point in either case is the alternating movement between those two moments: 'in front of' the image and 'inside' the image. It might be objected that the creative artist is dealing with a blank page or canvas, whereas the consumer is responding to an invitation (or a trigger) to an immersion that has been offered by the artist. But this would be to ignore the fact that the first brushstroke or the first word laid down by the artist plays precisely the same role of invitation (or trigger) for

their own creative process, even if this is not apparent in the final result (Tisseron 1995).

This relationship with fiction has its origins in what D.W. Winnicott called the transitional object:

> …[T]he essential feature in the concept of transitional objects and phenomena…is *the paradox, and the acceptance of the paradox:* the baby creates the object, but the object was there waiting to be created and to become a cathected object. …[I]n the rules of the game we all know that we will never challenge the baby to elicit an answer to the question: did you create that or did you find it? (Winnicott 1991: 119, emphasis in original).

The key feature of the transitional object is that it belongs at once to inner reality, the world of dream and fantasy, and to the external world. But this duality would mean nothing were it not put to use in a continuous movement between the two registers. The transitional object stands in for part of the inner world – the part psychoanalysts call an internal psychical object – that can be brought into play through the use of a concrete object in the environment. Contrary to widespread belief, it is not always the case that the object – an old piece of cloth, say – that a child carries around everywhere is a transitional object as far as that child is concerned. Such an object might equally well operate as a prosthesis and have no psychical function at all (Tisseron 1999). The distinction lies in the scope and significance of the child's uses of the object.

Leaving aside the world of infancy and security blankets, the same argument applies to the issue of cinematic fiction and the viewer's relationship with it. The defining feature of the fictional image as an object is that it allows the viewer to make her own uses of it and to imagine the story and its ending in various different ways. In this sense we can say that fiction is a type of transitional object. On the other hand, everyday reality, news programmes and documentaries cannot do this. Imagining these differently is an act of transgression, if not an 'offence to memory'. It is always dangerous to weave a fiction out of a real event, as the numerous negative criticisms of Roberto Benigni's film *La vita è bella/Life is Beautiful* (1997) attest. That said, a work of fiction can equally well lose its 'transitional' character if it blocks thought and bars the inner images' associations and psychical transformations.

In fact it is not a difference in the psychical use of films that gives them their particular status: rather, it is their status before the fact that shapes their psychical uses. From this standpoint, there is no

distinction between infant and adult in the capacity to identify a fiction as such: both organise their emotional responses around cues as to the fictional or the reality status of what they are watching. If these cues suggest that the film is fictional, we can experience pleasure – and also distress, fear, anger – always reminding ourselves that 'it's only a film'. We consequently see things from a distance, and as if they were being played out for us alone; we sit back and enjoy the drama and the spectacle. We might tell ourselves that one of the characters could have behaved differently; but the situation is one that we would rarely encounter, being so exceptional that we cannot imagine ourselves in it. In short, with fiction we can shield ourselves from pain in order to maximise pleasure. When watching a documentary or the news, on the other hand, we are taking part in a process of comparison. We put ourselves in the place of the victim; all the more so if the victim appears to be oppressed or damaged. We feel distress, rage, shame, anger and sadness, first on the victim's behalf and then on our own.

The only difference here between children and adults lies in the nature and source of the cues that help them determine whether images are real or not. Adults will seek these cues on the screen itself – in the CNN logo running alongside images of the 9/11 attacks, say; whereas small children, who have not yet mastered the codes and conventions of television, expect to be given cues by their parents or the adults around them. Children's questions about the 'reality' of what they see on television do not stem from any 'immaturity' on their part: their questions are simply evidence that they have not yet internalised the conventions of the genre. But these conventions do not need to alter very much for adults to feel lost as well, as the use of professional actors in reality TV has shown. Many adults give credence to the 'real' domestic scenes between husbands and wives in these programmes. Condemning the deception, the Press encouraged viewers to regard as fictional what they had previously believed were real-life human dramas.

There is another obstacle, however, to a child's understanding of fictional conventions: the difficulty he has with keeping his emotions in check. When a young child questions the status of a story or image that scares him, he is not concerned about whether what he is looking at is real or not: he wants to know if he is right or wrong to be frightened. In other words, a child's question that is apparently about the reality status of representations is actually about the status of his own feelings. Should he suppress them or let them overwhelm him? This

question is only partly about the distinction between reality and fiction. A news image showing an outrage in his own town might well frighten a child, while he has no reason to be troubled by one showing a similar event in a town a thousand miles away. But inversely, an image that is clearly fictional can terrorise a child if it upsets his parents, perhaps because it stirs up painful memories for them.

Learning about fiction is an emotional as well as a cognitive process. In the realm of fiction, the important thing is to learn how to take a distance with regard to the emotions experienced; while in real life the challenge is rather to know how to make use of emotions in a life lived well. This learning process is not as simple as it might appear. It calls for the viewer to be capable of keeping the feelings inside without being overwhelmed by them. It takes place through playing, where the child learns to manage feelings he knows have nothing to do with 'real life' but which are experienced 'as if' they do. In playing, every child chooses to let himself be invaded by intense feelings arising from situations that he knows full well are fictional. In this way he familiarises himself with these feelings, tames them and masters them. In other words, he gradually puts in place a capacity to isolate, check and, just as important, displace the feelings he has in real situations, where he cannot master them, onto playing situations, where he can. The adult cinema-goer does exactly the same. There is no difference in the feelings experienced, but in this case they are displaced onto the fictional situations playing out on the screen. In this way the viewer can give himself over to the experience without having to consider what would happen if he were in a real-life situation.

This is a complex learning process that takes place in stages. A small child confronted with images – violent ones in particular – that evoke intense emotional responses is not completely in a playing state, nor is he completely in a real-life one. He may well make a firm judgement as to the nature of the images, but this will not necessarily be assurance of any distance in relation to the intense emotions they evoke. To resolve this difficulty, he adopts the same response to a psychical threat that he would to a physical one: he runs away and hides. We should understand that in doing this the child is not confusing the real with the imaginary. He knows quite well that such images pose no real threat. Yet he makes use of his capacity for bodily movement to manage the threat of being overwhelmed by sensations and emotions that he fears being unable to control. It is not the images that frighten him, but the feelings they arouse: in hiding from them, his aim is to keep his feelings in check. There is a reason for adults' mistaken belief

that children confuse reality and fiction. A child will invest fiction – as well as make-believe situations in solitary and shared play – with considerable degrees of affect: this can be disconcerting for an adult who maintains an investment in reality. But as Freud remarked, the child distinguishes the world of playing and the world of reality perfectly well, notwithstanding this emotional investment (Freud 1984).

Children's involvement with fiction does not only have bad sides. I recall a five-year-old boy who, when watching *Bambi* (Walt Disney, 1942) with his mother, was so upset when the magnificent haughty stag – presumably Bambi's father – appeared onscreen that he cried out 'Tell him you're his father!' The image resonated with the child's difficult family setup because the boy's own father had never been acknowledged by *his* father. Such responses are not unusual. Some people may be upset by a painting, some people by a photograph, others by a comic. Extreme responses like that of the young viewer of *Bambi* are admittedly rare: it is more often the case that we are intrigued without knowing why. Was this the case with the boy and *Bambi*? In any event, he had no hesitation in uttering the words that sprang to his lips – thus giving himself the opportunity of under-standing, at some future date, the issue that was troubling him: that his grandfather had refused to acknowledge his, the boy's, father. As the boy grew up, this trip to the cinema was preserved in the family's memory. Had it not been, he would undoubtedly have forgotten his question and the words he cried out during *Bambi*. But he would prob-ably have remembered being upset by the film: the film could remain an entry to a buried memory, should he ever want to lift the lid on it.

More basically, fiction can help us feel less alone. A young man once told me about his feelings of relief on seeing *Mosafer/The Traveller* (Abbas Kiarostami, 1974), a film about a boy misunderstood by adults in general and by his parents in particular. The young man was upset by the film, but recognised in it something of his own situation. This helped him feel less lonely. Fictional (and indeed documentary) images can also help in clarifying our thinking. For example, a boy once told me how, after seeing *Les 400 coups/The 400 Blows* (François Truffaut, 1959), he realised that his mother was being unfaithful to his father. There is much else in Truffaut's film, but this is what the boy saw in it and this is what was meaningful for him. I also recall a friend who went to see the Disney film *The Lady and the Tramp* (1955) no less than six times. This boy lived in a family where there was a permanent state of tension between the parents. He felt disregarded, and such a failure

as well that he imagined himself ending up as… a tramp. The film helped him build a kind of personal mythology around the story of a lonely and rejected boy who nevertheless managed to make a good life for himself. In short, the film helped him visualise his own future.

Fiction can help us imagine our lives differently. This is by no means the same as escaping reality. For instance, a study carried out with children from all over the world, including some living in refugee camps and in the poorest countries, revealed that the unstoppable robot in *Terminator* 2 (James Cameron, 1991) often brought to these children's minds the people they wanted to emulate. This is not, as might be feared, about being aggressive towards others: it is about defending and protecting family members. Many of these children had witnessed their parents being victimised and humiliated by enemies, by more powerful people, even by other family members. None of them imagined that they would ever posses the Terminator's fantastic powers, but because of the film all of them could dream of being stronger some day. A child's developing personality is nourished by such imaginings.

Finally, fiction can sometimes offer models for our own lives. Sadly, the most memorable examples of this appear to involve mayhem and catastrophe: the epidemic of suicides across eighteenth-century Europe following the publication of Goethe's *Sorrows of Young Werther* and Bernardin de Saint-Pierre's *Paul and Virginia*, for example; or the more recent, though rare, murders committed in situations resembling those portrayed in films. There are plenty of other ways, realistic and unrealistic, of using fiction as a model, however. The case of Richard Durn, the man who shot a number of local councillors in Nanterre before killing himself, is clear demonstration of the unrealistic use of images: Durn claimed that he decided to commit the murders as after seeing *Taxi Driver* (Martin Scorsese, 1976).[3] He is said to have realised that the film's murderous protagonist, the Robert De Niro character, was acting out his own (Durn's) fate, and decided that the only way he could ever be 'himself' would be to 'get inside someone else's skin'– the someone else in question being a character in a story. For reality to melt into the image to the point that the image prevails over the real has to be evidence of serious mental disturbance. Fortunately, few film-goers are like this: models for life are invariably realistic. A great deal can be learned from films, especially about ways of dealing with difficult situations in daily life. Is this not what is shown by a phenomenal success like *Loft Story*,[4] whose participants have nothing to do but work through their couple or group conflicts (Tisseron 2001)?

Notes

1 Originally published as 'La réalité de l'expérience de fiction', *L'Homme* 175–176 (2005): 131–145 and translated by Annette Kuhn.
2 The term 'fiction' here covers any work of narrative art, including novels, comic books, films, plays, etc. [Translator's note].
3 On 27 March 2002, 33-year-old Richard Durn opened fire at the end of a council meeting in Nanterre, causing the deaths of eight councillors and injuring 19 others. [Translator's note].
4 The French equivalent of *Big Brother*, which had its first season in 2001. [Translator's note].

References

Abraham, Nicolas and Torok, Maria (1978). *L'Écorce et le noyau*, Paris: Flammarion.
Freud, Sigmund (1984). Splitting of the ego in the process of defence (1938), *Pelican Freud Library, Vol. 11*, Harmondsworth: Penguin, 457–464.
Gombrich, Ernst (1960). *Art and Illusion: A Study in the Psychology of Pictorial Representation*, London: Phaidon Press.
Rossignol, Véronique (ed.) (2001). *Filmer le réel: ressources sur le cinéma documentaire*, Paris: Bibliothèque du Film.
Rousseau, Jean-Jacques (1953). *The Confessions of Jean-Jacques Rousseau*, translated and with an introduction by J. M. Cohen, London: Penguin Books.
Tisseron, Serge (1995). *Psychanalyse de l'image, des premiers traits au virtuel*, Paris: Dunod.
——— (1999). *Comment l'esprit vient aux objets*, Paris: Aubier.
——— (2000). *Enfants sous influence: les écrans rendent-ils les jeunes violents?*, Paris: Armand Colin.
——— (2001). *L'Intimité surexposée*, Paris: Ramsay.
——— (2002). *Les bienfaits des images*, Paris: Odile Jacob.
——— (2003). *Comment Hitchcock m'a guéri: que cherchons-nous dans les images?*, Paris: Albin Michel.
Winnicott, Donald W. (1991). *Playing and Reality*, London: Routledge.

11 On the Use of a Film: Cultural Experiences as Symbolic Resources

Tania Zittoun

The work of D.W. Winnicott on transitional phenomena has inspired a new area in the investigation of lifelong development. He indeed showed that children, adolescents and adults do learn and develop a sense of themselves and a capacity to act in the many situations of daily life, especially as they engage in various forms of 'playing'. In this chapter, I borrow two ideas from Winnicott, *cultural experience* and *the use of an object*, to examine how people can develop as they watch films.

Winnicott observed the emergence of the young child's capacity to live as an autonomous being, able to experience the world and learn from it. An important moment is the transition from an early state of non-integration of the infant, quasi-merged with the mother, to a progressive state of integration and autonomy. The idea of 'the use of an object' designates an early relationship between mother and infant in which the child has strong needs which are more or less satisfied by her. A 'good enough' mother can satisfy, perhaps with some bearable delay, the needs of the child; she can also 'survive' the strong aggression and fear projected by the child who might have experienced too long a separation from her. The 'resistance' of the mother allows the child to experience her as an 'object' that can be 'used': that is, as trustable yet other, separate from self (Winnicott 1968: 227). From there the infant experiences its *fantasies* (desires and aggression) as distinct and separate from the *object* (which survives in spite of these fantasies), and what is 'me' is felt as distinct from what is 'not-me' (Winnicott 1968: 239).

At the point when the child becomes able to experience itself as separate from the mother, a 'transitional', or 'potential' area appears.

In healthy development, children learn to experience their own continuity through time, even when the mother is not present. They will use fingers, sounds and objects to comfort themselves in the mother's absence, as she would give comfort if she were present. The things being used – transitional objects, such as thumbs or blankets – are partly 'real', offered by the world, and partly 'created' by the child's desires and hallucinatory capacities (Winnicott 1991: 2). Hence in the same movement the possibility of symbolising is created – 'this stands for that'. The blanket is a stand-in for the relationship with the mother, who will return. The child's relationship with the transitional object models the capacity to be alone, to survive with the memory of the other; it also models the experience of being creative – the capacity to turn a blanket or a thumb into a symbol.

The capacity to engage with transitional phenomena enables the individual to distinguish three areas of experience (Winnicott 1991: 104), or three 'lives' (Winnicott 1986a: 35). Firstly, the area of inner psychical reality – where dreams and hallucination occur; secondly, the area of external (or shared) reality, 'with interpersonal relationships even as the key even to making use of the non-human environment' (Winnicott 1959: 57); and thirdly, the area of transitional phenomena, which will become the area of *cultural experience*:

> Cultural experience starts as play, and leads to the whole area of man's inheritance, including the arts, the myths of history, the slow march of philosophical thought and the mysteries of mathematics and of group management and of religion (Winnicott 1986a: 35).

Transitional phenomena will evolve as the child matures physically and cognitively and acquires more complex capacities and relationships with the world. Objects that initially had the function of enabling the child to deal with separation from the mother will lose their function: progressively decathected, they 'tend[s] to be relegated to the limbo of half-forgotten things at the bottom of the chest of drawers' (Winnicott 1959: 56). The 'potential use' of objects itself evolves into various forms of symbolic experience. Children develop the capacity to play with various objects; playing becomes more complex through socialisation as they master rules and can share activities (Winnicott undated: 61). Later, adolescents start to play with 'world affairs' (politics, love affairs, creation, science or wars) (Winnicott undated: 62–63).

In adult life, playing and transitional phenomena assume new forms and include three key, and mutually dependent, aspects of life: firstly, the basic capacity to enjoy life creatively – marriage, desires

and wishes, even daily routine; secondly, the more specialised creativity of the scientist or the artist, which calls for mastery of the tradition alongside creativity, talent, technical capability, and contact with the inner world. This, thirdly, encompasses all 'cultural experience', the specific experience of listening to music, of watching a film or of reading a novel:

> Put rather crudely: we go to a concert and I hear a late Beethoven string concert (you see I'm highbrow). This quartet is not just an external fact produced by Beethoven and played by the musicians; and it is not my dream, which as a matter of fact would not have been so good. The experience, coupled with my preparation of myself for it, enables me to create a glorious fact. I enjoy it because I say I created it, I hallucinated it, and it is real and would have been there even if I had been neither conceived of nor conceived (Winnicott 1959: 57–58).

The quality of cultural experiences such as listening to a string quartet or watching a film is obviously 'transitional' or 'potential': it occurs in the area between inner life and objective reality, demanding elements from each. The difference between cultural experience and children's play is that the former is highly social, and belongs to what Winnicott called a 'tradition' (Winnicott 1991: 99). Given that cultural experience is one of the ways through which adults can play, cultural experience in adult life becomes one of the areas in which people might develop a better knowledge and understanding of themselves, their relationships and the world in which they live. Winnicott thus opened the space to examine how people can actually develop through cultural experience, and in that sense, make use of the objects offered to them as what might be called 'symbolic resources'.

In sociocultural psychology, an area of developmental psychology, it has been demonstrated that the majority of complex psychological functions can develop only as people interact with others and with objects and meanings already present in their social and cultural environment. A core concept here is mediation: human capacities are expanded and developed through the use of specific 'tools' (Cole 1996). Some of these are material or technical – spectacles to improve eyesight, for example, or computers to think faster. Others are predominantly semiotic in nature: they are made out of signs of different modes, such as language, colours, images, sounds and movement, as in road signs, or in music or visual arts (Gillespie and Zittoun 2010). If some uses of 'tools' expand human power and mastery over things (planes to travel longer distances, for example) other uses of 'tools', because of their

semiotic nature, mainly expand people's minds. In *The Psychology of Art*, Lev S. Vygotsky, one of the authors regarded as founders of socio-cultural psychology, tried to account for the transformative effects of art for readers or viewers (Vygotsky 1971). In such a perspective, novels or art works are complex constructions of signs (words, shapes or colours) which, during the duration of painting-seeing, film-watching or book-reading, can somehow guide a person's psychological experience. Through this construction of signs, or semiotic guidance, people can thus feel emotions they have never felt before, or imagine alternative lives as they would not have done on their own. Such guidance is possible partly thanks to the fact that signs, or semiotic elements, can find a sort of translation from shared, socially visible forms to a mental plane. On this psychological plane, semiotic guidance becomes a way to regulate one's flow of consciousness.

Based on the same idea, scholars have looked at how semiotic processes enable people to take a psychological 'distance' from their here-and-now experience. When a person is experiencing an affective state – blushing cheeks, accelerated heartbeats, violent fantasies – she can detach from it, and from this distance can 'recognise' it thanks to similarities with past emotional experiences. Such distance becomes wider when she can use signs such as emotional words ('fear', 'anger') to name them. Such distance can vary according to the level of abstraction of these signs. Hence, it increases with the use of signs designating a class, or category (as in the types of encounter that are 'anger-provoking') or abstract values such as 'good' or 'bad'. Hence, semiotic means – internalised words, categories or values – become mediations of thinking, or of distancing from one's experience. Semiotic distancing enables one in turn to regulate one's thinking or emotions, and offers a form of guidance of thinking and action (Valsiner 2007).

My own work draws on both Winnicott and sociocultural psychology to account for the 'cultural experience' of fiction. I will consider film watching as taking place in a transitional space, in which semiotic guidance enables the transformation of a person's other zones of experience – her inner life and her relationship to the world. My proposition is thus that people can actually 'use' fictions as symbolic resources. Part of this research has involved gathering and interpreting the testimonies of cinema-goers, through their own writings or through interviews. Some of these are presented below.

* * *

To have a potential quality, cultural experiences need to be felt as distinct from real life. In our society, most cultural experience is marked by a material or social threshold. The beginning of storytelling ('once upon a time') or the ritualised entry into a cinema auditorium (the red velvet seats, the smell of popcorn, the darkness) creates a threshold between the world of the 'real' and the world of fiction, of cultural experience. Cultural experience, be it reading a novel, watching a film, listening to music and so on – demands a specific form of letting go, accepting what the film, the book or the music will offer. In that sense, it demands the trust and relaxation that is associated with potential space. During the experience, and as time passes, the individual will usually follow a semiotic stream – a flow of images and sounds, a series of words, a visual exploration of a painting (Benson 2001). It is during this semiotic guidance that the individual has to mobilise traces of past experiences – personal as well as cultural – to understand the story, the film, the fictional characters or the music. She will also draw on her expertise in that particular area of cinema, music or painting. In the course of the experience the individual has to allow herself to become emotionally engaged, and go through a series of bodily and affective states.

As the cultural experience unfolds in time, a co-constructed reality is built and progressively evolves: hence a given image in a film, for example, has value insofar as the viewer can relate it to some previous scene; but its aesthetic might also contribute to the general atmosphere of the experience. After the cultural experience, the individual will normally cross another threshold – go back into the daylight, say, or close the book; and her mind may struggle with the remnants of the experience as she leaves the cinema in a state of semi-blindness (Barthes 1975). At this point she can engage in various forms of *post hoc* elaboration: people talk about what they have seen, the meaning of song lyrics, about the plot of a novel; or they recall having been moved or upset by a story or a character in a film. This reflective examination can address two aspects: how the work is made, its technicalities as well as its anchorage in social reality or in a cultural tradition; and what 'it did' to them – what personal meaning it had for them, how it resonates with their own psychic reality (Tisseron 2000). Finally, afterwards – hours, days or even years later – an individual might think back about that film or novel, or recollection might be unexpectedly triggered by some event. Such recollection might bring him to see it or read it again, or invite him to reflect, through the memory of that fictional story, upon present or past experiences or real events. In such

cases, I would argue, people are using the film, the book or the song as a *symbolic resource* (Zittoun 2006): just as the child once 'used' its mother to expand its control over the world, so young people and adults 'use' books, songs and films to reflect on what is happening in their lives, their relationships, and the world they live in.

There are several ways in which a researcher can learn about how people use films as symbolic resources. In what follows, I draw on autobiographical material – either people talking about their experience, such as in research interviews (Zittoun 2008; Zittoun and Grossen 2012); or people writing about them in a diary, an online blog, or an essay (Gilmour 2010; Zittoun, Cornish, Gillespie and Aveling 2008; Zittoun and Gillespie in press). A series of cues are indication that people are using a given film as symbolic resource: in their discourse, they mention films that 'changed their lives', or 'impressed' them, or were 'eye-openers'. They might also mention that a film 'helped them', or 'was useful'. They will often choose to see the film again, come back to it, or share it with others. Following these criteria, I borrow on the diverse data to show how people seem to use films as symbolic resources. My argument is that as transitional phenomena mediated by complex semiotic objects, fictions – including films – enable a distancing from immediate, here-and-now, experience. Thanks to such distancing, film watching or remembering become a form of playing with the real and the possible, what is and what could be. This in turn can transform a person's other zone of experience – her inner life and her relationship with socially shared reality.

The use of films can participate in distancing in various ways. Firstly, viewers often talk about how a film functioned for them as a revealing mirror, enabling them to capture and reflect upon embodied, affective states. For example, in an autobiographical essay called 'I grew up in the cinema', a young French man, Gauthier Jurgensen, reflects on *The Graduate* (Mike Nichols, US, 1967), one of many films that played an important role in his youth, and on his feeling of similarity with the hero, Benjamin (Dustin Hoffman):

> Like the young Benjamin, I just finished my studies. My parents congratulated me many times. And, like him, I stay for hours sitting in my room. I look in the empty space and I wonder what I have to do to move to the next stage. All my life I thought it would be simple: kindergarten, school, college, university; study, get specialized, and work. No, it is not like that. There is a floating moment during which, like Benjamin, one stares at the empty space. What Nike Nichols made me feel, through the blurred gaze

of Dustin Hoffman, is the silence of death that is in the head of the young graduate. Everything is so noisy around us: job offers, ambitious projects, parental expectations, the desire to get some rest (Jurgensen 2008: 14).

Jurgensen makes a precise analysis of the feelings of a young man alienated from the world, prisoner of his internal silence, and needing to break free of his parents. In order to do so, he makes use of *The Graduate* and its multimodal construction (the image of Dustin Hoffman in a diving suit in the swimming pool; the film's theme music, 'The Sound of Silence') to reflect upon his own emotional and existential situation. The film seems to have captured and reflected this complex existential situation, as well as offering the viewer a term to name that state – that of a 'graduate'.

Distancing from immediate experience can go one step further: when a situation in a film enables a person to identify a *category* of actions or experiences. This is the case with Ismaël, a French-speaking young man aged 17, who was interviewed as part of a research project on the use of symbolic resources by secondary school students in Switzerland.[1] Ismaël mentions a film that he often watches, *Remember the Titans* (Boaz Yakin, US, 2000). The film shows how a mixed-race football team manages to overcome racism in the team itself and also in their opponents, with all the players eventually united in a common song chanted as the teams enter in the field. As with Gauthier Jurgensen, people will often start to use a film as a symbolic resource when they find something in the fictional world that resonates with them – characters, emotional situations, events and so on. The interviewer asked Ismaël about this experience:

Interviewer:	How come you resonate with the movie – did you experience racism personally?
Ismaël:	Actually, when I was younger, during a period I had a cousin who was a racist and he was always telling me that I was, well, that if one is not a racist one cannot be a good Swiss or so; so I told myself I could be a racist too, I sort of thought that it was a matter of style; but then after, seeing that movie, I reflected and I told myself that I didn't need to do that.

It seems that Ismaël initially identified spontaneously with the most racist characters of the film: like them, he would probably affirm his difference from young coloured people. But the evolution and resolution of the plot, in which the coach convinces his team that the only

way to win as a team is to play united, and to achieve this encourages them to sing a unifying song, seems to have invited him to reflect upon his real-life position and his self-identification as a racist. Hence we might think that the film made him aware, through the fiction, of the possibility of overcoming race-based boundaries, and of the benefits of opening oneself up to different young people (the film emphasises the emotional and moral strength of the unified group singing its song while confronting the opposing team). From then on, Ismaël would often watch the film again in specific situations:

Interviewer:	Could you say when you feel like seeing the movie again?
Ismaël:	For example, mornings, when I am watching Euro News, and I see bomb attacks or so, in the evening I might feel watching a bit of it.
Interviewer:	You see bits... (..) what are the bits which...
Ismaël:	Impressed me most, it's when they enter on the football field because they decided to make a song together in order to show everyone that they could associate together with that song.

In this case, Ismaël seems be using the film as a resource for dealing with racism and intergroup violence as these issues appear in the television news. The film reflects, to some extent, similar events; in addition, the film offers categories and moral principles to reflect upon such events; and finally, it offers a possible solution to such conflicts. Hence, the film becomes a means of developing more complex under-standings of real-life events.

The use of symbolic resources can even assume a more general value. Interviewed as part of a research project on youth transition in the UK,[2] Randy is a young man in his early twenties who had often moved house during his childhood and who became a keen film fan, encouraged in this by his father. He eventually developed an informed passion for cinema, and learned to appreciate classic, complex films such as *Casablanca* (Michael Curtiz, US, 1943). Reflecting on his long history of film-going, Randy suggests that it developed his 'romanticism':

Randy: I think it just... it made me always see... relationships just having to be special. [...] It is a cliché about... movies and stuff [...] But I don't think... It is not – as it were – romantic in a love sense? I think it is in a life sense? Making me more – -less cynical, I think. And believing that things are happening, that you should pursue interests and stuff. [...] I

think it just made me view, about how friendships, or relationships might be. And I think possibly, one of the reasons why... . I stopped watching as many movies, because I got to enter strong a personal relationship (Zittoun 2008: 94).

Films made him develop a generally 'romantic' frame of mind, and this led him to enter relationships with certain expectations: using the films, he imagined how his relationships might work out. Thus, general values seem to have consequences for specific courses of action and emotions, which can then be encouraged or dismissed.

The use of symbolic resources can also facilitate thinking about experiences in *time* – in relation, that is, to past and future experiences. Some films are used as a means of recreating or keeping alive memories of the past. Hence the narrator of David Gilmour's novel *The Film Club* tries to understand why his adolescent son seems to be watching a particular film over and over again. He eventually realises that the film's main character resembles his son's former girlfriend, who had left him heart-broken: 'And I understood suddenly why the movie had caught my attention, why that particular movie, *Chungking Express*. Because the beautiful girl in it reminded him of Rebecca; and watching the movie was a little bit like being with her' (Gilmour 2010: 139).

On the other hand, a film can be used a means of reflecting on the future. Also interviewed in the UK project, Lily, in her twenties, spon-taneously mentioned the film *After Life* (Hirokazu Koreeda, Japan, 1998) as having made a great impression on her when she was faced with decisions about her own future. The film is about dead people stranded in a kind of limbo: they have to choose the best memory of their life, and this will be recreated as their personal eternal paradise. This is how Lily describes it:

I think it was called *After Life* – it is a Japanese movie [...] it is like an immigration office, and they have to pick up a memory... and it is all about the selection process... So you have young people, you have old people, and all kind of people. And it is all about this process, you know, about going, choosing, and being able or not unable to choose, and these people who are unable to choose, so they are stuck there, for centuries. I always think of that – I think about that often for one reason or another. [...] It is interesting, because when I watched that movie, I didn't think automatically, what would I choose? But the people I was watching the movie with, just asked me – what would I choose, I really don't know – it would be sort of logical, but I didn't ask myself [...] I think about it when I think about sorts of life... about relative happiness, and the difference

between being content, and not, or having lots of energy, or not much energy. I mean all these things I have been thinking for a long time, it is a schedule for life. So every time these things come out, and because I am thinking about the future quite a lot right now, and about people, whether they are staying my life or not staying in my life. Because how people choose their memories, has a lot to do with how people choose their lives (Zittoun 2007: 120).

Here, Lily describes how, at her friends' request, she began to wonder what 'best memory' she herself would choose were she dead; and how this in turn brings her to question how she must live in the future, so that in a hypothetical afterlife she might have enough good memories to choose from. The film has become a symbolic resource that Lily draws on now that she has to make choices: it enables her to imagine hypothetical future positions, and from these to guide her current choices.

People engage in cultural experiences such as films, for which they have to draw on their inner worlds and life experiences as well as on their understanding of films as cultural constructs. My main argument here is not only that people engage with, or immerse themselves in, these fictional experiences; but also that, because of the very specific semiotic constitution of these cultural experiences, they consequently actually develop new means of distancing themselves from, and reflecting on, their lives. Hence films become symbolic resources that enable people to take progressive distance from affective experiences; to name them, organise them, and from this develop general orientations in life. They also enable the individual to maintain a sense of continuity with their past and with persons and places that are no longer in their lives, and to play with and imagine possible futures.

The use of symbolic resources can thus be seen as a form of everyday creativity, an adult variant of playing, enabling people to see what is there in a fresh light and to imagine what might be. Taking place in potential space, the use of symbolic resources can affect both one's relationship with oneself and one's relationship with the 'real world'. On the one hand, such creativity has consequences for people's sense of who they are: thus Ismaël uses *Remember the Titans* to reflect on his identity as a racist and to change his understanding of himself and his relationships with others; Jurgensen reflects on his own situation as a young man who, for the first time, has to take decisions for himself; Randy's film-cultivated romanticism helps him develop a romantic relationship; and the son of the narrator of *The Film Club* keeps alive,

or works through, a lost relationship with the help of a film. On the other hand, the use of films as symbolic resources can also be part of people's reading and understanding of the world in which they live, the socially shared reality. So, for example, Ismaël finds support in *Remember the Titans* in coming to terms with the harshness of world politics; Jurgensen develops an acute understanding of social demands on young people's trajectories through his viewing of *The Graduate*. In all these cases, the core process is *playing* – in the sense of manipulating what is given by the films, drawing on inner experiences, and creating new forms of understanding in the potential space offered by the film experience. Hence, Lily, Ismaël and Randy not only consider what *is*, but also – thanks to fiction – imagine what *might be*, or what would be if things were different: in this way, they create their own life paths.

* * *

Winnicott described three distinct zones of experiences; and what I have shown in this chapter is that the use of films, which develops through cultural experience taking place in potential space, engages a sort of creativity in which an individual may actually change her relationship with the two other spheres of experience: her inner life and her relationship with the external world. This circulation between the three zones – the potential zone of experiencing films, interiority and socially shared reality – is what Winnicott called *creative living*, the process by which we can constantly refresh our gaze on the world around us:

> In creative living you or I find that everything we do strengthens the feeling that we are alive, that we are ourselves. Once can look at a tree (not necessarily at a picture) and look creatively (Winnicott 1986b: 43).

Notes

1 This research project, co-directed with Michèle Grossen from the University of Lausanne, with the collaboration of Olivia Lempen, Christophe Matthey, Sheila Padiglia and Jenny Ros, and supported by the Swiss National Fund (FNS no. 100013-116040/1-2), aimed at identifying the variety of cultural experiences in which young people aged 16–20 engaged, in and out of school. The research documented cultural activities of about 200 young people in three secondary schools in the French-speaking part of Switzerland. Data included questionnaires

and semi-structured interviews with teachers and with about 20 young people (see Grossen, Zittoun and Ros 2012; Zittoun and Grossen 2012).

2 Randy was interviewed as part of a research project on youth transitions in the UK, based on 20 case studies. He was part of a group of students approached because they had recently moved onto campus to undertake university studies. The interview was 'on the role of culture in your life, especially in times of change'; and questions addressed changes recently experienced, past transitions, and plans for the future; they explored what the interviewee found 'helpful' in these times of change; and particular attention was given to mentions of cultural elements such as films, novels, etc. (Zittoun 2006).

References

Barthes, Roland (1975). 'En sortant du cinéma', *Communications* 23: 104–107.

Benson, Ciaran (2001). *The Cultural Psychology of Self: Place, Morality and Art in Human Worlds*, London: Routledge.

Cole, Michael (1996). *Cultural Psychology: A Once and Future Discipline*, Cambridge, MA: The Belknap Press of Harvard University Press.

Gillespie, Alex and Zittoun, Tania (2010). 'Using resources: Conceptualizing the mediation and reflective use of tools and signs', *Culture and Psychology* 16(1): 37–62.

Gilmour, David (2010). *The Film Club: No School. No Work … Just Three Films a Week*, London: Ebury Press.

Grossen, Michèle, Zittoun, Tania and Ros, Jenny (2012). 'Boundary crossing events and potential appropriation space in philosophy, literature and general knowledge' in Eva Hjörne, Geerdina van der Aalsvoort and Guida de Abreu (eds), *Learning, Social Interaction and Diversity: Exploring School Practices*, Rotterdam: Sense Publishers, 15–33.

Jurgensen, Gauthier (2008). *J'ai grandi dans des salles obscures*, Paris: Jean-Claude Lattès.

Tisseron, Serge (2000). *Enfants sous influence: les écrans rendent-ils les jeunes violents?*, Paris: Armand Colin.

Valsiner, Jaan (2007). *Culture in Minds and Societies: Foundations of Cultural Psychology*, New Delhi, Sage Publications.

Vygotsky, Lev S. (1971). *The Psychology of Art*, Cambridge, MA: MIT Press.

Winnicott, Donald W. (1959). 'The fate of the transitional object', in Claire Winnicott, Ray Shepherd and Madeline Davis (eds) (1989), *Psycho-analytic Explorations*, Cambridge, MA: Harvard University Press, 53–58.

——— (1968). 'On "The use of an object"', in Claire Winnicott, Ray Shepherd and Madeline Davis (eds) (1989), *Psycho-analytic Explorations*, 217–246.

——— (1986a). 'The concept of a healthy individual', in *Home is Where We Start From: Essays by a Psychoanalyst*, London: Penguin Books, 21–38.

——— (1986b). 'Living creatively', in *Home is Where We Start From*, 39–54.

——— (1991). *Playing and Reality*, London: Routledge.

——— (undated). Notes on play. C. Winnicott, R. Shepherd and M. Davis (eds) (1989), *Psycho-analytical Explorations*, 59–63.

Zittoun, Tania (2006). *Transitions. Development Through Symbolic Resources*, Greenwich, CT: InfoAge.

——— (2007). 'The role of symbolic resources in human lives', in Jaan Valsiner and Alberto Rosa (eds), *Cambridge Handbook of Socio-Cultural Psychology*, Cambridge: Cambridge University Press, 343–361.

——— (2008). 'Janet's emotions in the whole of human conduct', in Rainer Diriwaechter and Jaan Valsiner (eds), *Striving for the Whole: Creating Theoretical Synthesis*, Piscataway, NJ: Transaction Publishers, 111–129.

Zittoun, Tania, Cornish, Flora, Gillespie, Alex and Aveling, Emma-Louise (2008). 'Using social knowledge: a case study of a diarist's meaning making during World War II', in Wolfgang Wagner, Toshio Sugiman and Kenneth Gergen (eds), *Meaning in Action: Constructions, Narratives and Representations*, New York: Springer, 163–179.

Zittoun, Tania and Gillespie, Alex (2012). 'Using diaries and self-writings as data in psychological research', in Emily Abbey and Seth Surgan (eds), *Developing Methods in Psychology*, New Brunswick, N.J.: Transaction Publishers, 1–26.

Zittoun, Tania and Grossen, Michèle (2012). 'Cultural elements as means of constructing the continuity of the self across various spheres of experience', in Margarida César and Beatrice Ligorio (eds), *The Interplays Between Dialogical Learning and Dialogical Self*, Charlotte, NC: InfoAge, 99–126.

Part 3

Cultural Experience and Creativity

12 Cultural Experience and Creativity: An Introduction

Patricia Townsend

In our society there is a fascination with creativity. We can read books about it, written from the perspectives of psychology, sociology, philosophy, psychoanalysis and other disciplines (Koestler 1964; Storr 1972; Rothenberg 1990; Amabile 1996). We can go on courses to enhance our own creativity. But what exactly do we understand by the term? Do we understand it to be a quality possessed by certain exceptional individuals who produce outstanding artistic works or make important scientific discoveries? Or do we see it as a universal human attribute, necessary to our everyday lives? Or perhaps we think of it not as a personal quality but as a process by which something new is produced. If so, in order to merit the term creativity must the process produce something both original and of value? But who is to judge its value, and for whom must it be new and original?

There are many definitions of the term *creativity*. The online Oxford dictionary defines it as 'the use of imagination or original ideas to create something', and *to create* as 'to bring something into existence'. And, of course, creativity is linked to *creation,* and therefore to the most fundamental questions of life. All religious traditions have their own creation myths, their stories of how the world was brought into existence, their attempts to explain the mystery of how something appeared out of nothing or how form emerged from chaos.

These myths of the birth of the universe, usually through divine agency, convey a sense of mystery and awe, and this has influenced our perceptions of the creative process. Vestiges of these myths still attach to our notions of creativity and the origin of new ideas or images. We may wonder how the great artist is able to fashion inspiring sculptures or paintings from the mundane raw materials of clay or paint; or how

the Nobel prize-winning scientist can discover unsuspected order in the apparent confusion of unexplained data. Contemporary myths have grown up around the idea of the creative genius who is mysteriously inspired to produce great works of art or to make groundbreaking scientific discoveries. Some artists and scientists have perpetuated such ideas by suggesting that their inspiration comes from outside themselves, as if they are acting as a channel or instrument of some external force. For instance, the mathematician Karl Friedrich Gauss wrote of his discovery of the proof of a theorem: 'At last two days ago I succeeded, not by dint of painful effort but so to speak by the grace of God. As a sudden flash of light, the enigma was solved' (Montmasson 1931: 77). This aura of mystery has led some to feel that creativity can never be explained. Others have been spurred on to attempt to solve the conundrum or, at least, to explore the process of creating or the motivation behind it. The result is a plethora of research and writing on the subject – far more than can be discussed in this short introduction.

* * *

The four chapters in Part Three all develop their arguments with reference to the ideas of D.W. Winnicott. I will therefore limit my discussion of creativity to ideas stemming from the field of psychoanalysis, and begin by tracing the development of these theories from the time of Freud in order to give some sense of the background to Winnicott's writing.

Freud himself was no stranger to the world of myth, and famously drew on the legends of Greece in formulating his cornerstone theories of the Oedipus complex and of narcissism. Nevertheless, he was determined to establish psychoanalysis as a scientific enterprise on a par with the physical sciences, and he was suspicious of any phenomenon that he felt unable to explain in analytic terms. In particular, he was notoriously ambivalent about visual art. It is clear from his writings that certain works of art, notably the Moses of Michelangelo, did affect him profoundly (Freud 1955), but he maintained that he could not derive pleasure from a painting or sculpture without being able to analyse the mechanisms of its effect. However, even he was not immune to the mystique surrounding the idea of creativity. He was fascinated by the ability of writers and artists to arouse emotions, and at times wrote of them as if they were exalted beings, above the rest of mankind: 'Before the problem of the creative artist analysis must, alas, lay down its arms' (Freud 1961: 177). Here Freud seems to bow

before the mystery of creativity. However, at other times, rather than idealise artists he reduces artistic endeavour to the level of a symptom. He was interested in the motivation that drove artists to pursue their calling, and suggested that artistic creation is a defence mechanism, the sublimation of drives that cannot be satisfied in the real world (Laplanche and Pontalis 1988: 431–433; Adams 2003). In his paper 'Creative writers and daydreaming', Freud suggests that the writer builds a world of unconscious fantasy to fulfil his unsatisfied desires (Freud 1959). The resulting creation is, therefore, an example of wish fulfilment, an escape from the frustrations of reality.

The attempt on the part of psychoanalysts to explain creativity in rational terms continued with Hanna Segal's paper 'A psycho-analytical approach to aesthetics', in which she put forward not only her interpretation of the motivation of the artist but also a theory of aesthetics and of the experience of the viewer (Segal 1952). According to Segal, who based her ideas on Melanie Klein's theory of the depres-sive position, the artist is engaged in a struggle to restore and rebuild her damaged internal world, destroyed in phantasy (in Kleinian theory, 'phantasy' denotes unconscious fantasy) by her destructive attacks (Klein 1986). Segal claims that 'all creation is really a re-creation of a once loved and once whole, but now lost and ruined object, a ruined internal world and self' (Segal 1952: 199). She writes that 'The task of the artist lies in the creation of a world of his own' (198); but this world, according to her, is actually a reconstruction from the fragments, the ruins, of an already experienced world of inner objects. This idea of a new world rising from the ashes of the old is reminiscent of one class of creation myths which tell of the destruction or dismemberment of a god or primeval creature and the transformation of the fragments of the body into the elements of the universe. For example, in a Hindu myth recounted in a Rig Vedic poem, the primeval Man is sacrificed and the parts of his body are rearranged to become the various forms of life (O'Flaherty 1975: 27–28).

Segal's paper goes further to investigate the nature of aesthetic experience and the responses of the audience to the work of art. She suggests that a successful artist or author is able to express the loss and horror of the depressive position, whilst at the same time using the form of the artwork to bring order to the apparent chaos. According to her, it is this resolution, this recognition of loss and its transformation through the creation of the artwork that is so satisfying for the audi-ence as they identify with the work of art and with the struggle of the artist. In this way Segal makes a link between the creativity of artists,

the creative experience of the audience, and the normal developmental process of working through the depressive position.

Both Freud and Segal were primarily concerned with the motivation of the artist or writer and with the experience of the audience, and they attempted to explain creativity within the confines of predefined psychoanalytic frameworks. Ernst Kris, however, from the standpoint of ego psychology, considered creativity in terms of the process of the artist and introduced the idea of a healthy form of regression (Kris 1952). He suggested that the creative process involved 'regression in the service of the ego' which is not pathological, but rather is controlled by the ego and makes use of primary process functioning to access preconscious or unconscious material (Laplanche and Pontalis 1988: 339). Kris's model of creativity has something of the Native American myth of the earth-diver who goes into the watery depths to retrieve some primal material to act as the basis for the creation of the world (Leeming and Leeming 1994).

Winnicott, like Kris, was more concerned with the process of being creative than with motivation; but he went further, approaching the subject from a radically new direction. Rather than seeing creativity as the mysterious possession of a few gifted individuals, he regarded it as an integral part of healthy living for all of us. Whenever we feel moved by a piece of music or a work of literature, whenever we respond to a landscape, whenever something in the outside world seems to take on a particular significance for us, we are, according to Winnicott, engaging in a creative process. We are endowing the outside world with elements of our own inner experience and in so doing we give it life, a life that is personal to us. Winnicott's radical departure from earlier psychoanalytic theory was to postulate an intermediate area of experiencing, a potential space, between the world of external reality and the inner world of unconscious fantasy. This space, this third area, allows for an overlapping of internal and external; and is a space of illusion in which objects have both an autonomous existence in the outside world and a life in the inner world of the individual.

Through the concept of transitional phenomena, Winnicott linked the early experiences of the infant, who uses a transitional object such as a teddy bear or piece of blanket to comfort himself, with the play of the older child and with cultural experience in adult life. All these situations take us into 'an area that is not challenged, because no claim is made on its behalf except that it shall exist as a resting place for the individual engaged in the perpetual human task of keeping inner and outer reality separate yet interrelated' (Winnicott 1986: 3).

Winnicott was not primarily concerned with the process of the artist at work, and he did not develop a specific theory of artistic creativity. Rather, he insisted on the place of creativity in everyday life, and in doing so he freed it from the mystique surrounding the myth of the great artist. Yet his ideas do retain a sense of mystery. At the heart of the concept of transitional phenomena is the idea of paradox – an area where meaning cannot be pinned down, where things are not one way or another but both at the same time, a fluid and constantly shifting interplay between different viewpoints. We must not expect to come to a clear and unequivocal understanding. We are urged to accept and embrace the mystery inherent in paradox.

* * *

The authors of the four chapters in this section take the Winnicottian concept of potential or transitional space as a springboard from which to launch their explorations of different aspects of creativity. In 'Found Objects and Mirroring Forms' (Chapter 16), Kenneth Wright looks at artistic creation and the way in which a piece of art becomes an 'aesthetic object', an object that seems to have a dynamic inner life of its own with significance for both the artist and the audience. Wright also explores the question of the motivation of the artist, linking artistic creativity with early life experiences. Drawing on Winnicott's concept of 'mirroring' and Daniel Stern's concept of 'attunement', he describes the way in which the infant looks to his mother's face and physical gestures to reflect back or 'recast' the form of his inner experience. In a parallel way, he suggests that artists seek to create a form for experience and that they do so through the moulding of their materials, through a struggle with their media. Wright emphasises that the possibility of aesthetic experience depends upon certain conditions: it needs a space set apart from everyday life within which there is freedom from the demands of action. He sees the artist's studio as such a space, providing a sense of containment within which the artist can enter the 'domain of contemplation or reflection', the transitional space, necessary for the creative process to take place.

Patricia Townsend, in 'Making Space' (Chapter 14), also addresses the question of the creative process of the artist, taking as a starting point the reported experience of an artist as she creates a series of moving image artworks. She identifies a cyclical process in which the artist moves between conscious and unconscious and the in-between state of transitional space. She questions whether the concepts of

transitional space and illusion go far enough in describing the state of mind of the artist at certain points in the process, and suggests that the term delusion (which she redefines as a transitory state) might better convey the intensity of the experience. Like Wright, she emphasises the need for containment and suggests that the artist needs to provide a facilitating environment for herself within which her relationship with the artwork can develop (Winnicott 1965).

A consideration of different spaces, both internal and external, and the movement between them is a theme that runs through all four chapters of this section. In 'Cultural Experience and the Gallery Film' (Chapter 13), Annette Kuhn moves away from the experience of the artist to consider the nature of the aesthetic response in the viewer and the ways in which this response may be facilitated by the spaces within which artworks are encountered. Drawing on the work of Marion Milner, Christopher Bollas and others, she suggests that the aesthetic moment involves a temporary loss of the sense of self and a concomitant experience of feeling enfolded by, or absorbed in, a work of art. Just as the chapters discussed above emphasise the need for a sense of containment for the artist, so Kuhn suggests that the viewer needs a 'frame' within which he or she can experience the intensity of this response. Kuhn identifies four levels of 'framing' in the art gallery: the topographical, the architectural, the space within the gallery, and the form of the artwork itself; and goes on to examine the experience of the audience when viewing gallery films. Finally, she reminds us that whilst the particular spaces, or frames, of a gallery film may offer the necessary sense of containment, the aesthetic response can never be relied upon. Depending as it does on a resonance between inner and outer worlds, it may be facilitated but not predicted.

There is a focus, in these four chapters, on the experience of art – be it from the point of view of the artist or of the audience. Myna Trustram, in 'The Little Madnesses of Museums' (Chapter 15), takes us away from the realm of the artist's studio and the art gallery and into the museum store. She discusses the responses of a group of students, artists and researchers who were given access to the Mary Greg Collection of Handicrafts of Bygone Times in the store of Manchester Art Gallery. Trustram points out that the experience of discovering and handling these ordinary, worn, household objects in this context differs radically from the more usual museum experience of seeing (not touching) preserved or restored articles in controlled conditions where they are already named, catalogued, classified. She turns to Winnicott's concept of the transitional object to explore the intense and

highly emotional engagement of the researchers with the collection. Again, as in the other chapters in this section, the issue of space, both internal and external, assumes a central role. The space of the museum store became a holding environment for the researchers within which they felt contained enough to enter the transitional space between inner and outer worlds evoked by the objects. Trustram suggests that the articles in the collection restored or revitalised the internal objects of the participants in the project through an identification with the users of these household items, or perhaps with Mary Greg herself.

It seems appropriate to end with some thoughts about Winnicott's own creativity. His style of writing is poetic, elliptical, paradoxical – exemplifying the very ideas he puts forward and demanding that the reader responds creatively. He gave us highly condensed propositions, including those related to creativity and culture, and left it to others to unravel, extend and develop his ideas. The chapters in this section attempt to do just that – to use Winnicott's concept of potential or transitional space as the seed from which to grow more detailed and specific explorations of the intricacies of creativity. Winnicott does not spell things out or pin things down. His writing embodies the paradox inherent in his concept of transitional phenomena, and so he leaves us with a lingering sense of the mystery not only of creativity but of life.

References

Adams, Parveen (ed.) (2003). *Art: Sublimation or Symptom*, New York: Other Press.

Amabile, Teresa M. (1996). *Creativity in Context*, Boulder, Colorado and Oxford: Westview Press.

Freud, Sigmund (1955). 'The Moses of Michelangelo', *The Standard Edition of the Complete Psychological Works of Sigmund Freud*, Vol. XIII, London: The Hogarth Press and the Institute of Psychoanalysis, 209–238.

——— (1959). 'Creative writers and daydreaming', *Standard Edition*, Vol. IX, London: The Hogarth Press and the Institute of Psychoanalysis, 141–154.

——— (1961). 'Dostoevsky and parricide', *Standard Edition*, Vol. XXI, London: The Hogarth Press and The Institute of Psychoanalysis, 173–194.

Klein, Melanie (1986). 'A contribution to the psychogenesis of manic depressive states', in Peter Buckley (ed.), *Essential Papers on Object Relations*, New York: New York University Press, 40–70.

Koestler, Arthur (1964). *The Act of Creation*, London: Hutchinson.

Kris, Ernst (1952). *Psychoanalytic Explorations in Art*, New York: International Universities Press.

Laplanche, Jean and Jean-Bertrand Pontalis (1988). *The Language of Psychoanalysis*, London: Karnac.

Leeming, David A. and Leeming, Margaret Adams (1994). *A Dictionary of Creation Myths*, Oxford: Oxford University Press.

Montmasson, Joseph-Marie (1931). *Invention and the Unconscious*, London: Kegan Paul.

O'Flaherty, Wendy (1975). *Hindu Myths: A Sourcebook Translated from the Sanskrit*, London: Penguin Books.

Rothenberg, Albert (1990). *Creativity and Madness*, Baltimore, MD: Johns Hopkins University Press.

Segal, Hanna (1952). 'A Psycho-analytical approach to aesthetics', *International Journal of Psycho-Analysis* 33: 196–207.

Storr, Anthony (1972). *The Dynamics of Creation*, London: Secker & Warburg.

Winnicott, Donald W. (1965). 'From dependence towards independence in the development of the individual', in *The Maturational Processes and the Facilitating Environment: Studies in the Theory of Emotional Development*, London: Hogarth Press, 83–92.

——— (1986). 'Transitional objects and transitional phenomena', *Playing and Reality*, Harmondsworth: Penguin, 1–30.

13 Cultural Experience and the Gallery Film

Annette Kuhn

This chapter sets out some preliminary thoughts and questions about the character and the enabling conditions of what is variously called aesthetic feeling, aesthetic emotion, the aesthetic experience, the aesthetic moment and the aesthetic response, and looks at these in relation to gallery films. It considers cultural experience from the standpoint of the user or the consumer as opposed to the producer of artworks, cultural texts and media. Briefly, the aesthetic moment (the various terms are used here interchangeably) is the intense state of mind in which a viewer or consumer of a work of art or other cultural text feels herself to be at one with the work. Gallery films are moving-image works exhibited in art gallery or museum spaces rather than in cinema auditoria, the distinction between the venues commonly being characterised as 'white cube' (gallery) as against 'black box' (cinema). The nature and formation of the aesthetic moment will be looked at first of all, along with the psychodynamic and environmental factors that facilitate it; and this will be followed by some thoughts on distinctive responses that might be prompted by moving image media. The chapter concludes with a short examination, with examples, of the cultural experience and the aesthetic moment in relation to the gallery film.

* * *

D.W. Winnicott's insights on 'the experience of things cultural' took off from Freud's notion of sublimation, the psychical process through which sexual drives are diverted towards new, non-sexual, aims such as intellectual inquiry and artistic creation. Winnicott's quest was to

detect the place in the psyche and the object-world where the individual's experience and use of culture are at work, and to inquire into the ways in which cultural experience can be part of a satisfying life: this is what he meant by 'the location of cultural experience' (Winnicott 1991). He undertook the work of setting out the psychodynamic and environmental foundations of cultural experience, opening the way for explorations of how cultural experience works in practice. Among those who have taken up the baton is Winnicott's contemporary and friend Marion Milner, a psychoanalyst whose thought-experiments and clinical observations fed into a series of intriguing explorations of the psychical processes at work in the making of satisfying art. One of Milner's insightful observations – an account, discussed later in this chapter, of looking at the outlines of objects with a fresh eye – is cited in Winnicott's essay on the location of cultural experience (Winnicott 1991: 132).

Milner noted that certain intense mental states experienced when contemplating works of art are akin to those commonplace in healthy infancy. These, she said, are grounded in a particular relation between self and object in which the boundary between the two merges and a temporary sense of loss of self is experienced. She argued that the idea of *illusion* is helpful in thinking about this fusion, because unlike the term fantasy '[the] word does imply that there is a relation to an external object of feeling' (Milner 1993: 16–17, Milner's emphasis). In other words, the sense of merging or fusion described by Milner is an inner-world state that depends upon an external object. She posits that this merging of the self-other boundary and temporary loss of sense of self are states of mind that accompany and facilitate the discovery of new objects, the finding of the familiar in the unfamiliar and the unfamiliar in the familiar. By way of conveying this mental state in words, Milner quotes the art historian Bernard Berenson on what he calls the aesthetic moment:

> In visual art the aesthetic moment is that fleeting instant, so brief as to be almost timeless, when the spectator is at one with the work of art he is looking at, or with actuality of any kind that the spectator himself sees in terms of art, as form and color. He ceases to be his ordinary self, and the picture or building, statue, landscape, or aesthetic actuality is no longer outside himself. The two become one entity; time and space are abolished and the spectator is possessed by one awareness. When he recovers workaday consciousness it is as if he has been initiated into illuminating, formative mysteries (Berenson 1950, quoted in Milner 1993: 27).

The evanescence of this experience – of leaving one's ordinary consciousness behind and feeling oneself to be part of, even enfolded by, a work of art – is described by Christopher Bollas as a moment 'when time becomes a space for the subject. We are stopped, held, in reverie, to be released, eventually back into time proper'. Bollas adds: 'I believe such moments may occur within the reading of a text, or a poem, or during the experience of hearing an entire reading of a text or a symphony' (Bollas 1993: 48). The quality of the aesthetic experience as a kind of movement in space as well as a moment in time – indeed as a merging of space and time – is emphasised by Gilbert Rose when he refers to 'the ebb and flow of losing and refinding oneself personally and endlessly in space-time' (Rose 1995: 355; see also Rose 1980); while the oscillating quality of this 'losing and refinding' is characterised by Claire Pajaczkowska as a 'duality of being merged and e-merging' (Pajaczkowska 2007: 45).

The art historian Peter Fuller has described in detail just such a state, experienced on contemplating an abstract colour-field painting by the American artist Robert Natkin, *Reveries of a Lapsed Narcissist* (Fuller 1980: 177–180). Fuller explains his initial reaction to the painting's 'superficial seductiveness' in terms of its deployment of colour, texture and abstract iconography: cross-hatching, a row of dots, and a blue circle that seem to have been 'woven together' to form a 'taut, stretched surface of paint', a kind of skin. He then describes his observations and responses as he becomes drawn further in to the painting, concluding that although 'It is not easy to verbalise this experience precisely',

> [i]t is almost as if at this level of your interaction with the work the skin had reformed but this time *around you* so that you, originally an exterior observer, feel yourself to be literally and precariously suspended within a wholly illusory space which…contains its own time (179, Fuller's emphasis).

Of course, not every viewer of a work of art will experience the kind of aesthetic response that Berenson and Fuller describe. Nonetheless, the grain of the experience itself, as these writers express it, will undoubtedly be recognisable to many people: Fuller calls it feeling like a spectator who begins by watching a performance but who ends up as an actor within it. Both the object and the intense response it evokes feel in a way personal: the painting appears to be singling out and addressing the viewer alone: 'When you engage with it receptively', says Fuller, 'this Natkin painting offers the illusion that it is almost a

"subjective object" or a picture of which you are more than a viewer, and almost a literal *subject*' (179, Fuller's emphasis).

There may appear no obvious reason why a particular work of art seizes your attention in this way and draws you in: it somehow presents itself, it finds you just as much as you find it. There is something idiosyncratic about the process, too: you feel – you want to feel – that others will not respond to the work in this way. Looked at on another day, moreover, this same work might even have lost its glow and become an object of merely passing attention or even of indifference, or of no more than academic interest. What, then, are the processes by which, and the conditions under which, a work of art becomes fleetingly endowed with inner import and draws the viewer into an 'aesthetic response'? Rather than treating this response as some mystery into which one has been initiated – though this may be exactly how it feels – the aim here is to enquire into its psychodynamics and its environmental conditions.

* * *

Marion Milner's concepts of frame, framing and framed gap offer a helpful way of approaching these issues. In Milner's object-relations terms a frame, though it may assume various literal and metaphorical forms, does one crucial thing: it 'marks off the different kind of reality that is within it from that which is outside it' (Milner 1993: 17; see also Milner 1987). That is to say, it constitutes a *boundary* that *contains* something, and this something is qualitatively different from what is excluded, what is outside the frame. Just as the frame separates two kinds of reality, so the frame belongs in, is part of, each reality – it is liminal. For someone making a drawing, say, a blank sheet of paper will present what Milner calls a framed gap: this is not just a blank sheet to be filled with the artist's marks, but also a space with edges that offer the enabling security of boundary and containment for the artist's mental and physical activity.

For someone looking at a drawing, the frame 'marks off an area within which what is perceived has to be taken symbolically, while what is outside the frame is taken literally' (Milner 1971: 158). A frame, in these terms, can be temporal as well as spatial. Milner offers the example of a play in a theatre: it is framed in space by the stage and in time by the duration of the performance, punctuated as the latter might be by the raising of the curtain at the beginning and its lowering at the end (Milner 1971: 157). The space or the time contained inside

the frame may be experienced as heightened – in the manner of distillation, perhaps – as it is held in place by its boundary. In Winnicott's terms, the holding or facilitating environment would be a frame, a setting that permits the infant's or the adult's confident exploration of the new, the unfamiliar. With regard to the encounter with works of art as an aspect of cultural experience, four kinds of frame may be identified: firstly, the topographical and institutional frames provided by the space in which the gallery, if that is where the artwork is displayed, exists; secondly, the spatial frame provided by the building, by the architecture of the gallery itself; thirdly, the 'framed gap' provided within the gallery for displaying the work of art; and finally the frame constituted by the form and medium of the artwork itself.

An art gallery is framed in the first instance by its location within a wider – typically urban or metropolitan – geography and by its function as a place that people normally undertake a special journey to visit. In this sense, a gallery is unlikely to feel like a home from home (see Chapter 5): indeed the gallery's non-everydayness, its promise of offering something out-of-the-ordinary and different from daily routine, is its very *raison d'être*. This is true for both the occasional and the regular visitor, for the cultural tourist as for the art lover on a pilgrimage in pursuit of the aura of the real thing: both are on a journey that will take them away for a while from the ordinary, from the workaday as Berenson would say, and into another world, a kind of utopian counter-space to the everyday, a heterotopia (Foucault 1986).

Another aspect of the gallery's separateness from the ordinary is its institutional role as guardian of parts of what Winnicott called the inherited tradition or cultural inheritance: something that pre-exists, and exists independently of, the individual and is socially and culturally shared (Winnicott 1991: 133). An art gallery's remit will normally include acquiring and collecting artworks that are considered part of a heritage and thus worthy of preservation; and making works available, in a dedicated venue, for viewing by members of the public who want to partake of, perhaps in some sense to consume, the cultural heritage. Art galleries take care of the cultural heritage, in other words. In a sense that is becoming obsolescent, curating (from Latin *curare*) means precisely looking after; today the word just as often refers to the deployment of specialist knowledge in selecting works for exhibition and interpreting them for visitors in display captions, exhibition catalogues and the like. Curators may regard their interpretive role as educational, and indeed an informed understanding of historical context, technique, and so on of an artwork can enhance the consumer's

response – though curating can sometimes get in the way of a sponta-
neously engaged response to art gallery or museum objects.[1]

The architecture of the gallery building can offer the frame of a
holding environment (Bollas 2000; Ellsworth 2005; Rodman 2005).
Here the institutional remits of the art gallery find expression in the
design and layout of the building itself and of the spaces inside it.
Together the gallery's architectural spaces and the artistic heritage it
curates provide an outer-world frame for cultural experience that can
be facilitating – or indeed constraining – for the user. In the 1960s the
French sociologist Pierre Bourdieu conducted a large-scale inquiry
into people's attitudes towards, and use of, art galleries. As part of
this study, respondents were asked what kinds of places art galleries
reminded them of. Of the five options given (church, library, depart-
ment store, waiting room, classroom), by far and away the top choice in
all social classes, nominated by close to two-thirds of all respondents,
was church, with library in second place for a minority of middle- and
upper-class respondents. The usual sociological interpretation of this
finding is that churches and libraries are places with high-volume
cultural capital, and thus that art galleries must be regarded by large
sectors of the population as uninviting or exclusive (Bourdieu and
Darbel 1991; Grenfell and Hardy 2007).

However, while the frame of the cultural tradition may equally
well feel constraining as enabling of spontaneously-felt engagement
with works of art, it is surely not tenable to assume that differences
in people's responses to art and attitudes towards art galleries are
reducible entirely to socioeconomic factors, even though these may
be at work at some level. An alternate interpretation of Bourdieu's
findings might be, say, that churches and libraries are both places
of quiet contemplation, and that this could be exactly what people
expect or seek in art galleries – or at any rate did in turbulent 1960s
France. Certainly, the marked prominence of church in the public
image of art galleries is a reminder of the religious role and uses of art
in the pre-secular world, and that as secular institutions art galleries
(many of which of course contain examples of the religious art of
earlier times) remain imbued with something of the sacred in many
people's minds.

As regards the question of framing, it is worth noting that Marion
Milner considered that creativity called for a setting for contemplation
– or in her terms for reverie. The word reverie, she said, 'does empha-
sise the aspect of absent-mindedness, and therefore brings in... the
necessity for a certain quality of protectiveness in the environment'

(Milner 1971: 163; see also Bachelard 1971). Reverie, argued Milner, requires a physical setting in which we are free for the time being of external demands. 'Frame' or 'holding environment' may be substituted for 'setting' here; and the idea of a real-world, physical domain of contemplation, a *templum* that is protected, set apart from ordinary life, is a potent one. It highlights the importance of a physical frame for reflection in which we feel at once secure and uncoupled from everyday demands. Such a setting provides a frame for creative thinking, for creative activity and for aesthetic feeling. To the extent that it constitutes a space outside the everyday, a space that can offer opportunities for quiet contemplation, the architecture of the art gallery can be a facilitating environment, an enabling frame, for aesthetic experience.

Here it may be appropriate to consider some of the ways in which exhibition spaces within galleries become transformed when they accommodate moving-image installations. Chrissie Iles, curator of a 2002 Whitney Museum retrospective on the projected image in the art gallery, notes that the idea of gallery exhibition space as a brightly lit 'white cube' is challenged by 'the folding of the dark space of cinema into the white cube of the gallery'. This hybrid kind of space, she asserts, invites participation, movement and multiple viewpoints (Iles 2001: 33). Iles's remark can also be taken as applicable to the form and medium of the artwork itself and to the kinds of responses that exhibited works, in combination with their installation setup, evoke in the viewer/consumer.

What can be said specifically about the framing role for the aesthetic response played by artworks and other cultural artefacts? Kenneth Wright, subscribing to Milner's view that a feeling of freedom from workaday demands and a physical and/or mental domain of contemplation provide facilitating conditions for intense engagement with creative processes and works of art, adds that the work of art itself also has a particular, active role to play: it engages the viewer because an objective pattern in the artwork is felt to embody and resonate with an internal one. Adopting concepts from Winnicott and from Daniel Stern, Wright identifies two psychical processes at work here: mirroring and attunement (Wright 2009). The viewer discovers something in the work that resonates with her own inner patterns, and one might add that the work of art finds a counterpart in the viewer's psyche. A feeling of 'rightness' in a piece of art, says Wright, 'stems from the sense of concordance between a felt inner structure and an external form that captures exactly the "shape" of that inner structure'

(Wright 2000: 79). This is why the viewer feels that the experience is all her own, why she experiences the aesthetic response to the work as an entirely personal thing, even feeling that the work has somehow singled her out. Wright uses the terms 'resonant form' and 'analogical form' to denote these experiences: the form or pattern of the work becomes, for the viewer, part of her internal frame.[2]

Peter Fuller emphasises the element of surprise he experienced in his encounter with the Natkin painting that so 'caught' him. He stumbled upon an exhibition of the artist's work, of which he had previously known nothing, in the unlikely setting of a museum in a provincial English city. Although his training as an art historian equipped him with the tools to make an informed reading of the painting, his response to it was obviously more visceral than intellectual. It harked back, he ventures, to a 'pre-self' or 'not-self', recapturing 'aspects of infantile experience about the nature of time, space, and ourselves which, in adult life, we have been compelled to renounce' (Fuller 1980: 183); though as Winnicott might have expressed it, it is precisely in such 'maximally intense' experiences as Fuller's that we can revisit something of this early sensation of fusion.

The topographical and the institutional frames of the art gallery; the frame of the inherited tradition; the architectural frame provided by the gallery building; the frame of exhibition and installation spaces within the gallery; and the frame provided by the form and medium of the artwork itself: each constitutes an environment that can facilitate (or otherwise) engagement with the individual's inner-world patterns, and thus an aesthetic response. Like the transitional object, the artwork that occasions intense and meaningful experiences feels like something one has both stumbled upon and created. What this argument suggests is that while aesthetic feeling always retains a sense of something personal, of one's very own, there are external-world factors that can facilitate or constrain it.

* * *

The descriptions of the aesthetic experience quoted here relate predominantly to fine art – to paintings and sculpture especially (though Berenson alludes as well to experiences in nature). What, though, of cultural forms other than the traditional fine arts? What, in particular, of moving-image media, where the viewer cannot contemplate a work in its stillness? What kind of frame for aesthetic response is available with time-based media?

In the case of the moving image in the cinema, the cinema building and its 'black box' auditorium constitute topographical and architectural frames for the filmic experience; as of course does the 'inherited tradition' of cinema's own history and the formal conventions of the medium. Above all, the cinema screen arguably sits even more aptly than the picture frame as exemplar of the frame's marking off Milner's 'different kind of reality that is within it from that which is outside it'; besides which many commentators, Roland Barthes among them (Barthes 1989), have pointed out that the spatial setup of the darkened cinema auditorium – fixed seating, spectators' immobility and directed gaze – is highly conducive to absorption in the 'other' world on the screen. Furthermore the moving image, alongside the spatial organisation (through editing, for example) of the world on the cinema screen, invites particular kinds of embodied and kinetic, as well as visual, engagements with the filmic world.[3]

Also fitting here is Marion Milner's vivid description of an experience she once had of feeling suddenly freed from a kind of tyranny of *stasis* in the outlines she had believed were required in seeing and drawing objects:

> I woke one morning and saw two jugs on the table; without any mental struggle I saw the edges in relation to each other, and how gaily they seemed almost to ripple now that they were freed from this grimly practical business of enclosing an object and keeping it in its place (Milner 1971: 16).

Perhaps we can say that the sensation of visible movement or oscillation, the intimation of temporal and spatial plasticity, apparent in Milner's fresh way of seeing objects in the world is always already present in the moving image. Perhaps, to paraphrase Milner, the moving image releases objects in the frame from imprisonment inside themselves.

This aside, cinema proposes a number of potential modes of engagement, prominent among them being a kind of bodily engagement involving, even as one sits virtually immobile in one's seat, an imagined sense of bodily movement (Rutherford 2003). In concert with this embodied engagement, the temporality of the moving image proposes a quality of experience, as the work unfolds in time, that is both peculiar to the medium and variable in its modes of expression. The duration of a cinema film, its running time, and the speed of its unfolding (for example, the paced temporal unfolding of 'slow' film as against the intensified continuity of the action film) all offer their own kinds of framing.

What, though, of the black box in the white cube, as Chrissie Iles characterises it: the moving-image installation in the art gallery as against the film in the cinema auditorium? In the cinema, the exhibition and reception of a film are normally temporally framed by the feature-length picture's quality as a text bounded in time, one whose most common form is that of a fiction with linear exposition and with closure and resolution that coincide with the cessation of the screening. Gallery films, on the other hand, are rarely so tightly temporally bounded: they are usually set up so that the work is continuously repeated, while viewers may enter and leave the installation space at any point, remaining for as long or short a time as they choose. The gallery installation provides distinctive spatial frames for moving-image works in that, unlike cinema, viewers can typically stand or sit or move around in a darkened installation space, viewing the work from different angles and distances (that Chrissie Iles calls 'multiple viewpoints'). The work might deploy more than one screen, for example, so that the viewer can choose where to direct her attention and whether or not to attend to details, patterns and repetitions as they weave themselves in and through the different screened images. Not surprisingly, given the purposefully sculptural element of gallery film installations, the viewer's experience of the installation space on the one hand and of the space and time of the work on the other may merge into one another, the installation space being part of the artwork.

While installation spaces for gallery films often incorporate several screens, there may equally be no screens at all or non-screen media instead of or alongside screens. These varied sculptural elements can be deployed in any number of ways within the installation space, according to the design of the work as a whole. Therefore, unlike viewers entering a cinema auditorium, consumers of a gallery film may well have little idea what to expect as regards the setup of the projection space. The viewer's transition from the gallery's surrounding 'white cube' spaces into a darkened space is across a threshold that can be experienced as strongly marked, if only because of the physical adjustment required of her in moving from light into darkness. In addition, as she makes her entrance the visitor must adjust to the sculptural setup of the installation elements while in the process of beginning to take in the form and content of the projected image or images and, if present, sounds. As part of the work's distinctiveness, the structure, form and duration of these images and sounds will be organised according to a logic and pattern whose apprehension can become part of the viewer's

activity. Along with any curatorial interpretive material provided, all of these elements may constitute framings for the viewer's experience of, and responses to, the work.

* * *

I shall conclude these remarks by briefly considering some gallery films of different kinds along with their installation venues. *24 Hour Psycho* (Douglas Gordon) consists of a single-screen projection of Hitchcock's 1960 classic, projected at two frames per second (the conventional projection speed being 24 frames per second), thus extending the film's running time to close to the 24 hours of the title. Premiered in Glasgow in 1993, it formed part of a 2006 Gordon retrospective at the National Gallery of Scotland in Edinburgh, where it was shown on a large screen suspended from the ceiling of a lit room. *Five Angels for the Millennium* (Bill Viola, 2001) was shown at Tate Modern, London, and at other venues the world over. The Tate Modern installation consisted of five large wall-mounted screens in a sizeable darkened space, with each screen showing a looped, slowed-down film sequence of a person falling into or (with the film reversed) emerging from water, accompanied by an immersive soundtrack of rushing and splashing water. *David* (Sam Taylor-Wood) was commissioned by and exhibited at the National Gallery in London in 2004. It consists of a 67-minute film on a continuous loop showing the footballer in close-up, asleep, presumably in real time.[4] The diversity of these works precludes sweeping generalisations about the responses invited or invoked in viewers by gallery films. However, some thoughts might usefully be ventured concerning the environmental conditions and framings of these gallery films as they conduce to responses of different kinds.

The principal frame for Douglas Gordon's film must be an 'inherited tradition' one: prior knowledge of the Hitchcock film. While few visitors will (presumably) sit through the work's entire 24 hours, there is pleasure and satisfaction to be derived from identifying the particular moment arrived at in the Hitchcock narrative at the point at which one enters the installation space – and here one may be reminded, too, of the rumour that *Psycho*'s initial theatrical release put an end to the then normal practice of continuous programming in cinemas. Somewhat in the spirit of the experience of continuous programming, considerations of engagement with a narrative with a beginning, a middle and an end (in that order) will be set aside as the barely-moving image of *24 Hour Psycho* offers itself up for contemplation and, given time,

eventually resolves into near-abstraction. To this extent, *24 Hour Psycho* can offer, in varying combinations, pleasures of an intellectual and a visual-sensual kind.

In the case of Sam Taylor-Wood's film, both the subject (Beckham) and the installation's venue (the National Portrait Gallery) suggest that fame and celebrity are the key frames for this work. The NPG's interpretation of *David* places it in the frame also of the inherited tradition (of the history of avant-garde art and film) by reminding the viewer of its homage to *Sleep* (1963) – a film made, fittingly enough, by the artist credited with the invention of contemporary celebrity culture, Andy Warhol. The attraction for the viewer who chooses to spend time with Taylor-Wood's work can be the slow pleasure of immersing oneself in an 'other' real time as the film unfolds; and perhaps also the slightly uneasy voyeuristic gratification deriving from intimately witnessing a portrayal of someone in a vulnerable state. The immediate lure of celebrity (would the film be interesting if the sleeper were anonymous?) may, as time passes and nothing much happens on the screen, give way to more profound reflections on fame and mortality, the film perhaps ultimately revealing itself – harking back to a much older aspect of the inherited tradition of art – as a *memento mori*.

Unlike *24 Hour Psycho* and *David, Five Angels for the Millennium* overtly offers itself up as a piece of meditative art, in the inherited tradition of the icon; and as an invitation, in the artist's words, to 'live within the frame' (Viola 1995: 176). The sculptural form and installation setup of the work – the all-embracing darkness and enveloping sounds – are an invitation to enter a physical and mental space of contemplation; while the elemental content of the images – referencing the repeated cycles of birth, death and rebirth – invoke the sacred and the transcendent.

Clearly we cannot talk about 'cultural experience and the gallery film' as if it were something unitary – there are obviously shades and variations, with the nature of the exhibition site being of particular salience. The framing spaces of the gallery film often involve the viewer's entry into further spaces set apart from the everyday world, not merely by their presence inside an art gallery but also by the separateness and 'other-world' quality of the space of the 'black box' itself within the gallery. Time is a crucial factor in engagement with all of the three works discussed here – and possibly with any gallery film – in a manner entirely peculiar to moving-image media. In their very nature, gallery films urge the viewer to spend time with them; and if

the viewer is moved to accept the invitation, this can be the first step towards entering the other world of the aesthetic experience.

In the end, though, what this discussion suggests is that while we may speculate *a priori* about the frames and the facilitating environments of cultural experience, the intensity of the aesthetic response itself is not a given, and cannot be predicted, any more than a toddler can be presented with a transitional object, simply because of the activity of inner-world processes. Nonetheless it is clear that, through the concepts of potential space and analogical form in particular, object-relations psychoanalysis offers productive means of exploring and understanding the ways in which, and the conditions under which, human beings can derive satisfaction, and find ways to enjoy creative living, through cultural experience.

Notes

1 As argued by Myna Trustram in Chapter 15.
2 See also Wright's argument in Chapter 16; and Bowie (2000).
3 This point is considered in greater detail by Phyllis Creme in Chapter 4; and also in Kuhn (2010).
4 On *24 Hour Psycho* at the National Gallery of Scotland, see http://www.nation-algalleries.org/whatson/exhibitions/douglas-gordon-superhumanatural/themes-4418 (accessed 29 December 2011); on *Five Angels for the Millennium* at Tate Modern, see http://www.tate.org.uk/about/pressoffice/pressreleases/bill-viola_19-05-03.htm (accessed 29 December 2011); on *David* at the National Portrait Gallery, see http://www.npg.org.uk/collections/search/portrait/mw73998/David-Beckham-David?LinkID=mp14244&search=sas&sText=David+Beckham&role=sit&rNo=0 (accessed 29 December 2011).

References

Bachelard, Gaston (1971). *The Poetics of Reverie: Childhood, Language, and the Cosmos*, trans. Daniel Russell, Boston, MA: Beacon Press.

Barthes, Roland (1989). 'Leaving the movie theatre (1975)', *The Rustle of Language*, Berkeley, CA: University of California Press, 345–349.

Berenson, Bernard (1950). *Aesthetics and History*, London: Constable.

Bollas, Christopher (1993). 'The aesthetic moment and the search for transformation', in Peter L. Rudnytsky (ed.), *Transitional Objects and Potential Spaces*, 40–49.

——— (2000). 'Architecture and the unconscious', *International Forum of Psychoanalysis* 9(1–2): 28–42.

Bourdieu, Pierre and Darbel, Alain (1991). *The Love of Art*, trans. Caroline Beattie and Nick Merriman, Cambridge: Polity Press.

Bowie, Malcolm (2000). 'Psychoanalysis and art: the Winnicott legacy', in Lesley Caldwell (ed.), *Art, Creativity, Living*, Winnicott Studies Monograph Series; London: Karnac Books, 11–29.

Ellsworth, Elizabeth (2005). *Places of Learning: Media, Architecture, Pedagogy*, New York: Routledge Falmer.

Foucault, Michel (1986). 'Other spaces: the principles of heterotopia', *Lotus*, 48–49: 9–17.

Fuller, Peter (1980). *Art and Psychoanalysis*, London: Writers and Readers Publishing Co-operative.

Grenfell, Michael and Hardy, Cheryl (2007). *Art Rules: Pierre Bourdieu and the Visual Arts*, Oxford: Berg.

Iles, Chrissie (2001). 'Between the still and moving image', *Into the Light: the Projected Image in American Art 1964–1977*, New York: Whitney Museum of Modern Art, 33–83.

Kuhn, Annette (2010). 'Cinematic experience, film space, and the child's world', *Canadian Journal of Film Studies*, 19(2): 82–98.

Milner, Marion (1971). *On Not Being Able to Paint*, 2nd edn.; London: Heinemann.

——— (1987). 'The framed gap (1952)', *The Suppressed Madness of Sane Men*, Hove: Brunner-Routledge, 79–82.

——— (1993). 'The role of illusion in symbol formation', in Peter L Rudnytsky (ed.), *Transitional Objects and Potential Spaces*, New York: Columbia University Press, 13–39.

Pajaczkowska, Claire (2007). 'On humming: reflections on Marion Milner's contribution to psychoanalysis', in Lesley Caldwell (ed.), *Winnicott and the Psychoanalytic Tradition*, London: Karnac, 33–48.

Rodman, F. Robert (2005). 'Architecture and the true self', in Jerome A. Winer, James W. Anderson and Elizabeth A. Danze (eds), *Psychoanalysis and Architecture*, The Annual of Psychoanalysis, 33; Catskill, NY: Mental Health Resources, 57–66.

Rose, Gilbert J. (1980). *The Power of Form: A Psychoanalytic Approach to Aesthetic Form*, Psychological Issues Monographs, 49, New York: International Universities Press.

——— (1995). 'The creativity of everyday life', in Simon A. Grolnick and Leonard S. Barkin (eds), *Between Reality and Fantasy*, Northvale, NJ Jason Aronson, Inc, 347–362.

Rutherford, Anne (2003). 'Cinema and embodied affect', *Senses of Cinema*, 25. Available at: http://www.sensesofcinema.com/2003/feature-articles/embodied_affect/ (accessed 6 May 2006).

Viola, Bill (1995). *Reasons for Knocking at an Empty Door: Writings 1973–1994*, London: Thames and Hudson.

Winnicott, Donald W. (1991). 'The location of cultural experience ', in *Playing and Reality*, London: Routledge, 128–139.

Wright, Kenneth (2000). 'To make experience sing', in Lesley Caldwell (ed.), *Art, Creativity, Living*, London: Karnac Books, 75–96.

——— (2009). *Mirroring and Attunement: Self-Realization in Psychoanalysis and Art*, London: Routledge.

14 Making Space

Patricia Townsend

Winnicott prefaces his essay 'The Location of Cultural Experience' with a quotation from the Bengali poet Rabindranath Tagore: '*On the seashore of endless worlds, children play*' (Winnicott 1986). He first came across it as an adolescent when it 'found a place' in him, although at that time he did not know what it could mean. Many years later, when he formulated his concept of transitional phenomena, he felt that he had at last come to an understanding of this elusive phrase. One of Winnicott's great contributions to psychoanalysis was his formulation of the idea of an intermediate area of experiencing between inner and outer worlds (Winnicott 1986a) where unconscious phantasy and reality meet and overlap. He called this 'potential' space, and saw it as a third area of creative illusion, a space of play or imagination.

This chapter is concerned with inner, outer and 'potential' or 'transitional' space in the process of making art. It is concerned with the external spaces of the outside world, of landscape, of the studio, of the art object, of the gallery or the screen, the internal spaces of the mind and the spaces in between. How do these inner and outer worlds overlap, intermingle and colour one another and how can this interweaving be understood in the light of Winnicott's ideas and those of other psychoanalytic writers?

In order to explore these questions, I am going to refer to an artist's story of the way in which she came to create a series of video and installation works. These works were inspired by Morecambe Bay, a vast expanse of quicksands, channels and intertidal mudflats situated in north-west England, close to the mountains of the Lake District National Park.

When I first started going to the area regularly I stayed in a valley halfway between the mountains and the Bay. After a while I noticed that I would always travel to the mountains rather than to the coastline. The mountains attracted me. They seemed to me to be comforting, solid, dependable, containing. The Bay, on the other hand, seemed too open, too flat, too vast. There was something troubling about this landscape. Was it the history of the Bay, the fact that many lives have been lost here to the quicksands or to fast incoming tides? Looking out over the great expanse of the Bay at low tide, I imagined myself walking out alone towards the horizon until I could see no land. I imagined what it might feel like to be out in this wet desert, far from help. This sense of isolation and lack of containment seemed to be one aspect of my emotional reaction to the Bay. Another had to do with the imagined experience of being sucked beneath the ground by quicksands. Or being swept away, engulfed, by the incoming tide which is said to be as fast as a galloping horse. But I felt that there was more to my feelings about the Bay than these emotionally charged images. It was as if these reactions were the tip of an iceberg and that below the surface were less conscious associations, which I could not yet access. It was this feeling that propelled me to make a series of artworks related to the Bay.

Initially, I had no idea how I might approach the subject beyond the fact that my usual media are video, photography and installation. I spent long periods of time traversing the coastline and finding positions or vantage points that seemed 'right'. I could not necessarily say what was right about them. One favourite area at the mouth of an estuary had a small pier from which I could film the incoming tide. Another spot had deep channels in the sand that altered with every tide. I took many photographs and shot many hours of video footage in an attempt to clarify what it was that I wanted to make. But then came a long period when I felt that nothing was happening in my mind, that I had no ideas. No new images came to me. I felt stuck and frustrated, not knowing how to proceed.

This initial stage of the process starts with the artist's personal response to the landscape. Morecambe Bay is for her a space between inner and outer worlds, a transitional space. By this I mean that, from the beginning, she invested the landscape with aspects of her own inner experience, she saw it as a reflection of something internal. It was this experience that gave her the motivation to make these artworks and led to a period of research and experimentation during which she tried out many different approaches. This phase of the process could be regarded as one of data collection and it preceded work on each of the individual pieces in the series. It was followed by a period in which the artist felt that nothing was happening, as if the process

had entered a time of stagnation. However, as later events will show, on the level of internal processes things were very different. Rather than a period of stagnation this was a gestation phase during which, out of her awareness, a process of deconstruction and rebuilding was progressing. The unconscious imagination was at work, breaking down fragments of material from different sources – from her own unconscious fantasies, from earlier ideas and attempts to make earlier works, from facts stemming from her research, from images of the Bay itself, and so on – in order to resynthesise these into new forms. This was a purposeful process, set in motion by her conscious will although no longer controlled by it. It seemed that her unconscious imagination constructed images and ideas which reflected her as yet undefined inner experience. One could say that the unconscious imagination envisioned an unseen image and the task of the artist was to find a way to give this form.

> One evening I went to a stretch of the shore that I often visited. I was intending to take some still photographs in the evening light. On my solitary trips to the Bay I felt myself to be in a particular state of mind. It was as if I was in a bubble of time, a space of my own, in which I could detach myself from the concerns of everyday life. I was in a state in which I was highly tuned to elements in the landscape that seemed to resonate with something in me. I had only a vague idea of what I was looking for. On this occasion I found something unexpected. A small spring of water emerged from underneath the sands, danced before my eyes, reflecting the setting sun, and then disappeared beneath the ground again, only to re-emerge moments later. I was immediately captivated by the sight as if it was exactly this phenomenon that I had been waiting for without knowing it. All I had to do, it seemed, was to capture it on film. Of course, having made my film, there followed a process of revision and editing to produce the final work. But, in this case, whatever doubts I had about the details of the final presentation, I knew that the film reflected something of the inner state I was trying to reach (Figure 14.1).

Occasionally the artist is fortunate enough to find a ready-made form in the outside world. By the time this artist discovered the spring she filmed in *The Quick and the Dead* she already had an unconscious 'vision' of something that corresponded sufficiently closely to the form that appeared to her. When she saw the spring she seemed to *recognise* it as if she had been searching for just this phenomenon. However, in her experience this is rare and in making other works the process was much more tortuous. When no ready made form is to be found, the artist must construct a form for herself:

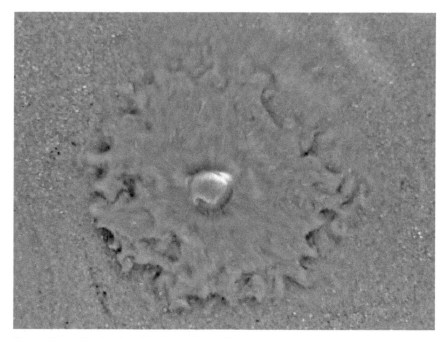

Figure 14.1 *The Quick and the Dead,* video still

I was fascinated by the rapid changes in the Bay as the tide swept in or out, the in-between state of the landscape when it was both land and sea. The idea came to me of making a print in which two blocks of text, one ochre and one blue, over-lapped each other, creating an intermediate space. From this beginning the piece evolved through a number of transformations or reincarnations as each attempt was rejected by me and further ideas came to my mind. Having made the print, it seemed to me to be too static, not reflecting the fluid nature of the tidal move-ment. For a while, I felt stuck again but then the idea emerged of reworking the piece as an animation and editing it so that the two blocks of text moved over one another in a wavelike motion. At the same time, the content of the text changed repeatedly as I decided on and then rejected many different versions. In the final version, the blue text is composed of words related to my emotional responses to the Bay and the ochre text is related to my responses to the nearby mountains. But I was still dissatisfied. Now it seemed too flat and I wanted to introduce a third dimension. Again, I could not immediately see a way through this impasse. Eventually I had the idea of projecting the animation onto a 'mountain' of sand. When this piece was exhibited I discovered another, unforeseen, movement in it. As the sand dried out over the course of the exhibition, the 'mountain range' began to crumble and slip. This unpredictable movement seemed to me to add something to the work (Figure 14.2).

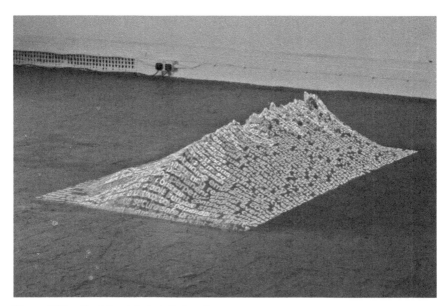

Figure 14.2 *Bay Mountain*, installation view

From this account it is clear that the progress of the making of the artwork was closely tied in with the interaction between the artist and her medium. As her ideas emerged and she tried them out in practice, as she began to construct her form, the response of her medium took her in unexpected directions. The print seemed too static and this led to the development of the text animation. The text animation seemed too flat and led to the idea of the installation, and so on. This process is also evident in the following example:

I had heard many stories of lives lost to the incoming tide or to the quicksands. Riders and walkers, carriages and horses, have disappeared beneath the sands. All have been swallowed up. The word quicksand means living sand and I wanted to make a piece which would bring the sands to life. At first I had no idea how I might do this. I went through a long period of apparent stagnation in which, despite struggling to find an image or an idea for a new approach, nothing seemed to fit and I felt unable to move forward as I could find no direction in which to go. I noticed that I went through a cycle in which periods of apparent stagnation would be followed by short periods in which I felt elated by an influx of images or ideas and then times when I felt disillusioned, dissatisfied with my efforts. Then the cycle would begin again. The process involved a dialogue, or a struggle, with my medium – first I had to find the images that seemed to 'fit' and then a way of editing the material to achieve the effect I wanted, although, at this point, I had

no clear idea of exactly what I was seeking. I had to try out different editing techniques, evaluating the effect of each one. Through this process of experimentation I realized that I wanted these images to move in such a way as to suggest that the surface of the sand was the skin of a living being (Figure 14.3).

Figure 14.3 *Under the Skin,* animation still

These descriptions suggest that, for this artist at least, the making of art is a cyclical process. After an initial preparatory stage of research and experimentation, the artist went through a cycle of experiences, a movement from a sense of stagnation, through a second phase in which ideas and images emerged, to a third stage of evaluation after which, if the piece was still found wanting, the cycle would recommence. I want now to look more closely at the second phase during which ideas emerged. Occasionally this happened all at once, so to speak, through the discovery of a ready-made form in the outside world, but more often ideas and images emerged in the artist's mind or through a dialogue with her medium. The artist describes a particular state of mind at this stage:

> *My attention is unfocused and yet seems acute. The space of the mind seems to open up, to expand. At certain moments I feel as if my awareness encompasses everything – the world outside, my own body, my mind. I am not aware of anything in particular and yet there is a heightened awareness. For a while, nothing might emerge from this generalized field, then perhaps a rush of ideas or images. This is exciting. I feel elated. Whilst these ideas are still in my mind and have not yet been realized in the outside world they remain full of potential. They are not yet clearly defined. If they do not feel quite right they can be instantly changed in my imagination. In this state of mind, internal judgmental voices are silenced: all is permitted, all is possible.*

In attempting to conceptualise this phase of the process, I turn first to Winnicott. I suggested above that the concept of transitional space as an intermediate area between inner and outer worlds is relevant to this artist's initial and continuing response to Morecambe Bay. But how closely does it correspond to the state of mind described by the artist above? Winnicott suggests that we, as adults, continue to need an intermediate area of experiencing, a transitional space, and that this can be provided for us through the arts:

> It is assumed here that the task of reality-acceptance is never completed, that no human being is free from the strain of relating inner and outer reality, and that relief from this strain is provided by an intermediate area of experience…which is not challenged (arts, religion, etc.) (Winnicott 1986a: 15).

Viewing a work of art, then, according to Winnicott, can provide us with this necessary intermediate area of experience. However, Winnicott does not extend his ideas to the experience of the artist in the act of creating. Can the experience of the artist be understood as different only in degree from that of the viewer of art? Is it simply a more intense version of the viewer's experience or is it different in kind?

Perhaps the concept of illusion may be relevant here. Winnicott saw potential or transitional space as a third area of creative illusion, a space of play or imagination. Illusion, for Winnicott, did not have the connotations ascribed to it by earlier psychoanalysts who tended to see it as a flight from reality (e.g. Freud 1959). Rather, he saw illusion as a space in which reality (the outer world) could be creatively transformed by inner experience. Marion Milner, a psychoanalyst who was contemporary with Winnicott and who wrote extensively about her own process of drawing and painting, also emphasised the value of illusion:

> Moments of illusion: necessary for symbol formation, moments when the me and the not-me do not have to be distinguished. Moments when the inner and outer seem to coincide. Needed for restoring broken links, bridges, to the outer world, as well as forming the first bridges. As necessary for healthy living as night dreams seem to be—and as playing is. (Milner 1969: 416)

Milner wrote of her state of mind whilst drawing, calling this 'absentmindedness' (Milner 1971). For me, however, the term 'absent-mindedness' belies the intensity of the artist's experience at the moment when ideas and images emerge into consciousness. Milner was writing from her experience of free drawing and painting, and her ideas emerged through the drawings she found herself creating on the page. This is a different process from the one considered in this chapter and it may be that Milner did not go through phases of research, gestation and the sudden emergence of ideas such as those I have described in this artist's process.

Do the concepts of transitional space and illusion capture the full extent of the experience of this artist at certain moments during the process of creation, those moments when ideas and images emerged into consciousness? I want to suggest that they do not go far enough. At these moments, I suggest that there was more than an overlap of outer and inner worlds. Rather there was a loss of differentiation. The distinction between inner and outer did not apply.

Perhaps this state of mind, at certain moments, is closer to delusion than illusion. I need here to define the way in which I am using the term 'delusion'. Unlike 'illusion', which tends to denote a transitory experiential state, the term 'delusion' is usually understood to refer to a fixed belief which is in opposition to 'reality' (i.e. the consensual reality of other people). Here I want to introduce the idea of a temporary delusional state that envelops the artist at a particular moment in the creative process. As ideas and images emerge, the artist sees them as the perfect answer to an unformulated question. In these moments, she is temporarily blind to potential problems and shortcomings which will be acknowledged only later in the process. She feels that she has found the ideal form. I want to suggest that this state of mind differs from that described by Winnicott and Milner. Milner writes that, in the space of illusion, the me and not-me do not have to be distinguished. Winnicott writes that we must not ask the playing child whether he found his plaything or whether he created it himself. Both Milner and Winnicott suggest that, in the area of transitional space or

illusion, the question of what is inside and what is outside can remain unanswered. Inside and outside coincide. But the child knows that the stick he is holding is actually a stick and not a gun. He knows that he is pretending. I want to suggest that, at fleeting moments during this phase of the creation of an artwork, there is no felt distinction between the me and the not-me. Inside and outside not only coincide, they cannot be distinguished.

Anton Ehrenzweig, an educationalist who used Kleinian psychoanalytic theory in his writing about the creative process, seems to capture the experience more closely. He uses the term 'dedifferentiation' to refer to the state of mind of the artist while making art and writes of it: 'all differentiation ceases. The inside and outside world begin to merge' (Ehrenzweig 1967: 103). And, again: 'The necessary blurring of conscious focusing is felt as a danger and a threat of total chaos' (46). Perhaps because this mental state is so close to that of delusion, the process of making art can sometimes seem to be a dangerous one, and there is a need to create the right mental conditions to engage in it. I would suggest that the artist needed to provide a safe internal space for herself within which she could develop her work. Winnicott wrote of the mother's role in creating a facilitating environment, free from outside impingements, within which her infant can develop and eventually discover himself to be a person in his own right, separate from his mother. I want to suggest that the artist needed to provide a facilitating environment for *herself* within which she could focus on the development of her artwork. In other words, the process of art making requires a particular kind of mental space, a space of safety and containment within which the artist can allow herself to tolerate the necessary dissolution of boundaries between inner and outer worlds.

So how does the artist provide herself with the necessary conditions to create this safe space? To try to explore this question, I turn again to this artist's description of the situations in which ideas and images arose:

> *I find that a very fertile time for ideas is lying in bed before getting up if I am in a drowsy state. Bus and train journeys and walks are also good times, but only if I am alone. I need to know that I have time to myself and that there will be no distractions.*

At these times she was able to let her mind drift, uninterrupted by everyday demands. At other times she deliberately tried to foster a situation in which she could work, perhaps by spending time in her studio or by working on footage on her computer, or on her many

visits to Morecambe Bay. These situations had something in common. In all of them she felt herself to be in a contained space in which she could safely let her imagination run free without distraction or interruption. The containment was provided by the fact that the spaces were boundaried, their boundaries being either spatial or temporal. In her studio she was contained by the physical boundaries of the room; on her walks the time set aside provided temporal limits; in bed she felt cocooned, enclosed. These boundaries set the space aside from everyday life. They ensured that she was protected from external demands but also, and equally importantly, she knew that she could and would return to everyday life by stepping outside these boundaries. The psychoanalyst Kenneth Wright has suggested that aesthetic experience, and the creation of art, requires a 'domain of contemplation' (Chapter 16) which 'excludes the world of *ordinary* action'. He describes this as a space in which 'presences can be conjured up and felt', in which the outer world can become suffused by inner experience.

Another psychoanalyst, Ronald Britton, uses a spatial metaphor for the imagination (Britton 1998). He calls it the 'other room' and suggests that, whenever we think imaginatively, we have placed ourselves in this other room in our minds. When we are in the other room we know that we are in a space which is not part of the real world. The artist imagines walking far out onto the sands but she knows that she is not actually doing so. So long as the boundaries of the other room are in place she can feel free to give full rein to her imagination knowing that it will not have direct consequences in the outside world.

The artist Grayson Perry speaks evocatively of this other room in his autobiography. His internal space takes on the characteristics of the shed which his father used as a workshop:

> My own creativity and art practice has been a mental shed – a sanctuary as well as a place of action – where I have retreated to make things. It gives me a sense of security in a safe, enclosed space while I look out the window to the world…. my internal shed is always available. I can retreat into my head while in bed or in the bath – wherever I am – to think about things I want to make (Jones and Perry 2007: 23).

So this 'domain of contemplation', this 'other room', this 'mental shed' provides a space within which the artist's relationship with her potential artwork can develop.

As the artworks described above began to develop, another kind of space came into play. The physical frame of the work (in this artist's

case, the frame of the screen or of the pile of sand) became a physical container for the artwork and, therefore, for that part of her experience which she had put into the piece. Milner writes of the importance of the frame to the work of art, describing it as a 'framed gap' which 'marks off what's inside it from what's outside it' (Milner 1987: 80). The space of the frame performs a function in that it separates the artwork from the rest of the world, including the artist. The artist puts a part of her experience outside herself into the artwork where she can recognise it and relate to it. Ehrenzweig recognises the importance of this to the artist:

> While the artist struggles with his medium, unknown to himself he wrestles with his unconscious personality revealed by the work of art. Taking back from the work on a conscious level what has been projected into it on an unconscious level is perhaps the most fruitful and painful result of creativity (Ehrenzweig 1967: 57).

A further layer of framing occurs when the piece is exhibited. The gallery space contains the artwork, provides it with an environment within which an audience can respond to it. The artist, in showing an artwork, is offering the spectator the possibility of entering a potential space, a space of illusion. As the psychoanalyst Michael Parsons writes:

> It is not just the artist who inhabits a potential space. If looking at a painting is to be truly a looking into what the artist has created, it demands the viewer's own creative participation. Aesthetic experience is, in fact, a form of aesthetic activity, which calls on the viewer to enter a potential space as well (Parsons 2000: 168).

The artist needs to provide the right conditions for this to occur. That is, the viewer, like the artist, needs a space set apart from everyday life. The gallery becomes the containing space for the viewer and the artist attempts to display her work in such a way that the viewer is able to enter into a relationship with it, perhaps to imbue the work with his or her own inner experience. Of course, not all art is displayed in galleries but wherever it is seen, if it is successful, the surroundings contribute to the experience, enabling the viewer to enter his or her own internal mental space.

* * *

In this chapter I have considered the mental and physical spaces involved in an artist's process of making a series of artworks. I have

focused on a spatial view of this process but temporal considerations have also crept into the discussion, especially through the idea that making art involves a cyclical process. I have concentrated in particular on the central phase of this cycle when ideas and images emerge into consciousness and I have considered this in relation to the concepts of transitional phenomena and the space of illusion, questioning whether these concepts adequately convey the intensity of the artist's experience at certain moments in the process. I have suggested that, at these moments, the experience may be closer to delusion than illusion. I have also suggested that the artist needs to provide for herself a contained environment within which she can allow herself to enter the state of mind in which boundaries between inner and outer experience dissolve. The question remains as to whether these ideas are relevant for other artists, perhaps working in different media, and for other types of artistic endeavour. The philosopher Susanne Langer asserts that the goal of the artist is to find form for feeling (Langer 1953), but this is not a view shared by all contemporary artists and it is likely that the process differs according to the particular artist's intentions. Comparing the processes of artists working in different media and with different objectives would need another chapter (or, perhaps, several chapters).

To return to the poem that inspired Winnicott, the picture depicted by the poem as a whole is not quite the peaceful scene suggested by the quotation at the beginning of this chapter. If the first lines of Tagore's poem inspired Winnicott's concept of transitional phenomena, perhaps the last lines suggest that to enter the space of illusion is to be in dangerous territory:

> On the seashore of endless worlds children meet. Tempest roams in the pathless sky, ships are wrecked in the trackless water, death is abroad and children play. On the seashore of endless worlds is the great meeting of children (Tagore 1913).

References

Britton, Ronald (1998). 'The other room and poetic space', *Belief and Imagination*, London and New York: Routledge, 120–127.

Ehrenzweig, Anton (1967). *The Hidden Order of Art*, Berkeley, CA: University of California Press.

Freud, Sigmund (1959). 'Creative writers and day-dreaming', *The Standard Edition of the Complete Works of Sigmund Freud Volume IX (1906–1908): Jensen's Gradiva and Other Works*, London: The Hogarth Press and the Institute of Psychoanalysis, 141–154.

Jones, Wendy and Perry, Grayson (2007). *Grayson Perry: Portrait of the Artist as a Young Girl*, London: Vintage.

Langer, Susanne (1953). *Feeling and Form*, London: Routledge and Kegan Paul.

Milner, Marion (1969). *The Hands of the Living God*, London: Hogarth Press.

—— (1971). *On Not Being Able to Paint*, 2nd edn.; London: Heinemann.

—— (1987). 'The framed gap', *The Suppressed Madness of Sane Men*, London and New York: Tavistock Publications, 79–82.

Parsons, Michael (2000). 'Creativity, psychoanalytic and artistic', *The Dove that Returns, The Dove that Vanishes*, London and Philadelphia: Routledge, 146–170.

Tagore, Rabindranath (1913). *The Crescent Moon*, London: Macmillan.

Winnicott, Donald W. (1986). 'The location of cultural experience', *Playing and Reality*, Harmondsworth: Penguin, 112–121.

—— (1986a). 'Transitional objects and transitional phenomena', *Playing and Reality*, 1–30.

15 The Little Madnesses of Museums

Myna Trustram

This chapter describes an initiative at an art gallery that confounds conventional museum[1] practice in that it evokes passionate attachments to seemingly worthless and worn-out objects. It draws attention to the congruence between the physical objects and the inner life, and indeed the inner objects, of the participants in the initiative. Museums gain their cultural status from their apparent adherence to reason, fact and exquisite objects. They can, though, provide opportunities for 'little madnesses' that fly in the face of seemingly rational museum behaviour and practice. Artworks that are imbued with the artist's subjective idiom perhaps more obviously invite that abandonment of 'discrimination between fact and fantasy' identified by Winnicott (1988: 107). But the objects under discussion here are humble craft or manufactured objects, more commonly found in local history museums than in art galleries. It is perhaps worth reflecting on the power of these humble objects to conjure aesthetic attachments; or in Meltzer and Williams's terms, 'to hold the dream' (1988: 178).

There is a risk in making universal statements about 'museums'. The term encompasses on the one hand massive national institutions standing at the heart of capital cities and on the other tiny neighbourhood museums run by volunteers. What they have in common is a commitment to preservation and an aversion to destruction, and it is this on which this chapter dwells. It is about the 'museum in the mind' – the conscious and unconscious mental constructs that a person holds about museums – as well as the museum in reality.

It might well be thought that museums are less likely than the other cultural forms and media discussed in this book to provide that transitional area of experience or opportunities for 'little madnesses'

that enable links to be made between inner and external reality. The museum as a resting place between fact and fantasy runs counter to an everyday sense of it as an authoritative place of knowledge. As a house of objects, sometimes millions of them, surely the museum lives decisively in the realm of fact. However, recent attempts, discussed below, to 'rationalise' museums are testimony to an acknowledgement that irrationality, if not madness, lies within.

The Mary Greg Collection of Handicrafts of Bygone Times consists of nearly 3,000 objects donated by Mary Greg to Manchester Art Gallery in 1922. They are mostly handcrafted nineteenth-century objects: domestic utensils and equipment, keys, spirit measures, scissors, clothing, personal accessories, embroidery, toys, children's books, dolls houses, basketware (Figure 15.1). There is also an archive of nearly 800 letters (1920 to 1949) from Mary Greg to William Batho, the curator who received the collection from her. In comparison with the fine and decorative art collections of the Gallery it is personal, worn,

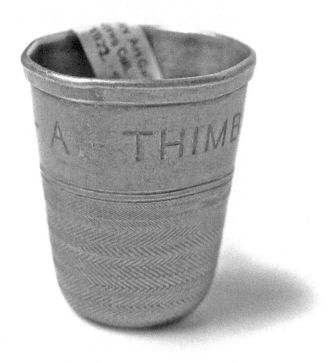

Figure 15.1 Nickel silver spirit measure made to look like a thimble, made in England, 1880s

broken and idiosyncratic. Some objects have been doodled on or inscribed with their owner's name.

Mary Greg's husband, Thomas Greg, was also a collector. He amassed one of the great collections of English pottery, covering a period of 1,000 years. Thomas gave his collection to the Gallery in 1904 but it was not formally donated until his death in 1920, and this was following negotiations with his widow, Mary. It is possible, but by no means confirmed, that Mary's collection was accepted in recognition of the donation of Thomas's collection. Inevitably, comparisons are made between the two collections: the one is seen to be scholarly and focused, the other personal, eclectic and unreliable; but Blakey and Mitchell argue that there was a strong educational and philanthropic motivation behind Mary Greg's collecting (Blakey and Mitchell 2011: 3) and she was concerned to preserve examples of traditional craft skills which were disappearing.

Since the 1940s, the collection has been mainly in storage away from the main Art Gallery and is almost forgotten. It sits uneasily within the Gallery and is barely mentioned in the Gallery's current 74-page collecting policy document. However, a small amount is on display in a gallery devoted to 'craft and design'. Included are a doll's house, a Noah's ark, clay pipes, scissors, thimbles, an abacus, a rushlight holder, a sewing workbox and tobacco stoppers. Along with everything else in this particular gallery, they are displayed as decorative art objects rather than as social history objects: attention is brought to their aesthetic rather than their purpose. Professional debate about the purpose of museums increasingly occurs within the notion of the need to 'rationalise' collections and make museums 'sustainable'. Museums do not have the resources to know about and to care adequately for their collections. As the president of the UK Museums Association wrote in 2005: 'Too many museum collections are underused – not displayed, published, used for research or even understood by the institutions that care for them... What business would allow up to 80 per cent of its assets to go unused, while continuing to consume significant resources?' (Wilkinson 2005: 8). 'Rationalisation' schemes attempt to deal with 'too much stuff' through reviews of the collections and programmes of disposal (NMDC 2003; Museums Association 2007). When considered from a positivist and business perspective much museum activity does appear quite irrational. A psychosocial perspective, however, reveals the underlying psychodynamic purposes that apparently unused and too plentiful 'stuff' can fulfil. The Mary Greg Collection was proposed as a candidate for disposal,

which led to strong protests and an examination of the collection in order to establish its value for the Gallery. As a result it is now the subject of an initiative between staff from the Gallery and lecturers, artists, and students from Manchester Metropolitan University.

The initiative, called 'Mary, Mary Quite Contrary: Investigating the Mary Greg Collection in Store', is like an extensive action review of the collection. As its name suggests, it is a slightly renegade project, which consists of research about Mary Greg herself and the history of the collection, making artwork, display and teaching in response to the collection. Central to the initiative is a blog (www. marymaryquitecontrary.org.uk/), where people record their activities and responses. The contributors to the blog talk as if they are under the collection's spell: 'I keep coming back to Mary's spoons'. There is an urge to get close to Mary Greg through the objects: 'it really felt like she was in that collection'; 'it was as if Mary was there in the room with us!'

In response to the collection the artists and students make artworks, a small number of which are displayed in the Art Gallery alongside the objects that have inspired them. A small box to hold a compass caught the eye of one student who then made a series of very small, fragile containers made from ceramic and textiles. The initiative is quite deferential to Mary and her objects. When artists are commissioned to respond to historic museum collections the artist's work can often gain the higher profile (Blakey and Mitchell 2011: 5).[2] However, the 'Mary, Mary' initiative kept Mary Greg and her objects to the forefront. The participants did not want to upstage the domestic craftiness of the collection through elite artistic interventions. Unwittingly adopting a Winnicottian stance, they wanted to respect it for what it is, for its true self perhaps.

The strongest work – perhaps the strongest 'madness' – has been generated when students were with the collection in the store (not always something that is easy to arrange[3]), and so could feel and smell the objects in a way that was not possible when they had to see them displayed behind glass in the Gallery (Blakey and Mitchell 2011: 5). The participants have both receptive and creative responses to the objects: they receive them into their self and they use them to create their own objects. People describe going into the store as stepping out of time 'into a sense of timelessness, a place of constancy'.[4] All the stuff is 'waiting for you to come and discover it' (16). It is the idiosyncratic aspects of the collection, the broken and missing objects, which appear to underlie the fascination.

When I've taken people to see the collection ninety nine out of a hundred are absolutely fascinated by it. They become so immersed in it at a very intimate level and in a very personal way and every time we go it's a real journey of discovery…and the time slows down and the pace slows down and you open up a cupboard or a drawer and you might find a little egg timer [Figure 15.2]…your heart rate comes down and everything is focused on this little thing that's in your hand.

As Sharon Blakey, one of the artists, says:

I was hooked the minute the first drawer was opened. Spoon upon spoon upon spoon, a seemingly random assortment of shapes and sizes of no particular style or era. No prized or polished silver here, but the tarnished, worn and broken. A spoon box containing the wrong spoon, handles showing family initials but with no sense of belonging, a tablespoon used so many times that one side of the bowl is almost worn flat.[5]

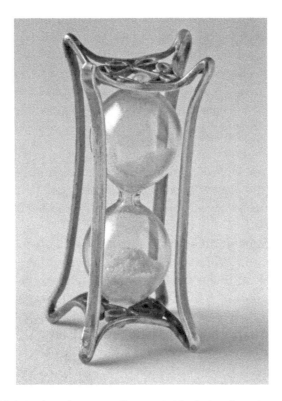

Figure 15.2 Miniature hourglass or egg timer, probably nineteenth century

Some participants make strong personal associations with a family member:

> I was immediately fixated by the sets of spillikins…this idea of inviting playfulness but projecting fragility…every piece in the collection is a depiction of my most fond memories, made using the techniques taught to me by my mother and grandmother.[6]

One participant said Mary Greg had 'a passion for the individual examples of humanity' (2). She was interested in the story of each individual object, even if this was not known, rather than in its place within a larger narrative. It is this that the participants respond to. The Gallery's procedures (listing, cataloguing, storage, conservation, display, lending to other museums and so on) have only been enacted on the collection to a minimal degree. Partly because of this, the collection has stayed closely aligned with Mary Greg herself, so that the passionate attachments are made to both the objects and to Mary. As the same participant put it:

> It's to do with the passing of time and a sense of your point on a continuum…about traces and echoes. And if somebody leaves traces and echoes that you can have a momentary connection with, then maybe *you* leave traces and echoes as well, that somebody will connect with. So maybe it's something to do with continuity and your place in the vastness of things. A tiny, tiny, tiny insignificant place, but a place nonetheless…there is a momentary point of stability around which everything else careers, kind of wantonly (18).

They are only momentary encounters because otherwise they would be too 'big': 'You occasionally just get a little glimpse of something that is like a little electric shock of something real' (19). And, 'it's not fragile, it's actually very strong, but it's easily trodden on or hidden or squashed' (20).

The participants in the initiative have found a 'passionate congruence' (Meltzer and Williams 1988: 181) between their inner life and the external object. To use the language of Meltzer and Williams, they are aesthetic critics of the collection rather than academic art historical critics: '…rather than standing guard over the external qualities of the object as a [literally] museum piece' (1988: 182) they speak to the congruence between the external form of the objects and the forms in their inner world. They bring an intense sensory awareness of the objects' materiality. (Bear in mind that the participants are academics, curators and students and therefore equally at home with a cognitive

approach.) This sensitivity to the physical being of the objects rallies them into an alliance with internal objects whereby inner world fantasies and desires are bestowed on the external object and they become symbolic representations of the internal object such as the grandmother. This process could be called the restoration of objects in inner lives. One participant talked about connecting Mary Greg closely with her grandmother who had recently died. The combination of the death of her grandmother and the subsequent dispersal of her possessions with 'finding' Mary Greg and her objects enabled her to revive inner resources. Painful feelings can be more easily borne if they are carried in a narrative because the narrative gives them meaning. The objects in the store, and Mary Greg herself, evoke associations of loss and forgetting. But these feelings are contained (literally and in the psychodynamic sense) within the store, locked up; and one can choose to take the key and enter or not.

Let us pause a minute and play with the word 'restore'. The museum re-stores objects (say, the Noah's Ark animals moved from a toy box into the museum store) and restores them (as in conserves, brings back to how they once were). Similarly, playing with the Mary Greg Collection enables the inner object (say the grandmother) to be re-stored (stored again internally) and to be restored, revived internally. As a result both inner and external objects are restored or given a new vitality.

The 'Mary, Mary' initiative is representative of recent developments within museum practice that recognise the contribution museums can make to experiential learning. However, it is out of kilter with traditional museum activity, or at least with the 'museum in the mind', in that it is essentially about playing rather than knowing or creating knowledge. Jane Flax argues that Winnicott's notion of transitional space 'decenters reason and logic in favour of "playing with" and "making use of" as the qualities most characteristic of human *being*' (quoted in Aitken and Herman 1997: 72). This is important to this account of museum activity, because museums are constructs of the seventeenth- and eighteenth-centuries Enlightenment which elevated reason and logic. The initiative moved away from the privileging of expert knowledge, which museums do so well, to an implicit recognition of internal processes. And since playing is not conclusive, the initiative is struggling with how to end. Staff at the gallery are bemused at the response of either themselves or others to the collection. The model of the human subject developed during the Enlightenment emphasised rationality, autonomy, and the quest for knowledge (Hoggett 2008:

65). Those who were deemed 'mad' were, a bit like museum objects, removed from society and placed in an asylum. In contrast to the Enlightenment model of the subject, the museum subject that emerges from the 'Mary, Mary Quite Contrary' initiative is passionate, subjective and relational.

The museum can be seen as an institutional counterpart of this model of the human subject. It is the responsible, rational father of society which foresightedly stows away treasures for the future. It instructs citizens and promises continuity of existence – that losses can be overcome – because all the things in the stores will be kept in perpetuity, and besides some of it is already millions of years old. Good practice within collection management in museums today has developed from this model. It requires collections to be fully catalogued, stored in perfect conditions and only used within stringent parameters. It is no secret that most museums fail to meet these exacting standards for all of their collections (Resource 2001). The Mary Greg Collection is a challenge to this concept of the museum: the irrational and the emotional have seeped through its walls.

The presence of the Mary Greg Collection in Manchester Art Gallery is contested in part because it cannot be classified as fine art or decorative art. These are not unique items, a quality which distinguishes objects in an art gallery from many objects in a historical or natural science museum. They cannot therefore be named and catalogued in quite the same way as, say, the spoons in the Gallery's silver collection. But maybe this is a reason why it was accepted in the first place and why it has survived in a somewhat unwelcoming environment. The purity of a form can be obfuscated by too much knowledge about it. To use a term of Christopher Bollas's, maybe its attraction lies in its 'nameless forms' (Bollas 2009: 58). He suggests that for some of us on some occasions it is the form of objects which moves us rather than our knowledge of them.

> We choose…to live in the visual, not the verbal, order. We choose, therefore, to live part of our life in the maternal order…rather than in the paternal order, which names objects and possesses them in language. And part of our wandering in this visual world – that shall go nameless – is to meander, then, in the preverbal world: one organised around sights, sounds, smells and affinities. This is a world of ours that has in many respects gone by. One's life within one's mother and then alongside her, before one knows about obligations and speech, fades and fades with age (Bollas 2009: 60).

The Mary Greg objects are simply spoons or scissors; and in their simplicity they are open to evocative, rather than museological, interpretation. The blog records a dialogue about the form of the objects, not their history or production. But 'nameless forms' sit uneasily within a museum because the work of a museum is to name objects. Perhaps the presence in the Gallery of the Mary Greg Collection is a defiance of the 'museumisation' of objects. The power of the collection lies somewhere in the unconscious associations it provokes which link to a preverbal existence where the form of objects was critical and there was no language to name them.

The idea of 'not knowing' is antithetical to a museum. Central to the 'Mary, Mary' initiative is something about not knowing the collection in the conventional curatorial way. One participant said 'there is something intangible about my relationship with this set of objects that I can't quite put my finger on and don't know if I want to put my finger on' (6). And there was, until recently, a 'not knowing', or at least a forgetting, of its very existence when it was locked away in stores. David Armstrong writes that the naming of an object can restrict enquiry: 'A limit is set; the unknown is robbed of its power to disturb'; and he goes on to say that 'the revenge of the unknown is that one can be left feeling curiously empty' (Armstrong 2005: 13). The Mary Greg objects have not been limited by a museum classificatory name. Perhaps, then, they have a particular (but by no means unique) capacity to lead us to a place of uncertainty where we can play with the preverbal forms of infanthood while also, as adults, bringing language into play.

So the museum's commitment to interpretation – to explaining and giving information – is confounded by the Mary Greg Collection. Playing with the collection rather than imposing museum procedures such as cataloguing and display facilitates this attachment. The participants play with the collection in imaginative (re)collections of personal pasts. Strikingly, museums and analysts share this word: interpretation. According to Adam Phillips, Winnicott was ambivalent about the value of interpretation, since playing as opposed to knowing is the aim of analysis (Phillips 1988: 143). Interpretation in the form of captions, displays, exhibitions, publications, tours and so on is the museum's way of assisting visitors to find meaning (whether it is deep personal meaning or the social meaning of shared public history) in the collections. Whilst it would be tempting to experiment with approaching objects 'without memory or desire' (Bion 1961) – that is, to rid one's mind of previous knowledge and see what emerges – the

political and moral imperative currently is to assist visitors through a didactic approach.

The original plans for the initiative included an exhibition as a rounding-off event. Participants are concerned, though, that an exhibition of the collection will fall far short of their pleasurable anticipation and discovery of what is 'in store', that people will leave 'feeling curiously empty' (Armstrong 2005: 13). Once on display, the objects can no longer be 'discovered' by unlocking the store door and opening drawers and cupboards. As one person said, when one encounters the collection in a store:

> It's not been organised and determined and presented and narrated, it's just a mass of stuff. Narratives and encounters will only happen if you make something in you connect because there's no one telling you anything about them, they're just there (6).

The other museum procedure that the initiative confounds besides interpretation and display, is conservation of objects. Or perhaps in this case conservation confounds the initiative. Museums fix objects, they arrest their change, with the aim of keeping them in perpetuity. We know that objects change in the course of their lives and so their cultural meanings change (DeSilvey 2006: 324). Museums try to preserve a small number of objects in their original form, or at least in the form in which they arrive at the museum. Much has changed in museum practice – modes of interpretation and display, governance, sense of obligation to the public – but their underlying rationale to maintain objects just as they are remains constant.

A museum's commitment to preservation and stasis can confound attempts to use objects for inner purposes. So people were dismayed when conservators replaced the head on a zebra in a set of Noah's Ark animals (Figure 15.3), 'at once removing all trace of the narrative we originally cherished' (Blakey and Mitchell 2011: 7). Ironically, the very aspects of the objects which, from a museum's perspective, reduce their value (worn out, broken, doodled, inscribed on) are what the initiative's participants respond to. Evidence of an object's use, such as a tarnished, worn-away spoon (Figure 15.4), points not only to a process of erasure (DeSilvey 2006: 323), but also to a generative process, a process that can produce intense personal identifications and inner restorations. The worn-away spoons are worn-away spoons; but they are also symbolic of Grandma's worn-away spoons. DeSilvey suggests that 'An approach that understands the artefact as a process, rather than a stable entity with a durable physical form, is perhaps

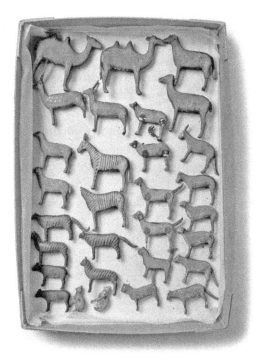

Figure 15.3 Noah's Ark animals, made in England c.1850–1900. Note that one of the zebras is headless

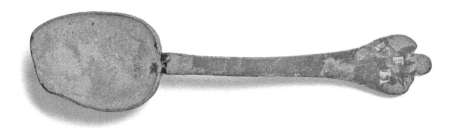

Figure 15.4 Pewter spoon, made in England, c.1680s

able to address some of the more ambiguous aspects of material presence (and disappearance)' (2006: 324).

Evidence of an object's use is evidence of its survival despite its actual use or misuse and attempts in fantasy to destroy it. Conveniently for us, Winnicott uses an example of someone who slashes an Old Master in an art gallery to describe the difference between pathological destruction and healthy destruction (Abram 1996: 35). The slasher is not motivated by a love of the painting, whereas the art-lover who applauds the preservation of the painting in the gallery but who in unconscious fantasy destroys it over and over again is healthily testing out the capacity of the painting, as perhaps a symbolic representation of the mother, to withstand his or her aggression. The zebra has lost its head but can still be played with. The broken zebra is loved in part because it has survived destruction, suggesting that destructive emotions can be expressed without loss of the inner or external object.

The museum's commitment to preservation means that the possibility of destruction is avoided. The museum *in the mind* (in reality museums are full of broken objects such as archaeological shards) is the one place where objects are safe from human destructiveness. The museum in the mind's apprehension of destruction – it both fears it and stops it – is perhaps what renders objects into those much maligned 'museum pieces', or rather 'museum-pieces-in-the-mind': objects which are not readily available for inner use. A typical example of this 'museum-piece-in-the-mind' occurs in a novel by Peter Carey, which describes a story regularly repeated about a character having gained 'a dull protective varnish like a ceramic captive in a museum which has been inquired of too often by the overly familiar' (Carey 2010: 8). The suggestion is that 'museum pieces' are too well protected and too well known to be available for discovery and destruction in fantasy.

Museums are a foil to nations' appalling history of destruction; they are the nation's redemption. Art galleries in particular are full of 'idealised good objects' (Meltzer and Williams 1988: 3). 'The malign and the random' (Meltzer and Williams 1988: 3) are equally necessary for a creative engagement with life and might be represented within the artworks hanging on the walls; but the institution itself represents the good. One might wonder then whether the museum *as an institution* can be available as a transitional space when it is frozen in its apprehension of destruction and its objects are omnipotently controlled? Whereas individual objects, whether they have escaped the commitment to preservation or not, *are* available as transitional *objects*.

Therefore, parallels can be drawn between museum objects and Winnicott's description of transitional objects. Museum objects live in that strange museum institution which is neither fantasy nor reality. The museum exists, it is real; and yet its inhabitants, the objects, have left behind their 'real' life and now live in the encompassing museum. Any object, in a museum or otherwise, can be found and used as a transitional object by a child or an adult, and conscious and unconscious fantasies can be aroused and played with. The Mary Greg objects, though, particularly lend themselves to be imagined as transitional objects: it is not quite clear if the gallery is their final resting place – should they be disposed of or retained? One description of the Mary Greg objects evokes comfort blankets: 'humble, forlorn, non-decorative, worn-out things which have been superseded by much more luxurious, better preserved, high end examples of their type' (12). Transitional objects are *used,* not 'revered, copied or complied with' (Phillips 1988: 143). The attraction of the objects in the Mary Greg collection for the participants in the initiative is the imprint on them of their use. In contrast, other museum objects tend to be idealised as perfect examples of their type and indeed are revered and copied. Above all it is perhaps because they have been 'found' in the store that the Mary Greg objects are available for psychic use.

The museum can perhaps be imagined as Goffman's (1961: 11) 'total institution', but for objects rather than for people. Or to be more specific it is like a benign asylum (Khanna 2006), a place of (mental and political) hospitality for both psychic and physical objects; a place where displacement (or, in museum terms, disposability) is not entertained. And yet displacement *is* in fact entertained by the museum as it is by nations and by mental asylums. Ambivalence and ambiguity are paramount. Fearful that the new economic and political order would destroy pre-industrial crafts, Mary Greg sought refuge for objects in the Gallery. In their turn, the 'little madnesses' evoked by the objects are contained within the hospitable museum and worked through.

Winnicott wrote: 'Feeling real is more than existing; it is finding a way to exist as oneself, and to relate to objects as oneself, and to have a self into which to retreat for relaxation' (Winnicott 1971: 138). These words have their own quite specific meaning within the Winnicottian framework of human development; but they also lend themselves to wider use, as this book shows. The Mary Greg initiative has enabled people to 'relate to objects as oneself'. The museum store is the 'holding environment' (Abram 1996: 193) for encounters with lost or denied inner objects. For the most part, museums meet human needs

for authority and containment. The Mary Greg initiative, though, shows how museums can meet needs for attachment and holding. Objects which, in museum terms at least, do not appear to have much intrinsic interest were used to elicit experiences which restored objects in inner lives.

I would like to thank Sharon Blakey, Hannah Chalk and Liz Mitchell for their help with the research for this chapter.

Notes

1 I am following the UK convention of including art galleries within the term museum. (The convention within North America is to use 'art museum' for an art gallery.)
2 For an example of this see Endt (2007).
3 Museum 'reserve' collections are often stored in a separate location which can make access difficult, and visitors have to be accompanied. It is worth speculating about the psychic meaning of most objects in a collection being inaccessible to most people, despite their public ownership. Like the unconscious, museum stores are present but not easily accessible.
4 'Mary Mary Quite Contrary', Interview 1, 30 March 2011, Transcript, page 13. Page numbers of all subsequent quotations from this interview are given in the text in parentheses.
5 http://www.marymaryquitecontrary.org.uk/artist-responses (accessed 10 December 2011).
6 Carly McDermott, caption in Object Memories case, Gallery of Craft and Design, Manchester Art Gallery, November 2010.

References

Abram, Jan (1996). *The Language of Winnicott*, London: Karnac.
Aitken, Stuart C. and Thomas Herman (1997). 'Gender, power and crib geography: transitional spaces and potential places', *Gender, Place and Culture* 4(1): 63–88.
Armstrong, David (2005). *Organisation in the Mind*, London: Karnac.
Bion, Wilfred R. (1961). *Experiences in Groups*, London: Tavistock Publications.
Blakey, Sharon and Mitchell, Liz (2011). 'A question of value: re-thinking the Mary Greg Collection', unpublished paper delivered at the International Conference 'Pairings: Conversations, Collaborations, Materials', Manchester Metropolitan University, May 2011.
Bollas, Christopher (2009). *The Evocative Object World*, London: Routledge.
Carey, Peter (2010). *Parrot and Olivier in America*, London: Faber and Faber.
DeSilvey, Caitlin (2006). 'Observed decay: telling stories with mutable things', *Journal of Material Culture* 11: 318–338.

Endt, Marion (2007). 'Beyond institutional critique: Mark Dion's surrealist Wunderkammer at the Manchester Museum', *Museum and Society* 5(1): 1–15.

Goffman, Erving (1961). *Asylums*, London: Penguin.

Hoggett, Paul (2008). 'Relational thinking and welfare practice', in Simon Clarke, Herbert Hahn and Paul Hoggett, *Object Relations and Social Relations*, London: Karnac, 65–86.

Khanna, Ranjana (2006). 'Asylum', *Texas International Law Journal* 41: 471–490.

Meltzer, Donald and Williams, Meg Harris (1988). *The Apprehension of Beauty*, Strath Tay: The Clunie Press.

Museums Association (2007). *Making Collections Effective*, London: Museums Association.

NMDC (2003). *Too Much Stuff? Disposal from Museums*, London: National Museum Directors Conference.

Phillips, Adam (1988). *Winnicott*, London: Penguin.

Resource (2001). *Renaissance in the Regions: a New Vision for England's Museums*, London: Resource, the Council for Museums, Archives and Libraries.

Wilkinson, Helen (2005). *Collections for the Future*, London: Museums Association.

Winnicott, D.W. (1971). *Playing and Reality*, London: Penguin.

———— (1988). *Human Nature*, London: Free Association Books.

16 Found Objects and Mirroring Forms

Kenneth Wright

In this chapter I examine artistic creation from the viewpoint of psychoanalysis. My approach is relational and I lean heavily on the work of Donald Winnicott (1953, 1958, 1967, 1971) and Daniel Stern (1985). In particular I make use of their respective concepts of *mirroring* and *attunement* and elaborate on Winnicott's model of *transitional phenomena* by linking it with the work of the American philosopher Susanne Langer on symbolism and the nature of the art object (Langer 1942, 1953, 1988). Finally, I touch on the concepts of *holding* and *containment* which I use in a way that retains their commonsense meaning. These terms can be linked with *mirroring* and *attunement* through the bridging concept of *form*. For something to be contained or held there has to be a container, and in the argument I develop it emerges that the best container for living experience is resonant form.[1]

I begin with something the sculptor Henry Moore said in an interview in 1964:

> [The] sculptor is a person who is interested in the shape of things....
> A poet is interested in words, a musician... in... sounds, but a sculptor
> is... obsessed with... the form and shape of things... the shape of
> anything and everything: the growth in a flower; the hard tense strength,
> although delicate form of a bone; the strong solid fleshiness of a beech
> tree trunk (James 1966: 58).

This statement suggests that the sculptor's conception of 'shape' was selective and broad: selective because he preferred natural forms that bore the imprint of life, and broad because of the wide range of objects that caught his interest:

> Everything, every shape, every bit of natural form, animals, people, pebbles, shells, anything you like [anything that catches his attention in a particular way] are all things that can help you to make a sculpture. And for me, I collect odd bits of driftwood – anything I find that has a shape that interests me – and keep it around in that little studio, so that if any day I go in there, …within five or ten minutes of being in that little room, there can be something that I can pick up or look at, that would give me a start for a new idea. This is why I like leaving all these odds and ends around in a small studio – to start one off with an idea (James 1966: 60).

Moore spoke in down-to-earth Yorkshire tones, and you have to read between the lines to appreciate fully what he is saying. Thus when he speaks of 'shape', he is clearly referring to the sensual and tactile qualities of an object as well as its visual form; and when he speaks of an object that 'interests him', he surely has in mind a more significant experience than simple stimulation of his sensory imagination. In other words, the objects he describes are emotionally significant: they are *found objects* in the aesthetic sense, and his 'little studio' is a *templum* – a *contemplative space* – that is set apart from ordinary life and perhaps also from his workshop with its pressing practical needs of actual production. We could say that each of these found objects embodies a significant moment: it 'caught his eye' and continues to 'speak' to him in a way that enables him to commune with something in himself that would otherwise be inaccessible. Each object gives him a 'glimpse' of something elusive in his own experience – a semblance perhaps of its living 'shape' and 'form'. And we could, I think, surmise that only through such physical incarnations is he able to apprehend such elements, and only through the repetition of such experiences will he come to know and appropriate them in a way that he can use in his creative work.

Many years earlier (1941), in a discussion with the art critic, Kenneth Clark, Clark had made the point that

> …every artist has inside him a few controlling rhythms… *and those control-ling rhythms are really him,* and it's to those he has to make his vision of the external world conform, if he is to make it truly expressive. I would say that even the greatest artists have quite few forms, or rhythms, or chords of colour, whichever it may be, which they feel to be completely expres-sive (James 1966: 80, emphasis added).

And Moore had agreed with this, saying that every artist 'has a sort of individual form vision', the seeds of which have been present 'even

in their early work, and to some extent their work has been a gradual unfolding of this rhythm throughout. …It's something the artist can't control – *it's his make-up* (James 1966: 80, emphasis added).

It is tempting to conclude that these 'forms' and 'controlling rhythms' that in some sense define the artist are closely related to the felt experiential 'shapes' which he glimpses 'out there' in his found objects and then embodies and recreates in his work. This was in fact the view of Langer, who defined art as 'the creation of forms symbolic of human feeling' (Langer 1953: 40). For Langer, an art object 'exhibits the morphology of feeling' (Langer 1988: 44): the artist's, and by extension, our own. This way of thinking gains support from the way Moore speaks about his work. Thus he writes:

> …I would like to feel that my sculpture has… a force,… a strength,… a vitality from inside it, so that you have a sense that the form is pressing from inside trying to burst [out] or trying to give off the strength from inside itself, rather than having something which is just shaped from outside and stopped. *It's as though you have something trying to make itself come to a shape from inside itself* (James 1966: 60, emphasis added).

From this point of view, a successful work of art is one that transforms the relatively inert material of the artist's medium into something 'alive' that now contains, or expresses, an inner form. It creates an illusion of dynamic *inner* life by embodying (re-presenting) in *external* form the essential 'shapes' (or 'controlling rhythms') of the *artist's* feelings. Moore attempts to describe this state of affairs when he speaks of 'something trying to come to a shape from inside itself' rather than being 'shaped from the outside and stopped'. In the latter case, the created object would simply mimic the shape of something external while in the former it would incorporate within its constitution the 'shape' of an inner rhythm.

* * *

I now want to turn to Winnicott's work on transitional phenomena (Winnicott 1953) in order to highlight certain formal similarities between such structures and the kind of *aesthetic* objects I have discussed in relation to Henry Moore. Winnicott never explicitly constructed a psychoanalytic theory of *artistic* creativity, though arguably he gave us some excellent tools for doing so and was himself a kind of artist. In his work and writing he was more interested in what he called the creativity of everyday life – with explaining the difference

between a meaningful and satisfying life and one that was meaning-
less and lacking in interest. From this perspective, the most important
question was not the creation of a work of art but the quality of a
person's experience; and in this context he attempted to describe the
structure of a meaningful object – the particular relation between inner
and outer in its constitution. It was clear that a meaningful life did not
simply develop through the unfolding of inner dynamisms, and he
argued that its full realisation crucially depended on early experience
in the mother-infant relationship, especially in the preverbal period.
This basic idea informs the whole of his work and emerges through a
range of different concepts: *primary creativity*, the *adaptive mother*, the
baby's *transitional object, mirroring, the capacity for play and imagination*,
and finally, the *capacity to participate in cultural experience and the art*s.

Weaving through these different areas is a single question that could
be put as follows: 'By what process does an external object – an external,
physical object – become endowed with subjective or inner signific-
ance?' From a formal perspective, this is similar to the question that
concerned Henry Moore and exercises every artist in a practical way –
namely, how a block of stone, or other inert and lifeless material, can be
transformed into something that seems to pulsate with a life of its own
('pressing from inside, trying to burst [out]... from inside itself').

Commencing with his now famous 1953 paper, Winnicott approached
this question – the question of life and art – through his model of the
transitional object (Winnicott 1953). For in this context, it seemed to
him that the baby is 'doing' something that prefigures what a healthy
person does in ordinary life (and, we could say, that an artist does in
creating his aesthetic object). Namely, he imbues an object or activity
that has no intrinsic meaning – it simply exists – with a charge of
personal significance: in other words, it now 'speaks' to him in a mean-
ingful and personal way. To bring about such a transformation the baby
does not, like the sculptor, have to *change* the object physically, but only
to *perceive it in a new way*. In other words, the ordinary object (the bit
of blanket) becomes a 'found object' for the baby simply by an act of
creative seeing. In this simple yet important way it becomes emotion-
ally charged and a bearer of personal significance. Such *re-visioning* of
the object is a genuinely creative act. It does not matter that the external
object remains the same: creative *perception* precedes creative *activity*.

To account for such transformational moments,[2] Winnicott goes
back to an earlier phase of *primary creativity* in which the *adaptive
mother* plays a crucial role. Closely identifying with her baby from her
position of *primary maternal preoccupation*, she intuitively anticipates

the baby's *imagining* of the breast and gives her *actual* breast in a way that conforms to this infant expectation. According to this argument, it is the *co-incidence* of infant imagination and maternally adapted reality that allows the baby to find the object he has been searching for. The mother's breast, in this sequence, becomes the first 'found object'; and when discovered in this way it provides the first experience of creativity. First imagination and searching, then discovery and realisation: *'This is what I was searching for! Look! I have created it for myself!'* Having established this position, Winnicott links the earlier scenario with the infant's 'creation' of the *transitional object,* arguing that it must be *because* the mother made the first creative experience with an object possible that the baby is able to approach other objects with the expectation of 'creating' (subjectively transforming) them.

In the next stage of his argument – an argument that has to be made explicit – Winnicott imagines a situation in which the mother's breast (her bodily warmth and closeness) is *not* there when the baby wants it: the baby looks for it but *cannot* find it. With *searching* gestures he mouths and grasps the objects within his reach, and perhaps at some moment catches hold of the soft bit of blanket. '*Eureka*!' says the baby, 'I have *found* it, the object I was looking for!'

Winnicott called such a 'found' object a *subjective object* because it constitutes a point of conjunction, or interpenetration (Balint's 'harmonious mix-up', Balint 1959), of subjective and objective. (Note the similarity to Langer's formulations of the art object: 'Art is the objectification of feeling, and the subjectification of nature', Langer 1988: 40.) The new, 'transitional' object – the object creatively (subjectively) perceived – is no longer just a physical object, but one that is saturated with personal significance and just beginning the journey towards the symbolic. The term 'transitional' attempts to capture the in-between status of the new object. It lies *between* the purely physical and the mental which has yet to come; it *contains* significance and meaning but does not yet *represent* them in a fully symbolic way (see Langer's definition of presentational symbols below). Such objects have the function of reviving or recreating experience in all its vividness, but not yet of representing it *in absentia*. Experientially the new object occupies a different 'space' from ordinary objects: Winnicott calls this *potential* space. This is not yet a mental 'space' because the mind as internal *symbolic* space does not yet exist; yet it constitutes a domain of objects in the external world that is set apart from the purely physical arena.

To recapitulate, this new domain that transcends the physical but precedes the mind is populated by subjectively transformed objects

with a new capability: that of evoking and conjuring up experience in specific and vivid ways. Winnicott calls it the realm of *illusion*, which in other terms is a realm of vivid *presences*, evoked by presentational symbols that 'contain [their] sense as a being contains its life' (Langer 1988: 28). They create an illusion of presence because they reproduce in their structure (form) experiential patterns of the absent object. Langer (1942) calls such evocative objects *presentational symbols* because they portray, or directly *present*, the experiential entity to which they refer. Although still rooted in the physical domain their essence is iconic, and they recreate experience by *recasting* it (Stern 1985) – see my account of maternal attunement below – and displaying its form within their structure. Like the transitional object, presentational symbols *reverberate* with remembered experience and through their iconic patterns are able to *resurrect* it.

The 'magic' of such symbols – the 'secret' of how they work – lies in their analogical form. For the baby, the bit of blanket *evokes*, or *re-presents* a remembered experience of the mother's body – her warmth and softness – by reduplicating its sensory pattern within its structure, thus providing an image within which to 'hold' the experience. The presentational or 'holding' structure is an analogue of the original experiential structure. Langer writes:

> What makes a work important is not the category of its expressed feeling, which may be obvious or, on the contrary, impossible to name, but *the articulation of the experiential form*. In actual felt activity the form is elusive, for it collapses into a condensed and foreshortened memory almost as fast as the experience passes; *to hold and contemplate it requires an image in which it can be held for contemplation* (Langer 1988: 29, emphasis added).

Similarly, for the artist (and the audience) a work of art *evokes*, or *re-presents* an experience because the artist has found a way of grasping its form, and a means of recreating and embodying this form within his or her artefact. In this sense, the art object can be seen as a repository of experience, a complex form within which human experience can be contained and revived – or in Wordsworth's terms, 'recollected in tranquillity'. In Moore's language, we could say that while an object that is 'shaped from the outside and then stopped' is simply a depiction of an object in the real world with a certain likeness to the original, an object that 'come[s] to a shape from inside itself' transcends the realm of physical objects by rendering the form and pattern of lived experience within its structure. An object of this kind – whether 'found', 'transitional' or 'aesthetic' – becomes in this way an object that is almost

alive. It creates this *illusion* of life because it 'speaks' to us: it has an almost human capacity to engage with (and mirror, recognise, resonate with) corresponding areas of feeling and experience in the person who engages with it. Endowed with life by its creator, it now has the capacity to enhance and strengthen our own life.

* * *

Many years after his work on transitional objects, Winnicott wrote his seminal paper on the mother's face as the child's first emotional mirror (Winnicott 1967), thereby introducing the concept of maternal mirroring. To me, this paper was groundbreaking in two ways: firstly, it moved the formative transactions between mother and infant more directly into the social sphere of communication; and secondly, it argued that fundamental aspects of emotional development in the realm of self-feeling and experience depended on the adequacy of these *social* (or interpersonal) transactions: I refer to the idea that the mirroring response is foundational for the sense of self, the experience of being an 'I' who is feeling and experiencing in a particular way. In both these respects, the paper continued the themes of his earlier work – the importance of maternal identification and adaptive response, the timing of these, and their fundamental effects on the baby's emotional development – but it lifted them into a different arena, a field in which separation from the mother was more sustained and in which communicative *visual* signals could play a richer part.

From this point of view, maternal mirroring can be seen as a special form of nonverbal communication (and a special form of maternal adaptation), in which the mother visually and iconically gives back (or 'presents') to the infant the 'shape' (or 'semblance') of his current feeling state.[3] Her smile, for example – the way her face lights up in response to the infant's pleasure – becomes for the infant the visual, external form of his own happy feeling-state. On the other hand, her sad expression and perhaps her sad tone of voice reveal to the baby an external view of his own unhappy state.

From a formal and structural point of view, these are important contributions to a theory of infant development, in particular the development of the self. In reality, however, the scope of mirroring as defined by Winnicott is quite limited. Its feedback is confined to a small range of maternal expressions, and it is only when we consider the work of Daniel Stern on *maternal attunement* (Stern 1985) that we fully appreciate the *limitations* of the face as a reflective medium.

Stern's concept, based on mother-infant observation, broadens out the concept of mirroring in every way. It extends the process into the later preverbal period when separation-individuation is more advanced, and it greatly extends the range of modalities in which the maternal feedback takes place. It is no longer confined to facial expressions, but recruits gestures and different tones of voice, rhythmic vocalisations, rhythmic body movements, and varied combinations of all of these. Finally, it extends the time-span available for feedback, allowing it to take the form of mini-enactments – the presentation of little dramas through time – each with its own dynamic and unique configuration. Unlike the fleeting time-span of a smile, for example, an attuned enactment can last for many seconds.

Stern describes how the mother 'tracks' the infant's emotional state over time and spontaneously and, almost unconsciously, plays it back to him ('recasts' it) through a series of relatively complex displays. Moreover, in attunement the infant states reflected by the mother are no longer discrete emotions as in mirroring (moments of joy or anxiety, for example), but more extended and complex *patterns* of infant experience which Stern calls *vitality affects*. We can think of a vitality affect as the emotional contour of any ongoing experience – the waxing and waning of tension and interest, frustration and satisfaction – something like the background 'tone' of ordinary activity. In her enactment, it is as though the mother is saying to her baby: Look! This is what it was *like* – 'the feeling of what happens' (Damasio 2000) – when you were doing what you were just doing! This was the *shape* or *pattern* of your experience as I experienced it![4]

The importance of this kind of enactment lies in its potential effects. The mirroring hypothesis suggests that maternal expressions 'hold' or 'contain' a corresponding infant experience, and by giving it external form enable it to be *real-ised* (experienced, or more accurately re-experienced) in a new way by the infant. A similar argument applies to attunement, but more cogently because the forms provided by the mother are patterned over time and thus catch the 'feel' and vital rhythm of infant experience as it unfolds. They thus offer the infant a more specific form of self-realisation than mirroring, fostering perhaps a background awareness of self as agent and *locus* of patterned experience. In saying this, I am making the assumption that the earliest processes of self-realisation *require* an embodying reflection that comes from the outside, and that this is normally provided by the mother.

* * *

To close this chapter, I want to draw out some implications of these ideas and show how they might contribute to an understanding of the art object and aesthetic experience. Within the perspective I have sketched, the *possibility* of aesthetic experience depends on two main conditions: firstly, the uncoupling of life and experience from the demands of action (this point is forcefully argued by Langer 1942, 1953); and secondly, the availability of perceptual forms within which the 'feel' of lived experience can be captured and held.

The first condition establishes a *domain of contemplation or reflection* (transitional space), in which the *qualities* of objects – their shapes, textures and patterns – can be more fully experienced because they are now divorced from practical concerns. Such a domain excludes the world of *ordinary* action and practical concerns, and establishes a place in which 'presences' can be conjured up and felt (though this might include forms of *symbolic action* such as play or creative modification of a medium as in the making of an art work). Moore's studio, his 'little room', is an example, but so is the analytic consulting room (at least sometimes), the theatre, the art gallery and of course the picture space, the concert hall, the church, the graveyard, and so on.[5] The study in which one writes is another example, or the painter's studio, but in each case, the physical situation and location are important because they create the conditions within which an aesthetic state of mind becomes possible. For some people, the right conditions can be achieved in commonplace circumstances like a country walk (Wordsworth walking in the Lake District, for example). I am thinking of moments when a landscape can suddenly appear in pristine freshness as plenitude of form and we feel 'at one' with it. 'What a lovely view!' we might say, for want of better words; but what we don't, and probably can't describe is the fact that in that moment (a moment out of ordinary time) the landscape has touched us differently, revealing itself as a complex organisation of forms and colours, creating a sense of 'something far more deeply inter-fused' (Wordsworth) and a sense of ourselves as somehow more alive and 'fulfilled'. The poet Francis Thompson beautifully described such momentary 'subjectification' of the landscape: 'The angels keep their ancient places;/ Turn but a stone, and start a wing;/ 'Tis ye, 'tis your estranged faces [too much caught up in ordinary doing] / That miss the many-splendoured thing' (*The Hound of Heaven*).

The second condition, by capturing the essence of an experience, provides an antidote to its natural tendency to fade and disappear: see my note above on the in-between quality of the new, 'transitional' object – the object creatively (subjectively) perceived.

However, the *realisation* of aesthetic experience depends on a further important factor, namely the *quality of the image* that enables it to engage with the subject's own patterns of feeling. (I am speaking here of aesthetic experience in a general sense that would include minor and momentary instances of aesthetic feeling. This does not attempt to describe our more complex experience of works of art in which many smaller elements have been integrated into larger wholes through the artist's skill.) I refer to the formal qualities of the image: the way it replicates, or reproduces analogically, the felt patterns of subjective experience. In order to be aesthetic, an image must offer a *semblance* of such patterns, a morphological similarity that reflects, echoes and recasts them within the new medium.

The relevance of Winnicott and Stern to this understanding of the aesthetic should now be clear, for *mirroring* establishes[6] a space that is uncoupled from action and devoted to preverbal expressiveness, while *attunement* develops this space in what can only be called an aesthetic direction. I mean by this that the forms provided by the mother in attunement have many of the qualities of aesthetic images. They offer semblances of infant feeling states (as intuited by the mother), and in their patterns and rhythms give back to the infant an objective vision or revelation (an objective phase) of them.

By operating in this way, the mother functions as a *medium* for the infant through which a kind of self-realisation can begin to occur. Within the resonant and holding forms which she creates, the infant can begin to perceive and contemplate his own subjective rhythms and thus appropriate a sense of his own being. From the beginning the adaptive mother has been a malleable and plastic medium in which the infant (with very little effort) could concretely realise his subjective strivings: for example, in her provision of the imagined breast. In mirroring and attunement the process becomes attenuated as the answering patterns acquire a less substantial and more nearly symbolic quality.

When we come to artistic creativity, we find that the artist too depends on his chosen medium. In the beginning, in the first glim-mering of an intuition, the medium may be, as it was for Moore, the natural world: the 'found objects' or the images of landscape in which the artist discovers the first echo of his 'idea'. In this case the *world* provides the resonant forms in a way that looks back to the adaptive mother. But when we come to the *work* of creation, of which the baby knows nothing, the medium is now less willing and the artist must struggle to draw from it the expressive forms that he needs. Although

he has taken the mirroring and attuning process into himself, he has to engage with the external object as he strives to shape the resistant medium. A solipsistic circle is not enough. In the passage to self-realisation, the artist's subjectivity must still proceed through the defile of the other, as though in recognition of early history it still requires the other's transforming recognition.

Notes

1 This chapter is a summary of ideas discussed at greater length in Wright (2009).
2 I use this term in a slightly different way from Bollas (1987), who emphasises the visceral aspects of transformation – the baby's experience of moving from discomfort and distress to a more positively toned emotional state. The 'aesthetic' of such an experience lay, for Bollas, in the pattern of the mother's activity that brought the transformation about – the particular way she did things. It is this which is later 'remembered' in the pattern of the aesthetic object, giving rise to aesthetic feeling. In this account, therefore, aesthetic experience is only *contingently* associated with transformation (of a bodily state). However, in the account I develop, aesthetic experience and transformation are *integrally* related – aesthetic feeling occurs whenever an objective pattern is felt to embody and resonate with an internal one.
3 I am using Langer here to illuminate Winnicott's insights. The terms in brackets come from Langer's writing on art.
4 From a quite different context, this reminds me of Thomas Ogden's description of the analytic process in which he stresses the importance of iconic reflection: 'The analytic discourse requires of the analytic pair the development of a metaphorical [i.e. image-based] language adequate to the creation of sounds and meanings *that reflect what it feels like* to think, feel and physically experience (in short to be alive as a human being to the extent that one is capable) at a given moment' (Ogden 1997: 3, emphasis added).
5 See Chapters 13 and 14.
6 It may be the case that mirroring builds on a pre-established arena that is hardwired in our human makeup. I refer to the possibility that the face, as locus of emotional signals, is regarded differently from birth (there is much experimental evidence in support of this idea) and in that sense is already from the beginning set apart from other objects which can be explored and related to in a purely instrumental fashion (Wright 1991).

References

Balint, Michael (1959). *Thrills and Regressions*, London: Hogarth Press.
Bollas, Christopher (1987). *The Shadow of the Object: Psychoanalysis of the Unthought Known*, London: Free Association Books.
Damasio, Antonio (2000). *The Feeling of What Happens: Body, Emotion and the Making of Consciousness*, London: Vintage Books.

James, Philip (ed.) (1966). *Henry Moore on Sculpture*, London: Macdonald.

Langer, Susanne (1942). *Philosophy in a New Key*, Cambridge, MA: Harvard University Press.

—— (1953). *Feeling and Form*, London: Routledge and Kegan Paul.

—— (1988). *Mind: An Essay on Human Feeling*, abridged by Gary Van den Heuval, Baltimore, MD: Johns Hopkins University Press.

Ogden, Thomas H. (1997). 'Some thoughts on the use of language in psychoanalysis', *Psychoanalytic Dialogues* 7: 1–21.

Stern, Daniel (1985). *The Interpersonal World of the Infant*, New York: Basic Books.

Winnicott, Donald W. (1953). 'Transitional objects and transitional phenomena: a study of the first not-me possession', *International Journal of Psycho-Analysis* 34: 89–97.

—— (1958). *Collected Papers: Through Paediatrics to Psychoanalysis*, London: Tavistock.

—— (1967). 'Mirror role of mother and family in child development', *Playing and Reality*, London: Tavistock, 111–118.

—— (1971). *Playing and Reality*, London: Tavistock.

Wright, Ken (1991). *Vision and Separation: Between Mother and Baby*, London: Free Association Books.

—— (2009). *Mirroring and Attunement: Self-realisation in Psychoanalysis and Art*, London: Routledge.

Select Bibliography

This bibliography comprises a selection of works read or referred to during T-PACE Study Group meetings and workshops, along with some additional items cited in contributions to this book. Many of Winnicott's writings are published in different editions and/or by different publishers. Here, only one edition (usually the original one) is cited; and not all of his publications are listed. A complete listing of published works by Winnicott can be found in Abram (2007); and Karnac (2007) lists published works based on Winnicott's ideas and writings.

Abram, Jan (ed.) (2000). *André Green at the Squiggle Foundation*, London: Karnac.
——— (2007). *The Language of Winnicott: A Dictionary and Guide to Understanding His Work*, 2nd edn.; London: Karnac.
Adams, Laurie S. (1993). *Art and Psychoanalysis*, New York: HarperCollins.
Adams, Parveen (ed.) (2003). *Art: Sublimation or Symptom*, New York: Other Press.
Aitken, Stuart C. and Thomas Herman (1997). 'Gender, power and crib geography: transitional spaces and potential places', *Gender, Place and Culture* 4(1), 63–88.
Aitken, Stuart C. and Deborah P. Dixon (2006). 'Imagining geographies of film', *Erdkunde* 60, 326–336.
Armstrong, Isobel (2000). *The Radical Aesthetic*, Oxford: Blackwell.
Bachelard, Gaston (1969). *The Poetics of Space*, Boston, MA: Beacon Press.
——— (1971). *The Poetics of Reverie: Childhood, Language, and the Cosmos*, trans. Daniel Russell, Boston, MA: Beacon Press.
Bainbridge, Caroline (ed.) (2007). *Culture and the Unconscious*, London: Palgrave Macmillan.
Bainbridge, Caroline and Candida Yates (2010). 'On not being a fan: masculine identity, DVD culture and the accidental collector', *Wide Screen* 1(2), 1–22.
Balint, Michael (1957). *Problems of Human Pleasure and Behaviour*, The International Psycho-Analytical Library, 51; London: Hogarth Press.

———— (1959). *Thrills and Regressions*, International Psycho-Analytic Library, 54; London: Hogarth Press.

Balint, Enid (1993). *Before I Was I: Psychoanalysis and the Imagination*, London: Free Association Books.

Barkin, Leonard S. (1995). 'The concept of the transitional object', in Simon A. Grolnick and Leonard S. Barkin (eds). *Between Reality and Fantasy*, 511–36.

Barthes, Roland (1989). 'Leaving the movie theatre (1975)', *The Rustle of Language*, Berkeley, CA: University of California Press, 345–349.

Bazin, Andre (1971). 'The ontology of the photographic image', *What Is Cinema?*, Berkeley, CA: University of California Press, 9–16.

———— (1971). 'The evolution of the language of cinema', *What is Cinema?*, Berkeley, CA: University of California Press, 23–40.

———— (1971). 'The myth of total cinema', *What is Cinema?*, Berkeley, CA: University of California Press, 17–22.

———— (1997). 'William Wyler, or the Jansenist of directing', *Bazin at Work: Major Essays and Reviews from the Forties and Fifties*, New York: Routledge, 1–22.

Bell, David (ed.) (1999). *Psychoanalysis and Culture: a Kleinian Perspective*, London: Karnac Books.

Benson, Ciaran (2001). *The Cultural Psychology of Self: Place, Morality and Art*, London: Routledge.

Berenson, Bernard (1950). *Aesthetics and History*, London: Constable.

Bergman, Anni (1995). 'From mother to the world outside: the use of space during the separation-individuation phase', in Simon A. Grolnick and Leonard S. Barkin (eds), *From Fantasy to Reality*, 147–165.

Bertolini, Mario (ed.) (2001). *Squiggles and Spaces: Revisiting the Work of D.W. Winnicott*, 2 vols., Philadelphia, PA: Whurr Publishers.

Bick, Esther (1968). 'The experience of the skin in early object relations', *International Journal of Psycho-Analysis* 49, 558–566.

Bingley, Amanda (2003). 'In here and out there: sensations between Self and landscape', *Social and Cultural Geography* 4(3), 329–345.

Bollas, Christopher (1987). *The Shadow of the Object: Psychoanalysis of the Unthought Known*, London: Free Association Books.

———— (1992). *Being a Character: Psychoanalysis and Self-Experience*, New York: Hill and Wang.

———— (1993). 'The aesthetic moment and the search for transformation', in Peter L. Rudnytsky (ed.), *Transitional Objects and Potential Spaces*, 40–49.

———— (1995). *Cracking Up: The World of Unconscious Experience*, New York: Hill and Wang.

———— (2000). 'Architecture and the unconscious', *International Forum of Psychoanalysis* 9(1–2), 28–42.

———— (2009). *The Evocative Object World*, London: Routledge.

———— (2011). 'The transformational object ', *The Christopher Bollas Reader*, New York: Routledge, 1–12.

Bourdieu, Pierre and Alain Darbel (1991). *The Love of Art*, trans. Caroline Beattie and Nick Merriman, Cambridge: Polity Press.

Bowie, Malcolm (2000). 'Psychoanalysis and art: the Winnicott legacy', in Lesley Caldwell (ed.), *Art, Creativity, Living*, 11–29.

Brody, Sylvia (1980). 'Transitional objects: idealization of a phenomenon', *Psychoanalytic Quarterly* 49(4), 561–605.

Brooker, Will (2002). *Using the Force: Creativity, Community and Star Wars Fans*, New York and London: Continuum.

Bull, Michael and Les Back (eds) (2003). *The Auditory Culture Reader*, Oxford: Berg.

Burgin, Victor (1996). *In/Different Spaces: Place and Memory in Visual Culture*, Berkeley, CA: University of California Press.

——— (2004). *The Remembered Film*, London: Reaktion Books.

Burgin, Victor, James Donald and Cora Kaplan (eds) (1986). *Formations of Fantasy*, London: Methuen.

Caldwell, Lesley (ed.) (2000). *Art, Creativity, Living*, Winnicott Studies Monograph Series, London: Karnac Books for the Squiggle Foundation.

——— (ed.) (2005). *Sex and Sexuality: Winnicottian Perspectives*, Winnicott Studies Monograph Series, London: Karnac.

——— (ed.) (2007). *Winnicott and the Psychoanalytic Tradition: Interpretation and Other Psychoanalytic Issues*, London: Karnac.

Caldwell, Lesley and Angela Joyce (eds) (2011). *Reading Winnicott*, London: Routledge.

Callard, Felicity (2003). 'The taming of psychoanalysis in geography', *Social and Cultural Geography* 4(3), 295–312.

Casetti, Francesco (2009). 'Filmic experience', *Screen* 50(1), 56–66.

Casey, Edward (1987). *Remembering: A Phenomenological Study*, Bloomington, IN: Indiana University Press.

Certeau, Michel de (1984). *The Practice of Everyday Life*, trans. Steven Rendall, Berkeley, CA: University of California Press.

Charney, Maurice and Joseph Reppen (eds) (1987). *Psychoanalytic Approaches to Literature and Film*, London and Toronto: Associated University Press.

Clancier, Anne and Jeannine Kalmanovitch (1987). *Winnicott and Paradox: From Birth to Creation*, trans. Alan Sheridan, London: Tavistock Publications.

Clarke, Graham (1994). 'Notes towards an object-relations approach to cinema', *Free Associations* 4(3), 369–390.

Cole, Michael (1996). *Cultural Psychology: A Once and Future Discipline*, Cambridge, MA: The Belknap Press of Harvard University Press.

Coltart, Nina (1992). *Slouching Towards Bethlehem… and Further Psychoanalytic Explorations*, London: Free Association Books.

——— (1996). *The Baby and the Bathwater*, London: Karnac.

Creme, Phyllis (1994). 'The Playing Spectator: an exploration of the applicability of the theories of D.W. Winnicott to contemporary concepts of the viewer's relationship to film', PhD Thesis, University of Kent.

Damasio, Antonio (2000). *The Feeling of What Happens: Body, Emotion and the Making of Consciousness*, London: Vintage Books.

Davis, Madeleine and David Wallbridge (1990). *Boundary and Space: An Introduction to the Work of D.W. Winnicott*, London: Karnac.

Delbanco, Nicholas (2011). *Lastingness: The Art of Old Age*, New York and Boston: Grand Central Publishing.

Deri, Susan K. (1984). *Symbolization and Creativity*, New York: International Universities Press, Inc.

——— (1995). 'Transitional phenomena: vicissitudes of symbolisation and creativity', in Simon A. Grolnick and Leonard S. Barkin (eds), *From Fantasy to Reality*, 45–60.

Dovey, Jon (2006). 'How do you play? Identity, technology and ludic culture', *Digital Creativity* 17(3), 135–139.

Dovey, Jon and Helen W. Kennedy (2006). *Game Cultures: Computer Games as New Media*, Maidenhead: McGraw-Hill.

Eigen, Michael (1991). 'Winnicott's area of freedom: the uncompromiseable', in Nathalie Shwarz-Salant and Murray Stein (eds). *Liminality and Transitional Phenomena*, The Chiron Clinical Series; Wilmette, IL: Chiron Publications, 67–88.

––––––– (1992). 'The fire that never goes out', *Psychoanalytic Review* 79(2), 271–287.

Ellsworth, Elizabeth (2005). *Places of Learning: Media, Architecture, Pedagogy*, New York: Routledge Falmer.

Erikson, Erik H. (1959). *Identity and the Life Cycle: Selected Papers*, New York: International Universities Press.

Feld, Steven and Keith Basso (eds) (1996). *Senses of Place*, Santa Fe, NM: School of American Research Press.

Fogel, Gerald I. (1992). 'Winnicott's antitheory and Winnicott's art: his significance for adult analysis', *The Psychoanalytic Study of the Child* 47, 205–222.

Foucault, Michel (1986). 'Other spaces: the principles of heterotopia', *Lotus*, 48–49, 9–17.

Freud, Sigmund (1953). 'The Interpretation of Dreams', *The Standard Edition of the Complete Psychological Works of Sigmund Freud, Volume V (1900–1901)*, London: Hogarth Press.

––––––– (1955). 'The Moses of Michelangelo', *The Standard Edition of the Complete Psychological Works of Sigmund Freud, Vol. XIII*, London: The Hogarth Press and The Institute of Psychoanalysis, 209–238.

––––––– (1957). 'On narcissism', *The Standard Edition of the Complete Psychological Works of Sigmund Freud, Volume XIV (1914–1916)*, London: Hogarth Press, 73–104.

––––––– (1959). 'Creative writers and daydreaming', *Standard Edition, Vol. IX*, London: The Hogarth Press and the Institute of Psychoanalysis, 141–154.

––––––– (1961). 'A note upon the mystic writing pad', *The Standard Edition of the Complete Psychological Works of Sigmund Freud, Volume XIX (1923–1925)*, London: Hogarth Press, 227–234.

––––––– (1961). 'Dostoyevsky and parricide', *Standard Edition, Vol. XXI*, London: The Hogarth Press and The Institute of Psychoanalysis), 173–194.

––––––– (1973). 'Introductory Lectures on Psychoanalysis (1916–17)', *The Pelican Freud Library, vol. 1*, Harmondsworth: Penguin.

––––––– (1973). 'The dreamwork (1916)', *The Pelican Freud Library, vol. 1*, Harmondsworth: Penguin, 204–218.

––––––– (1977). 'Three essays on the theory of sexuality (1905)', *The Pelican Freud Library, vol. 7*, Harmondsworth: Penguin, 45–169.

––––––– (1984). 'Beyond the Pleasure Principle (1920)', *The Pelican Freud Library, vol. 11*, Harmondsworth: Penguin, 269–338.

––––––– (1984). 'Splitting of the ego in the process of defence (1938)', *Pelican Freud Library, vol. 11*, Harmondsworth: Penguin, 457–464.

Fuller, Peter (1980). *Art and Psychoanalysis*, London: Writers and Readers Publishing Co-operative.

Gabbard, Glen O. (ed.) (2001). 'Psychoanalysis and Film', *International Journal of Psycho-Analysis*, London: Karnac.

Gabbard, Krin, 'Psychoanalysis and film study in the 1990s'. Available at http://www.apsa.org/tap/kgabbard.htm (accessed 6 December 2005).

Galenson, David W. (2006). *Old Masters and Young Geniuses: The Two Life Cycles of Artistic Creativity*, Princeton, NJ: Princeton University Press.

Gargiulo, Gerald J. (2004). *Psyche, Self and Soul: Rethinking Psychoanalysis, the Self and Spirituality*, Philadelphia: Whurr Publishers.

George, Linda (1998). 'Self and Identity in Later Life: Protecting and Enhancing the Self', *Journal of Aging and Identity* 3(3), 133–152.

Gillespie, Alex and Tania Zittoun (2010). 'Using resources: conceptualizing the mediation and reflective use of tools and signs', *Culture and Psychology* 16(1), 37–62.

Glover, Nicola (c2000). 'Psychoanalytic Aesthetics: the British School', PhD, University of Kent.

Gomez, Lavinia (1997). *An Introduction to Object Relations*, London: Free Association Books.

Green, André (1978). 'The double and the absent', in Alan Roland (ed.), *Psychoanalysis, Creativity and Literature: a French-American Inquiry*, New York: Columbia University Press, 271–292.

——— (1978). 'Potential space in psychoanalysis: the object in the setting', in Simon A. Grolnick and Leonard S. Barkin (eds), *Between Reality and Fantasy*, 169–189.

——— (1979). *The Tragic Effect: The Oedipus Complex in Tragedy*, trans. Alan Sheridan, Cambridge: Cambridge University Press.

——— (1995). 'Potential space in psychoanalysis: the object in the setting', in Simon A. Grolnick and Leonard S. Barkin (eds), *Between Reality and Fantasy*, 167–187.

Greenacre, Phyllis (1957). 'The childhood of the artist: libidinal phase development and giftedness', *The Psychoanalytic Study of the Child* 12, 47–72.

Grenfell, Michael and Cheryl Hardy (2007). *Art Rules: Pierre Bourdieu and the Visual Arts*, Oxford: Berg.

Grolnick, Simon A. (1990). *The Work and Play of Winnicott*, Northvale, NJ: Jason Aronson, Inc.

Grolnick, Simon A. and Leonard S. Barkin (eds) (1995). *Between Reality and Fantasy: Winnicott's Concepts of Transitional Objects and Phenomena*, Northvale, NJ: Jason Aronson, Inc.

Haase, Donald (2000). 'Children, war, and the imaginative space of fairy tales', *The Lion and the Unicorn* 24(3), 360–377.

Harker, Christopher (2005). 'Playing and affective time-spaces', *Children's Geographies*, 3 (1), 47–62.

Harrington, Lee, C. and Denise Bielby (1995). *Soap Fans: Pursuing Pleasure and Making Meaning in Everyday Life*, Philadelphia, PA: Temple University Press.

——— (2010). 'A life course perspective on fandom', *International Journal of Cultural Studies* 13 (5), 429–450.

Harrington, Lee, C. and Denise A. Brothers (2010). 'Life course built for two: acting, aging, and soap operas', *Journal of Aging Studies*, 24, 20–29.

Harrington, C. Lee, Denise Bielby and Anthony R. Bardo (2011). 'Life course transitions and the future of fandom', *International Journal of Cultural Studies*, 567–590.

Hart, Roger (1979). *Children's Experience of Place*, New York: Irvington Publishers, Inc.

Hatz, Madeleine (2000). 'The work process as spatial situation: a sketch', *International Forum of Psychoanalysis* 9(1–2), 93–96.

Hills, Matt (2002). *Fan Cultures*, London: Routledge.

——— (2005). 'Patterns of surprise: the "aleatory object" in psychoanalytic ethnography and cyclical fandom', *American Behavioral Scientist* 48(7), 801–821.

——— (2007). 'Essential tensions: Winnicottian object-relations in the media sociology of Roger Silverstone', *International Journal of Communication* 1, 37–48.

Howes, David (ed.) (2005). *Empire of the Senses: The Sensual Culture Reader*, Oxford: Berg.

Hunt, Celia and Fiona Sampson (2006). *Writing, Self and Reflexivity*, London: Palgrave Macmillan.

Iles, Chrissie (2001). 'Between the still and moving image', *Into the Light: the Projected Image in American Art 1964–1977*, New York: Whitney Museum of Modern Art, 33–83.

Jenkins, Henry (2007). 'Death-defying superheroes', in Sherry Turkle (ed.), *Evocative Objects: Things We Think With*, 195–207.

Jernstedt, Arne (2000). 'Potential space: the place of encounter between inner and outer reality', *International Forum of Psychoanalysis* 9(1–2), 124–131.

Kahne, Merton J. (1967). 'On the persistence of transitional phenomena into adult life', *International Journal of Psycho-Analysis* 48(2), 247–258.

Karnac, Harry (2003). 'The works of D.W. Winnicott', in F. Robert Rodman (ed.), *Winnicott: Life and Work*, Cambridge, MA: Perseus, 419–437.

——— (2007). *After Winnicott: Compilation of Works Based on the Life, Writings and Ideas of D.W. Winnicott*, London: Karnac.

Kavaler-Adler, Susan (1993). *The Compulsion to Create: a Psychoanalytic Study of Women Artists*, New York: Routledge.

Keathley, Christian (2006). *Cinephilia and History or, the Wind in the Trees*, Bloomington, IN: Indiana University Press.

Kirshner, Lewis A. (ed.) (2011). *Between Winnicott and Lacan: A Clinical Engagement*, New York: Routledge.

Klein, Melanie (1986). 'A contribution to the psychogenesis of manic depressive states', in Peter Buckley (ed.), *Essential Papers on Object Relations*, New York: New York University Press, 40–70.

Kline, T. Jefferson (1987). *Bertolucci's Dream Loom: a Psychoanalytic Study of Cinema*, Amherst. MA: University of Massachusetts Press.

Konigsberg, Ira (1996). 'Transitional phenomena, transitional space: creativity and spectatorship in film', *Psychoanalytic Review* 83(6), 865–889.

——— (2000). 'Children watching movies', *Psychoanalytic Review* 87(2), 277–303.

Kris, Ernst (1952). *Psychoanalytic Explorations in Art*, New York: International Universities Press.

Kuhn, Annette (2002). *An Everyday Magic: Cinema and Cultural Memory*, London: I.B.Tauris.

——— (2004). 'Heterotopia, heterochronia: place and time in cinema memory', *Screen* 45(2), 106–114.

——— (2005). 'Thresholds: film as film and the aesthetic experience', *Screen* 46(4), 401–14.

——— (2010). 'Cinematic experience, film space and the child's world', *Canadian Journal of Film Studies* 19(2), 82–98.

——— (2011). 'What to do with cinema memory?', in Richard Maltby, Daniel Biltereyst and Philippe Meers (eds), *Explorations in New Cinema History: Approaches and Case Studies*, Malden, MA: Wiley-Blackwell, 85–97.

——— 'Transitional Phenomena and Cultural Experience (T-PACE)'. Available at: http://www.sllf.qmul.ac.uk/filmstudies/t_pace/index.html (accessed 15 August 2011).

Kuhns, Richard (1983). *Psychoanalytic Theory of Art: A Philosophy of Art on Developmental Principles*, New York: Columbia University Press.

Kullman, Kim (2010). 'Transitional geographies: making mobile children', *Social and Cultural Geography* 11(8), 829–846.

Lacan, Jacques (1988). *The Seminar of Jacques Lacan, Book II: The Ego in Freud's Theory and in the Technique of Psychoanalysis 1954–1955*, New York: Norton.

LaMothe, Ryan (2005). *Becoming Alive: Psychoanalysis and Vitality*, London and New York: Routledge.

Laplanche, Jean and Jean-Bertrand Pontalis (1988). *The Language of Psychoanalysis*, London: Karnac.

Lasch, Christopher (1985).*The Minimal Self: Psychic Survival in Troubled Times*, London: Picador.

Lebeau, Vicky (2001). *Psychoanalysis and Cinema: The Play of Shadows*, London: Wallflower.

——— (2009). 'The arts of Looking: D.W. Winnicott and Michael Haneke', *Screen* 50(1), 35–44.

Lerner, Leila (ed.) (1992). 'Illusion and culture: a tribute to D.W. Winnicott', *Psychoanalytic Review* 79(2), 79–167.

Lewis, Michael (2008). 'The emergence of human emotions', in Jeannette M. Haviland-Jones, Michael Lewis and Lisa F. Barrett (eds), *Handbook of Emotions*, 3rd edn.; New York and London: The Guilford Press, 304–319.

Magai, Carol (2008). 'Long-lived emotions: a life-course perspective on emotional development', in Jeannette M. Haviland-Jones, Michael Lewis and Lisa F. Barrett (eds), *Handbook of Emotions*, 3rd edn.; New York and London: The Guilford Press, 376–392.

Magai, Carol and Jeannette M. Haviland-Jones (2002). *The Hidden Genius of Emotion: Lifespan Transformations of Personality*, Cambridge: Cambridge University Press.

Mahler, Margaret S. (1979). *The Selected Papers of Margaret S. Mahler, Vol II: Separation-Individuation*, New York: Jason Aronson, Inc.

——— (1986). 'On human symbiosis and the vicissitudes of individuation', in Peter Buckley (ed.), *Essential Papers on Object Relations*, New York: New York University Press, 200–221.

Marcia, James E. (2010). 'Life transitions and stress in the context of psychosocial development ', in Thomas W. Miller (ed.), *Handbook of Successful Transitions Across the Lifespan*, New York: Springer, 19–34.

Mavor, Carol (2007). *Reading Boyishly: Roland Barthes, J.M. Barrie, Jacques Henri Lartigue, Marcel Proust, and D.W. Winnicott*, Durham, NC: Duke University Press.

McDougall, Joyce (2003). *Donald Winnicott the Man: Reflections and Recollections*, Donald Winnicott Memorial Lecture Series; London: Karnac.

Merleau-Ponty, Maurice (1964). 'Film and the new psychology', *Sense and Non-sense*, Evanston, IL: Northwestern University Press, 48–59.

Milner, Marion (1952). 'Aspects of symbolism in comprehension of the not-self', *International Journal of Psycho-Analysis* 33(2), 181–195.

——— (1958). 'Psycho-analysis and art', in John D. Sutherland (ed.), *Psycho-Analysis and Contemporary Thought*, The International Psycho-Analytical Library, no.53; London: Hogarth Press, 77–101.

——— (1971). *On Not Being Able to Paint*, 2nd edn.; London: Heinemann.

——— (1986). *A Life of One's Own*, London: Virago Press.

——— (1987). *The Suppressed Madness of Sane Men: Forty-four Years of Exploring Psycho-analysis*, Hove: Brunner-Routledge.

——— (1987). 'The framed gap (1952)', *The Suppressed Madness of Sane Men*, 79–82.

——— (1993). 'The role of illusion in symbol formation', in Peter L. Rudnytsky (ed.), *Transitional Objects and Potential Spaces*, 13–39.

——— (1995). 'D.W. Winnicott and the two-way journey', in Simon A. Grolnick and Leonard Barkin (eds), *Between Reality and Fantasy*, 147–165.

Minsky, Rosalind (1998). *Psychoanalysis and Culture: Contemporary States of Mind*, Cambridge: Polity Press.

Mitchell, Juliet (ed.) (1987). *The Selected Melanie Klein*, New York: Free Press.

Montmasson, Joseph-Marie (1931). *Invention and the Unconscious*, London: Kegan Paul.

Morse, Stephen J. (1972). 'Structure and reconstruction: a critical comparison of Michael Balint and D.W. Winnicott', *International Journal of Psycho-Analysis* 53, 487–500.

Muensterberger, Werner (1995). 'Between reality and fantasy', in Simon A. Grolnick and Leonard S. Barkin (eds), *Between Reality and Fantasy*, 5–13.

Newman, Kenneth M. (1996). 'Winnicott goes to the movies: the false self in Ordinary People', *Psychoanalytic Quarterly* 65(4), 787–807.

Ogden, Thomas H. (1985). 'On potential space', *International Journal of Psycho-Analysis* 66(2), 129–141.

——— (1989). 'On the concept of an autistic-contiguous position', *International Journal of Psycho-Analysis* 70, 127–140.

——— (1992). 'The dialectically constituted / decentred subject of psychoanalysis II: the contributions of Klein and Winnicott', *International Journal of Psycho-Analysis* 73 (4), 613–626.

——— (1997). 'Some thoughts on the use of language in psychoanalysis', *Psychoanalytic Dialogues* 7, 1–21.

——— (2001). 'Reading Winnicott', *Psychoanalytic Quarterly* 70, 299–323.

Pajaczkowska, Claire (2007). 'On humming: reflections on Marion Milner's contribution to psychoanalysis', in Lesley Caldwell (ed.), *Winnicott and the Psychoanalytic Tradition*, 33–48.

Pedder, Jonathan R. (1992). 'Conductor or director? Transitional space in psychotherapy and in the theater', *Psychoanalytic Review* 79(2), 261–270.

Phillips, Adam (1988). *Winnicott*, Fontana Modern Masters; London: Fontana Press.

Philo, Chris (2003). '"To go back up that side hill": memories, imaginations and reveries of childhood', *Children's Geographies* 1(1), 7–23.

Philo, Chris and Hester Parr (2003). 'Introducing psychoanalytic geographies', *Social and Cultural Geography* 4(3), 283–293.

Podro, Michael (2007). 'Destructiveness and play: Klein, Winnicott, Milner', in Lesley Caldwell (ed.), *Winnicott and the Psychoanalytic Tradition*, 24–32.

Pontalis, Jean-Bertrand (1981). *Frontiers in Psychoanalysis: Between the Dream and Psychic Pain*, ed. Clifford Yorke, trans. Catherine Cullen and Philip Cullen, International Psycho-Analytical Library, 111; London: Hogarth Press.

Rashkin, Esther (2008). *Unspeakable Secrets and the Psychoanalysis of Culture*, Albany, NY: State University of New York Press.

Rodman, F. Robert (2005). 'Architecture and the true self', in Jerome A. Winer, James W. Anderson, and Elizabeth A. Danze (eds), *Psychoanalysis and Architecture*, The Annual of Psychoanalysis, 33; Catskill, NY: Mental Health Resources, 57–66.

Rose, Gilbert J. (1980). *The Power of Form: A Psychoanalytic Approach to Aesthetic Form*, Psychological Issues Monographs, 49; New York: International Universities Press.

——— (1995). 'The creativity of everyday life', in Simon A. Grolnick and Leonard S. Barkin (eds), *Between Reality and Fantasy*, 347–362.

Rose, Jacqueline (1984). *The Case of Peter Pan, or The Impossibility of Children's Fiction*, Language, Discourse, Society; London: Macmillan.

Rudnytsky, Peter L. (1992). 'A psychoanalytic Weltanschauung', *Psychoanalytic Review* 79(2), 289–305.

——— (ed.) (1993). *Transitional Objects and Potential Spaces: Literary Uses of D.W. Winnicott*, New York: Columbia University Press.

Rustin, Margaret and Michael Rustin (2001). *Narratives of Love and Loss: Studies in Modern Children's Fiction*, revised edn.; London: Karnac.

Rutherford, Anne (2003). 'Cinema and embodied affect', *Senses of Cinema*, 25. Available online: http://www.sensesofcinema.com/2003/feature-articles/embodied_affect/ (accessed 22 December 2011).

Rycroft, Charles (1968). *Imagination and Reality: Psycho-Analytical Essays, 1951–1961*, International Psycho-Analytical Library, 75; London: Hogarth Press.

Sabbadini, Andrea (ed.) (2003). *The Couch and the Silver Screen: Psychoanalytic Reflections on European Cinema*, New Library of Psychoanalysis, 44; Hove: Brunner-Routledge.

——— (2011). 'Cameras, mirrors, and the bridge space: a Winnicottian lens on cinema', *Projections* 5(1), 17–30.

Said, Edward W. (2006). *On Late Style: Music and Literature against the Grain*, New York: Pantheon.

Sandvoss, Cornel (2005). *Fans: The Mirror of Consumption*, Oxford: Polity.

——— (2008). ' On the couch with Europe: The Eurovision Song Contest, the European Broadcast Union and belonging on the Old Continent ', *Popular Communication: The International Journal of Media and Culture* 6(3), 190–207.

Santner, Eric (1990). *Stranded Objects: Mourning, Memory and Film in Postwar Germany*, Ithaca, NY: Cornell University Press.

Scalia, Joseph (ed.) (2002). *The Vitality of Objects: Exploring the Work of Christopher Bollas*, London: Continuum.

Schwartz, Murray M. (1992). 'Introduction: D.W. Winnicott's cultural space', *Psychoanalytic Review* 79(2), 169–174.

Schwartz-Salant, Nathan and Murray Stein (eds) (1991). *Liminality and Transitional Phenomena*, The Chiron Clinical Series, Wilmette, IL: Chiron Publications.

Segal, Hanna (1952). 'A psycho-analytical approach to aesthetics', *International Journal of Psycho-Analysis* 33, 196–207.

Siegelman, Ellen Y. (1991). 'Playing with the opposites: symbolization and transitional space', in Nathan Schwartz-Salant and Murray Stein (eds), *Liminality and Transitional Phenomena*, 151–168.

Silverstone, Roger (1993). 'Television, ontological security and the transitional object', *Media, Culture and Society* 15(4), 573–598.

——— (1994). *Television and Everyday Life*, London: Routledge.

——— (1999). *Why Study the Media?*, London: Sage Publications.

Sobchack, Vivian (1992). *The Address of the Eye: A Phenomenology of Film Experience*, Princeton, NJ: Princeton University Press.

Stern, Daniel (1985). *The Interpersonal World of the Infant*, New York: Basic Books.

Stewart, Harold (1966). *Michael Balint: Object Relations Pure and Applied*, New Library of Psychoanalysis, 25; London: Routledge.

Storr, Anthony (1989). *Solitude*, London: Flamingo.

Tisseron, Serge (1995). *Psychanalyse de l'image, des premiers traits au virtuel*, Paris: Dunod.

———— (1999). *Comment l'esprit vient aux objets*, Paris: Aubier.

———— (2000). *Enfants sous influence: les écrans rendent-ils les jeunes violents?*, Paris: Armand Colin.

———— (2001). *L'Intimité surexposée*, Paris: Ramsay.

———— (2003). *Comment Hitchcock m'a guéri: que cherchons-nous dans les images?*, Paris: Albin Michel.

Tonnesmann, Margret (2000). 'Donald W. Winnicott's diagram of the transitional object, and other figures', in Bernard Burgoyne (ed.), *Drawing the Soul: Schemas and Models in Psychoanalysis*, Encyclopaedia of Psychoanalysis; London: Rebus Press, 22–33.

Tornstam, Lars (1997). 'Gerotranscendence: the contemplative dimension of aging', *Journal of Aging Studies* 11(2), 143–154.

Townsend, Patricia (2005). 'Transitional spaces: surface, fantasy and illusion', in Liz Wells and Simon Standing (eds), *Surface: Land/Water and the Visual Arts*, Plymouth: University of Plymouth Press, 28–41.

Turkle, Sherry (ed.) (2007). *Evocative Objects: Things We Think With*, Cambridge, MA: MIT Press.

Viola, Bill (1995). *Reasons for Knocking at an Empty Door: Writings 1973–1994*, London: Thames and Hudson.

Vroomen, Laura (2004). 'Kate Bush: teen pop and older female fans', in Andy Bennett and Richard A. Peterson (eds), *Music Scenes: Local, Translocal, and Virtual*, Nashville, TN: Vanderbilt University Press, 238–253.

Williams, Rebecca (2011). '"This is the night TV died": television, post-object fandom and the demise of *The West Wing*', *Popular Communication: The International Journal of Media and Culture* 9(4), 266–279.

Winnicott, Claire (ed.) (1989). *D.W. Winnicott: Psycho-Analytic Explorations*, London: Karnac.

Winnicott, Donald W. (1953). 'Transitional objects and transitional phenomena: a study of the first not-me possession', *International Journal of Psycho-Analysis* 34, 89–97.

———— (1958). *Collected Papers: Through Paediatrics to Psycho-Analysis*, London: Tavistock.

———— (1964). *The Child, the Family, and the Outside World*, Harmondsworth: Penguin.

———— (1965). *The Maturational Processes and the Facilitating Environment: Studies in the Theory of Emotional Development*, International Psycho-Analytic Library, 64; London: Hogarth Press.

———— (1965). *The Family and Individual Development*, London: Tavistock.

———— (1971). *Playing and Reality*, London: Tavistock.

———— (1986). *Home Is Where We Start From*, Harmondsworth: Penguin.

———— (1988). *Human Nature*, London: Free Association Books.

Wright, Ken (1991). *Vision and Separation: Between Mother and Baby*, London: Free Association Books.

———— (2000). 'To make experience sing', in Lesley Caldwell (ed.), *Art, Creativity, Living*, 75–96.

———— (2009). *Mirroring and Attunement: Self-Realization in Psychoanalysis and Art*, London: Routledge.

Young, Robert M. (1989). 'Transitional phenomena: production and consumption', in Barry Richards (ed.), *Crises of the Self: Further Essays on Psychoanalysis and Politics*, London: Free Association Books, 57–72.

———— 'Mental space'. Available online: http://www.shef.ac.uk/~psysc/mental/chap8.html (accessed 23 May 2005).

Zittoun, Tania (2006). *Transitions: Development Through Symbolic Resources*, Greenwich, CT: Information Age Publishing.

———— (2007). 'The role of symbolic resources in human lives', in Jaan Valsiner and Alberto Rosa (eds), *Cambridge Handbook of Socio-Cultural Psychology*, Cambridge, Cambridge University Press, 343–361.

Index

Page numbers in bold refer to illustrations.

24 Hour Psycho 169–70, 171
400 Blows, The/Les quatre cents coups
 (1959) 131

Aciman, André 74
Ackerman, Diane 66
aesthetic experience 153–4, 155, 156, 159,
 160–2, 166, 171, 182, 183, 211–12,
 213n2
affect *see* emotion
After Life (1998) 143–4
ageing 82, 87–98
 see also lifelong development
aggression xvii, xix, 17, 92, 135, 198
Aitken, Stuart 7
analogical form 166, 171, 208–9
 see also resonant form
Armstrong, David 195, 196
art galleries 156, 159, 163–4, 165, 183,
 194, 198–200
 as holding environment 164, 165
 see also gallery films; museums
attunement 155, 165–6, 203, 209–10, 212
audience studies 79–80, 82, 84
 see also fan studies

Bachelard, Gaston 16, 18, 34n7
Back, Les 67, 69, 79
Bacon, Francis 106, 107, 118

Bainbridge, Caroline 114, 116, 118
Balint, Michael 16, 207
Bambi (1942) 131
Barthes, Roland 139, 167
Bay Mountain 176–7, **177**
Benson, Ciaran 139
Berenson, Bernard 160, 161, 163, 166
Berger, John 74
Bergson, Henri 27, 34n7
Bielby, Denise 7, 79–80, 82
Bion, Wilfred 195–6
Blade Runner (1982) 83, 103–4, 105–6, 107,
 111–13, 114, **115**, 116, 118
Blakey, Sharon 189, 190, 191
Bollas, Christopher xviii, 68, 74–5, 82,
 90–1, 98, 113, 161, 194, 213n2
 see also transformational object
Bordwell, David 104
Bourdieu, Pierre 164
Britton, Ronald 182
Brooker, Will 91, 112, 117
Brotherhood of the Wolf (2001) 123
Bruno, Giuliana 69
Bull, Michael 67, 69

Călinescu, Matei 117
Carey, Peter 198
Casablanca (1943) 142–3
Casey, Edward 54, 74

Certeau, Michel de 54
children's mobilities 17–18, 19
cinema *see* Cinema Culture in 1930s
 Britain; cinema memory; cinema-
 going; films
Cinema Culture in 1930s Britain 19, 53,
 62n1
cinema-going 19–20, 53–6, 58, 59–60, 84
cinema memory 20, 39, 50, 53, 59, 60–1,
 91, 131
Clark, Kenneth 204
computer games 2, 7, 8, 17, 33, 35n15,
 35n16, 82
computer-generated imagery 29–30
computers 18, 23–4
 see also Facebook; internet; YouTube
contained environment *see* holding
 environment
Cooper, Emily 107–8
creative living 5, 8, 9, 49, 50, 80, 84, 112,
 136–7, 144, 145, 154, 171, 205–6
creative process 151–2, 155–6, 173–84
 and delusion 180–1, 184
creativity 3, 79, 87, 127–8, 151–7, 165,
 212–3
 holding environment and 181–3
cultural experience xviii, 3–4, 5–6,
 23–4, 80, 104, 136–7, 138–40, 144, 145,
 159–61
cultural inheritance *see* inherited
 tradition
curating 163–4, 188–9, 195

Dark Knight Rises, The (2012) 105
Dark Knight, The (2008) 105
David (2004) 169, 170, 171
Delbanco, Nicholas 87, 98
Deleuze, Gilles 27–8
Derrida, Jacques 28
destructiveness *see* aggression
Dovey, Jon 7, 33, 35n11, 82
Duchamp, Marcel 33

ecological perception 16–17, 69
Ehrenzweig, Anton 181, 183
Elsaesser, Thomas 103, 105, 113, 118
embodiment 15–16, 18, 19, 46, 49, 54–5,
 58, 68, 69, 73, 124, 130, 167

emotion 92–4, 96–7, 98, 126, 129, 130–1, 138
Erikson, Erik 92, 98
everyday creativity *see* creative living;
 creativity
evocative objects 90–1, 97, 195

Facebook 81
facilitating environment *see* holding
 environment
'false self' 33, 35n13, 85
fan studies 79, 82–3, 88, 89–90, 91, 98,
 103, 111
 see also audience studies
Feld, Steven 74
films 18–19, 39–50, 79, 103–18, 122, 123,
 131–2, 139, 166–8
 cinematic space 40–5, 47, 62
 documentary 129
 framing 48
 melodrama 45, 48, 122
 musical 45, 48–9
 puzzle film 84, 103, 104–5, 109, 118
 romance 122
 science fiction 105
 spectators 18–19, 40, 41, 45, 47, 83,
 107–8, 125, 128, 130, 138
 as symbolic resources 140–5
 voyeurism 41
 see also Cinema Culture in
 1930s Britain; cinema-going;
 cinema memory; gallery films;
 psychoanalytic film theory; video
Fiske, John 79–80
Five Angels for the Millennium 169, 170,
 171
Flax, Jane 193
fort/da game 13, 35n12, 54, 55–6
Foucault, Michel 34n8, 163
frames *see* Milner, Marion
Freud, Sigmund xvi, 13, 27, 34n8, 65, 131
 on creativity 152–3
 fort/da game 13, 35n12, 54, 55–6
 sublimation 3, 4, 159
Fuller, Peter 161–2, 166
Funny Games (1997) 122

Gaddini, Renata 81
Galenson, David 87

gallery films 156, 159, 165, 168–9, 170–1
 see also art galleries
Gauss, Karl Friedrich 152
Gibson, James 69
Goffman, Erving 199
Gombrich, Ernst 124
Gorney, James E. 24
Graduate, The (1967) 140–1, 145
Gray, Jonathan 112
Green, André 24–5, 29, 39, 42–3
Greenacre, Phyllis 35n17

Harrington, C. Lee 79–80, 82
Haviland-Jones, Jeannette 92–3, 99n4
heterotopia 163
Highmore, Ben 67
Hills, Matt 7, 84, 90–1, 97, 99n7
holding environment 5, 20, 29, 139, 156,
 163, 181–3, 184, 203, 204, 211
 art gallery as 164, 165
 museum as 157, 199–200
home 15–18, 45, 47, 48, **49**, 55, 56, 58–9,
 68, 70, 74
Hopkins, Brooke 106
Howes, David 66, 73
Human Resources/Ressources humaines
 (1999) 122

identification 43, 71, 72, 84, 108, 123,
 141–2, 196, 206–7, 209
Iles, Chrissie 165, 168
illusion 2, 7, 59, 87, 92, 98, 109, 154, 160,
 179–81, 208, 209
Inception (2010) 82–3, 103–5, **104, 107**,
 108–10, 111, 112–13, 115–18
inherited tradition 137, 163, 164, 169, 170
installation art *see* gallery films
internet 23–4, 31, 80, 116
introjection 61, 126
Issroff, Judith 81–2

Jenkins, Henry 91–2, 97, 111
Jung, Carl 6

Kennedy, Helen W. 7, 33, 35n11, 82
kinesis 8, 15, 54–5, 58, 69, 70
Klein, Melanie 6, 49, 65, 153, 181
Klinger, Barbara 105

Kluzer, Almatea Usuelli 107
Konigsberg, Ira 43
Kris, Ernst 154
Kuhn, Annette 39, 44, 49, 50, 71, 91, 99n6,
 104

Lacan, Jacques 6, 26–7, 28, 34n8, 42, 43, 103
Lady and the Tramp, The (1955) 131–2
Langer, Susanne 184, 203, 205, 207, 208,
 211
Lebeau, Vicky 103, 104
Levinas, Emmanuel 28
Life is Beautiful/La vita è bella (1997) 128
lifelong development 81, 135
 see also ageing

Magai, Carol 92–4, 96, 99n4
Manchester Art Gallery 188, 189, 194
 Mary Greg Collection 156, 188–90,
 194–5
 'Mary, Mary' initiative 190–4, 195, 196,
 199–200
maternal voice 20, 67–8, 72
Matrix, The (1999) 123
McDougall, Joyce 110–11
Meet Me in St Louis (1944) 19, 40, 44–8,
 47, 49
Meltzer, Donald 187, 192, 198
Memento (2000) 117
memory 19, 20, 54, 58, 74, 126, 139
 see also cinema memory
Metz, Christian 41, 45
Milner, Marion 4, 9, 17, 23–4, 156, 160,
 167, 179–81
 frames 17, 19, 46–7, 122, 124, 156,
 162–3, 165, 183
 reverie 3, 164–5
mirroring 107, 155, 165, 203, 206, 209–10,
 212, 213
mobile phones 31, 80, 81
Molloy, Claire 117
Moore, Henry 203–5, 208, 211
movement *see* kinesis
museums 156–7, 187–8, 189, 195, 196,
 198–9
 as holding environment 157, 199–200
 see also art galleries
music hall 49–50

Nolan, Christopher 82, 83, 107, 109–10, 111, 112–13, 116, 118
Nolan, Christopher (*continued*)
 Nolanfans website 104–5, 109, 112–13, 116, 117, 119n1
Nussbaum, Martha 67, 70, 72, 73

object-relations psychoanalysis xv, 6–7, 20, 40, 56, 65–6, 98
Odden, Karen 108
Ogden, Thomas 4–5, 24, 213n4

painting 75, 124, 139, 151, 161–2, 166, 179–80, 198
Pajaczkowska, Claire 71, 161
Panofsky, Erwin 29, 35n8
paradox 17, 18, 41, 73, 80, 81, 84, 110, 128, 155, 157
Perry, Grayson 182–3
perspectival system 28, 29–30, 32, 34n8
phenomenology 16, 19, 27, 53, 54, 62
Phillips, Adam 15, 49–50, 65, 68, 195, 199
photography 28, 30, 31, 34n8, 174
playing *see under* Winnicott, Donald Woods
potential space xxvii–xviii, 4–5, 9n2, 14–15, 18, 23–4, 39–41, 45, 46, 50, 57, 105, 118, 139, 144, 154–5, 173, 179–81, 193
proprioception 16–17, 19, 69
Psycho (1960) 169
psychoanalytic film theory 18, 40

Quick and the Dead, The 175, **176**

Randolph, Jeanne 109
Remember the Titans (2000) 141–2, 144, 145
resonant form 166, 203, 212
 see also analogical form
reverie 3, 18, 126, 161, 164–5
 see also Milner, Marion
Rose, Gilbert 15, 161
Rosolato, Guy 68
Rousseau, Jean-Jacques 125, 126
Rustin, Margaret 16
Rustin, Michael 16

Rutherford, Anne 16, 69, 167
Ryle, Gilbert 25–6

Sabbadini, Andrea 15, 41, 79, 103, 104, 109–10
Said, Edward 87
Sandvoss, Cornel 82, 90, 111, 114
Scott, Ridley 111
Segal, Hanna 6, 153–4
semiotics 4, 80, 137–8, 139, 144
senses 16, 25, 49, 66, 69, 73, 74
separation-individuation 15–16, 55–6, 58, 61, 62, 71, 81, 135–6, 209, 210
Silverman, Kaja 72
Silverstone, Roger 7
Sleep (1963) 170
soap operas 7, 80, 82, 84, 89–90, 91, 93, 94, 96–7, 98
sociocultural psychology 137–8
sound 20, 66–9, 70–2, 73, 136
space/spatiality 8, 28–9, 54, 66–7, 70, 156, 157, 168, 173, 184
 cinematic space 40, 41, 42, 43–4, 45, 47, 62
 virtual space 8, 14, 18, 23, 26–8
spectators *see under* films
Squiggle Game 13, 29
stage *see* theatre
Star Wars (1977) 91
Stern, Daniel 155, 165, 203, 209–10
Stiegler, Bernard 31–2, 32–3, 35n14
Storr, Anthony 87, 151
subjective objects xix, 110, 162, 207–8
symbolic resources 84, 137–8, 139–40, 143
 and everyday creativity 144–5
symbolisation 4, 18, 25, 136

Tagore, Rabindranath, 'On the seashore' v, 18, 23, 28, 33, 103, 173, 184
Taxi Driver (1976) 132
television 83, 121, 125
 reality TV 129, 132
 as transitional object 61, 80
 see also soap operas
Terminator 2 (1991) 132
theatre 42–3, 162, 211

Thompson, Francis 211
Tisseron, Serge 139
Titanic (1997) 123
Tonkiss, Fran 74
transformational objects xviii, 206
transitional objects xvi–xvii, **14**, 25–6,
 106, **107**, 113, 115–16, 128, 136–7,
 154–5, 207
 and computer simulation 32
 and museums 156–7, 198–9
 'secondary' 90
transitional phenomena 3–4, 8, 25, 32,
 34n4, 57, 58, 88–9, 205–6
 'second-order' 114
transitional space *see* potential space
transitive objects 110–11, 118
Traveller, The/Mosafer (1974) 131
Turkle, Sherry 90, 91

Under the Skin 176–7, **178**

video 61, 116, 174
video games *see* computer games
virtual space 8, 14, 18, 23, 26–8
Vygotsky, Lev S. 138

Williams, Meg Harris 187, 192, 198
Wiltshire, John 79, 110
Winnicott, Donald Woods
 'Capacity to be alone, The' 73
 'Dreaming, fantasying, and
 living' 35n13, 72–3

'false self' 33, 35n13, 85
'Fate of the transitional object, The' 23,
 136, 137
'Location of cultural experience,
 The' 3, 4, 23, 29, 103, 106, 118, 136,
 159–60, 173
'Mirror role of mother and family in
 child development, The' xvii, 107,
 209
playing xvii–xviii, 16, 18–19, 39–40, 50,
 57, 89, 130, 131, 136, 145, 180–1
Squiggle Game 13, 29
'String: a technique of
 communication' 13–14, 20, 80–1
theoretical first feed 2, 5
'Transitional objects and transitional
 phenomena' xvii, 24, 88–9, 108,
 206–7
'Use of an object, The' xvii, xix, 71, 135
see also aggression; holding
 environment; inherited tradition;
 mirroring; paradox; potential space;
 symbolisation; transitional objects;
 transitional phenomena
Woolf, Virginia 41, 81
Wordsworth, William 208, 211
Wright, Kenneth 182

Yates, Candida 114, 116, 118
YouTube 30, 116

Zittoun, Tania 85, 111